ARTISTIC VOYAGERS

ARTISTIC VOYAGERS

Europe and the American
Imagination in the Works of
Irving, Allston, Cole,
Cooper, and Hawthorne

JOY S. KASSON

CONTRIBUTIONS IN AMERICAN STUDIES, NUMBER 60

GREENWOOD PRESS

WESTPORT, CONNECTICUT • LONDON, ENGLAND

Library of Congress Cataloging in Publication Data

Kasson, Joy S.
 Artistic voyagers.

 (Contributions in American studies, ISSN 0084-9227 ;
no. 60)
 Bibliography: p.
 Includes index.
 1. American literature—19th century—History and
criticism. 2. Europe in literature. 3. Art, American.
4. Art, Modern—19th century—United States. 5. Europe
in art. 6. United States—Civilization—European
influences. I. Title. II. Series.
PS217.E87K37 1982 810'.9'003 81-23743
ISBN 0-313-23089-7 (lib. bdg.) AACR2

Library of Congress Catalog Card Number: 81-23743
ISBN: 0-313-23089-7
ISSN: 0084-9227

First published in 1982

Greenwood Press
A division of Congressional Information Service, Inc.
88 Post Road West
Westport, Connecticut 06881

Printed in the United States of America

10 9 8 7 6 5 4 3 2 1

For John

CONTENTS

ILLUSTRATIONS

ACKNOWLEDGMENTS

I am grateful for the assistance I received from many quarters during my work on this book. My research was facilitated by the knowledgeable and helpful staff members at the following libraries: the Massachusetts Historical Society, the New-York Historical Society, the New York Public Library, the Boston Public Library, the Boston Athenaeum, the Houghton Library, Yale University Library, the Library of Congress, the University of North Carolina Rare Book Room, and the North Carolina Collection. I also appreciated the opportunity to work with manuscripts housed at the Longfellow National Historical Site in Cambridge, Massachusetts. The Detroit Institute of Arts generously allowed me access to paintings, drawings, and files, and the Archives of American Art in Detroit was very helpful in answering my inquiries.

I greatly appreciated the financial assistance given by the Smith Fund of the Graduate School of the University of North Carolina and by the dean's fund for the support of scholarly publications at the University of North Carolina.

For their cheerful and diligent help in the preparation of this manuscript I would like to thank Jane Birken, Stan Gilliam, and Debbie Riggsbee.

Chapter One, "Washington Irving: The Citadel Within," appeared in a slightly different form in *Prospects* 3 (1977): 371-417. I would like to thank Jack Salzman and Burt Franklin Publishers for their permission to include it here.

This project began under the direction of Charles Feidelson and Jules Prown, and I would like to thank them for their encouragement and suggestions at that time and since. My work benefited from correspondence with E. P. Richardson and Ellwood C. Parry III. I am especially

grateful for the thoughtful suggestions offered by those colleagues who read all or part of my manuscript, including Carl Smith, David Hall, Richard Ellmann, Richard Rust, Richard Fogle, Giles Gunn, Donald Mathews, Arthur Marks, and Malcolm Call. Needless to say, I am responsible for any errors that have escaped their careful attention.

Most of all, I wish to acknowledge the support and encouragement of my best critic and wisest advisor, my husband, John F. Kasson.

ARTISTIC VOYAGERS

INTRODUCTION

This study explores a paradox. During the half-century that preceded the Civil War, American art and literature flowered in an extraordinary renaissance of self-consciously national expression. Yet most of the major figures of that period, both writers and painters, were drawn to visit, learn from, and come to artistic terms with the Old World. Even while pursuing the goal of artistic nationalism, these artists found something stimulating and sustaining in their exposure to Europe. Although the nativist aspects of American art, the development of distinctive forms in both literature and the visual arts, have been thoroughly explored by critics and historians, the opposing tendency, the pull toward Europe, has been largely overlooked.[1]

There are two major reasons for the relative neglect of the European aspects of these major American artists. First, from the nineteenth century to the present, some of the most articulate and energetic critics of the arts have been passionately committed to the idea of American exceptionalism and have been especially sensitive to those aspects of American art and literature that set them apart from their Old World counterparts. Furthermore, both literary criticism and art history have been slow to admit American works to their canons except as expressions of a national culture. As a result, the European works of major American figures often have been dismissed as aesthetically inferior, imitative, and uninteresting. This study seeks to reexamine these works and to place them in a critical and historical context.

American voyagers, artistic and otherwise, had been visiting and responding to Europe since colonial times, and in the Victorian period travel would become a popular pastime for a newly affluent upper middle class. In all these periods, American travelers shared certain perceptions, contrasting their country's youth with Europe's dense

historical associations, remarking on the richness of Europe's artistic
heritage in comparison with art life in the United States. During the
first half of the nineteenth century these issues had a special urgency
for the citizens of this country, for its political and artistic character
were still very much in question. Themes of empire and national destiny
particularly were compelling to American travelers, whose own country
was struggling toward self-definition. American artists of this period
seem to have been especially sensitive to questions about the meaning
of an artistic vocation and their relationship as Americans to European
models and mentors.

I have chosen to explore the question of European influences on the
American imagination during this period through a close study of five
figures: Washington Irving, Washington Allston, Thomas Cole, James
Fenimore Cooper, and Nathaniel Hawthorne. This list includes both
writers and painters because similar issues occupied artists in both
media.[2] Although dozens of others shared their experiences and responded
in a similar fashion, these five men were clearly identified by their
contemporaries and later critics as major artists, and each traveled to
Europe at a pivotal point in his career. They were known to each other
and in some cases mutually influential or competitive. They shared
mutual friendships, discussed philosophy, aesthetics, and politics with
each other, appreciated and commented on each other's achievements,
and sometimes chose subjects inspired by each other's works. Their
expectations from their travel varied from those of Allston, who went
to Europe to become an artist, to those of Cooper, who expected to
remain unchanged by his experiences abroad.

For these men, a European voyage stimulated significant changes in
their artistic goals, their concepts of themselves as artists, and the kinds
of artistic work they preferred to do. Often it changed their relationship
with their public as well, and their subsequent careers brought them
frustrations as they tried to balance their artistic aims with the expecta-
tions and desires of their American audience. In each case one major
work seems to epitomize the artist's imaginative struggle and resolution.
Close attention to these novels and paintings can increase our appreciation
of them as works of art arising out of a particular biographical context
and artistic tradition. At the same time, such a study can help to elucidate
a problem central to the American creative experience: how to lay
claim to an ambiguous past.

After considering in some detail individual lives and specific artworks,
I found larger themes beginning to emerge. For all these artists, European
travel was an intense, highly charged experience. The physical scene—
natural landscape, architecture, artifacts, an anonymous populace—
impressed them deeply. Schooled in an associationist psychology and
a picturesque aesthetic, they read the European scene for its deeper
meanings. Contact with the Old World made Americans acutely con-

scious of history and of art. It brought them into intimate contact with artistic predecessors previously known only by reputation, and it made them think more deeply about the meaning of history. Nineteenth-century America was proud of its exemption from the corruptions of history, but what about history's lessons for the future? The Old Masters in painting and sculpture offered insights into human nature tried by extremity. If America was the realm of the innocent, the unfallen, how could it produce profound art? Yet if the American artist tried to probe the questions that Europe opened to his imagination, was he not abandoning American themes and leaving his audience behind?

Although later generations would explore many of these same questions thoroughly and self-consciously, it was during the antebellum period that the crucial themes in American imaginative life began to coalesce. Scholars have long recognized this as the "classic" period in the development of an art and literature native to the American soil. A study of the international aspects of these same artists can deepen our sense of the period. By moving outside America these men gained insights, sometimes liberating, sometimes paralyzing, into the meaning of their work as American artists.

Notes

1. From F. O. Mathiessen, *American Renaissance: Art and Expression in the Age of Emerson and Whitman* (New York: Oxford University Press, 1941), through Benjamin T. Spencer, *The Quest for Nationality: An American Literary Campaign* (Syracuse, N.Y.: Syracuse University Press, 1957), and J. Meredith Neil, *Toward a National Taste: America's Quest for Aesthetic Independence* (Honolulu: University Press of Hawaii, 1975), numerous studies have probed the nativist aspects of American art and literature. Studies of Americans in Europe, such as Nathalia Wright, *American Novelists in Italy, The Discoverers, Allston to James* (Philadelphia: University of Pennsylvania Press, 1965) and Ernest Earnest, *Expatriates and Patriots: American Artists, Scholars, and Writers in Europe* (Durham, N.C.: Duke University Press, 1968), have been biographical and narrative rather than analytical.

2. For a discussion of aesthetic theory linking painting and poetry see Donald Ringe, "Painting as Poem in the Hudson River Aesthetic," *American Quarterly* 12 (Spring 1960): 71-83. For background on the history of this aesthetic linkage see Rensselaer W. Lee, *Ut Pictura Poesis: The Humanistic Theory of Painting* (1940; reprint ed., New York: The Norton Library, 1967) and Jean H. Hagstrum, *The Sister Arts: The Tradition of Literary Pictorialism and English Poetry from Dreyden to Gray* (Chicago, Ill.: University of Chicago Press, 1958). The best study of biographical links between writers and painters is James T. Callow, *Kindred Spirits: Knickerbocker Writers and American Artists, 1807-1855* (Chapel Hill: University of North Carolina Press, 1967). Numerous articles link specific writers with painters: Cole and Cooper, Cole and Bryant, and so on.

1
WASHINGTON IRVING:
The Citadel Within

The Sketch Book, published between 1819 and 1820, marked a watershed in the career of Washington Irving and the history of American letters. Its critical success on both sides of the Atlantic helped bolster the self-confidence of a new nation, the cultural life of which lay in disarray. "In the four quarters of the globe," Sydney Smith asked, "who reads an American book?"[1] *The Sketch Book* proved, as Irving later put it, that a "demi-savage" from the New World wilderness could hold "a feather in his hand, instead of on his head."[2] Yet his achievement came at some cost. Irving's very success in conforming to European literary standards opened him to charges of imitativeness and overrefinement; critics claimed his work was too Anglicized and prettified, that he sold his native birthright for the pottage of international acclaim.[3]

In retrospect it is all too easy to view the book as the first of a series of literary successes in the same mold: *Bracebridge Hall, The Alhambra,* and the rest of the shelfful of volumes read so avidly by his contemporaries and collected so stylishly in the Author's Revised Edition of 1848. Yet, *The Sketch Book* represented the resolution of an acute personal crisis for Irving himself and, at the time of its serial publication, seemed to its author a literary gamble, a slow and uncertain venture toward an indistinctly glimpsed goal. A closer examination of Irving's career at the time of *The Sketch Book*'s composition reveals a man struggling to define his aims and ambitions.

The Sketch Book should be read not only as an American's response to a European visit but also as an exploration of the creative process itself. In this sense it is a pioneer work, for like the other figures to be discussed later Irving found that the European scene, the landscape and the history, raised fundamental artistic issues for him. His responses to the Old World became the keys to his own artistic identity.

Irving was thirty-six years old when he published *The Sketch Book*. He had already passed through a number of career decisions and personal crises, but his early life offered only hints of the literary stance he successfully adopted after 1820. As the youngest of four brothers, he enjoyed considerable indulgence as a young man uncertain of his career goals. To please his family he studied law in a desultory way and dabbled in journalism and business.

In 1804 Irving's brothers sent him to Europe, where they hoped he would improve his health and clarify his ambitions. At the age of twenty-one, however, he proved to be a conventional and somewhat lazy traveler, dutifully recording his impressions of important monuments in letters and journals but reserving his real enthusiasm for good company on the road. Early in his travels he set down in his journal the irreverent comments of a fellow traveler, Henry Hamilton Schiefflin: "S_____ is quite tired of traveling. He says he finds himself a little older than when he sat out [sic], but very little wiser. Two thousand Dollars out of pocket and not two thousand cents worth of improvement in."[4] Irving must have thought of his countryman's complaint as his own trip progressed, for after a year of traveling he was clearly suffering from tourist fatigue. "Milan contains several churches possessing some pieces of painting and sculpture worthy the attention of the traveller but we were so fatigued in body and our imagination so much satiated with the profusion of masterpieces we had seen that we could not prevail upon ourselves to visit any of them."[5] Comments like this brought scorching replies from his sponsoring brothers, who were shocked that Irving was trying to "*gallop through Italy*" and thus passing up important opportunities. William Irving wrote severely, "All Italy, I presume, is to be scoured through (leaving Florence on your left and Venice on your right,) in the short period of eight or nine weeks!"[6]

Irving's attitudes on this early trip show what a long road he traveled to reach *The Sketch Book*. By 1804 he already possessed what he would later describe as "a fatal propensity to Belles lettres."[7] He had written the "Letters of Jonathan Oldstyle" for the *Morning Chronicle* and had contributed essays and sketches to *The Corrector*. Yet, despite the obvious labor displayed in the corrections and rewriting of parts of his European journal, nothing in these notes forecast the traveling persona who emerged in *The Sketch Book*. In 1804 he presented himself as a somewhat bored young gentleman traveling for his health. He was still a dabbler, still a dilettante, and his discovery of a literary vocation was yet to come.

Irving's attitudes toward travel and his career had changed very little when he embarked on his next trip to Europe in 1815. Much had happened in the nine-year interval. He had studied law and tried to settle down; he had become engaged to Matilda Hoffman, whose death left him

profoundly shaken; and he had rendered military service during the War of 1812. His literary interests had expanded. In partnership with his brother William, James Kirke Paulding, and publisher David Longworth, he had impressed New York with *Salmagundi*; his *History of New York* had received wide acclaim; and he had put in two years as the editor of *Analectic Magazine*. Compared to the restless youth of twenty-one, he was much closer to an identity as a literary man, but he found it hard to concentrate his talents. His grief at Matilda Hoffman's death seemed to linger, despite rousing drinking parties with his New York friends and frequent trips to Washington on behalf of his brothers' business. When the war ended in 1815 he prescribed for himself another trip abroad for reasons as conventional as those that prompted the first. He found "my time & thoughts dissipated and my spirits jaded. I became weary of every thing and of myself."[8] Like many overworked businessmen or out-of-sorts gentlemen of leisure, he hoped that travel would refresh him.

The change in Irving's attitude toward Europe, and the accompanying change in his concept of himself as a writer, came sometime between May 1815 when he left New York for Liverpool, and March 1819 when he sent to New York the first number of *The Sketch Book*. Between these two dates Irving underwent a personal crisis that profoundly shook him, and he emerged completely committed to a literary career in a different sense than before. An old self died and new self was born.

The event that triggered this reorientation was the failure of his brothers' business, P. & E. Irving, an experience that Irving later said "altered the whole tenor of my life."[9] The financial collapse would have affected him wherever he was, for it removed his chief source of support. His older brothers had made him a silent partner and agent-at-large for their import business in 1810, when Irving was at loose ends after Matilda Hoffman's death. His duties were minimal, supposedly leaving the young author leisure for writing. He was to travel occasionally to Washington to keep an eye on legislation affecting their interests, while Peter Irving handled the purchasing in Liverpool and Ebenezer Irving oversaw the sales in New York. It was, in fact, a continuation of that same generous concern that had prompted his brothers to send him abroad in 1804-1806. This support enabled Irving to travel and live in leisure like a gentleman. Financial reverses would have necessarily changed his way of living, even if only temporarily. The collapse of the business, however, affected Irving even more directly since it occurred when he was directly involved in it. Arriving in England in 1815, he found Peter physically incapacitated; he was drawn into active participation; and to his horror, he soon saw the business founder and sink while he stood helplessly by.

Irving's letters to his friend Henry Brevoort during this period show

clearly his changing expectations as the financial crisis unfolded. His first letter after his arrival in Liverpool was cheerful, if not very perceptive. His mind was still on his own health, and he seemed curiously impervious to the drastic change in Peter, who was confined to the house with a violent attack of erysipelas, a debilitating skin disease. "Poor fellow," Irving commented lightly, adding that he found him "the same identical being he was in America."[10] By August, Irving found himself "attending a little to our business here on account of Peter's indisposition," but he anticipated no problems. In fact, his letter was full of cheerful puns. "Our business I trust will be very *good*—it certainly will be very *great*, this year, and will give us credit, if not profit."[11] At this point Irving was still joking about what was to be the firm's downfall: Peter's drastic overpurchasing, which stretched their resources too thin and ruined them when the market collapsed.[12] By October, Irving's letters to Brevoort show him plunging up to his shoulders in the struggle. Taking a course in bookkeeping, he wrestled with the company records. His letter of October 17, 1815, speaks with the voice of a harried merchant, a different being from the bored gentleman who had arrived in Europe seeking amusement. "For several weeks past I have been more *really* busy than I ever was in my life. As I am a complete novice in business it of course takes up my whole time and completely occupies my mind, so that at present I am as dull commonplaced a fellow as ever figured upon Change. When I once more emerge from the mud of Liverpool, and shake off the sordid cares of the Counting House, you shall hear from me."[13]

He remained mired in the Liverpool mud for nearly three years, sending out frequent reports on his ever-worsening state of mind. Although there were temporary reprieves—improvements in business, holidays with his sister's family in Birmingham, with friends in London, and trips to Wales and Scotland—for the most part his letters chronicle a rising tide of despair. In March 1816, he wrote to Brevoort, "I have been so completely driven out of my usual track of thought and feeling, by 'stress of weather' in business that I have not been able to pen a single line on any subject that was not connected with traffic. . . . I have never passed so anxious a time in my life—my rest has been broken & my health & spirits almost prostrated."[14] In November he wrote a limp and weary letter, pleading the inability to concentrate. "In fact I was always a poor precarious animal but am just now worse than ever."[15] By July 1817, impending collapse was clear, and Irving wrote of "waiting to extricate myself from the ruins of our unfortunate concern," but in fact the struggle dragged on into 1818, when the Irvings finally declared bankruptcy.[16]

Bankruptcy was a shock and a disgrace, although Irving received gentle treatment from officials. Certainly all members of the family

suffered financially. Ebenezer, the father of a family of eight (soon to be enriched by twins and to swell eventually to thirteen), Peter, and even his brother-in-law, Henry Van Wart, were damaged by the failure. While the bachelor Irving was better off than his brothers, and indeed worried about their welfare,[17] the crisis affected him in a way that went beyond financial embarrassment. In an extraordinarily revealing letter written to a sympathetic friend, Mrs. John Foster, during a later crisis in Dresden, Irving expanded on the meaning of those years of financial anxiety. "Good heavens what I suffered for months and months and months. I lost all appetite I scarcely slept—I went to my bed every night as to a grave." In a sense, his bed was a grave: an old self was dying. Despite the fact that he shared the financial ordeal with his brothers, its impact on him was direct and lonely. "I felt cast down—abased—I had lost my *cast*—I had always been proud of spirit, and in my own country had been, as it were, a being of the air—I felt the force of the text 'a wounded spirit who can bear?' I shut myself up from society—and would see no one." In fact, as Irving described the experience, it was the major crisis of his life, even more shattering than the death of his fiancée Matilda Hoffman in 1809. "This new calamity seemed more intolerable even than that which had before overcome me. That was solemn and sanctifying, it seemed while it prostrated my spirits, to purify & elevate my soul. But this was vile and sordid and humiliated me to the dust."[18]

Irving's own comparison of this financial crisis to his fiancée's death is significant, for the seventeen-year-old Matilda Hoffman and her effect on Irving have fascinated Irving's biographers from his day to ours. This is not meant to denigrate the impact of her death, which he witnessed in all its agony. That it was a painful experience is undeniable, and it seems fully plausible that it left permanent emotional scars: "For years I could not talk on the subject of this hopeless regret; I could not even mention her name; but her image was continually before me, and I dreamt of her incessantly."[19] However, after a period of intense melancholy Irving returned to the easy sociable life he loved. In his letters to Brevoort he always liked to appear a gay blade, but it is significant that in 1812 he was joking about the advantages of getting "happily married."[20] Nineteenth-century observers liked to speculate on why Irving never married, and a heart yearning after a lost love supplied a convenient answer.[21] Given his volatile temperament, his delight in male companionship, and his pattern of relationships with very young girls or safely married women, Irving may not have been emotionally suited to marriage under any conditions. The possibility of marriage was foreclosed, however, by the financial anxiety in which he was enmeshed from the ages of thirty-two to thirty-seven. During this same period his old bachelor cohorts Paulding and Brevoort married, and Brevoort

promised to "marry you at once" as he urged Irving to return to New York.[22] To Paulding, Irving wrote wistfully, "Your picture of domestic enjoyment indeed raises my envy. With all my wandering habits, which are the result of circumstances rather than disposition, I think I was formed for an honest, domestic, uxorious man, and I cannot hear of my old cronies snugly nestled down with good wives and fine children round them but I feel for the moment desolate and forlorn." He went on to lament his situation: "Youth slipping away without any means or prospect of entering into matrimony, which I absolutely believe indispensable to the happiness and even comfort of the after part of existence."[23] Without doubt, the financial crisis of 1815-18 was a more powerful influence on the shape of Irving's personal life than even his engagement to Matilda Hoffman and her subsequent death.[24]

This three-year period of financial anxiety also triggered a professional crisis for Irving, arousing in him questions about the purpose and direction of his life. He had lost his financial base, that indulgent backing of his older brothers, which had served as a cushion in all his previous endeavors, but the loss of his privileged leisure alone cannot explain his despair. Irving had acted responsibly in this crisis and pulled his weight in the family business for the first time. Yet his efforts were futile; the business failed despite his exertions. It is interesting to speculate on what might have happened if Irving had been able to avert financial ruin: would he have drifted into a business career like his brother Peter, who had dropped out of collaboration on the *History of New York* when he discovered the joys of purchasing? Irving had no such opportunities to enjoy business suceess; his experience was one long frustration. Because he had happened to be available when the financial crisis loomed, he had made a major deviation from his own life pattern: he became a businessman, only to watch the business fail. It was his sense of failure and the accompanying guilt and loss of self-esteem that made the business collapse so devastating for him. It was not something that had simply happened to him, as he might have felt if he had still been in New York or Washington, but something in which he had actively participated. He had failed as a businessman, and he could no longer be a man of leisure. Where then could he seek his identity?

To return to writing and to write well seemed to Irving the only possible escape from the crisis into which he had plunged. His sense of self hung in the balance; he felt defensive and cornered. He complained in his journal, "I have repeatedly applied for some paltry public situation, but have been as often disappointed. It has pleased heaven that I should be driven in upon my own strength—and resort to the citadel within me."[25] This short entry delineates the process Irving went through during these years: a retreat from his former sense of himself as a gentleman, a man of affairs who could pick up an easy living and dabble

in literature, and a new vision of himself as a more serious, more private and self-reliant individual. Perhaps for the first time, the lover of congenial company and good times was discovering an inner strength, the "citadel within." From this inner self would come his vindication. "The idea suddenly came to me," he wrote in the confessional manuscript of 1823, "to return to my pen, not so much for support, for bread & water had no terrors for me, but to reinstate myself from the degradation into which I considered myself fallen."[26] Quite explicitly, Irving saw a literary career as a way to salvage his self-respect and sense of identity.

Unfortunately, the financial crisis and its accompanying sense of failure made it even more difficult for Irving to resume his literary career. As he wrote to Brevoort at the beginning of his involvement in the business, he felt himself a "dull commonplaced" fellow, enmired in "the mud of Liverpool."[27] The deeper he delved into business, the less he was able to think of himself as a writer. "I have attempted to divert my thoughts into other channels; to revive the literary feeling & to employ myself with my pen, but at present it is impossible," he wrote on July 16, 1816.[28] His mind felt "as bare as a market place," he complained on November 6, 1816. "When I do take hold of my pen, I feel so poverty struck, such mental sterility that I throw it down again. . . ."[29] No wonder those years seemed to Irving such a purgatory; just at the time he needed to marshall his literary resources they seemed more inaccessible than ever.

In some ways this anxiety and sense of crisis were salutary. Throughout his life Irving suffered from fits of ennui and mental lassitude; necessity jolted him into action. The mental sterility that he complained about in these letters represented the very problem he had to solve. As his friend James Ogilvie wrote in an encouraging letter of 1817, "You want nothing but a stimulus strong enough to overcome that indolence which, in a greater or less degree, besets every human being. This seemingly unfortunate incident will supply the stimulus—you will return with renovated ardor to the arena you have for a season abandoned, and in twelve months win trophies, for which, but for this incident, you would not even have contended."[30] As in his previous period of depression after Matilda Hoffman's death, Irving again wrestled with his despair, trying to turn anxiety into creative drive.[31]

He emerged from this crisis with a renewed commitment to a literary career. But the question remained, what kind of career should that be? Beginning with the venerable Benjamin Franklin, ample precedents existed in the bustling American scene for Irving's youthful efforts in journalism, which culminated in *Salmagundi*. But even Franklin had not made his living by writing, and during the first decades of the nineteenth century, literature was still regarded as an avocation rather than a profession in America. As Irving had justifiably observed in a review in the *Analectic Magazine*, in a business society "the man of letters is

almost an insulated being, with few to understand, less to value, and scarcely any to encourage his pursuits."[32] Irving's cohorts among the New York literati—Paulding, Brevoort, Verplanck, even his own brothers— engaged in literature only in their spare time and otherwise earned their livings in business, like Brevoort, or from a public office, like Paulding. *Salmagundi* and *History of New York* had been *jeux d'esprit*, and editing the *Analectic* had been a part-time job. In his determination to write for a living Irving had to reevaluate the shape of his literary career.

For this reason, it was fortunate that Irving happened to be in Europe when financial disaster struck. Surely there was no better place to study the possibilities of a literary career. Literature was just coming into its own as a profession in England.[33] By observing successful writers and by noting the ways in which they defined their careers, Irving could set his own goals. When he resisted his friends' pleas to return to America and instead moved to London, determined to make himself a writer, he came prepared to use the resources of the literary capital. Gratefully accepting invitations to dine at John Murray's, he met D'Israeli and heard gossip about Byron.[34] Washington Allston, whom he had met in Rome, introduced him to Coleridge.[35] In the absence of American models, Irving explored the literary profession as it existed in England, for he was determined to develop his own version of it.

The turning point of Irving's struggle came during the summer of 1817. By this time, he had accepted the inevitability of bankruptcy. His mother's death in April 1817 had forestalled his plan to return to America and at the same time had increased his sense of isolation from the past. In August 1817, he took his first active steps toward a serious literary career.

In that month Irving set off for a tour of Scotland with a fellow American, William Preston. He had always used travel as a diversion from his troubles, but this trip had a business dimension as well. On July 11, 1817, he had written to Brevoort of "a plan which, with very little trouble, will yield me for the present a scanty but sufficient means of support, and leave me leisure to look round for something better."[36] Apparently he intended to gather material from English publishers for reprinting in America under the auspices of his old publisher, Moses Thomas. For this purpose Irving sought introductions to literary circles in Scotland; and indeed the trip yielded agreements with Constable, the publisher of the Waverley novels, and with Blackwood.[37]

This publishing scheme led him to an experience that changed the tenor of his trip and gave his literary hopes an unexpected boost. From August 30 to September 3, 1817, he visited Sir Walter Scott at his home, Abbotsford. Scott, whose authorship of the Waverley novels was not yet publicly acknowledged, was working on *Rob Roy*, and the promise of

publishing rights for that novel was one of the prizes Irving carried back from Edinburgh. However, if Irving originally had called on Scott in his role as literary agent, the visit then took a turn that bore more directly on the larger problem of his artistic vocation. Scott treated Irving kindly and took his literary aspirations seriously. Together the two men toured the local scenery and discussed literature; Scott talked about his interest in folklore and urged Irving to learn German. Irving found in Scott his model for a professional literary career, and the older man's encouragement helped to boost his self-confidence and break the downward spiral of despair that had kept him from writing.

Throughout the remainder of his life, Irving thought of Scott as a benefactor and a source of inspiration. "I felt it a happiness to have lived in the same time with him," he declared of Scott later.[38] By suggesting Irving's name for an editorship when his finances were low and helping to arrange for an English edition of *The Sketch Book*, Scott offered Irving practical help as well as encouragement. Irving repaid this debt with a grateful preface to *The Sketch Book* and a reminiscence he published after Scott's death. His note of thanks after the 1817 visit shows the emotional impact of the older man's kindness at a time of personal crisis: "Surrounded as you are by friends among the most intelligent and illustrious, the good will of an individual like myself cannot be a matter of much importance, yet I feel a gratification in expressing it, and in assuring you that I shall consider the few days I passed with you and your amiable family as among the choicest of my life."[39]

The visit to Scotland in 1817 represented a turning point in Irving's discovery of a true literary vocation. Like his work on the *Analectic*, his English publishing scheme cast him in the role of literary agent and facilitator of transatlantic exchange. He planned a new edition of the *History of New York* and commissioned engravings from Allston and Charles Leslie. Yet even while he revived these older projects, he began to grope toward the new literary identity he sought. It was during this trip that he began openly to envision himself as a professional writer. "Irving decided that literature was to be his profession and the means of support," wrote his traveling companion William Preston, adding that he "occasionally asked me when he gave an account of anything that touched him how would that do in print."[40]

From 1817 when he reopened his literary career until 1819 when he began sending the *Sketch Book* essays to America for publication, Irving forged the literary identity that would become so famous. From madcap journalist and mock-historian he evolved into a sentimental essayist and melancholy traveler. The exhausted dilettante who had complained of the mental sterility of the counting house underwent a period of significant growth and emerged as the easy stylist of *The Sketch Book*.

Irving's sojourn in Europe played an essential role in developing this literary identity. Although his presence in Europe during the crisis of his brothers' business was mere chance, his decision to remain after bankruptcy was a choice that bore directly on his literary plans. Europe had not been connected with Irving's own writings previously; in fact, those works derived their charm from their local, immediate, even provincial quality. In his appreciation of Irving's *History of New York*, Sir Walter Scott had qualified his delight in the style and humor with the observation that the satire remained rather inaccessible to "a stranger to American parties and politics."[41] At that stage in his career, Irving had written as an insider, a purveyor of inside jokes and local allusions.

The man who now found his identity so deeply shaken by financial crises was no longer capable of being an insider. He could not return to his old haunts on the same terms, for he felt alienated from his previous life. His friend Brevoort had urged him to come back and to pick up his career in America. But on the eve of his trip to Scotland, Irving firmly asserted his decision to stay abroad, at least for the time being.

I have weighed every thing *pro and con* on the subject of returning home and have for the present abandoned the idea. My affections would at once prompt me to return, but in doing so, would they insure me any happiness? Would they not on the contrary be productive of misery? I should find those I love & whom I had left prosperous—struggling with adversity without my being able to yield them any comfort or assistance. Every scene of past enjoyment would be a cause of regret and discontent. I should have no immediate mode of support & should be perhaps a bother to my friends who have claims enough on their sympathy & exertions. No—no. If I must scuffle with poverty let me do it out of sight—where I am but little known—where I cannot even contrast present penury with former affluence.[42]

If he could not return home in triumph he would remain in exile, scuffling with his problems out of sight, retreating, as he said in his journal, to the citadel within. And if he could not be an insider he could not write like an insider. In his sense of wounded pride and shaken identity, the image of the wanderer began to stir his imagination. It was this image of the outsider, melancholy, lonely, yet observant, that would serve him so well in his literary persona, Geoffrey Crayon.

This new fictional identity clearly was gestating by the summer of 1817 when Irving, for the first time in several years, began to keep literary notebooks. In these he recorded notes on his travels in Scotland strongly reminiscent of his travel journals of 1804-1806 and 1815. Mixed with the day-to-day observations, however, are personal reminiscences, notes for stories, and fragments of sentences that show that he was also experimenting with style, reflecting on his past, and planning for his future. At least one essay for *The Sketch Book*, "The

Wife," appears in condensed form. One uncompleted project, either a novel or a long tale, entitled "Rosalie," contains themes of wandering and settling down, gaining and losing one's heart's desire, and shows the direction in which his imagination was moving. Scattered throughout the notebooks are fragments of melancholy expression: "In the days of early youth before I had lost a friend or experienced a disaster," and "I have seen the world I have tasted its pleasures I have explored its recesses & what have I gained what but a distaste for life a distrust for man."[43] Some of these fragments would find their way into such sketches as "The Widow" or "The Broken Heart," while others were never expanded. These notebooks also contain a lamentation on the death of Matilda Hoffman, a sign that Irving was reflecting on his past sorrows and attempting to turn these emotions into words, an effort he had not made previously in the eight years since her death.[44] In his search for a new identity, Irving was trying to come to terms with his past. Mixing private and fictional melancholy in his notebooks, he groped toward his literary self.

While his new persona began to take shape in his notebooks, Irving moved toward a different view of his career. In deciding to resume the role of literary agent and to reprint the *History of New York*, he had not strayed far from his earlier, part-time literary efforts. In the fall of 1817 he apparently was still hoping to maintain a nonliterary source of income that could offer him the kind of support previously provided by P. & E. Irving. In Washington his brother was lobbying to have him appointed to the United States legation in London. Irving wrote Brevoort that he was not optimistic about his chances of success, but clearly he would have liked the appointment.[45] Irving had sought political patronage several times, beginning as early as 1807 when he asked Judge Hoffman to "speak a 'word in season' for me" at the "dispensation of loaves and fishes" in Albany.[46] Since Irving's political activities had been minimal, political rewards had eluded him then, and the situation was no different in 1817.

Coming on the heels of his business failure, this political rejection drove Irving even more sharply to his resolution to be self-reliant and to seek a new identity as a writer. He must have been in the throes of such an emotion when he wrote the journal entry vowing retreat to "the citadel within." In December 1817 he wrote to William to thank him for his efforts, and his letter took a new, bitter tone: "I do not anticipate any favors from government, which has so many zealous and active partisans to serve, and I should not like to have my name hackneyed about among office-seekers and office-givers at Washington." He feared that he had not only been denied appointment but also exposed to ridicule because of his misfortunes. Once again he determined to remain an outsider if he could not be an insider on his own terms. He went on

to make the strongest assertion to date of his maturing plans for a literary identity and linked this identity with continued residence in Europe: "I have been urged by several of my friends to return home immediately; their advice is given on vague and general ideas that it would be to my advantage. My mind is made up to remain a little longer in Europe, for definite, and, I trust advantageous purposes. . . . I feel that my future career must depend very much upon myself, and therefore every step I take at present, is done with proper considerations."[47]

Irving's sense of anger over one more political rejection was the culmination of the larger sense of separation from his earlier life that he had experienced in 1817-18. In January 1818, shortly after filing for bankruptcy, he wrote Brevoort of his desire to move ahead with his life: "In the course of two or three months I hope to have finally got through difficulties here, and to close this gloomy page of existence—what the next will be that I shall turn over, is all uncertainty. But I trust in a kind providence that shapes all things for the best, and yet I hope to find future good springing out of these present adversities."[48] Although he did not mention it in the letter, he was writing again; his commitment to a literary career seemed firm. In August 1818 he moved to London in order to write with greater concentration.[49] Although his health was troublesome and he was still working in fits and starts, by the end of the summer he had decided to risk everything on his literary venture.[50]

The change in Irving's attitude may be seen in his response to the job offer that suddenly came to him in the autumn of 1818. After more than a year of effort, William had finally secured a political position for him. With the aid of their old friend Stephen Decatur, Irving was offered the job of first clerk of the Navy Department at a salary of $2,400, which, as William said, "is sufficient to enable you to live in Washington like a prince." He would have to return to America, but he could continue his writing, if he wished, on a part-time basis. "It is a birth [sic] highly respectable. Very comfortable in its income, light in its duties, and will afford you a very ample leisure to pursue the bent of your literary inclinations. It may also be a mere stepping stone to higher station and may be considered at any rate permanent."[51] A year earlier Irving would have jumped at the chance, believing he could continue to dabble in literature in the old way, but by this time he was committed to an experiment in the literary profession. Later he described his state of mind: "Just as I was getting my pen into activity I received a letter from America offering me an honorable place under government. I declined it—my pride was up—I would receive nothing as a boon granted to a ruined man—I was resolved to raise myself once more by my talents, and owe nothing to compassion."[52] He wrote to his brother and declined the position, asserting his commitment to a literary identity: "I do not

wish to undertake any situation that must involve me in such a routine of duties as to prevent my attending to literary pursuits."[53] The break with the past was final, as his brothers in America realized. As Irving's new self was coming into existence in London, they lamented to each other the demise of the old. "Home has lost its charms to both [Peter] and Washington," wrote William to Ebenezer. "It is as well to accommodate the heart to its loss, and to consider them, as to all but epistolary correspondence, dead to us."[54]

The Sketch Book, then, should be seen as the product of Irving's break with the past and his resolution to embark on a full-fledged literary career. He sent the first installment to America in March 1819, with an elaborate letter to his brother Ebenezer explaining his literary plans. First, he repeated his reasons for declining the navy job:

The fact is, that situation would have given me barely a genteel subsistence. It would have led to no higher situations, for I am quite unfitted for political life. My talents are merely literary, and all my habits of thinking, reading, &c. have been in a different direction from that required for the active politician. It is a mistake also to suppose I would fill an office there, and devote myself at the same time to literature. I require much leisure and a mind entirely abstracted from other cares and occupations, if I would write much or write well. I should therefore at Washington be completely out of my element, and instead of adding to my reputation, stand a chance of impairing that which I already possess. If I ever get any solid credit with the public, it must be in the quiet and assiduous operations of my pen, under the mere guidance of fancy or feeling.

Although he described himself diffidently ("merely literary," "mere guidance of fancy or feeling"), Irving served notice that he was serious about a career in literature. Aware of his audience, he tried to describe the literary profession in terms that his businessman brothers could understand. Following up the metaphor of "credit," Irving continued, "I have been for some time past nursing my mind up for literary operations, and collecting materials for the purpose. I shall be able, I trust, now to produce articles from time to time that will be sufficient for my present support, and form a stock of copyright property, that may be a little capital for me hereafter." Having asserted his intentions of entering into the business of literature, Irving went on to describe his aims and methods in an extremely revealing way:

To carry this into better effect it is important for me to remain a little longer in Europe, where there is so much food for observation, and objects of taste on which to meditate and improve. I feel myself completely committed in literary reputation by what I have already written; and I feel by no means satisfied to rest my reputation on my preceding writings. I have suffered several precious years of youth and lively imagination to pass by unimproved, and it

behooves me to make the most of what is left. If I indeed have the means within me of establishing a legitimate literary reputation, this is the very period of life most auspicious for it, and I am resolved to devote a few years exclusively to the attempt.

The twin themes of these two years of struggle emerge clearly in his letter: his commitment to a literary career as a means of regaining a reputation and the importance of Europe in the endeavor as he has planned it. He stated in the plainest possible language his sense of entering upon a venture:

In fact, I consider myself at present as making a literary experiment, in the course of which I only care to be kept in bread and cheese. Should it not succeed— should my writings not acquire critical applause, I am content to throw up the pen and take to any commonplace employment. But if they should succeed, it would repay me for a world of care and privation to be placed among the established authors of my country, and to win the affections of my countrymen.

Irving concluded this part of his letter with a plea for cooperation that indicated the cost of this experiment to him. His nerves, uncertain and precarious, were finely strung on this issue; he perceived it as an all-out venture:

I have but one thing to add. I have now given you the leading motive of my actions—it may be a weak one; but it has full possession of me, and therefore the attainment of it is necessary to my comfort. I now wish to be left for a little while entirely to the bent of my own inclination, and not agitated by new plans for subsistence, or by entreaties to come home. My spirits are very unequal, and my mind depends upon them; and I am easily thrown into such a state of perplexity and such depression as to incapacitate me for any mental exertion. . . . I am living here in a retired and solitary way, and partaking in little of the gaiety of life, but I am determined not to return home until I have sent writings before me that shall, if they have merit, make me return to the smiles, rather than skulk back to the pity of my friends.[55]

Irving was not such a hermit as he implied in this letter; this was the period of his friendship with the painters Charles Leslie and Stuart Newton. Nevertheless it was a quiet and refined way of life when compared to his Knickerbocker days, and he was working hard. As in other letters of this two-year period, he stressed his sense of deprivation and discipline. Clearly he felt he was making a new self, as he indicated in his unusually strong request to his brothers to leave him alone. He was changing his role, breaking patterns, and forecasting the emergence of a successful self who would return to applause rather than pity.

Irving's letters to Brevoort, whom he entrusted with the publication

details, show this same sense of a momentous experiment. "I feel great diffidence about this re-appearance in literature," he wrote in the letter that accompanied his manuscripts. "I am conscious of my imperfections— and my mind has been for a long time past so preyed upon and agitated by various cares and anxieties, that I fear it has lost much of its cheerfulness and some of its activity."[56] The debut of his new literary persona brought him considerable anxiety, which was exacerbated by the vagaries of transatlantic communication. After launching his manuscript with so much explanation and so many indications of its importance to him, Irving had to wait more than four months for any response from his friends. He sent the second and third installments into an ominously silent void, having prepared them for publication before he even saw the first installment in print. No wonder he wrote Brevoort on July 10, 1819, "various circumstances have concurred to render me very nervous & subject to fits of depression that incapaciate me for literary exertion. All that I can do at present is in transient gleams of sunshine which are soon overclouded and I have to struggle against continual damps and chills." In the same letter he worried that his brothers might be angry with him for rejecting the navy job and restated his sense of artistic vocation with even more diffidence than before: "My mode of life has unfortunately been such as to render me unfit for almost any useful purpose. I have not the kind of knowledge or the habits that are necessary for business or regular official duty. My acquirements, tastes & habits are just such as to adapt me for the kind of literary exertions I contemplate. It is only in this way I have any chance of acquiring real reputation, and I am desirous of giving it a fair trial. I have long since been committed in print—& when once launched a man has no alternative—he must either do better or be judged by what he has done."[57] Irving clearly felt that the publication of *The Sketch Book* was a watershed in his life; it was an all-out effort to recoup the losses of the last few years and to restore his shattered sense of self. On this literary experiment hung his plans for the future.

The book achieved such acclaim and popularity that it is hard to see it through the eyes of its nervous and uncertain author. Individual sketches have taken on a life of their own. "Rip Van Winkle" and "The Legend of Sleepy Hollow" are frequently cited as the first American short stories; during the nineteenth century "Rip Van Winkle" won wide popularity as a play, and it and "The Legend of Sleepy Hollow" were frequently reprinted. But *The Sketch Book* must be viewed as a whole if Irving's experiment is to be evaluated, and these American tales were firmly embedded in a setting of travel sketches, reveries, and literary essays. The sketches appeared in seven installments, the first three of which were arranged before Irving had received any criticism or response to his efforts. The first number, sent from England

on March 3, 1819, included "Prospectus," "The Author's Account of Himself," "The Voyage," "Roscoe," "The Wife," and "Rip Van Winkle." Number two, sent from England on April 1, 1819, included "English Writers on America," "Rural Life in England," "The Broken Heart," and "The Art of Book-Making." Number three, sent on May 13, 1819, included "A Royal Poet," "The Country Church," "The Widow and her Son," and "The Boar's Head Tavern, Eastcheap. A Shakespearean Research." Irving seemed to falter after this burst of energy, for he complained to Brevoort of low spirits and slowed his pace of publication.[58] On August 2, 1819, he sent the contents for number four: "The Mutability of Literature, A Colloquy in Westminster Abbey," "Rural Funerals," "The Inn Kitchen," "The Spectre Bridegroom," and "John Bull." He later revised the last essay for number 6 and substituted "Rural Funerals" for it in number four. In October 1819, he sent the contents of number five, which obviously were designed for the Christmas season: "Christmas," "The Stage-Coach," "Christmas Eve," and "Christmas Day." On December 29, 1819, Irving added to "John Bull," which he had sent earlier, the sketches "The Pride of the Village" and "The Legend of Sleepy Hollow," to make up number six. The last number, which Irving sent off on June 28, 1820, included "Westminster Abbey," "The Angler," "Stratford-on-Avon," and "Little Britain." By this time the first English volume had appeared; the second volume came out in July 1820, with the addition of two Indian essays, "Traits of Indian Character" and "Philip of Pokanoket," which had been published earlier in the *Analetic.*[59]

The method of presentation Irving chose for his work had ample precedent. After all, *Poor Richard's Almanac* had been a serial publication, presented in the name of a fictional persona. *Salmagundi* had appeared as a serial at no fixed intervals but rather whenever the authors could get an issue together. Irving cautioned Brevoort a number of times that he wanted to remain flexible rather than committed to a definite production schedule. Irving also had a flair for marketing his writings, as his promotional scheme for the *History of New York* had shown. Under that scheme, he had published a series of missing person notices to arouse interest in the eccentric Diedrich Knickerbocker, the ostensible author of the work. In fact, the little old gentlemen with "a small bundle tied in a red bandana handkerchief" who left behind in a wayside hotel room "*a very curious kind of a written book,*" serves as a kind of ancestor to the unsettled, peripatetic Geoffrey Crayon.[60]

Yet, the presentation of *The Sketch Book* deviated from that of the earlier works in a number of ways. Both *Salmagundi* and the *History of New York* came roaring off the page with comic exaggeration evident in their first lines. *The Sketch Book,* in contrast, begged politely for the reader's approval. From assertive self-assurance Irving moved to genteel deference. The authors of *Salmagundi* had brashly refused to give an

account of themselves "because it is nobody's business," yet the first number of *The Sketch Book* contained not one but two explanatory pieces, including just such an "Author's Account of Himself" as Irving had parodied earlier. Whereas *Salmagundi* promised "to instruct the young, reform the old, correct the town, and castigate the age," the writer of *The Sketch Book* asserted that "it is the dearest wish of his heart to have a secure and cherished, though humble corner in the good opinions and kind feelings of his countrymen."[61] In his very method of presenting the work Irving made clear his new stance toward his audience. No longer a carefree insider writing outrageous jokes for the fun of it, he was now a sober, meditative outsider petitioning to be taken seriously.

Irving embodied his new literary stance in the persona of Geoffrey Crayon, whose creation, most critics agree, is one of the great achievements of *The Sketch Book*. As portrayed in "The Author's Account of Himself," Crayon is the perfect narrator for a rambling, low-key miscellany. He is imaginative, eloquent, and easily distracted. He has a sense of irony: "Even when a mere child I began my travels, and made many tours of discovery into foreign parts and unknown regions of my native city, to the frequent alarm of my parents, and the emolument of the town-crier." His humor has a double edge and can be turned against others as well as himself, as he shows when he describes with seeming naiveté the "swelling magnitude of many English travellers among us, who, I was assured, were very little people in their own country." Moreover, he is sensitive to poetic association, yearning for "the shadowy grandeurs of the past."[62] This brief sketch creates a narrator who can lead us through the shifting scenes of the miscellany, wandering about the streets of London, sitting in a churchyard watching a funeral, or touring Windsor Castle or Westminster Abbey. At times Crayon's diffidence is comic: at the beginning of "Stratford-on-Avon" the weary traveler is chased away from a yearned-for sitting-room fire by a chambermaid who wants to close up; in "The Angler" he "hooked myself instead of the fish; tangled my line in every tree; lost my bait; broke my rod."[63] These comic touches keep Crayon at an arm's length from the reader; we feel slightly removed from him just as he is slightly removed from the scene he describes.

In this somewhat inept, mildly comic, gently alienated figure Irving embodied his own doubts and hesitations about his recast literary career. The "Prospectus" Irving published with the first serial number of *The Sketch Book* is even more hesitant and self-protective than "The Author's Account of Himself." In this introductory note Irving clearly indicates his sense of the tentativeness of his endeavor. "The following writings are published on experiment," he wrote. "Should they please, they may be followed by others." Irving went on to describe the "disadvantages" under which he labored: "He is unsettled in his

abode, subject to interruptions, and has his share of cares and vicissitudes."
This is certainly an accurate description of Irving's previous four years
in England, but the defensiveness is unmistakable. "He will not be able
to give them that tranquil attention necessary to finished composition;
and as they must be transmitted across the Atlantic for publication, he
will have to trust to others to correct the frequent errors of the press."
Apologizing in advance for everything that could go wrong and offering
small thanks to Brevoort for his efforts, Irving seemed exceptionally
guarded. Only one sentence in the "Prospectus" described the work he
was presenting in a more positive way, one that, like "The Author's
Account of Himself," turned diffidence into an artistic resource: "His
writings will partake of the fluctuations of his own thoughts and feelings—
sometimes treating of scenes before him, sometimes of others purely
imaginary, and sometimes wandering back with his recollections to his
native country."[64] This is the true prospectus; all the rest is defense.

The mood of the "Prospectus" was no mere literary device, no con-
cession to his persona, but a reflection of his fears, and it is worth
noting that it was not reprinted in the collected edition of 1848. This is
the Irving who defended his choice of careers to his brothers by saying
he was "only" fit for literature. In his letter to Brevoort accompanying
the first number of *The Sketch Book* he wrote of his "diffidence" and
then added, "my writings may appear therefore light & trifling in our
country of philosophers & politicians—but if they possess merit in the
class of literature to which they belong it is all to which I aspire in the
work. I seek only to blow a flute accompaniment in the national concert,
and leave others to play the fiddle and French horn."[65]

However, as the writing of *The Sketch Book* progressed and he began
to feel comfortable with his literary identity, he became more able
to control his fears and turn them to literary use. In November 1819,
he had another opportunity to accept a part-time position, an editorial
office offered by Sir Walter Scott. In his letter of refusal he described
himself in a way that sounds even more like a Crayon self-portrait: "My
whole course of life has been desultory, and I am unfitted for any
periodically recurring task, or any stipulated labor of body or mind.
I have no command of my talents such as they are, and have to watch
the varyings of my mind as I would a weathercock. Practice and train-
ing may bring me more into rule; but at present I am as useless for
regular service as one of my own country Indians or a Don Cossack."
The very elaborateness of Irving's statement reveals a sort of pride in
the situation he ostensibly laments. His description of himself as "a very
good-for-nothing kind of being" in a letter to a man he admired in-
dicates his growing confidence. He went on to add that the publisher
who worked with him would find it "something like bargaining with
a gipsy, who may one time have but a wooden bowl to sell and at another

a silver tankard.''[66] The metaphoric language and easy style belie Irving's self-castigation. By this time he knew *The Sketch Book* was doing well; he could afford to advance a Crayon-like image. He reprinted this letter, unlike "Prospectus," in the preface to the Author's Revised Edition of 1848, thus making it in effect a part of his creation of persona.

It seems obvious then that there was much of Crayon in Irving and much of Irving in Crayon. In the creation of this character Irving was able to use his uncertainties to create an authorial voice for his new stance as an outsider, a serious writer and observant sensibility. His struggle to express and control his uncertainties and fears through the creation of a persona is evident throughout *The Sketch Book*. Geoffrey Crayon is the best developed and most obvious of Irving's avatars in the miscellany. Ichabod Crane, whose name, as one critic has pointed out, is a sort of pun on Crayon, represents a comic exaggeration of Irving's persona.[67] A ludicrous character, solitary to the point of eccentricity, he is dependent on others for his support and ambitious but ineffectual—all traits the bankrupt Irving feared. Crane's overactive imagination, which makes him an easy prey for Brom Bones, is a parody of Crayon's romantic sensibility.

Similarly, Simon Bracebridge, the genial bachelor of "chirping, buoyant dispostion" who leads the children of Bracebridge Hall in games, provides a "complete family chronicle," and offers scraps of pedantic knowledge as he lives with his wealthy relatives, represents another persona of comic warning for Irving.[68] The anxious author surely saw a bit of Bracebridge in himself as he escaped from his bachelor quarters for visits to "Castle Von Tromp," as he called the Van Warts' house in Birmingham, to play on the flute and romp with his nieces and nephews. In fact, the sequence of Christmas sketches presents a trio of characters who embody exaggerated identities for Irving. In addition to Master Simon, Squire Bracebridge himself is an avatar of Irving as an artist. An antiquarian and lover of old customs who arranges tableaux, superintends games, and revives old customs, the squire turns his historical research into action rather than words. Like a writer he is creating something and hopes to be taken seriously. Although he is the jovial host who spreads good cheer, he too has his ludicrous aspect. He is perceived as an eccentric, and some folks wink and grimace behind his back.[69] As a widower, the squire also qualifies as another bachelor. The third comic avatar, still another bachelor, is a parson who was the squire's Oxford classmate. The parson is a serious antiquarian; his very face "might be compared to a title-page of black-letter."[70] Seeing the two former schoolmates together, Crayon reflects on "what men may be made by their different lots in life": the squire lived "lustily on his paternal domains" while the parson "had dried and withered

away, among dusty tomes, in the silence and shadows of his study."[71] Like Simon's inefficacy and the squire's eccentricity, the parson's aridity is something that Irving, retreating to the inner citadel to become a writer, clearly feared. These characters from the Bracebridge sequence, like Ichabod Crane, provide exaggerations of Irving's hopes and fears in his search for a literary career.

Other personae introduced throughout *The Sketch Book* are specifically literary figures. Diedrich Knickerbocker makes a cameo appearance in the introduction to "Rip Van Winkle" and "The Legend of Sleepy Hollow," as if to legitimize the inclusion of this American material by a reference to an earlier pseudonym. Irving treats Knickerbocker with great condescension; this uncouth persona now lies buried with the rest of Irving's past. Neither tale is represented as Knickerbocker's own invention. His source for the first is said to be Rip Van Winkle himself, and the "Legend of Sleepy Hollow" purports to be a transcription "almost in the precise words in which I heard it" of a tale told at a New York corporation meeting. This narrator, three times removed from the reader, represents another version of Irving as struggling artist: "a pleasant, shabby, gentlemanly old fellow, in pepper and salt clothes, with a sadly humorous face; and one whom I strongly suspected of being poor, he made such efforts to be entertaining."[72] What this pleasant fellow is doing at a corporation meeting is not clear; in the sketch a skeptical businessman (reminiscent of Irving's practical brothers) severely questions the point of his story. Irving, of course, was confronting his own poverty with just such an attempt to be entertaining, hoping for acceptance rather than rebuff.

The Sketch Book is filled with multiple levels of narration. The speaker in "Little Britain" is not Geoffrey Crayon but "an odd-looking old gentleman in a small brown wig and a snuff-colored coat" whom he has met in the city and who, like Diedrich Knickerbocker, is a local historian.[73] "The Spectre Bridegroom" is narrated by "a corpulent old Swiss" with "a double chin, aquiline nose, and a pleasant twinkling eye," whom Geoffrey Crayon has met around the kitchen fire of an old Flemish inn.[74] Irving has Crayon draw on local informants for the tales of the widow and her son and the pride of the village; he also has the old angler and the resident of the charter house tell Crayon about their lives.

This emphasis on the making of a narrative shifts the focus of *The Sketch Book* again and again to the question of the literary process itself. Books, bookmaking, and book reading figure in almost every essay. A book bursts into speech in one chapter ("The Mutability of Literature"), and five essays directly discuss writers and writing. In "The Voyage" Geoffrey Crayon describes how books have nourished his propensity

for wandering; the bankrupt Roscoe writes a sonnet to his books. Quotations and citations adorn nearly every sketch, and at least half a dozen sketches represent fictional treatments of literary research.

With its plethora of narrators and its constant concern for the creation of literature, *The Sketch Book* emerges as an exploration of the literary process itself. Resolving his personal crisis of 1815-18 through the creation of a literary persona, Irving used this first appearance as a professional writer to offer a definition of the literary process that would vindicate his decision to remain in Europe. The making of literature, Irving implied, demanded not only a search for and a confrontation with literary models but also an environment that nourished literature.

"Stratford-on-Avon" most directly embodies this aspect of *The Sketch Book*. In his description of a visit to Shakespeare's home, Irving included an appreciation of Shakespeare's works and a meditation on the nature of literature, which also conveys, by implication, his own goals as a writer. One need not credit his own barely expressed hope that his work might rank with the great playwright's to see how Irving experienced literary influence as a liberating and inspiring force in his own search for an artistic identity.

Irving begins the sketch in the typically languid, detached stance of Geoffrey Crayon, who is mildly amused at the sights a traveler sees. In the opening scene Crayon feels a moment of satisfaction in his "empire" of an inn sitting-room, only to be routed by a chambermaid.[75] The next morning he tours Shakespeare's house, reporting with some amusement on the garrulous guide and noting the sense of competition between the guardian of the house and the keeper of the grave. Approximately one-third of the essay is narrated in this humorous, slightly detached tone.

As Crayon stands at Shakespeare's grave, however, the mood of the essay changes. He feels a genuine stirring of emotion: "It was something, I thought, to have seen the dust of Shakespeare." The essay begins to move into a more serious vein; as Crayon thinks about the dead writer he finds that his own feelings,

no longer checked and thwarted by doubt, here indulge in perfect confidence: other traces of him may be false or dubious, but here is palpable evidence and absolute certainty. As I trod the sounding pavement, there was something intense and thrilling in the idea that, in very truth, the remains of Shakespeare were mouldering beneath my feet. It was a long time before I could prevail upon myself to leave the place; and as I passed through the churchyard, I plucked a branch from one of the yew trees, the only relic that I have brought from Stratford.[76]

Through these sentences Irving travels from comic skepticism to fairly conventional but well-expressed reverence.

At this point Irving has Crayon break away from "the usual objects of a pilgrim's devotion" and decide to walk across the park to the Lucy mansion at Charlecot. As if the freedom to "ramble" unlocks his imagination, Crayon begins to ponder the process by which a poet develops. Although his subject is Shakespeare, Crayon's musings also are relevant to Irving's own literary identity. His thoughts have two main thrusts, both of which concerned Irving himself: the life history of the poet whose exile enabled him to become a writer and the contrast between his humble beginnings and ultimate fame.

Irving pictures the young Shakespeare as a high-spirited youth participating in drinking contests with the neighboring "Bedford topers," who sound remarkably like the Knickerbocker circle of his own past. Using one of his favorite self-descriptions, he characterizes the young poet as a "vagabond," remarking that "Shakespeare, when young, had doubtless all the wildness and irregularity of an ardent, undisciplined, and undirected genius." Then Irving comes to the event that was said to have catapulted the poet into a literary career: caught poaching, he was forced to leave Stratford and went to London. Like Irving, shaken by the failure of P. & E. Irving, Shakespeare had the choice of a career thrust upon him. "Stratford lost an indifferent wool-comber, and the world gained an immortal poet."[77]

As he walks through the fields, Crayon's imagination moves from biographical drama to the scene around him. He begins to describe the landscape with a lyric expressiveness that is punctuated with appropriate quotations from Shakespeare: "It was inspiring and animating to witness this first awakening of spring, to feel its warm breath stealing over the senses; to see the moist mellow earth beginning to put forth the green sprout and the tender blade. . . ."[78] Inspired by the landscape that inspired the great writer, Irving moves from describing a poet to writing poetically. He begins to create serious literature.

After a detailed and serious description of the manor house, Crayon meditates on a crucial literary problem: the source of the poet's ability to transmute life into literature. "On returning to my inn, I could not but reflect on the singular gift of the poet; to be able thus to spread the magic of his mind over the very face of nature; to give to things and places a charm and character not their own and to turn this 'working-day world' into a perfect fairy land. He is indeed the true necromancer, whose spell operates not upon the senses, but upon the imagination and the heart." Crayon thus describes Shakespeare as the consummate romantic artist. "Under the wizard influence of Shakespeare I had been walking all day in a complete delusion. I had surveyed the landscape through the prism of poetry which tinged every object with the hues of the rainbow. I had been surrounded with fancied beings; with mere airy nothings, conjured up by poetic power; yet which, to me, had all

the charm of reality."[79] Through Crayon Irving formulates an artistic creed for Shakespeare that may have evolved from Irving's own highland rambles with Scott. He praises Shakespeare in terms of his own literary goals, and he then sets out to follow him.

The essay concludes with an emotional tribute to Shakespeare that signals Irving's final shift from ironic humorist to aspiring serious writer: "Ten thousand honors and blessings on the bard who has thus gilded the dull realities of life with innocent illusion—who has spread exquisite and unbought pleasures in my chequered path—and beguiled my spirit, in many a lonely hour, with all the cordial and cheerful sympathies of social life!" He offers a vision of the humble plot where Shakespeare insisted on being buried and celebrates the virtues of home: "He who has sought renown about the world, and has reaped a full harvest of worldly favour, will find, after all, that there is no love, no applause so sweet to the soul as that which springs up in his native place." The essay ends by contrasting the "youthful bard . . . wandering forth in disgrace upon a doubtful world," with the renowned poet who lies in state, his name "the boast and glory of his native place."[80] It is the ringing conclusion of the would-be writer fending off his brothers' advice to come home and determined to make a name for himself in the literary world in order to return in triumph rather than in disgrace. In this carefully crafted hymn to Shakespeare, Irving poured out his own hopes and ambitions for a literary career.

In the context of Irving's search for literary identity "Stratford-on-Avon" is the linchpin of *The Sketch Book*. In this essay Irving dramatized his own literary goals and explicitly demonstrated what he meant when he told his brothers he had to stay in Europe. In common with his contemporaries, Irving believed in the powers of poetic association; he also believed in the importance of literary models. His bold evocation of Shakespeare, an acknowledged master, showed the seriousness of his literary endeavor. The European scene became for Irving the key that would unlock his own imagination and creative energy.

Crayon's stance as an observer gave Irving both a rich subject and a literary technique. Crayon's movement through space, as seen in the walk to the Lucy mansion, supplied Irving with a means of moving from one subject to another. By making Geoffrey Crayon the consummate tourist, Irving could draw on the tradition of travel literature to dramatize his own literary growth and development. The "rambles" of his persona represent imaginative excursions as well as spatial ones. The loose structure of *The Sketch Book,* depicted in Geoffrey Crayon's strolls from one scene to another, is the ideal solution to Irving's problem of how to create literature. Through the strolls of his persona, he could react to one stimulus after another and could allow his thoughts to follow the changing scene. The metaphor that served Irving so well for a title—

Crayon's sketches—fails to capture the essential dynamism of his essay form. These are *animated* sketches that capture not only a variety of scenes but also a variety of mental processes.

Three other essays in *The Sketch Book* amplify and continue Irving's study of literary models: "A Royal Poet," "The Angler," and "The Boar's Head Tavern. Eastcheap. A Shakespearean Research." This last one is especially interesting because it represents a kind of comic answer to "Stratford-on-Avon," and humor was always one of Irving's most important and reliable tools. Throughout *The Sketch Book* in such stories as "The Wife" and "Rip Van Winkle," or "The Legend of Sleepy Hollow" and "The Pride of the Village," similar themes appear in both comic and serious incarnations.[81] As we shall see with "The Art of Book-Making," "The Mutability of Literature," and "The Boar's Head Tavern," some of Irving's most serious beliefs fueled his best comic sketches.

"The Boar's Head Tavern" begins by mocking the kind of homage to past writers that Irving had struggled to achieve in other sketches. In this essay, Irving compares tributes to past authors to the votive candles that Catholics burn before pictures of the saints. The smoke rising from these lamps, Irving maintains, can obscure rather than enlighten: "I have occasionally seen an unlucky saint almost smoked out of countenance by the officiousness of his followers." The same unfortunate circumstance is true of Shakespeare, Irving remarks: "Every casual scribbler brings his farthing rushlight of eulogy or research, to swell the cloud of incense and of smoke." Having set up this unappealing image, Irving sends the humorous and slightly ineffectual Crayon, to join in the effort. "As I honor all established usages of my brethren of the quill, I thought it but proper to contribute my mite of homage to the memory of the illustrious bard."[82]

Having started in this mildly irreverent tone, Irving moves on to write an appreciation of Shakespeare's comic side by sending Crayon to search for the remains of the Boar's Head Tavern in Eastcheap. As in his serious sketches, the susceptible wanderer reaches into the past and evokes the associations of a writer from his environment. In this case, however, all is comic: the sexton has his mind on dinner, and the landlady finally produces only two very questionable relics. Still, Crayon presents his findings with comic inflation, suggesting his discovery is "a rich mine, to be worked by future commentators . . . almost as fruitful of voluminous dissertations and disputes as the shield of Achilles or the far-famed Portland vase."[83] Like the comic subplots in Shakespeare's plays, this mock appreciation echoes and complements its serious counterpart.

Another essay, "A Royal Poet," amplifies Irving's exploration of the literary vocation in *The Sketch Book*. Crayon's model here is the relatively minor poet James I of Scotland whose career the narrator has recalled during a visit to Windsor Castle. While imprisoned in the castle as a

young man, James developed a talent for poetry. He wrote love poems
to the English princess whom he later married. Eventually he regained
his position in Scotland only to be murdered by his rebellious lords.
Crayon relates James' history with sentimental intensity. Like "The
Wife," "The Broken Heart," and "The Widow and her Son," "A
Royal Poet" tells a romantic tale. Yet the hero of this romance is a writer,
and Irving is fascinated by the making of literature.

As in "Stratford-on-Avon," Irving uses the surrounding landscape to
evoke literature and in turn uses literature to enrich his appreciation
of the landscape. A visit to Windsor Castle makes him think of James,
for "it is full of storied and poetical associations." Correspondingly, a
reading of James' poetry helps him to appreciate the site more fully:
he sees the window and garden of which the poet wrote. "It is, indeed,
the gift of poetry to consecrate every place in which it moves; to breathe
around nature an odour more exquisite than the perfume of the rose,
and to shed over it a tint more magical than the blush of morning."[84]
Although James is no Shakespeare, he can still spread "the magic of his
mind" across the landscape, and Irving once more affirms the importance
of the interchange between landscape and imagination.

In the royal poet, Irving found another example of the writer finding
his vocation. The Scottish prince, confined to a dungeon cell, gazing
wistfully at a beautiful girl outside his window and wrestling with
words, embodied an aspect of Irving's own literary struggle. Feeling
exiled in Liverpool, confined, enmired, and unable to reach his desired
goal, Irving, like James, turned to writing as a means of restoring his
sense of competence. The Scottish poet represented for him a romance
of the triumphant imagination: "It is the divine attribute of the imagi-
nation, that it is irrespressible, unconfinable—that when the real world
is shut out, it can create a world for itself, and, with a necromantic
power, can conjure up glorious shapes and forms, and brilliant visions,
to make solitude populous, and irradiate the gloom of the dungeon."[85]
In his biographical and critical tribute to James, Irving created another
avatar of the writer in search of his vocation.

The final essay of literary homage, "The Angler," contains more
description and less explication than the others. Geoffrey Crayon
appears at his best, loitering, blending reminiscence with observation,
and sketching the colorful characters he meets on his travels. It begins
with a mock-serious disquisition on the impact of literature on readers'
lives: "It is said, that many an unlucky urchin is induced to run away
from his family, and betake him to a sea-faring life, from reading the
history of Robinson Crusoe; and I suspect that, in like manner, many
of those worthy gentlemen, who are given to haunt the sides of pastoral
streams, with angle rods in hand, may trace the origin of their passion
to the seductive pages of honest Isaak Walton." Irving strikes a humorous

tone with his description of the budding anglers "stark mad as was ever Don Quixote from reading books of chivalry," but this is clearly another instance of the comic rendering of a theme taken quite seriously elsewhere.[86] He had visited the "scenes hallowed by honest Walton's simple muse" in January 1817, as he wrote Brevoort.[87] An essay describing the scene and evoking Walton, another artistic progenitor, was a natural one for Irving to attempt. Although he treats his subject lightly, the sketch shares the underlying structure of his other essays of literary homage. Taking his "morning's stroll," Crayon comes upon "a veteran angler and two rustic disciples," who remind him of his own youthful enthusiasm for Walton. This time the scene from life makes him think of literature: "I thought I could perceive in the veteran angler before me, an exemplification of what I had read."[88] The rest of the sketch consists of a description of this old man, his method of fishing, and his way of life, with references to Walton. Unlike the other sketches, in this essay the literary predecessor has shrunk in importance, and Crayon's observations have expanded. Yet the process is reaffirmed: the scene that inspired Walton stimulates Irving; he makes literature in the footsteps of his predecessors, not by imitating but by following their art to its source and building his own upon it.

These four essays in *The Sketch Book* provide a key to Irving's efforts to prove himself as a writer. By confronting the writers of the past and drawing inspiration from their environment, he attempted to create a literature of his own that would receive similar recognition. In this light, the importance of other sketches, often dismissed by critics as pedantic or imitative, becomes clearer. In his search for the roots of literature Irving went to historical or antiquarian sources as well as to great writers and landscapes. An essay such as "Rural Funerals" began in research, just as "Stratford-on-Avon" began with relics of the poet; and like the latter, which concludes with a hymn to the bard, the former makes its own literary contribution, a moving meditation on death: "Oh the grave—the grave!"[89] The Bracebridge sequence, describing traditional English Christmas customs, represents another of Irving's solutions to the problem of making literature out of history. Like the Shakespearean scholars burning their votive candles, Squire Bracebridge lights his Yule log as a massive offering to tradition. Irving maintains a comic distance from such successful research: the "old gentleman" is quaint and a little foolish. Yet at the same time the spectacle is lovingly displayed. The making of a Christmas holiday becomes another analogy for the making of literature, for both have their roots in an appreciation of the past.

Similarly, "Westminster Abbey" builds its attempt at serious literature on the materials of guidebooks. As in all of Irving's best sketches, exploration of a physical setting sets the stage for inner movement;

"rambling about Westminster Abbey," Geoffrey Crayon ranges through a variety of ideas. The sights available to every tourist at the Abbey—Henry the Seventh's Chapel, Poets' Corner, the Shrine of Edward the Confessor—become the stimuli for meditation very much like Walton's stream or Shakespeare's park. The essay juxtaposes passages of perception and reflection; verbs like "see," "behold," "gaze," "observe," or even more striking, "my eye was attracted," "the eye darts," "the eye is astonished," alternate with others like "contemplate," "muse," "feel," "conjure." Once again, the psychology of association operates on Crayon. The Abbey makes him think of history and literature; these thoughts enrich his appreciation of the scene and help him to "spread the magic of his mind over . . . nature."

In using Westminster Abbey as a setting for a meditation on mutability and the vanity of human wishes, Irving followed in the footsteps of literary models as surely as he had at Stratford. He doubtlessly knew of similar essays by Addison, Browne, and Hervey.[90] In fact, he showed his awareness of operating within a tradition by using as an epigraph for the chapter a sixteenth-century sonnet on the same theme. Yet in the essay, one of the most skillful in *The Sketch Book,* he makes the subject his own. As Stanley Williams has pointed out, the theme of mutability that runs throughout *The Sketch Book* is grounded in Irving's own character and mood.[91] After Irving's long period of depression and self-doubt, melancholy themes were near the surface. As his notebooks prove, he was reliving his private agonies as well as creating fictional scenes of grief and mourning; *The Sketch Book* contains echoes of his long-buried memories of Matilda Hoffman as well as his fresher grief for his mother's death.[92] This all-pervasive mutability theme also bears on his anxiety over his literary identity. Irving describes the Poets' Corner with a special poignancy: it seems as if visitors linger there with a "kinder and fonder feeling." To Irving it seemed that a great writer achieved his fame through suffering: "He has sacrificed surrounding enjoyments, and shut himself up from the delights of social life, that he might the more intimately commune with distant minds and distant ages."[93] Irving obviously felt he had experienced this suffering in leading a disciplined and comparatively solitary life while working on *The Sketch Book*; and the reward he now sought was fame and recognition. Staking everything on his writing, he hoped to make *The Sketch Book* an enduring monument. Yet, he was haunted by the fear that his work would prove ephemeral. Hoping for glory and fearing oblivion, Irving found his situation embodied in that monument to the vanity of human wishes, Westminster Abbey. The essay ends with a meditation on "the emptiness of renown," as Irving pictures the Abbey falling into ruin:

The time must come when its gilded vaults, which now spring so loftily, shall lie in rubbish beneath the feet; when, instead of the sound of melody and praise, the wind shall whistle through the broken arches, and the owl hoot from the shattered tower—when the garish sun-beam shall break into those gloomy mansions of death, and the ivy twine round the fallen column; and the fox-glove hang its blossoms about the nameless urn, as if in mockery of the dead. Thus man passes away; his name perishes from record and recollection; his history is as a tale that is told, and his very monument becomes a ruin."[94]

This peroration on life's vanities becomes even more moving when it is seen as a reflection of the writer's own fears about the insubstantiality of his cherished goal.

"The Mutability of Literature. A Colloquy in Westminster Abbey" offers further support for this interpretation of the mutability theme as a key to Irving's struggle for artistic identity. As in the case of the essays on Shakespeare, Irving once more offers two sides—the serious and the comic—of the same theme. Like stereoptic vision, this double approach to major issues gives them depth and substance and makes them stand out in the memory like three-dimensional objects. "The Mutability of Literature" takes the meditative seriousness of "Westminster Abbey" and turns it inside-out; and significantly the focus of the humor is books and bookmaking.

"The Mutability of Literature" begins exactly in the vein of "Westminster Abbey," except for the slight note of comic exaggeration that creeps into Geoffrey Crayon's meditative stance: "There are certain half-dreaming moods of mind, in which we naturally steal away from noise and glare, and seek some quiet haunt, where we may indulge our reveries and build our air castles undisturbed. In such a mood I was loitering about the old gray cloisters of Westminster Abbey, enjoying the luxury of wandering thought which one is apt to dignify with the name of reflection. . . ." The pose is more languid ("half-dreaming") and less serious ("air castles," "dignify with the name of reflection"), but the scene is the same. A group of noisy schoolboys interrupts Crayon's mood at this point, and he seeks refuge in the library, a place "fitted for quiet study and profound meditation." The sight of the dusty old books, apparently untouched for years, sets off "a train of musing" on the vanity of human achievement. The affirmation of his vision of Poets' Corner changes to horror: "How have their authors buried themselves in the solitude of cells and cloisters, shut themselves up from the face of man and the still more blessed face of nature, and devoted themselves to painful research and intense reflection. And all for what? to occupy an inch of dusty shelf. . . ." The paragraph ends with a lamentation like that which closes "Westminster Abbey": "Such is the amount of this boasted immortality. —A mere temporary rumor,

a local sound, like the tone of that bell which has just tolled among these towers, filling the ear for a moment—lingering transiently in echo— and then passing away like a thing that was not!''[95]

So far Irving has created a miniature version of his essay "Westminster Abbey," a bit drier and more droll, but sounding the same themes and focusing on the same issue: the vanity of human ambition, especially literary aspiration. With the next sentence, however, the essay leaps into the realm of comic fantasy. Crayon loosens the clasps on a book, which "gave two or three yawns, like one awakening from a deep sleep; then a husky hem; and at length began to talk." The talking book, like a choleric old man, complains of the neglect into which it has fallen, asserts the superiority of its own era, and laments the decline of publishing standards. His pique at the volume's crochety self-righteous- ness shakes Geoffrey Crayon out of his earlier mood of melancholy. "For my part," he tells the wheezing speaker, "I consider this mutability of language a wise precaution of Providence for the benefit of the world at large, and of authors in particular. To reason from analogy, we daily behold the varied and beautiful tribes of vegetables springing up, flourishing, adorning the fields for a short time, and then fading into dust, to make way for their successors. . . . In like manner the works of genius and learning decline, and make way for subsequent pro- ductions." Crayon goes on to propose a sort of Malthusian view of literature: mutability provides "one of those salutary checks on population spoken of by economists." Meditation on the vanity of human wishes crosses over the line to peevish antiquarianism in the character of the talking book, and Irving reaches out to comedy for a breath of fresh air. The sketch reaches its climax when the old quarto snobbishly refers to a "poor half-educated varlet, that knew little of Latin, and nothing of Greek, and had been obliged to run the country for deer- stealing." Crayon's reaction is predictable, and the essay ends on a serious note with another eulogium to Shakespeare: "Of all writers he has the best chance for immortality. Others may write from the head, but he writes from the heart, and the heart will always understand him."[96] In the midst of this earnest speech Crayon is distracted by the opening of a door; the talking book falls silent, and the sketch ends with the suggestion that the colloquy was all a dream. Using comedy Irving reintroduces the important themes of "Westminster Abbey": hopes and fears for literary recognition, questioning and affirmation of the permanence of literary achievement.

One other pair of serious and comic sketches illuminates Irving's struggle for literary identity: "English Writers on America" and "The Art of Book-Making." Both of these essays deal explicitly with the questions of imitation and literary borrowing, asking what should be the modern writer's relationship to his predecessors.

"English Writers on America" is a topical piece, reminiscent of Irving's days at the *Analectic;* it chastises English travel writers for their uncharitable descriptions of American society. Such an essay has historical significance, for the war between English and American critics lasted well into the nineteenth century. Melville was still bristling with a sense of inferiority when he wrote his famous review of Hawthorne's *Mosses from an Old Manse,* predicting the emergence in the New World of "a greater than Shakespeare."[97] However, Irving was not anticipating Young America in this essay. He lamented the transatlantic animosity and sought to make peace, but once again in terms that were significant to his own situation. The essay begins by focusing on English writers but quickly shifts to a discussion of the American reaction to these writers. After several pages of fairly detached critical analysis of English travel literature, the essay turns from the observer to the observed: "But why are we so exquisitely alive to the aspersions of England?" He might almost have written, "Why am I so vulnerable to fear of failure?" He went on to say that Americans, rather than feeling defensive, should have pride in their own achievements. He acknowledged America's (and his own) need for models. "We are a young people, and an imitative one, and will form ourselves upon the older nations of Europe." Although at times he felt like an old man, he might still have a long literary career ahead of him if he could mobilize his talents. The stimulation he had found in the English scene was essential to his own development, and he insisted in his essay that England formed a valuable literary model for Americans. The essay ends with a plea for a more appropriate American stance toward England: "We may thus place England before us as a perpetual volume of reference, wherein the sound deductions of ages of experience are recorded; and while we avoid the errors and absurdities which may have crept into the page, we may draw thence golden maxims of practical wisdom, wherewith to strengthen and to embellish our national character."[98] Speaking to national concerns, Irving formulates a personal credo: the writer needs the inspiration of models in the search for his own identity.

This statement on the need for literary models appeared in the same number of *The Sketch Book* as the comic warning against excessive imitation, "The Art of Book-Making." One of Irving's most successful humorous sketches, "The Art of Book-Making" begins in mock-serious description, slides into fantasy, and concludes with a deflation, or return to the real world. The sketch opens with Geoffrey Crayon in his stance as tourist, visiting the British Museum, though he displays less than his usual seriousness, sauntering about listlessly, "lolling" over display cases and gazing blankly at the allegorical paintings. He eventually finds himself in a "mysterious apartment" filled with "many pale, cadaverous personages, poring intently over dusty volumes," whom he

takes to be "a body of magi, deeply engaged in the study of occult
sciences." After drawing analogies from chivalric romance and Arabian
tales, Crayon shares his realization that he has wandered into the Reading
Room of the British Library and that the mysterious personages are
"principally authors, and were in the very act of manufacturing books."
As Irving himself had "manufactured" much of *The Sketch Book* in this
way, the humor has a double edge for him. He goes on to describe
the motley assortment of authors, all of whom are engaged in stealing
from writers of the past. One "lean, bilious-looking wight," surrep-
titiously chewing on a dry biscuit, is "constructing some work of
profound erudition," while an "old gentleman in bright-colored clothes,
with a chirping, gossipping, expression of countenance," a "diligent
getter-up of miscellaneous works, that bustled off well with the trade,"
goes about his work in a more cheerful fashion. As in "The Mutability
of Literature," this sight stimulates Geoffrey Crayon to a mildly facetious
meditation on the life and death of literary productions: "May not this
pilfering disposition be implanted in authors for wise purposes; may it
not be the way in which providence has taken care that the seeds of
knowledge and wisdom shall be preserved from age to age, in spite of
the inevitable decay of the works in which they were first produced."
He celebrates this literary "metempsychosis": "What was formerly a
ponderous history, revives in the shape of a romance—an old legend
changes into a modern play—and a sober philosophical treatise furnishes
the body for a whole series of bouncing and sparkling essays."[99]

At this point the essay crosses the border from humor to fantasy.
Geoffrey Crayon falls asleep in the library and his dream takes his
vision of authorship to its furthest extreme. He now sees the writers as
ragpickers scrounging clothing from the books, which have become
garments of "foreign or antique fashion"; each takes a "sleeve from
one, a cape from another, a skirt from a third, thus decking himself
out piecemeal, while some of his original rags peep out from among his
borrowed finery." Instead of powerful wizards, the authors have become
sinister scavengers transforming their very appearance by their borrow-
ings. At last the "literary masquerade" is brought to a halt with a cry
of "thieves! thieves!" as the ancient authors step down from their
portraits on the wall and set out to recover their stolen property.[100]
The scavengers are stripped bare as the outraged authors reclaim their
own, and Crayon finds the spectacle so amusing he bursts into laughter,
awakening himself from the dream and causing his ejection from the
library.

"The Art of Book-Making" presents a parodic version of the problem
of authorship as Irving faced it in "English Writers on America,"
the essays of literary appreciation, and *The Sketch Book* as a whole.

To become a professional writer he felt he needed models, yet if he followed those models too closely he would be guilty of mere imitation or, worse, the sort of shabby pilfering he envisioned in the figures of the seedy ragpickers. He had staked his identity on literary success, yet he was haunted by the fear that his achievement would prove ephemeral, the "wizard influence" of the writer's imagination mere sorcery, the literary vocation mundane "book-making." Irving resolved his conflict in this essay in the same way he dealt with the larger problems it exemplified, through the saving grace of humor. Just as Crayon's laughter dispels his nightmares, Irving's ability to embody his personal uncertainties in the mildly ludicrous figure of Geoffrey Crayon and to pair his serious essays with comic counterparts enabled him to overcome his anxiety and become the writer he yearned to be.

In essay after essay, *The Sketch Book* takes for its subject Irving's search for a literary vocation and reflects the intense personal struggle he underwent in 1815-19. In addition to the sketches that deal directly with literature, others sound the theme of strength in adversity ("The Wife," "Roscoe") or the agony of losing one's heart's desire ("The Broken Heart," "The Widow and her Son," "The Pride of the Village"), themes that echo Irving's experiences during these four years. *The Sketch Book* represents the fruit of Irving's resolve to become a professional writer, and it takes its form and content from that decision as well.

In this context, the American materials in *The Sketch Book* are particularly important. As Irving emphasized again and again in his letters, he saw his period of literary apprenticeship in Europe as a prelude to an eventual homecoming. Although he needed Europe to become a writer, he still saw himself as an American artist.[101] The literary process as he had come to understand it involved emulation rather than imitation. One studied Shakespeare and immersed oneself in the landscape that inspired him in order to make one's own literature out of the same materials. The final step in this process, of course, was the application of this technique to one's own native landscape; by attempting to "spread the magic of his mind over the very face" of American nature, Irving took the final step that would affirm his identity as an author. Thus, the American tales, which seem out of place if *The Sketch Book* is regarded as mere travel literature, become an essential part of the work when it is viewed as a literary proving ground.

Two of the American pieces were reprinted from the *Analectic*. Although "Traits of Indian Character" and "Philip of Pokanoket" did not appear in the serial numbers of *The Sketch Book*, Irving included them in the second volume of the English edition, published in July 1820. In part Irving's resurrection of these sketches indicates his ex-

haustion; his letters show that he had trouble completing the last few numbers of *The Sketch Book,* and he may have seized upon these earlier pieces to round out a thin second volume.[102] Yet the sketches also are related to his literary development. In March 1816, when he was beginning to think of reviving his literary career, he asked Brevoort to send him copies of the essays and the *History of New York.*[103] The sketches form a transition of sorts between the *History of New York* and *The Sketch Book* since, like the *History,* they represent research into the American past, but their tone is sentimental rather than comic. "Traits of Indian Character" praises the Indians' stoic resignation under suffering, an attitude Irving himself was trying to cultivate between 1815 and 1819. "Philip of Pokanoket" describes the Indian rebel in terms that recall Scott's romantic outlaws, and the focus on the melancholy outcast, the misunderstood outsider, harmonizes with other *Sketch Book* material such as "The Broken Heart" and "A Royal Poet." Although the sketches were written earlier, they embody important aspects of Irving's struggle for literary identity.

Far more significant from this point of view, however, are the charming and popular American tales, "Rip Van Winkle" and "The Legend of Sleepy Hollow." "Rip" appeared in the first number of *The Sketch Book* and "Sleepy Hollow" in the last, forming a sort of invocation and benediction to Irving's emergence as a serious writer. Both tales owe a debt to Irving's folklore researches, for this sort of borrowing was fully consistent with Irving's theory of literary process.[104] From his point of view, the central achievement was his ability to bring the aura of legend to his native landscape, to create literature out of the Hudson River scenery as Shakespeare had done for Stratford and Scott for the Highlands. No wonder Irving felt such excitement when he and his brother-in-law Van Wart reminisced about the scenery and legends of Tarrytown. In these reminiscences the aspiring author recognized the material for native art.[105] Both "Rip Van Winkle" and "The Legend of Sleepy Hollow" apply the lessons of *The Sketch Book:* the mixture of humor with sentiment, the exploitation of the poetical potential of landscape, the celebration of local custom and regional peculiarity.

The favorable response to *The Sketch Book* in both England and America was gratifying to Irving, who was close to the end of his emotional and financial resources when he wrote it. As he wrote to Brevoort when he sent the third number, still ignorant of the reception of the first two, "my fate hangs on it."[106] The work's success did not mark the end of Irving's struggles, however. If anything, the first positive reviews from America left him even more anxious than before. "I feel almost appalled by such success," he wrote Brevoort in September 1819, "and fearful that it cannot be real—or that it is not fully merited, or that I shall not act up to the expectations that may be formed. . . .

I begin to fear that I shall not do as well again."[107] Irving's fears were legitimate; he did not equal *The Sketch Book* again for a number of years. For some reason hidden within his own contradictory character, he needed a balance of security and insecurity to produce his best work, to save him from despair and sloth. Far from solving his problems once and for all, *The Sketch Book* led onward to a chequered career with peaks and valleys, recurring periods of depression and elation, sterility and productivity.

A product of the crisis period 1815-19, *The Sketch Book* signaled Irving's emergence as a serious writer. Forced by bankruptcy to reevaluate his personal and professional goals, Irving found that Europe held the key to a new literary identity. By immersing himself in the European scene he was able to make literature about the process of making literature, to turn observation into participation. With *The Sketch Book* he clearly established himself as a professional writer, not a playful provincial but a serious aspirant to international stature.

Notes

1. *The Works of the Rev. Sydney Smith*, 3 vols. (London: Longman, Brown, Green, Longmans & Roberts, 1859), 2: 122.

2. Washington Irving, *Bracebridge Hall*, author's rev. ed. of 1848 (New York: G. P. Putnam and Son, 1857), p. 1.

3. Emerson, for example, included Irving in a list of "American geniuses" who "all lack nerve and dagger." A. W. Plumstead and Harrison Hayford, eds., *The Journals and Miscellaneous Notebooks of Ralph Waldo Emerson*, vol. 7, 1838-1842 (Cambridge, Mass.: Harvard University Press, 1969), p. 200 (May 26, 1839). H. L. Mencken called Irving an "Anglomaniac" in his *The American Language* (New York: Alfred A. Knopf, 1937), p. 67.

4. Washington Irving, *Journals and Notebooks, vol. 1, 1803-1806*, ed. Nathalia Wright (Madison: University of Wisconsin Press, 1969), p. 51.

5. Ibid., pp. 347-48. Here, as in other quotations from the journals, cancelled phrases have been omitted.

6. Pierre M. Irving, *The Life and Letters of Washington Irving*, 4 vols. (New York: G. P. Putnam; Hurd & Houghton, 1865), 1: 139-40.

7. Stanley T. Williams, *The Life of Washington Irving*, 2 vols. (New York: Oxford University Press, 1935), 2: 256.

8. From undated manuscript fragment, probably 1823, printed in ibid., 2: 258.

9. Ibid., 1: 150.

10. Washington Irving, *Letters of Washington Irving to Henry Brevoort*, ed. George S. Hellman (New York: G. P. Putnam's Sons, 1918), pp. 106-7.

11. Ibid., pp. 122, 123.

12. See Williams, *Washington Irving*, 1: 149-50.

13. Irving, *Letters to Brevoort*, p. 140.

14. Ibid., p. 154.

15. Ibid., p. 192.

16. Ibid., p. 252. On bankruptcy proceedings, see Williams, *Washington Irving,* 1: 166.

17. See Irving, *Letters to Brevoort,* pp. 274-75.

18. Printed in Williams, *Washington Irving,* 2: 259.

19. Ibid., p. 258. See also Williams, *Washington Irving,* 1: 102-7 and Stanley T. Williams, "Introduction" to Washington Irving, *Notes While Preparing Sketch Book & c. 1817* (New Haven, Conn.: Yale University Press, 1927), pp. 24-42. For a more recent treatment of the question, see Richard Ellmann, "Love in the Catskills," *The New York Review of Books* 23 (February 5, 1976): 27-28.

20. Irving, *Letters to Brevoort,* p. 84.

21. Irving, *Notes While Preparing Sketch Book,* pp. 28-30.

22. Henry Brevoort, *Letters of Henry Brevoort to Washington Irving,* ed. George S. Hellman (New York: G. P. Putnam's Sons, 1918), p. 113.

23. P. M. Irving, *Life and Letters,* 1: 457.

24. Irving did not totally renounce the prospect of marriage.. He later had a romance with and perhaps proposed to Emily Foster in Dresden. See Williams, *Washington Irving,* 1: 239-54.

25. Washington Irving, *Tour in Scotland 1817 and Other Manuscript Notes,* ed. Stanley Williams (New Haven: Conn.: Yale University Press, 1927), p. 104.

26. Williams, *Washington Irving,* 2: 260.

27. Irving, *Letters to Brevoort,* p. 140.

28. Ibid., pp. 179-80.

29. Ibid., p. 191.

30. P. M. Irving, *Life and Letters,* 1: 370.

31. See Williams, *Washington Irving,* 1: 153-58.

32. *Analectic Magazine* 1 (March 1813): 252. Quoted by William L. Hedges, *Washington Irving: An American Study, 1802-1832* (Baltimore, Md.: Johns Hopkins Press, 1965), p. 14. See also Williams, *Washington Irving,* 1: 23.

33. William Charvat, *The Profession of Authorship in America, 1800-1870, The Papers of William Charvat,* ed. Matthew J. Bruccoli (Columbus: Ohio State University Press, 1968), pp. 29-48.

34. P. M. Irving, *Life and Letters,* 1: 373-75.

35. Williams, *Washington Irving,* 1: 156.

36. Irving, *Letters to Brevoort,* p. 252.

37. See letter to Peter Irving, September 16, 1817 in P. M. Irving, *Life and Letters,* 1: 384.

38. Williams, *Washington Irving,* 1: 163.

39. Sir Walter Scott, *Familiar Letters,* 2 vols. (Boston, Mass.: Houghton Mifflin & Co., 1894), 1: 441.

40. This account of Irving at a transition point in his life was written much later, and Preston may have benefitted from hindsight, especially when he suggested that the notion of a sketch book was already matured at this point. Williams, *Washington Irving,* 1: 165.

41. P. M. Irving, *Life and Letters,* 1: 240.

42. Irving, *Letters to Brevoort,* pp. 253-54.

43. Irving, *Notes While Preparing Sketch Book,* pp. 55, 67.

44. Ibid., pp. 63-64.

45. Irving, *Letters to Brevoort*, p. 271.

46. P. M. Irving, *Life and Letters*, 1: 174.

47. Ibid., pp. 392-93.

48. Irving, *Letters to Brevoort*, pp. 275-76.

49. P. M. Irving, *Life and Letters*, 1: 404, or Williams, *Washington Irving*, 1: 169. The latter gives the date as July.

50. Irving, *Letters to Brevoort*, pp. 293-94.

51. Williams, *Washington Irving*, 1: 170.

52. Ibid., 2: 260.

53. P. M. Irving, *Life and Letters*, 1: 409.

54. Ibid., p. 410.

55. Ibid., p. 412-14.

56. Irving, *Letters to Brevoort*, p. 299.

57. Ibid., pp. 308-10.

58. Ibid., p. 314.

59. Publishing information from P. M. Irving, *Life and Letters*, 1: 416, 420, 427, 428, 447, 448, 459. For content of numbers see Williams, *Washington Irving*, 1: 426.

60. Irving's promotional scheme is described in Williams, *Washington Irving*, 1: 112-13.

61. Washington Irving, *Salmagundi; or the Whim-Whams and Opinions of Launcelot Langstaff, Esq., and Others* (New York: D. Longworth, 1808), pp. 3, 4. Washington Irving, *The Sketch Book of Geoffrey Crayon, Gent.*, 7 vols. (New York: C. S. Van Winkle, 1819), 1: iv.

62. Irving, *Sketch Book*, 1: 5, 9, 8.

63. Ibid., 7: 34.

64. Ibid., 1: iii.

65. Irving, *Letters to Brevoort*, pp. 299-300.

66. P. M. Irving, *Life and Letters*, 1: 440-41.

67. Hedges, *Washington Irving: An American Study*, p. 141.

68. Irving, *Sketch Book*, 5: 386.

69. Ibid., p. 421.

70. Ibid., p. 409.

71. Ibid., pp. 432-33.

72. Ibid., 6: 118.

73. Ibid., 7: 92.

74. Ibid., 4: 300.

75. Ibid., 7: 54.

76. Ibid., pp. 65-66.

77. Ibid., pp. 68-71.

78. Ibid., p. 71.

79. Ibid., pp. 86-87.

80. Ibid., pp. 88-89.

81. Both pairings are mentioned by Hedges, *Washington Irving: An American Study*, p. 137.

82. Irving, *Sketch Book*, 3: 220-21.

83. Ibid., p. 242.

84. Ibid., pp. 175, 191.

85. Ibid., pp. 180-81.

86. Ibid., 7: 33, 32.

87. Irving, *Letters to Brevoort*, p. 273.

88. Irving, *Sketch Book*, 7: 36, 38.

89. Ibid., 4: 287.

90. See Williams, *Washington Irving*, 1: 177.

91. Ibid., pp. 187-88.

92. See P. M. Irving, *Life and Letters*, 1: 431, for a comment by Matilda Hoffman's mother linking "Rural Funerals" to her daughter's death. For the notebook passage on Matilda Hoffman, see Irving, *Notes While Preparing Sketch Book*, pp. 63-64.

93. Irving, *Sketch Book*, 7: 11.

94. Ibid., pp. 26-28.

95. Ibid., 4: 247-48, 249, 250-51.

96. Ibid., pp. 251, 261, 263, 264, 266.

97. Herman Melville, "Hawthorne and His Mosses: By a Virginian Spending a July in Vermont," *Literary World*, August 17, August 24, 1850. Reprinted in Herman Melville, *The Works of Herman Melville*, 16 vols., ed. Raymond W. Weaver (New York: Russell & Russell, 1963), 13: 132.

98. Irving, *Sketch Book*, 2: 109, 118, 119.

99. Ibid., pp. 157-58, 159, 150-60, 161, 162.

100. Ibid., pp. 164, 167.

101. See letters of July 11, 1817 and March 10, 1821 to Brevoort in Irving, *Letters to Brevoort*, pp. 252-55 and 353-56. See also letter to William Irving, December 1817, in P. M. Irving, *Life and Letters*, 1: 392-93.

102. See Irving, *Letters to Brevoort*, p. 340.

103. Ibid., p. 168.

104. See H. A. Pochmann, "Irving's German Sources in *The Sketch Book*," *Studies in Philology* 27 (July 1930): 477-507. See also Williams, *Washington Irving*, 1: 179, 183-84.

105. P. M. Irving, *Life and Letters*, 1: 448-49. P. M. Irving offers Van Wart as a source for "The Legend of Sleepy Hollow" and claims that Irving "scribbled off the framework" for the tale "in a few hours" after a conversation in 1818. This story seems oddly close to the legend that he wrote "Rip Van Winkle" overnight at the Van Warts' house. See Williams, *Washington Irving*, 1: 168-69. Whether one or both of these tales were born in this manner, it is interesting that both were remembered as the products of intense excitement and rapid composition in an atmosphere connected with home.

106. Irving, *Letters to Brevoort*, p. 307.

107. Ibid., pp. 327-28.

2

WASHINGTON ALLSTON:
In the Footsteps of the Old Masters

Washington Allston's monumental painting, *Belshazzar's Feast,* frequently has been seen as the epitome of his career. A massive canvas depicting a dramatic biblical scene, the painting was conceived in accordance with the dictates of English academic art, and Allston executed sections of it with the technical finesse that had earned him recognition in Paris and Rome as well as in London and the United States.[1] When he brought the nearly finished painting to Boston, his contemporaries viewed it as triumphant evidence of American genius, a magnificent rejoinder to those who doubted Americans' capacity to compete with Europe in the arts. As the years drew on and the picture never reached completion, observers began to cite it as an example of good intentions unfulfilled. When Allston died with the picture still unfinished twenty-six years after he had begun work on it, his admirers concluded that his ambitions were too noble to be realized, that his imagination had outstripped his mortal powers. Less sympathetic commentators called the fragmentary painting a judgment on a dreamy or indolent character or an indication of the hostility of the American environment to art. Twentieth-century critics have seen *Belshazzar's Feast* as Allston's albatross, the misguided effort of a painter whose best talents lay elsewhere but who was trapped by a sense of obligation to it.[2]

Allston's modern reputation, which emphasizes his failures and frustrations, seriously understates his historical significance. In his own time Allston was widely admired by Americans who shared his passionate dedication to art. Washington Irving stood in awe of his intensity in Rome and later imagined that he had been tempted by Allston's example to become a painter himself.[3] Thomas Cole sought Allston's advice at the beginning of his own career. Samuel F. B. Morse, Robert Leslie, and Horatio Greenough found Allston an inspiring and articulate teacher.

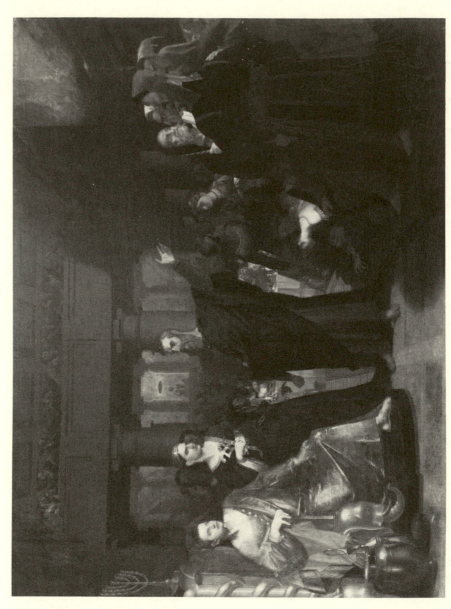

1. Washington Allston, *Belshazzar's Feast*, oil on canvas, 144¼ × 192⅝ in. Detroit Institute of Arts, Gift of the Allston Trust, 55.515.

During the first quarter of the nineteenth century, Allston seemed capable of bridging the gulf between the Old World and the New by establishing himself as a respected artist on both sides of the Atlantic. Although he was equipped with the best European education and inspired by the European scene and the artistic colleagues he found there, he chose to live in America. *Belshazzar's Feast,* begun in Europe and carried to America, seemed to many to embody the transatlantic bond in a tangible form. For a quarter of a century Allston struggled with this painting and others, while his countrymen viewed him as their link with the Old Masters. The promise and disappointment of Allston's career, his high hopes and their cruel disappointment, served as both an example and a warning to Americas in search of an artistic identity.

When Allston graduated from Harvard in 1800 with the determination "to be the first painter, at least, from America," he took it for granted that the pathway to his goal led through Europe.[4] Like his friend and contemporary Washington Irving, Allston sought the stimulation and encouragement of older artists who could serve as models and teachers for a young artist. Even more than in literature, a career in the visual arts seemed to demand an apprenticeship and initiation into professional mysteries. From the practical matters of pigments and the preparation of a canvas to the more abstract problems of perspective and composition, painting required technical skills that the novice could best learn from an experienced artist. America in 1800 offered few opportunities for such learning, and Allston had already sampled most of these. He had observed such practicing artists as the miniaturist Edward Malbone and had pored over the few paintings available to him in private and public collections, but these lessons provided a meager diet for an ambitious artist. Like John Singleton Copley and Benjamin West a generation earlier, Allston felt that he needed still more thorough training and direct exposure to works of art, which could be found only in Europe.

In the eyes of Allston's family, prominent South Carolina landholders, the European voyage represented a momentous step toward the artistic career they opposed. Although Allston had shown his interest in art from an early age, his stepfather, Henry Collins Flagg, had urged him to study medicine and had sent him to school in Newport, Rhode Island, and then to Harvard. After his graduation, Allston's announcement of his renewed determination to study art greatly distressed his family. Instead of going home he remained in New England until his twenty-first birthday. He then returned to South Carolina only to convert his inheritance into cash. His family may have continued to object to his activities, but Henry Collins Flagg died in April 1801, and Allston sailed for Europe within a month. Although Allston's nephew later claimed that the family became

reconciled to his career choice, Allston's break with them seems quite complete. Apparently he never again visited South Carolina, and although his mother lived until 1840, he saw her only once more, in 1809.[5] In traveling to Europe Allston made a sharp break with his past and declared his identity as an artist. Unlike Irving, whom he met in Rome in 1805, Allston had a clear sense of his vocation early in his life.

Arriving in London in 1801, he found a highly structured art world in which aesthetic ideas and professional practice conformed to well-defined standards. As a student and then as a painter just beginning to win recognition, Allston accepted many of the English School's assumptions about the nature of art and the artistic vocation. These ideas shaped his goals and aspirations throughout his career.

A generation earlier, Sir Joshua Reynolds had enthroned the painting of historical subjects as the highest form of art and had provided a vocabulary for judging both Old Masters and modern paintings. Reynolds' *Discourses* were available to Allston in published form before he left America, and Reynolds' ideas formed the groundwork for his own thinking. "So familiar is the image of Sir Joshua to me," Allston wrote later ". . . that I feel almost persuaded at times I had actually been acquainted with him."[6] Reynolds had written that imitation, or "the study of other masters," should be "extended throughout our whole lives." It was, he felt, the source of all "variety, and even originality of invention." He described in great detail the type of subject that he considered appropriate to art. "It ought to be either some eminent instance of heroick action, or heroick suffering. There must be something either in the action, or in the object, in which men are universally concerned, and which powerfully strikes upon the public sympathy."[7] Reynolds' definition of the grand style and his exhortations encouraging young painters to dedicate themselves to its pursuit impressed the young Allston and left its mark on his future career. Although he eventually valued some artists differently from Reynolds, notably the Venetian colorists and the Dutch genre painters, Allston worked within Reynolds' general framework for the rest of his life.

Benjamin West, Reynolds' successor to the presidency of the Royal Academy, exerted a more personal influence on Allston. West, a native of Philadelphia, was particularly helpful and encouraging to American artists in London. In West's studio Allston saw paintings that reflected Reynold's concern for a noble and inspiring subject but employed a looser, freer, and more romantic technique. Allston especially admired West's *Death on a Pale Horse* and wrote home a glowing account of the older painter's talents.[8] West too preached the importance of the study of past masters as a basis for an artistic career. "The paths pursued by those great examples must become yours, young gentlemen," he urged in one

lecture, "or you can neither be eminent in coloring, nor sure in the execution of your art."[9]

Allston's artistic education, guided by such teachings, culminated in a visit to the Continent to study the Old Masters firsthand. Years later he vividly recalled the impact of his confrontation with art objects that he had previously known only through engravings and descriptions. "Titian, Tintoret, and Paul Veronese absolutely enchanted me," he wrote, and added, "It is needless to say how I was affected by Raffaele [sic], the greatest master of the affections in our art. . . . Of Michaelangelo, I know not how to speak in adequate terms of reverence."[10] He described his first sight of the Apollo Belvedere, the revered statue that West had compared to a Mohawk warrior, as a sort of artistic epiphany: "I know not that I could better describe it than as a sudden intellectual flash, filling the whole mind with light, and light in motion. It seemed to the mind what the first light of the sun is to the senses, as it emerges from the ocean; when from a point of light the whole orb at once appears to bound from the waters, and to dart its rays, as a visible explosion, through the profound [sic] of space."[11] His contact with the Old Masters provided him with one of the deepest intellectual and emotional experiences of his life.

In more practical terms, Allston's study of the Old Masters gave him important technical skills. By examining Titian's paintings he learned to mix his colors in a way that would reproduce the brilliant coloring effects of that painter. It was this ability that earned him the title, "the American Titian" in America and abroad.[12] But beyond the training he received, Allston's European study clearly gave him a sense of participating in a tradition, of adding his talents to those of the great artists of the past, in fact of joining an artistic fraternity. "The *old* masters are *our* masters," he told an aspiring young artist.[13] Later in his life he looked back on his European experience as uniquely stimulating. "As to the glowing works of art by which you will be surrounded in Rome," he wrote a friend embarking for Italy in 1842, "they will breathe new life into you. Even at this distance of time I live upon them in memory."[14] As an old man, he reported that he often read from Pilkington's *Dictionary of Art* to bring him into contact again with the Old Masters before going into his studio.[15] This gesture of homage to artistic tradition, like a prayer or invocation, shows how Allston drew spiritual nourishment from the sense of fraternity that formed the legacy of his European studies.

During his visit to the Continent, Allston encountered one other major spiritual and intellectual influence. In 1805 he met Samuel Coleridge in Rome, and the two men enjoyed an intense, invigorating friendship. "To no other man whom I have known, do I owe so much, *intellectually,*

as to Mr. Coleridge," Allston later wrote. "When I recall some of our walks under the pines of the Villa Borghese, I am almost tempted to dream that I once listened to Plato in the groves of the Academy."[16] Coleridge returned his enthusiasm and poured out his affection for Allston in a letter written after his departure from Italy. "Had I not known the Wordsworths [I] should have loved & esteemed you *first* and *most*, and as it is next to them I love & honor you."[17]

With his classical education and literary bent (he wrote poetry throughout his life), Allston could meet Coleridge on the common ground of philosophy and aesthetics. Allston's early enthusiasm for the Gothic and the sublime prepared him to join Coleridge in discussions sounding the depths of the human spirit. Years later, in a sonnet written after Coleridge's death, Allston used Romantic poetic imagery to evoke the atmosphere of their explorations.

> And I no more
> Shall with thee gaze on that unfathomed deep,
> The Human Soul,—as when, pushed off the shore
> Thy mystic bark would through the darkness sweep,
> Itself the while so bright![18]

It is possible that Coleridge introduced his friend to the ideas of Immauel Kant and the German idealists, which Allston later incorporated into a systematic art treatise.[19] Above all, the long friendship with Coleridge expanded Allston's notion of the potentialities of artistic imagination. Listening to his friend's brilliant conversation and his exhortations to follow his own genius, to commune with nature, to exert his will, Allston developed a notion of the artist's calling that he affirmed and taught to others—despite his own painful disappointments—throughout his life.[20]

Allston's European studies also gave him a clear sense of artistic goals. From West and Reynolds he learned the importance of tradition and came to see himself as part of a historical continuum with its roots in the art of the Renaissance. Coleridge encouraged him to value the spiritual and expressive aspects of art, to see his mission as the discovery and communication of the truths of the human soul. Through the medium of history painting, Allston aspired to embody Romantic poetic ideas.

After a brief return to America to marry his fiancée, he returned to Europe in 1811. This second sojourn in England, which lasted until 1818, represented a rich period of development during which Allston established a style and artistic reputation of his own. Benefitting from the friendship of Coleridge and West and the stimulating artistic life of London with its exhibitions, competitions, and prizes, Allston moved from apprentice to fledgling painter. Upon his return to England he became

a teacher himself and instructed two young Americans, Samuel F. B. Morse and Charles Leslie. Morse eventually returned to the United States and, frustrated by his inability to interest Americans in history painting, turned to his work on the telegraph. Leslie made his career in England as a genre painter and later became the close friend and biographer of John Constable. As students, however, both young men imbibed Allston's enthusiasm for "our *divine* art," as Morse phrased it in a letter to his parents.[21] The letters and memoirs of these two enthusiastic pupils offer a clear idea of the artistic environment in which *Belshazzar's Feast* was conceived and of which it was intended to form the epitome.

Allston instructed his pupils not only in the technical aspects of art but also in matters of theory and taste. "It was Allston who first awakened what little sensibility I may possess to the beauties of color," wrote Leslie. "He first directed my attention to the Venetian school, particularly to the works of Paul Veronese, and taught me to see, through the accumulated dirt of ages, the exquisite charm that lay beneath." Leslie reported to his sister in 1813 that he was embarking on a course of reading, undoubtedly at Allston's suggestion: "I have lately read the Mysteries of Udolpho' for the first time, and with very great pleasure, I am now going through Homer, Milton, and Dante's works, which every painter should be well acquainted with."[22] Like Reynolds and West before him, Allston taught his students to admire the art of history painting as "the intellectual branch of the art," one closely akin to poetry and requiring the firmest discipline and purest thoughts. Morse no doubt reflected Allston's view of the artist's vocation when he wrote to his family in May 1814 stating his determination to become a history painter:

I need not tell you what a difficult profession I have undertaken. It has difficulties in itself which are sufficient to deter any man who has not firmness enough to go through with it at all hazards, without meeting any obstacles aside from it. The more I study it, the more I am enchanted with it; and the greater my progress, the more I am struck with its beauties, and the perseverance of those who have dared to pursue it through the thousands of natural hindrances with which the art abounds. . . . A golden age is in prospect, and art is probably destined to again revive as in the fifteenth century.[23]

Morse's statement captures the principles of Allston's concept of the artistic vocation. The notion of art as a primarily intellectual activity, a heroic struggle against obstacles, with the hope—which proved illusory—for a revival of a support and enthusiasm that would rival the Renaissance, gave Allston's work its power and yet ultimately proved its limitation.

Hindsight reveals that in his enthusiasm for history painting Allston committed himself to a declining art form and pulled the impressionable Morse with him. J.M.W. Turner had been elected to the Royal Academy

in 1802, David Wilkie in 1809, and John Constable was elected in 1829. Patronage as well as public and professional enthusiasm were shifting to the fields of landscape and genre at the time Morse made his declaration. Yet Allston was not alone in his failure to recognize these changes. Benjamin Robert Haydon had arrived in London in 1804, dreaming of "High Art" and "resolved to be a great painter, to honour my country, to rescue the art from the stigma of incapacity which was impressed upon it."[24] This unfortunate painter, whose career offers a fascinating counterpoint to Allston's, plunged recklessly into the production of monumental history paintings despite the fact that he had alienated both patrons and professional peers. But at the time Morse was formulating his goals under Allston's direction, prospects for history painting still seemed encouraging. West passed the torch to Allston in praising *The Dead Man Restored to Life by Touching the Bones of the Prophet Elisha* in 1812. "Why sir," exclaimed West, "this reminds me of the fifteenth century. . . . There are eyes in this country that will be able to see so much excellence."[25] As Morse's letter makes clear, Allston certainly expected to live in a period of artistic revival and renascence, one in which his own field of art would be appreciated and honored as a noble intellectual enterprise.

During his residence in Europe, Allston developed the practical aspects of his profession, establishing work patterns and attitudes toward the production and sale of his paintings that he maintained throughout his life. It was unfortunate for his later development that he was able to enter the profession with enough financial security to overlook the practical questions of income and sales. When he first arrived in England in 1801, he announced to Henry Fuseli, professor of painting at the Royal Academy, that he intended to become a history painter. "You have come a great way to starve," the older painter responded. "I have a certain patrimony," replied Allston. "Ah," Fuseli answered, "that makes a difference."[26] Unaware that his resources were dwindling, Allston continued to ignore financial considerations during his second stay in Europe. He chose his subjects according to his still developing concept of higher art, and although he was grateful for commissions and prizes, he did not believe he had to depend upon them for his livelihood. As he explained in 1830, he had "in the commencement of my art and for the greater part of my subsequent life, only the pleasure of its pursuit to consult[.] I of course engaged in nothing which had not that for its chief end—the realizing of my conceptions being my chief reward; for though pecuniary profit was always an acceptable contingency, it was never at that time an exciting cause; so far from it, that I have in some instances undertaken works for less than I knew they would cost."[27] Even from the beginning of his career, Allston displayed the diffidence and generosity more suited to a gentleman of independent

income than to a struggling artist. In 1817 when his painting *Uriel in the Sun* received first prize at the British Institution, Allston called upon a fellow artist, William Brockhedon, whose large painting *Christ Raising the Widow's Son at Nain* had won second place. Knowing his colleague needed money, Allston insisted on sharing his prize money with him.[28]

Allston's financial situation began to change at some point during his second residence in England. It is difficult to reconstruct the exact timing or reasons for the change. An early biographer suggested that Allston, in his innocence of financial dealings, had spent the principal of his patrimony instead of using the interest; another account suggested that a dishonest agent had deprived him of his income.[29] In September 1814, Coleridge wrote to a friend about Allston's financial problems and described "his little property" as "lost by a London Bankruptcy," presumably that of his banker.[30] Contemporaries connected Allston with Irving's story "The Wife," which was published in the first number of *The Sketch Book* and describes a young husband's financial reverses. The fictional husband is named Leslie, but Allston's young friend Charles Leslie was unmarried at the time the story was written.[31] The sudden death of his wife in 1815 added to Allston's cares and perhaps cut off an additional source of income. Certainly Allston had begun to feel the pinch of financial necessity by August 1815 when he wrote to John Vanderlyn about some packing cases he had recovered from their earlier trip to the Continent. Allston lamented that paintings he had planned to sell as Old Masters had proved to be copies; he was "just now rather straitened for cash & I had hoped, when I heard of their arrival, to have sold mine for a good sum."[32] Hereafter Allston's letters began frequently to refer to financial problems.[33]

Even as his financial situation darkened, he continued to maintain the same work patterns and attitudes that he had established as a young man with a comfortable patrimony. An exchange of letters at the end of 1817 clearly reveals Allston's attitude and presaged future problems. On December 27, 1817, Allston answered a letter from Francis B. Winthrop of New Haven, Connecticut, who complained that a painting he had bought from Allston had declined in value. Purchased around 1810 for $500, the picture had brought only $200 when Winthrop subsequently sold it. Instead of dismissing this letter with a resounding *caveat emptor,* Allston took the complaint seriously and attempted to explain to Winthrop his attitude toward the pecuniary aspects of his profession. "Money alone is not [the] whole reward of an artist," Allston wrote. "It is but secondary to the satisfaction arising from the consciousness of giving pleasure to those who possess or see his works; and I would never deliberately accept the former where I knew it was un-

accompanied by the latter. No: were I to paint a picture, by commission, for any nobleman here, and he should dislike it when finished (even though I thought it the happiest effort of my pencil), I would instantly release him from his engagement."[34] Allston concluded by offering to send Winthrop another painting to make up for the decreased value of his first. Unfortunately, as he became enmired in financial problems he found himself unable to send the promised painting, and Winthrop continued to hound him. "It is painful for me to write down the name of this hard, mean & vulgar man," Richard Henry Dana noted beside Winthrop's name in his catalogue of Allston's paintings. "A. should have treated his very first letter with contempt, & there left him."[35] Of course, Allston's lofty notion of the artistic vocation would not have allowed him to follow Dana's advice.

While he was shaping his views on the theory and practice of the artistic vocation, Allston also was winning recognition and a favorable reputation from the English artistic establishment. The painting that Benjamin West praised so lavishly in 1812, *The Dead Man Restored to Life by Touching the Bones of the Prophet Elisha,* won a prize of 200 guineas at the British Institution in the spring of 1814.[36] Allston's reputation grew steadily in London, and some of England's most important art patrons purchased his pictures. Sir George Beaumont commissioned *The Angel Liberating St. Peter from Prison*; the Marquis of Stafford purchased *Uriel in the Sun,* and Lord Egremont bought *Jacob's Dream* for his country house at Petworth.[37]

By 1818 Allston had achieved a respectable measure of recognition in England, although he was not as successful as his American advocates later suggested. Although his nephew and biographer Jared B. Flagg wrote in 1892, "It goes almost without saying, to those familiar with his career, that had Allston remained in England he would have succeeded West as President of the Royal Academy," this description of Allston's success now seems overly sanguine.[38] His European career was by no means triumphant. In 1818 Allston was nearly thirty-nine years old, and despite considerable praise and patronage, he had not yet been elected even an associate of the Royal Academy. At his age more than half of the members had already become full-fledged academicians.[39] Furthermore, his financial situation remained precarious. *The Angel Liberating St. Peter from Prison,* a canvas nearly as large as his monumental *Dead Man Restored to Life,* received only 200 guineas from Sir George Beaumont, who in fact had asked for "a picture of small dimensions."[40] Allston considered this nobleman one of the most important of his English patrons, but Beaumont's support consisted primarily of encouraging words rather than commissions.[41] Coleridge wrote to mutual friends that Allston was "cruelly used" by Beaumont, West, and others, who made promises only to break them later. In his outspoken way

Coleridge fulminated against the "excessive meanness of Patrons" and the "malignant Envy & Brutality of the Race of Painters."[42] Beaumont's letters to Wordsworth expressing disappointment in Allston's work seem to indicate that Coleridge may have had good cause for his anger.[43] Allston himself received scant comfort from the affairs of other history painters at the time. With the waning of royal patronage, Benjamin West had begun to exhibit his paintings as an independent enterprise; he hired a hall and charged admission, a form of showmanship that required personal effort and supervision.[44] Meanwhile, the situation of Haydon, who was falling ever more deeply into debt despite the success of *The Judgment of Solomon* in 1814, provided a sobering lesson for Allston. In 1818 Haydon was still hard at work on *Christ's Triumphal Entry into Jerusalem*, a painting he had begun in 1814; he already had to borrow more money, and the picture's completion was not yet in sight.

In 1818 Allston reached the decision that his biographers later lamented: he returned to the United States in September. Why he decided to leave England at this particular time is unknown. Irving expressed surprise and regret to Leslie over Allston's departure.[45] Certainly Allston had mixed emotions over his decision, for he always recalled his English years with great warmth. "Next to my own country," he wrote almost twenty years later, "I love England, the land of my adoption."[46] In a letter to William Collins in April 1819, Allston wrote that he hoped to be able to "preserve my claim as one of the British school," unless he could "have the satisfaction of founding an English school here."[47] Although he was a notoriously bad correspondent, Allston maintained close contact with his English friends for nearly eight years, and as late as 1830 Leslie still was urging him to return.[48] In a letter to Collins in May 1821, Allston wrote that he dreamed of a return to England but was forced to content himself with "visionary" visits in which he imagined reunions with his friends.[49] Yet, Allston's sojourn in England had brought him mixed happiness at best: his own health had broken down, and the sudden death of his wife had shaken him deeply.[50]

With such ambivalent feelings about England, Allston must have been particularly sensitive to signs of encouragement from America. Throughout his years abroad, he had maintained a strong sense of his American identity, and he had kept in touch with the art world at home.[51] New prospects now appeared to beckon from America. The Pennsylvania Academy of Fine Arts purchased *The Dead Man Restored to Life* for $3,500, and his correspondence with James McMurtrie of Philadelphia seemed to promise further sales and commissions.[52] Samuel Morse, who had already returned to America, wrote Allston from Boston in April 1816 to congratulate him on the Pennsylvania sale: "I am sincerely rejoiced for you and for the disposition which it shows of future encouragement. I really think the time is not far distant when we shall

be able to settle in our native land with profit as well as pleasure."[53] In the spring of 1818 Allston was elected an honorary member of the American Academy of Fine Arts in New York. In his letter of acceptance he declared himself "deeply interested in all that may add to the reputation of my native land" and congratulated his country "on the auspicious opening of so fair a fountain of national greatness."[54] Allston must have seen encouraging·signs for his profession in the revival of this institution under the presidency of the history painter John Trumbull.

Such hopeful indications may have tipped the balance for Allston. Years later a biographer quoted Allston's explanation for his return to the United States as, "Something like encouragement seems to appear on our horizon. If we have any talents we owe something to our country when she is disposed to foster them."[55] In a fragment of a letter written just before his departure, Allston announced his decision to return home and spoke rather stiffly of patriotism: "It is both natural and honorable to love the land of our nativity. . . . It has become dearer to me as I have grown older." Yet there are hints of a warmer, more emotional desire to return home. Across the envelope he scrawled more spontaneously a message to his friend Richard Henry Dana: "Tell him I already sniff [the fra]grance of his segar."[56] Perhaps Allston was drawn home at least partially by the feelings he later described to William Dunlap as "a homesickness which . . . I could not overcome."[57]

Viewed from Allston's perspective the decision of 1818 was a reasonable, even adventurous, one. He brought to a close his period of training and apprenticeship in Europe and returned to the country with which he had identified throughout his period abroad. His two visits to Europe had provided him with an education he never could have obtained at home and had enabled him to establish a reputation within his profession. He believed he could return to America and resume the career that he had forged in Europe. Preliminary signs showed that he could expect at least as much patronage as he found abroad and possibly more. He had sufficient contacts in Europe to assure him ready access to professional supplies and other necessities.[58] And, as Irving pointed out, America offered a relatively fresh field for development. "It is infinitely preferable to stand foremost as one of the founders of a school of painting in an immense and growing country like America—in fact, to be an object of national pride and affection, than to fall into the ranks in the crowded galleries of Europe."[59]

Allston left England with only one unsold picture, *Elijah in the Desert Fed by Ravens.*[60] Before his departure he completed two small studies for *Belshazzar's Feast,* and he brought with him "on the stocks" the large version of this painting of which he wrote in November 1818, "all the laborious part is over, but there remains still about six or eight months'

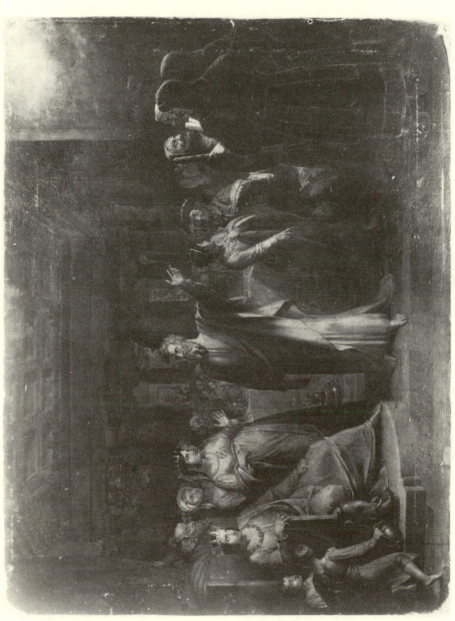

2. Washington Allston, *Study for Belshazzar's Feast* (sepia), oil on millboard 63.5 × 86.4 cm. Courtesy of the Fogg Art Museum, Harvard University, Washington Allston Trust.

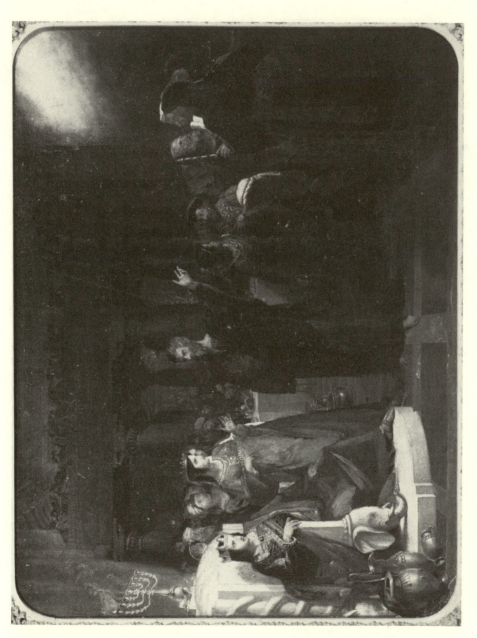

3. Washington Allston, *Study for Belshazzar's Feast* (color), oil on cardboard, 64.8 × 87 cm. Bequest of Ruth Charlotte Dana, 06.1875. Courtesy, Museum of Fine Arts, Boston.

work to do on it."[61] He hoped to begin his American career by exhibiting this impressive painting for profit, expanding his reputation and generating further commissions.

Belshazzar's Feast, as Allston had conceived it in 1817, reflected the aesthetic values that he had developed during his years in Europe. In the tradition of West and Reynolds, he chose a biblical subject of high drama. In his presentation of the subject, he strove for the effects of the sublime, that is the poetic intensity, the aura of the supernatural, that characterized those English Romantic poets with whom he had been in contact. Like so many of Coleridge's poems, the painting depicts a visionary moment and explores the effect of the vision upon those who witness it. It portrays a scene from the Book of Daniel. According to this account, Belshazzar, king of Babylon, held a great feast with his wives and concubines for a thousand of his lords. He drank wine from the gold and silver vessels that his father, Nebuchadnezzar, had taken as spoils from the temple in Jerusalem. In the midst of this impious feast, mysterious handwriting appeared on the wall. In terror Belshazzar called upon his wise men, enchanters, Chaldeans, and astrologers, but none of them could interpret it. The queen suggested sending for Daniel, one of the Jews who had earlier prophesied Nebuchadnezzar's downfall. Daniel then compared Belshazzar's pride to that of his father: he had not humbled his heart, but had continued to oppose the Lord. The writing on the wall predicted his destruction. *Mene, Mene, Tekel, Upharsin:* God has numbered the days of your kingdom; you are weighed in the balances and found wanting; your kingdom is to be divided and given to the Medes and Persians. That very night Belshazzar was slain, and Darius the Mede conquered the kingdom.

From the first, Allston's imagination sought the Romantic elements in the scene. He described his subject in a letter to Washington Irving in 1817:

A mighty sovereign surrounded by his whole court, intoxicated with his own state, in the midst of his revellings, palsied in a moment under the spell of a preternatural hand suddenly tracing his doom on the wall before him; his powerless limbs, like a wounded spider's, shrunk up to his body, while his heart, *compressed to a point,* is only kept from vanishing by the terrific suspense that animates it during the interpretation of his mysterious sentence. His less guilty but scarcely less agitated queen, the panic-struck courtiers and concubines, the splendid and deserted banquet table, the half arrogant, half astounded magicians, the holy vessels of the temple (shining as it were in triumph through the gloom), and the calm solemn contrast of the prophet, standing like an animated pillar in the midst, breathing forth the oracular destruction of the empire![62]

In its emphasis on terror and heightened emotion, Allston's description reads like a passage from one of the Gothic novels he admired so much.

The future author of the Gothic romance *Monaldi*, the mentor who urged Leslie to read the *Mysteries of Udolpho*, moved instinctively toward the sublime mode in thinking about this composition. He used metaphor and highly wrought descriptions—"palsied in a moment," "powerless limbs like a wounded spider's," "shining, as it were, in triumph through the gloom," "breathing forth the oracular destruction of the empire!" Allston wrote to Irving that he wished to unite the "magnificent and the awful" in his painting. Working directly in the Gothic tradition, he conceived the painting as an emotional moment of the sublime.

This same Romantic mood informed a number of Allston's other paintings during his second English period. As E. P. Richardson has pointed out, from *Dead Man Restored to Life* and *The Angel Liberating St. Peter* through *Jacob's Dream*, Allston explored "the border line of the known and the unknown, dramatic, solemn, rich, and mysterious." *Belshazzar's Feast* was an extension of the same theme.[63] At the time he sketched out the composition for *Belshazzar's Feast*, Allston was working busily and productively, feeling the flush of success. "Ah, I was then in health, young, enthusiastic in my art, in a measure independent as to my pecuniary affairs, and I painted solely from the impulse within," he wrote later. "I felt that I could do the work of a Titan or a Hercules. . . . I painted my pictures of 'Uriel' and 'Elijah in the Desert' in eight weeks, of which I gave five to the 'Uriel' and three to the 'Elijah.'"[64] It was in this mood of enthusiasm that Allston evolved an ambitious plan that would embody his interest in the sublime moment in a composition larger and more complex than any he had attempted previously.

In 1817, while still in London, Allston prepared two studies for the painting, the sepia first study now in the Fogg Art Museum at Harvard University, and the color study now in the Museum of Fine Arts in Boston. Both are skillful and complete. They show the complexity of Allston's conception of the composition in both the size of the projected painting and the number of figures. Allston's previous paintings of the sublime moment, for example *The Angel Liberating St. Peter from Prison*, had been tightly organized and highly concentrated; he had embodied the drama in the interchange between two figures. While *The Dead Man Restored to Life* presents more complexity, the composition clearly centers on the man miraculously returning to life, as waves of emotion radiate from him to the observers. The other paintings on which Allston worked in 1817 were also more concentrated, each centering on a single dramatic figure: *Uriel in the Sun* and *Elijah in the Desert Fed by Ravens*. *Jacob's Dream*, it is true, contains a number of figures, but the angels surround and respond to the sleeper in a composition almost as concentrated as the composition of *The Dead Man Restored to Life*. Like *The Dead Man Restored to Life*, *Jacob's Dream* is focused and unified by the contrast of a dark background with a bright central core.

With *Belshazzar's Feast,* Allston struck out in a new direction. The painting portrays a variety of reactions to a miraculous event, from the terror of the king and queen to the bewilderment of the magicians and the confusion of the crowd. Moreover, the characters in the painting react not only to the supernatural presence as embodied in the brilliant light of the handwriting on the wall but also to the figure of Daniel, the interpreter of the message, and to each other. In his letter to Irving, Allston had commented on the "multitude of figures," saying that he was trying to arrange them "without confusion."[65] As his comment shows, he was struggling with a highly complex composition.

In these early sketches, *Belshazzar's Feast* resembles nothing so much as a theatrical tableau. The major figures are grouped in a shallow space in front of a table that serves to separate action from backdrop. The relatively low point of sight reinforces the sense of looking across the footlights. Daniel stands at center stage with a commanding gesture. The handwriting on the wall appears just off-stage to the front, like the flashing lightning or billowing smoke in a theatrical production. Allston had long maintained an interest in the theater and had dabbled in the writing of drama in London in 1803.[66] He probably had heard Coleridge's lectures on Shakespeare in Bristol, and he numbered actors among his friends.[67] A theatrical form of composition undoubtedly seemed a natural way to organize his large, ambitious canvas.

In his original conception of the subject, Allston drew upon the work of other painters of the English school. Benjamin West, whose example so often inspired Allston, had painted a *Belshazzar's Feast* earlier in his career. Allston might have known either the painting, exhibited in 1776, or the engraving made in 1777. He adapted several basic elements of composition from West, including the arrangement of the three main groups: the gesticulating Daniel, the seated king, and the wary, huddled magicians. Like West, Allston gave his painting a strong diagonal thrust from the cowering king in the lower corner, past the pointing hands of the prophet, to the blazing handwriting in the opposite upper corner. Yet the substantial differences between the two compositions clearly indicate that Allston was moving into a new territory even in his early studies for the painting. West's composition is shallow and contained. Billowing smoke and draperies frame the picture, drawing the eye toward the center and focusing attention on the three central groups. Allston's central figures are posed before a richer backdrop, and he used a stately architectural setting to provide added complexity. While West portrayed only the men in King Belshazzar's court, Allston added color by including women courtiers, and he heightened the drama by introducing another major protagonist, the queen. As in so many of his paintings, Allston owed a debt to West but adapted the painter's ideas to his own purposes.

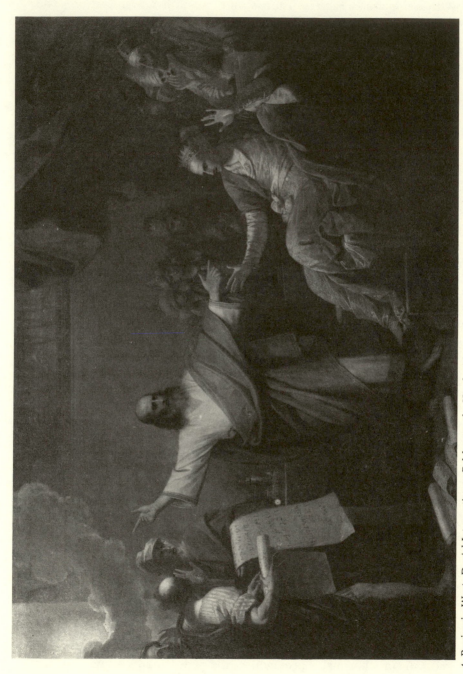

4. Benjamin West, *Daniel Interpreting to Belshazzar the Handwriting on the Wall*, oil on canvas, 50¾ × 73½ in. Gift of Zenas Crane. The Berkshire Museum, Pittsfield, Massachusetts.

Another contemporary history painting may have also influenced Allston's conception of *Belshazzar's Feast:* Richard Westall's *The Sword of Damocles.* Westall painted two versions of this picture. The first was exhibited at the Royal Academy in 1811, the second commissioned that same year by the collector Thomas Hope and subsequently displayed at his country home, the Deepdene.[68] This painting also depicts a prophecy of doom amid opulent splendor. Damocles, a young courtier, flattered the tyrant Dionysius by praising his happiness. The tyrant invited the courtier to a magnificent banquet and entertained him lavishly, but he hung above Damocles' head a sharp sword suspended by a hair. As it appears in Cicero's *Tusculan Disputations,* the incident shows the dread and insecurity that underlie wealth and power; like the story of King Belshazzar it suggests the instability of empire. The moment Westall chose to portray—Damocles' terrified perception of his situation—suggests the same dynamic contrast between the pleasures of the moment and the doom to follow, the same irony of terror in the midst of luxury that Allston would develop in *Belshazzar's Feast.*

In the summer of 1811, Allston had just returned to London from America. He probably was especially eager to see the latest works of his fellow artists, and he probably shared the general interest in the changes Westall was making as he painted the second version of *Damocles* for Hope. Because he was painting for an outstanding collector of antique art and a leader in the neoclassical revival, Westall made the furniture, sculpture, vases, and architecture surrounding the figures even more elaborate than in the first version.[69] But more strikingly, in his second version of the painting Westall sharpened the confrontation between the two main figures and changed their relationship to make a far more effective image, although in the process he strayed rather far from his literary source. In the painting's first version, Damocles and Dionysius are almost contemporaries, and the tyrant looks on his courtier's discomfort with a superior sneer. In the second version, however, Damocles is younger and more visibly terrified, his body writhing and twisting as he tries to escape the threatening blade. Dionysius has grown older and more solemn, his right arm raised, his finger pointing to the sword as if to draw the moral of the scene. A heavy cloak and long sleeves have replaced the more ornate costume of the earlier version, and the tyrant takes on a righteous, Old Testament appearance at odds with the historical depiction of this cruel and capricious prince. Like the rest of the London art world, Allston would have been interested in these changes and may have seen the painting in Westall's studio, in Hope's London townhouse, or at the Deepdene. His conceptualization of *Belshazzar's Feast* owes an important debt to this painting with its opulent setting for a dramatic confrontation between solemn prophet and doomed, cowering victim.

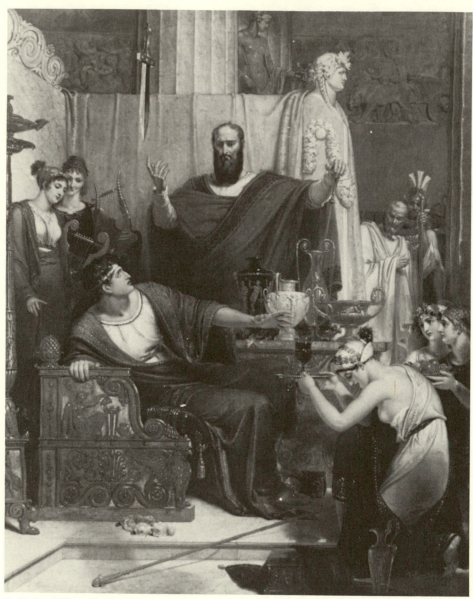

5. Richard Westall, *The Sword of Damocles,* oil on canvas, 130.3 × 103.1 cm. The Ackland Art Museum, the University of North Carolina at Chapel Hill, Ackland Fund 79.10.1.

Allston's *Belshazzar* also bears an interesting relationship to one other contemporary version of the same subject, John Martin's *Belshazzar's Feast,* exhibited to great acclaim in London in 1821. Martin acknowledged that his idea for the painting had originated in a discussion of the subject with Allston. "He was himself going to paint the subject," Martin wrote, "and was explaining his ideas, which appeared to me altogether wrong, and I gave him my conception. He then told me, that there was a prize poem at Cambridge, written by T. S. Hughes, which exactly tallied my notions, and advised me to read it. I did so, and determined on painting the picture."[70] This account of the exchange between two artists provides several insights into Allston's method of developing a subject. Like the relationship with West, it underscores Allston's belief that several artists might work on the same subject with no threat to any of them.[71] Allston's ready reference to the Hughes poem shows that literary research played an important part in his preparation of a subject. Finally, the anecdote demonstrates the generosity and openness that made Allston such an attractive figure to his contemporaries. When Leslie wrote of the tremendous success of Martin's picture, Allston replied without a shred of jealousy: "Tell Martin I would get up before sunrise and walk twenty miles to see his picture, which is saying a great deal for me, who have seen the sun rise about as often as Falstaff saw his knees, and who had almost rather stand an hour on my head than walk a mile."[72] Martin later quoted Allston's generous message, which indicates that Allston's lines of communication with other English artists remained strong at least through 1821.[73]

Martin, who shared so many of Allston's interests, contrasts tellingly with the American painter in other respects. While Martin's huge paintings of opulence and destruction attracted tremendous public enthusiasm, he never won recognition from the artistic establishment. A popularizer of history painting, he succeeded financially but never gained admission to the Royal Academy even as an associate. Allston maintained throughout his life the opposite course, adhering strictly to what he considered the highest artistic standards even at the expense of financial reward.

These differences in artistic philosophy and practice manifest themselves in the two versions of *Belshazzar's Feast*. While Allston concentrated on the intense emotions of his characters, Martin presented a sweeping panorama of doomed opulence. Leslie described the painting in progress as an architectural composition with small figures, "the writing on the wall to be about *a mile long*."[74] Whereas Allston staged his composition like a Shakespearean drama, Martin drew on a more popular art form, the panorama.[75] Martin's canvas was even larger than Allston's: twelve and a half feet high and almost twenty-one feet in length. Martin placed the feast in the open air beneath swirling clouds and illuminated

by lightning and moon. Miles of arches and columns stretch behind the courtyard, which is filled with revelers, and fantastic towers rise in the distance. As Leslie indicated, the handwriting fills an immense wall and throws its glare across the courtyard. Although Daniel, the cowering king, and the huddled magicians are visible in the picture, human drama plays a subordinate role. Martin stressed the opulence of the court and the scale of the coming destruction, not its impact on human life.

By contrast, even in his early sketches Allston envisioned the scene as a drama of consciousness. As the letter to Irving indicates, Allston differentiated among the emotions felt by various characters: Belshazzar was guilty, the queen agitated, the courtiers panic-stricken, the magicians arrogant and astonished. Eight or ten figures in the sketches display finely delineated emotions. The revisions Allston made in moving from the sepia study to the color study sharpened the focus and heightened the drama: the two subordinate figues at the left of the sepia picture were removed, and the pointing gesture of the figure to the right of Daniel was changed to reduce distraction and tighten the composition.

From its very beginning, *Belshazzar's Feast* contained innovative elements and promised to advance Allston's career. It represented the fulfillment of Allston's hope to bring back to America the skills and artistic vision he had developed during his years in Europe. If the painting he had sketched in the Old World could be completed and successfully exhibited in the New World, Allston would have smoothly transplanted his artistic life across the ocean and grafted rare European stock to strong American roots.

Instead of the transatlantic triumph Allston had hoped it would be, *Belshazzar's Feast* became a symbol of artistic failure. History painting, the medium Allston espoused so fervently, failed to excite American audiences and art patrons, and even more markedly than in England, nineteenth-century art in America came to favor landscape and genre compositions. Trumbull, Vanderlyn, and Morse all experienced frustrations in trying to pursue careers emphasizing history painting. Nonetheless, the grand style was not neglected totally in America. Other painters, for example, Rembrandt Peale, did achieve popular success by displaying religious and historical paintings.[76] Allston's magnificent reputation and technical virtuosity certainly gave him advantages over his less skillful countrymen. The tremendous success of his retrospective exhibition in 1839 proves that there was an audience that would have supported Allston if he had been able to exploit it.

Allston's inability to finish *Belshazzar's Feast* has often been compared to Coleridge's creative blocks, which left so many poems in fragments. Contemporaries criticized Allston's perfectionism. Gilbert Stuart, whose

suggested changes occasioned a major alteration of the painting in 1820, declared: "He can never be satisfied with what is best done in one part of the picture, for it will cease to be so when he has finished another. The painting will never be finished, sir."[77] Even Allston's most sympathetic modern critic, William Gerdts, writes of Allston's "excuses" for interrupting work on the project and sees no sensible explanation for his erratic progress.[78] A careful examination of Allston's pattern of work on *Belshazzar's Feast,* however, shows the ways in which external events and his own temperament conspired to frustrate his hopes. The assumptions he brought with him from Europe about the nature of the artistic enterprise proved, in the end, his own undoing.

As Allston often asserted, financial matters were a major cause of his distress. The loss of his patrimony had made him, while still in England, totally dependent upon sales and commissions. When he settled in Boston he had only one painting available for sale, but he was owed money by the Pennsylvania Academy of Fine Arts, which had purchased *The Dead Man Restored to Life.* Allston planned to live on this sum while completing *Belshazzar.* However, something delayed the delivery of these funds, and Allston decided to leave the large painting rolled up and to support himself by painting a few small pictures for immediate sale.[79] He was always highly scrupulous in his financial dealings: from on board the ship to America he wrote a letter to Leslie asking him to settle a bill of six shillings he had forgotten to pay, covering "four or five tooth brushes and some writing paper. . . . This is but a trifling debt; but still it is a *debt.*"[80] Allston might well dread debt; Haydon in London was already painting himself into the first of four bankruptcy proceedings. The great success of his *Christ's Triumphal Entry into Jerusalem* only whetted his creditors' appetites, and in July 1823 a shocked Leslie wrote to Allston, "Haydon is in King's Bench. It is said he owes ten thousand pounds. . . ."[81] Thus Allston spent the first year of his residence in Boston, painting one small picture after another trying to avoid "the misery of involving myself in debt."[82] Meanwhile another commission was waiting, for by April 1819 Boston Hospital had engaged him to paint a large picture as soon as *Belshazzar* was completed.

Even in his production of small paintings, Allston never deviated from the strict professional standards he had set for himself in England. Unlike some of his contemporaries who could cheerfully produce "pot boilers," Allston insisted on devoting the same kind of concentration and intellectual effort to small paintings as to large ones.[83] During 1820 and 1821 Allston continued to struggle to avoid debt and to establish himself in his profession. In May 1821, he listed nine paintings that had been completed in the two years since his return to America, including the life-sized *Jeremiah Dictating the Prophecy of the Destruction of Jerusalem to Baruch the Scribe.*[84] Doggedly he attempted

to put his affairs in order so that he could return to the painting he considered most important. If only he could save enough money to do the six months' work on *Belshazzar*, he wrote in May 1820, he would exhibit it for profit to support himself while he spent another eighteen months on the picture for the hospital.[85] In September 1820, he finally was able to unroll *Belshazzar's Feast* and to begin to work on it; but he found the picture farther from completion than he had estimated. He undertook a major mechanical adjustment in the perspective, probably at the suggestion of Gilbert Stuart, whom he invited, as he would have invited West in London, to criticize the painting.[86] He was just finishing this task when financial necessity again caught up with him, and he was forced to put the painting aside for another six months. In May 1821, he announced to his friends that he was engaged to be married as soon as *Belshazzar* was completed; but he could not free himself from the responsbilities of numerous small commissions until November 1821, when he declared he was resuming work on the painting for "the *last* time."[87] In his exasperation Allston took an important, if unfortunate, step in the definition of his professional habits: he resolved to fall into debt in order to work on his monumental painting. "I have made up my mind," he wrote in a letter, "rather to borrow money (which I must soon do) than thus fritter away my time for a bare daily subsistence."[88]

The decision to borrow money represented a disastrous turning point in his career. Throughout the 1820s an ever-enlarging burden of debt accumulated. By 1824 severe health problems began to interrupt his work: bleeding at the lungs, stomach pains, eye troubles. By 1825 his early enthusiasm and optimism about his American career had faded, and his attitude toward his work had changed drastically. In December 1825, he wrote to a friend that he was still "Belshazzar's *slave*—as much so indeed as the genie was to Aladdin's lamp." His sense of frustration broke to the surface as he continued, "the painter's magic, as long experience has taught me, is no 'hey, presto' work!—indeed it *is* work—that is labour, though of the brain, yet labour—which makes it, as the world might think, no magic at all." He added that he felt "deeply anxious," for "on this alone depends so much besides fame"; yet he could carry on with "patience and humility" as befitted a man of sense and a Christian.[89] By July 1826, Allston's patience had been stretched thin. Although he claimed he had been "inured to disappointment," he admitted that the fear of failure began to haunt him:

I could not always drive from me the benumbing, anxious thought, it would come in the midst of my work; and there have been times when it has fallen upon me like the gigantic hand in the "Castle of Otranto," as if it stretched forth from my picture and was about to crush me through the floor. This may seem

strong, but if you ever felt the 'sinking of the heart,' when in the midst of a work, on the success of which your all depended, and that success, too, depending on a thorough self-possession, you will not think it too strong.[90]

Allston's Gothic imagery leaves no doubt of his increasing frustration; the painting began to seem an antagonist. The ambition and high standards he had brought with him from Europe forbade him to produce an inferior work, but external circumstance frustrated his efforts as he tried to be both an American and a follower of the Old Masters.

Allston was later to look back on his struggle with debt as an unmitigated disaster to his art. "From the moment I felt the pressure of want, and began to look upon my pictures as something I must finish in order to get so much money," he wrote later, "from that moment I worked to a disadvantage, and the spirit of the artist died away from me. I never did anything well in my art under the pressure of poverty."[91] In 1832, Allston wrote a cautionary letter to a young friend who was thinking of giving up a government job to devote his full time to art:

Are you prepared to coin your brain for bread—at all times and under all circumstances, of depression, of illness, and the numberless harrassments of unavoidable debt? To produce an original work of the imagination, requiring of all human efforts a pleasurable state of the mind, with a dunning letter staring you in the face? With an honest heart yearning to give everyone his due, and an empty purse, I know from bitter experience that the fairest visions of the imagination vanish like dreams never to be recalled, before the daylight reality of such a visitor.[92]

In poor health, his morale sinking, Allston found it ever more difficult to give his ambitious canvas the concentrated effort it required. Haydon had worked so long on *Christ's Triumphal Entry into Jerusalem* that Wordsworth suggested the nickname "Tenyears" for "you have been ten years about this work." Still, Wordsworth added later, "it is worth waiting fifty years to get so complete a work."[93] But unlike Haydon, who could pile one debt on top of another with complete self-confidence, Allston felt oppressed by his financial dependency.[94] By the late 1820s, his progress on the painting had faltered. In 1828 he told a friend he had blotted out five years' work on his picture.[95] The next spring a fellow artist reported that Allston "smoked incessantly, became nervous, and was haunted by fears that his great picture would not come up to the standard of his high reputation."[96] In 1832 he resolved to work no more on *Belshazzar's Feast* until he had freed himself from debt: "Should I attempt it now, it would be to no purpose, except, perhaps, to ruin it."[97] The financial burdens under which Allston labored were more real

and more severe than has previously been realized. Brought up as a gentleman and accustomed to disregarding financial concerns during his early life, Allston found it difficult to acknowledge even to close friends the sordid facts of his economic situation during the 1820s and 1830s. Dunned by the coal merchant and other creditors, he begged for loans and sold his paintings at great loss, often accepting as little as $70 or $80 for paintings worth $500 in order to meet his rent payments or food bills.[98] After his initial decision to borrow money in 1821 or 1822, he accumulated debts so substantial that at last he was forced to mortgage his unfinished picture. The famous offer of twelve gentlemen, eleven from Boston and one from South Carolina, to buy *Belshazzar's Feast* for $10,000 ultimately proved a heavy moral and financial burden for Allston, as his biographers have affirmed. It is not usually recognized, however, that this arrangement, far from relieving Allston's economic worries, only confirmed them. The tripartite agreement, signed in May 1827, actually transferred the legal ownership of *Belshazzar's Feast* to the subscribers. The arrangement was to be supervised by a third group of trustees until Allston declared the painting finished. At the time of signing, Allston already had received half the purchase price in loans, and the agreement brought him only $1,500 more.[99] By 1827 Allston had gone so deeply into debt that he was forced to surrender ownership of his own painting, which he had previously hoped to retain and exhibit independently.

The financial arrangements of the tripartite agreement confirmed Allston's sense of working under tremendous pressure, of having lost control of his own life. By 1827 his painting seemed to have become public property. Newspapers had published speculations about it and well-meaning friends urged him to make haste. Some of his creditors, with a solicitude that only increased Allston's discomfort, took to calling at his studio to inquire about the picture's progress. In an attempt to give the sensitive and scrupulous Allston some relief, the 1827 agreement contained stipulations that the subscribers should "not unnecessarily visit the place where the said painting may be kept, unless by his request, nor exercise any unecessary acts of ownership over the said painting until the completion thereof, and that they will . . . do nothing to hinder or molest the said Allston about the progress and execution of his said work."[100] Even with these safeguards the pressures were enormous, and Allston's work on the painting eventually stumbled to a halt.

Still worse humiliation lay ahead. By 1831 Allston was forced to put his affairs into assignment, a private agreement equivalent to bankruptcy.[101] Although he was spared the kind of public shame Haydon underwent in England—arrest, imprisonment, auctioning of his effects— Allston's spirits and energy were badly depleted. Businesslike friends took charge of his affairs, lining up commissions and paying his bills,

and Allston devoted all his efforts to becoming "a free man" once again.[102] Yet even when he most despaired of his financial stability he expressed the desire to return to *Belshazzar's Feast* as soon as he was free to do so.[103]

Sound management of his resources, lucrative commissions, and the success of a retrospective exhibition in 1839 eventually improved Allston's financial situation. At the age of sixty he at last returned to the work he had considered his major project throughout these years. "The 'King of Babylon' is at last liberated from his imprisonment, and now holding his court in my painting-room," he wrote a friend on December 5, 1839.[104] But the years of pressure had taken a toll on Allston. Instead of inviting his friends to visit and criticize his picture, he now worked in utter secrecy, determined to ignore the speculations of the newspapers, which were already printing fabricated accounts of the painting. "I do not now admit even my friends into my room—so nobody can know anything about this picture," he wrote.[105] During this last period of work Allston took on the character his biographers have portrayed, struggling beyond his strength as he climbed on ladders and scaffolding, hiding the picture from view behind a curtain.[106] Shortly before his death in 1843 Allston confided to a friend, "My wrists are so tired every night that they absolutely *ache.*"[107]

Unfortunately, the freedom to work on *Belshazzar* came too late. The picture was still unfinished when he died in 1843, and its frag- mentary state proved as much of an embarrassment to his friends and executors after his death as it had during his life. The legal status of the picture was cloudy: since the artist alone reserved the right to declare the picture finished, and since it would not belong to the subscribers until it was finished, to whom did the incomplete canvas belong?[108] When Allston's friends and relatives entered the painting room to unveil the picture, they found that the painter, shortly before death, had blotted out the figure of the king, covering him with a thick coat of paint. "That is *his shroud,*" declared the elder Richard Henry Dana in despair.[109] Investigation showed the paint could be removed, and family and friends with the aid of professionals like Morse proceeded carefully to clean and restore the painting to some semblance of exhibitable order.[110] Yet the long-awaited picture proved a disappointment because of its confusion and lack of coherence. Most viewers found more to mourn than to celebrate, and the view of Allston's life as a tragedy of wasted effort became entrenched. An Old Master, observers concluded, could not survive in Boston.

Once the stringency of Allston's financial situation is appreciated, his long struggle with *Belshazzar's Feast* and his attempt to practice Old World art in the New World may be seen in a new light. The practical

and psychological effects of debt, combined with severe bouts of ill-health, interfered seriously with Allston's ability to work on the painting. Nonetheless, he was actively engaged on the painting for long periods of time, working on it off and on during parts of 1820, 1822, and from 1824 to 1828. Were his endless revisions mere perfectionist fiddling, as some observers believed, or did he make significant changes? Did he lose his inspiration, as most modern critics have asserted, or did he have good reasons for wanting to make revisions? Did he continue to grow and develop throughout his American years? By comparing the painting to the sketches and attempting to unravel the progress of his work on it, it becomes possible to understand its significance in Allston's imaginative development.

All observers agree that Allston's first effort upon unrolling the canvas in 1820 involved a radical change in the picture's perspective, probably at the suggestion of Gilbert Stuart. "It was a sore task to change the perspective in so large a picture; but I had the courage to do it," he wrote to Leslie on May 20, 1821. "Now it is over I do not regret the toil."[111] He went on to explain that he had lowered the point of sight and pushed back the point of distance, thus giving the picture more depth.

A comparison of the large canvas to the studies shows the effectiveness of these changes. Allston enlarged the pillars and gallery, giving the background greater depth. Lowering the point of sight made the banquet table seem farther away and placed the figures behind the table in the same range as the figures in the gallery.[112] The picture's increased depth opened up a new scene in the far distance, where a flight of stairs leads to a landing holding pagan idols. In the sketch, a shallow stairway was surmounted by two flat friezes, or statues in niches. In the large painting, Allston deepened the landing and crowded it with figures, which, as he wrote to Leslie, "being just discoverable in the dark, have a powerful effect on the imagination. I suppose them to be principally Jews, exulting in the overthrow of the idols and their own restoration."[113] Allston capped the distant landing with a single massive statue of a pagan god, illuminated by a chandelier. The contrast between this puny, distant light and the brilliance of the handwriting on the wall advances the theme of divine revelation. Oddly enough, Allston designed his pagan god as a mirror image of his heroic painting, *Uriel in the Sun.*

After changing the perspective, Allston presumably turned to the completion of the major figures. Here too he began to improve upon the sketches. On February 7, 1823, Allston wrote to Leslie, "I have made so many changes in "Belshazzar's Feast' that it is yet unfinished, but they are all for the better."[114] Morse, who visited Allston at about this same time, testified to the effort this revision cost. "I have not seen his great picture," he wrote to his wife on February 19, 1823.

"He is finishing some part, before I can see it; he has had a great deal of perplexity with it, some parts he has painted over 6 or 7 times and one part 16 times. He will finish it soon."[115] Presumably the painting was at this stage when Chester Harding saw it before his departure for England in 1823 and reported that the composition was finished except for the figure of Daniel.[116] The bluff, businesslike Harding could not understand why Allston could not finish the picture and be done with it; when he returned from Europe to find it still incomplete he concluded that Allston had been idle during the three-year interval. Yet a careful study of the painting shows that Allston's conception of it underwent remarkable alterations as he continued to work on it. His changes show that he developed as an artist in Boston quite as fully as he might have in the Old World.

The most notable changes in the large canvas involve the poses and expressions of the principal figures. Of these, only the queen is relatively complete. One of the magicians is completely revised, while two float on the canvas, new heads over old bodies. Daniel's right shoulder and arm retain the old proportions, throwing his figure into confusion. The king, as we see him, was retrieved from under the coat of paint with which Allston had covered him; destruction of pigment either by Allston or the nineteenth-century restorers leaves his figure sketchy and imperfect.

Despite these difficulties, the figures in the later painting represent a far more interesting and profound portrayal of character than those in the sketches, In the sketches Belshazzar looks like a frightened boy, shrinking downward and inward in his chair; only his eyes look upward at the mysterious writing. The fragmentary Belshazzar of the large canvas has more dignity. His head and shoulders are thrown back to confront his fate, and his expression is less petulant and more self-aware. The queen, who in the sketch fell back with upraised hands in a wooden stage gesture of astonishment, takes on special depth and power in the large canvas. Richard Henry Dana, Jr., remarked on her "character and energy," comparing her to Lady Macbeth and adding that she had "a Bonaparte countenance."[117] Her hand grasps the chain around her shoulder in a gesture of power and distraction. That hand, solid and full of life against the brilliant metal links, is the best-preserved and best-executed part of the picture in its present state. Her face is extremely effective, for it is strongly delineated, showing passion and tragic consciousness.

Indeed, the queen, the most nearly completed figure on the canvas, best displays the ambitiousness of Allston's changing concept. In a period in which women were increasingly idealized and sentimentalized in American art, Allston painted a vigorous, conscious woman, a fallen Eve rather than a woman on a pedestal.[118] In his paintings of "dreamy

women" throughout the 1830s and in the poems that accompanied them, Allston showed his interest in and sympathy for inward psychological states.[119] In *Belshazzar's Feast* he depicted the inner life of a Romantic "dark woman," like Hawthorne's Zenobia or Melville's Isabel, a passionate and powerful figure. Considered quite apart from the larger canvas, Allston's queen represents the most probing depiction of a woman in American art between John Singleton Copley and Thomas Eakins with the possible exception of a few of Gilbert Stuart's portraits.

Changes in the expressions of Daniel and the magicians reflect Allston's maturing powers of characterization in a less dramatic but equally unmistakable way. Daniel's solid, upright body, like an extension of the pillar behind him, contrasts with the twisting, leaning bodies all around him just as his calm face contrasts with the violent emotions of the doomed Babylonians. His fixed, almost expressionless eyes, set deep in a masklike face, create a more solemn impression than the more severe, rebuking face in the sketch, where he looks directly into the queen's eyes. In the final version he stares into space, a conduit of divine inspiration rather than a messenger of personal doom.

The magicians register much the same emotions in the large canvas as in the sketch: fear, wariness, and chagrin. In the sketches the figure closest to Daniel gazes at the blazing handwriting and shrinks back with a sneer. In the final canvas this figure gazes toward a fellow magician and in so doing shows a recognition of their mutual defeat. Like the king and queen, the magicians in the revised painting demonstrate a greater consciousness of their situation. Rather than presenting figures that merely register surprise and horror, Allston in his painting attempted to portray human beings confronting their own doom, a far more complex and difficult conception.

One further improvement in the final canvas involves a group of figures in the shadows between the magicians and Daniel. The sketches show a group of courtiers adding their reactions to those of the principal figures: two women looking to heaven, two men staring with amazement at Daniel, and a woman pointing downward at a kneeling man in a turban, presumably a servant or a Jew, paying homage to Daniel. The kneeling man, however, is barely visible, and the supporting group conveys a sense of amazement. In the final canvas the balance of this group is changed. Two men in turbans now kneel before Daniel, while a beautiful young girl leans forward into the light, her hands clasped in homage to the prophet. A woman reaches out to her solicitously, while a standing woman points downward and another gazes solemnly at Daniel. The mood of this group in the painting is one of reverence rather than amazement; like the kings in a nativity scene, the kneeling men pay tribute to the prophet, stressing the solemnity rather than the terror of the moment.

The changes in the large canvas reflect the shift in Allston's conception of the meaning of the scene. While the letter to Irving in 1817 had stressed its sublimity and dramatic contrast, its combinations of "the magnificent and the awful," the painting that emerged from revision sought greater weight and dignity; it reached for a solemn and tragic, rather than a sensational or Gothic effect. As Allston matured, his artistic ideas deepened, and he began to see the scene not so much as a drama of circumstance but as a drama of consciousness. In this change he walked in the footsteps of the Old Masters, moving from the more superficial effects of a Fuseli or Salvator Rosa to the more profound, probing treatment of a Titian or Rembrandt.

Allston's movement toward a new conception of the scene may have been aided by the appearance of a dramatic poem on the subject, H. H. Milman's *Belshazzar,* published in Boston in 1822. Milman was professor of poetry at Oxford; perhaps he wrote his poem in answer to the Cambridge prize poem by T. S. Hughes that Allston had recommended to John Martin. Since literary research always played an important part in Allston's formulation of his subjects, he probably purchased Milman's poem soon after its appearance. In any case, Allston's library contains a copy of the book inscribed with his name.[120]

Milman's *Belshazzar* differs markedly from the literary sources, including an oratorio by Handel and a poetic treatment by Byron, that were available to Allston when he began work on *Belshazzar's Feast.*[121] Hannah More's *Belshazzar: A Sacred Drama,* published in 1782, might have contributed to Allston's early conception of the painting, especially as it stressed the importance of the queen whom More identified as Nitocris, Belshazzar's mother. More depicted Belshazzar as a dissolute, pleasure-loving young man, whose virtuous mother tries to warn him from his folly. Although temporarily shaken by the handwriting on the wall, More's Belshazzar returns to his feast; the Medes overrun the palace and slay him in the midst of his revels.

In Milman's *Belshazzar* the proud and arrogant Belshazzar is abetted in his wickedness by his mother, a fierce, martial woman who urges her son to be more warlike. Mother and son sin equally, and both are chastised and humbled by the prophecy of destruction. Upon hearing Daniel's explanation of the handwriting on the wall, Belshazzar and Nitocris repent. "My Mother!" exclaims the king, "And how shall we two meet the coming ruin?"[122] Conscious of their fate, the king and queen are powerless to avert their doom as the Medes invade their kingdom.

Milman went beyond the biblical story by introducing a subplot that contrasted the fall of the wicked with the salvation of the good. On the day of the feast, Benina, a beautiful young Jewish girl, has been torn from her parents and suitor by the wicked priests, who plan to sacrifice her as the bride of the pagan god, Bel. Her grief-stricken father

pleads in vain for mercy from Belshazzar and Nitocris. Benina, sustained by her faith, endures her terrible trials, and at the last minute she is saved by the commotion in the hall as the priests rush away to hear their doom.

Plot and subplot reach their climax together. The poem ends in the confusion of invasion during which Nitocris seeks shelter in the humble cottage of the Jews she scorned earlier in the day. As Benia returns safely to her family, the wounded Belshazzar stumbles in to die in his mother's arms.

The romantic subplot and the depth of character offered by the repentant king and queen in Milman's poem must have seemed suggestive to Allston as he reevaluated his conception of the painting. The raised head and shoulders of the reworked king show dignity and consciousness of his fate and resemble Milman's tragic Belshazzar far more than More's callow wastrel. The queen with her "Bonaparte countenance" matches Milman's martial Nitocris who later repents of her pride. Finally, the subplot of the beautiful Jewish girl suggests the source for Allston's revision of the group of figures between Daniel and the magicians. The kneeling woman who pays homage to Daniel, a figure much admired by contemporary viewers of the painting, might well be Benina, the maiden snatched from defilement. The poem describes her in conventional romantic imagery: "Like a sweet violet, that the airs of heaven / scarcely detect in its secluded shade"; "She was the dove of hope to our lorn ark / The only star that made the strangers' sky less dark"; "Bashfully sportive, timorously gay / Her white foot sounded from the pavement stone / Like some light bird from off the quivering spray"; "Beautiful as the doe upon the mountains / Pure as the crystal of the brook she drinks."[123] The girl in the painting leans forward from darkness into light; her half-hidden face and warm gold and silver gown supply a touch of youth and innocence to contrast with the somber darkness of the rest of the picture. The figures surrounding her, two kneeling men and a consoling woman, further suggest the Jewish family of Milman's poem. The shift from terror to solemnity that Allston brought about by the introduction of this group corresponds to the effect Milman sought through the use of a romantic subplot. Interestingly enough, Milman does not focus clearly on the character of Daniel in his poem. The prophet remains rather stiff and distant, which may explain why this figure changed so little as Allston revised his painting.

With all its faults, the large canvas of *Belshazzar's Feast* represents a thoughtful and interesting revision of Allston's early sketches. As he developed a more complex notion of the scene, which perhaps was inspired by Milman's dramatic poem, he undertook to deepen his portrayal of the major figures on the canvas. That his work was hampered

by external circumstances, illness and the mounting pressure of debts, makes his effort no less remarkable. Although he was unable to proceed directly to his goal because he experienced second thoughts, new insights, and conceptual difficulties that slowed his progress at various points, his changes nonetheless show steady improvement. In his interest in probing the character of his major figures, Allston demonstrated his insight and maturity of conception. Despite its unfinished state, *Belshazzar's Feast* remains the most interesting large painting executed in America before Eakins' *The Gross Clinic*.

Allston's painting marks an important stage in American artists' imaginative response to Europe. Like Irving, Allston registered his appreciation of the rich art world of Europe by trying to make its subjects and styles his own. Still bedazzled and enchanted by his first sight of the Old Masters, he attempted to recreate their pomp, drama, and brilliance. *Belshazzar's Feast* with its colors and chiaroscuro, its monumental architecture and swirling crowds, provides a feast for the eye. But the painting condemns the shallowness of external splendor, showing the corruptness of luxury and predicting its downfall. The brilliance of the fiery handwriting dims the luster of earthly gold and silver. Like *The Dead Man Restored to Life*, *Belshazzar's Feast* would have told its story at least partly through the use of light, and the unfinished state of the handwriting in the large canvas shows Allston's effort to render this important element of the painting with maximum effect. In *Belshazzar's Feast*, Allston pays homage to the visual splendor associated with the Old World, its art treasures and rich history, yet sounds a warning against its spiritual inadequacies. In his fascination with these themes of luxury and corruption, the attractions of European art and the lessons of European history, Allston joined his contemporaries, both painters and writers, in pondering the meaning of the Old World for artists of the New World.

Belshazzar's Feast unfinished is an uneven work, brilliant in some passages but ruined in others. Because for so many years it was supposed to be a masterpiece on the very point of completion, it is nearly impossible not to share the dismay and disappointment of Allston's friends who unveiled the picture after his death. Still, with all of his failings, Allston did walk in the footsteps of the Old Masters. He continued to grow artistically and intellectually despite adversity. The fact that with his European training and skills he continued to live and work in Cambridgeport made an important impression upon his contemporaries. Emerson wrote that Allston was a "chip off the old block; boulder of the European ledge; a spur of those Apennines on which Titian, Raphael, Paul Veronese, & Michael Angelo sat—cropping out here in this remote

America [and] unlike anything around it. . . ."[124] Young artists paid homage to him and asked his advice; like Washington Irving he represented to his generation a national resource, an artistic example. Voyaging into the past, to the cultural treasure trove of Europe, he had made himself an artist. Even in his failure he represented something for which American artists continued to yearn throughout the nineteenth century: transatlantic continuity, participation in a tradition, membership in the fraternity of great artists. Nathaniel Hawthorne, whose wife had called Allston a "tiger of the age," referred to the painter in "The Artist of the Beautiful" as an example of a vision unrealizable on earth.[125] Even in its fragmentary state *Belshazzar's Feast* pays tribute to an American's fervent desire to create art of the highest seriousness in the New World, to bring to America the artistic legacy of the European scene.

Notes

1. In a memoir of Allston, Henry Greenough reported a moment of triumph in Paris when Allston's coloristic effects were praised by a visiting cardinal. See Jared B. Flagg, *The Life and Letters of Washington Allston* (New York: Charles Scribner's Sons, 1892), pp. 188-89. A German painter studying in Rome recognized Allston as a master of glazing and coloring techniques. See E. P. Richardson, *Washington Allston: A Study of the Romantic Artist in America* (1948; reprint ed., New York: Apollo Edition, 1967), pp. 58-59. Allston also had received copious praise from Benjamin West and Samuel Taylor Coleridge (Flagg, *Life and Letters*, pp. 101, 136). In 1816, his painting, *The Dead Man Restored to Life by Touching the Bones of the Prophet Elisha*, was purchased by the Pennsylvania Academy of Fine Arts in Philadelphia (Richardson, *Washington Allston*, p. 106).

2. Allston's career was reinterpreted in the twentieth century by Edgar P. Richardson. His biography also offered a sensitive evaluation of the history of the painter's reputation. See Richardson, *Washington Allston*, pp. 1-9 and 154-56 for a discussion of the way in which Allston was viewed by his contemporaries.

3. See my discussion of this incident in Joy Kasson, "The Citadel Within: Washington Irving and the Search for Literary Vocation," *Prospects* 3 (1977): 374-78.

4. Washington Allston to his mother, August 12, 1800, in Flagg, *Life and Letters*, p. 20.

5. Information about Allston's relationship with his South Carolina relatives is reconstructed from letters appearing in Flagg, *Life and Letters*, and from notes among the papers of Henry Wadsworth Longfellow Dana (Washington Allston Archive, Longfellow National Historical Site, Cambridge, Mass.). For family attitudes toward Allston, see J. H. Easterby, ed., *The South Carolina Rice Plantation as Revealed in the Papers of Robert F. W. Allston* (Chicago, Ill.: University of Chicago Press, 1945), pp. 52-53. See also Flagg, *Life and Letters*, p. 34.

6. Washington Allston to Charles Leslie, November 15, 1819, in Flagg, *Life and Letters*, p. 160. For an excellent recent study of Americans' debt to Reynolds and the English school see Wayne Craven, "The Grand Manner in

Early Nineteenth-Century American Painting," *American Art Journal* 11 (April 1979): 4-43.

7. Sir Joshua Reynolds, *Discourses on Art*, with an Introduction by Robert R. Wark (1797; reprint ed., New York: Collier Books, 1966), pp. 87, 55.

8. Washington Allston to Charles Fraser, August 25, 1801, in Flagg, *Life and Letters*, pp. 43-44.

9. Undated lecture sometime after 1797, rendered by West's biographer, John Galt in *The Life, Studies, and Works of Benjamin West*, 2 vols. (London: T. Cadell and W. Davies, 1820), 2: 138.

10. Quoted in William Dunlap, *History of the Rise and Progress of the Arts of Design in the United States*, 2 vols. (New York: George P. Scott and Co., 1834), 2: 162, 166.

11. Washington Allston, *Lectures on Art* in *Lectures on Art and Poems, 1850; and Monaldi, 1841*, introduction by Nathalia Wright (1850; 1841; reprint ed., Gainesville, Fla.: Scholars' Facsimiles and Reprints, 1967), p. 100.

12. See Henry Greenough's description of Allston's coloristic techniques in Flagg, *Life and Letters*, pp. 181-203. Richardson also assesses Allston as a colorist in *Washington Allston*, pp. 54-61, as does Barbara Novak in *American Painting of the Nineteenth Century* (New York: Praeger, 1969), pp. 58-60.

13. Allston's remarks as recorded by Henry Greenough and quoted in Flagg, *Life and Letters*, p. 197.

14. Washington Allston to John Cogdell, July 4, 1842, ibid., p. 319.

15. Quoted in Dunlap, *History of the Rise and Progress of the Arts of Design*, 2: 161.

16. Ibid., p. 167.

17. Samuel T. Coleridge to Washington Allston, June 17, 1806, in *Collected Letters of Samuel Taylor Coleridge*, 6 vols., ed. Earl Leslie Griggs (Oxford: Clarendon Press, 1956), 2: 1173.

18. Allston, *Lectures on Art and Poems*, p. 346.

19. See Regina Soria, "Washington Allston's Lectures on Art: The First American Art Treatise," *Journal of Aesthetics and Art Criticism* 18 (March 1960): 329-44.

20. For a perceptive discussion of the Allston-Coleridge friendship, see Richardson, *Washington Allston*, pp. 112-15. See also Kathleen Coburn, "Notes on Washington Allston from the Unpublished Notebooks of Samuel Taylor Coleridge," *Gazette des Beaux Arts*, Series 6, 25 (1944): 249-52.

21. Edward Lind Morse, ed., *Samuel F. B. Morse, His Letters and Journals*, 2 vols. (Boston, Mass.: Houghton Mifflin Co., 1914), 1: 104.

22. Charles R. Leslie, *Autobiographical Recollections* (Boston, Mass.: Ticknor, 1860), pp. 22, 192.

23. Morse, *Samuel F. B. Morse*, 1: 132-33.

24. Clarke Olney, *Benjamin Robert Haydon, Historical Painter* (Athens: University of Georgia Press, 1952), pp. 14, 17.

25. Leslie, *Autobiographical Recollections*, p. 179.

26. Recorded in Dunlap, *History of the Rise and Progress of the Arts of Design*, 2: 160, and with some alterations in Flagg, *Life and Letters*, p. 39.

27. Washington Allston to G. Verplanck, March 1, 1830, in Flagg, *Life and Letters*, p. 231.

28. Ibid., pp. 130-31. This friendship continued after Allston's return to America. In 1830 Brockhedon sent Allston a copy of his *Illustrations of the Passes of the Alps,* with the inscription, "in testimony of the sincere esteem and respect with which I remember many acts of your kindness and friendship." The book is now part of the Washington Allston Archive. With his characteristic generosity, Allston mentioned Brockhedon's book in his letter to Dunlap, which appeared in Dunlap, *History of the Rise and Progress of the Arts of Design,* 2:165.

29. See Richardson, *Washington Allston,* pp. 45-46.

30. S. T. Coleridge to Daniel Stuart, September 12, 1814, in Griggs, *Collected Letters,* 3: 951.

31. See Stanley T. Williams, *The Life of Washington Irving,* 2 vols. (New York: Oxford University Press, 1935), 1: 428.

32. Washington Allston to John Vanderlyn, August 17, 1815, Dana Family Papers, Massachusetts Historical Society, Boston, Mass.

33. See letters to James McMurtrie, June 13, 1816, and October 25, 1816, in Flagg, *Life and Letters,* pp. 119, 124.

34. Washington Allston to Francis Winthrop, December 27, 1817, Dana Family Papers.

35. Richard Henry Dana, ms. notes, ibid.

36. Richardson misdates this exhibition. Allston's work on the painting was interrupted by his illness in 1813. See Morse, *Samuel F. B. Morse,* 1: 122.

37. Flagg, *Life and Letters,* pp. 90-91, 130, 132.

38. Ibid., p. 136.

39. Of the members of the Royal Academy in 1818, twenty-two had been elected to membership at the age of thirty-nine or under. See the list of members and election dates in Sidney C. Hutchinson, *The History of the Royal Academy, 1768-1968* (New York: Taplinger Publishing Company, 1968).

40. Flagg, *Life and Letters,* p. 91.

41. See Dunlap, *History of the Rise and Progress of the Arts of Design,* 2: 182, and Flagg, *Life and Letters,* pp. 137-38, for Allston's view of Beaumont. No further commissions from Beaumont are recorded, and Flagg reprinted a letter from Beaumont in January, 1814, declining to aid the artist. Flagg, *Life and Letters,* p. 103.

42. S. T. Coleridge to Daniel Stuart, September 12, 1814, in Griggs, *Collected Letters,* 3: 534.

43. George Beaumont to William Wordsworth, February 20, 1814, and April 17, 1816, copies in the Washington Allston Archive.

44. Olney, *Benjamin Robert Haydon,* p. 77. William T. Whitley, *Art in England 1800-1820* (Cambridge: The University Press, 1928), pp. 231-32.

45. Flagg, *Life and Letters,* p. 139.

46. Ibid., p. 178. Dunlap changed "adoption" to "ancestry" when he printed Allston's letter; see Dunlap, *History of the Rise and Progress of the Arts of Design,* 2: 182.

47. Washington Allston to William Collins, April 16, 1819, Dana Family Papers.

48. Charles R. Leslie to Washington Allston, February 17, 1830, Washington Allston Trust, Houghton Library, Harvard University, Cambridge, Mass.

49. Washington Allston to William Collins, May 18, 1821, Misc. Manuscripts Allston, New-York Historical Society, New York.

50. See Samuel F. B. Morse to Samuel F. Jarvis, February 8, 1815, Morse

Family Papers, Sterling Memorial Library, Yale University, New Haven, Conn.

51. Even the warm friendship with Coleridge was occasionally disturbed by a sense of conflicting nationalities. See Richardson, *Washington Allston*, p. 113.

52. Flagg, *Life and Letters*, pp. 119-25.

53. Morse, *Samuel F. B. Morse*, 1: 197.

54. Washington Allston to Alexander Robertson, May 9, 1818, American Academy of Fine Arts, New-York Historical Society.

55. Washington Allston to Samuel F. B. Morse, early in 1819, quoted in Moses Foster Sweetser, *Allston* (Boston, Mass.: Houghton, Osgood & Company, 1879), pp. 94-95.

56. Washington Allston to William [Allston?], March 2, 1818, Washington Allston Papers, Archives of American Art, Smithsonian Institution, Washington, D.C.

57. Dunlap, *The Rise and Progress of the Arts of Design*, 2: 183. I cannot agree with William Gerdts, who thinks the decisive factor in Allston's return was his distress at being pestered by beggars. William H. Gerdts, ''The Paintings of Washington Allston'' in William H. Gerdts and Theodore E. Stebbins, Jr., ''A Man of Genius,'' *The Art of Washington Allston (1779-1843)* (Boston, Mass.: Museum of Fine Arts, 1979), pp. 110-11. Sensitive though Allston was, such an explanation seems too trivial and unprofessional. Allston had painted through his tears after his wife's death. See Flagg, *Life and Letters*, p. 111.

58. He continued to purchase supplies from Brown, his English color man, throughout his life. See his letters in the Dana Family Papers.

59. Pierre M. Irving, *The Life and Letters of Washington Irving*, 4 vols. (New York: G. P. Putnam; Hurd & Houghton, 1865), 1: 366.

60. Flagg, *Life and Letters*, p. 144.

61. Washington Allston to James McMurtrie, November 7, 1818, ibid., p. 144.

62. Washington Allston to Washington Irving, May 9, 1817, published by Irving in ''Washington Allston'' in E. A. Duyckinck and George I. Duyckinck, *Cyclopedia of American Literature*, 2 vols. (New York: Charles Scribner, 1856), 2: 15.

63. Richardson, *Washington Allston*, p. 123.

64. Flagg, *Life and Letters*, p. 129.

65. Duyckinck, *Cyclopedia*, 2: 15.

66. Washington Allston to John Knapp, August 24, 1803, in Flagg, *Life and Letters*, pp. 52-54.

67. For a discussion of Coleridge's lectures see Leslie, *Autobiographical Recollections*, p. 25. Allston wrote a poem on the Shakespearean actor Edmund Kean during his American tour. See Washington Allston to William Collins, May 18, 1821, Dana Family Papers. The poem is published in Allston, *Lectures on Art and Poems*. John Howard Payne, another actor, was a close friend, one of only four people present at Mrs. Allston's funeral in 1815.

68. David Watkin, *Thomas Hope, 1769-1831, and the Neo-classical Idea* (London: John Murray, 1968), p. 177.

69. The Hope commission is discussed in Josephine Gear, *Masters or Servants? A Study of Selected English Painters and their Patrons of the Late Eighteenth and Early Nineteenth Centuries* (New York: Garland Publishing, Inc., 1977), pp. 174-75.

70. Martin's account is quoted in Dunlap, *The Rise and Progress of the Arts of Design*, 1: 180-81.

71. This fact and Allston's relationship with West belie the speculation advanced by Anna Jameson and others that Allston abandoned *Belshazzar* because Martin had stolen his subject. See Anna Jameson, "Washington Allston," *The Atheneum* 845 (January 6, 1844): 15-16 and 846 (January 13, 1844): 39-41.

72. Washington Allston to Charles R. Leslie, September 7, 1821, in Flagg, *Life and Letters*, pp. 171-72.

73. See Dunlap, *The Rise and Progress of the Arts of Design*, 2: 181.

74. Charles Leslie to Washington Allston, March 3, 1820, in Flagg, *Life and Letters*, p. 162.

75. Indeed, his work stands squarely in the popular art tradition. D. W. Griffith drew on Martin's depiction for his Belshazzar's feast scene in the 1916 film *Intolerance*.

76. Today Allston's *Belshazzar's Feast* hangs in the same gallery of the Detroit Institute of Arts as Rembrandt Peale's *Court of Death*, which brought its creator phenomenal sums on numerous exhibition tours. A friend informed Allston that Peale's painting had earned $1,000 in four weeks in Baltimore and assured him that *Belshazzar* had even better prospects. James McMurtrie to Washington Allston, December 5, 1820, Dana Family Papers.

77. Stuart is quoted in W. Channing, "Reminiscences of Washington Allston," *Boston Advertiser*, July 24, 1843.

78. William Gerdts, "Allston's *Belshazzar's Feast*," *Art in America* 61 (March-April, 1973): 66.

79. Washington Allston to James McMurtrie, November 7, 1818, and March 17, 1819, Dana Family Papers.

80. Washington Allston to Charles R. Leslie, August 23, 1818, ibid.

81. Flagg, *Life and Letters*, pp. 177-78.

82. Washington Allston to Francis Winthrop, November 23, 1821, Dana Family Papers.

83. See Flagg, *Life and Letters*, p. 361.

84. Washington Allston to William Collins, May 18, 1821, Dana Family Papers.

85. Washington Allston to Henry Pickering, May 18, 1820, ibid.

86. Stuart's role in Allston's revision of the painting has been widely accepted by biographers, although Allston did not attribute his decision to Stuart in letters written at the time. See Washington Allston to Charles Leslie, May 20, 1821, in Flagg, *Life and Letters*, pp. 165-67.

87. Washington Allston to Francis Winthrop, November 23, 1821, Dana Family Papers.

88. Ibid.

89. Flagg, *Life and Letters*, pp. 221-22. Flagg misdates this letter as December 25, 1828. Study of the manuscript in the Dana Family Papers convinces me that the earlier date is correct, which increases the letter's significance.

90. Washington Allston to John Cogdell, July 1, 1826, in Flagg, *Life and Letters*, pp. 209-10.

91. Quoted in ibid., p. 129.

92. Washington Allston to John Cogdell, February 27, 1832, ibid., pp. 257-78.

93. Olney, *Benjamin Robert Haydon*, p. 105.

94. While struggling with *The Judgment of Solomon*, Haydon established credit

with a wine merchant by bringing him to the studio and asking whether the artist of such a work should be denied the wine his physician had prescribed. Ibid., p. 77.

95. Allston made this statement to Laommi Baldwin, according to Chester Harding's account in *A Sketch of Chester Harding, Artist, Drawn by his Own Hand*, ed. Margaret E. White (1929; reprint ed., New York: Da Capo Press, 1970), p. 143.

96. Ibid., p. 143.

97. Washington Allston to John Cogdell, February 7, 1832, in Flagg, *Life and Letters*, p. 260.

98. See for example, Washington Allston to J. Mason, December, 1833, ibid., pp. 271-72.

99. "An Indenture Tripartite. . .," Boston Athenaeum manuscript collection, Boston, Mass. Allston's biographers have usually assumed the purchase of his painting was agreed on much earlier, perhaps in 1820. Possibly they were misled by a statement to that effect by Arthur Dexter, "The Fine Arts in Boston," in *The Memorial History of Boston*, 4 vols., ed. Justin Winsor (Boston, Mass.: James R. Osgood and Company, 1881), 4: 383-414. Dexter's article contains many inaccuracies, and I see no reason to accept his date. I believe the plan to purchase the picture dates from 1826. In May of that year Horatio Greenough wrote Allston from Rome, "We have all been delighted with the news of the sale of your picture." Horatio Greenough, *Letters of Horatio Greenough, American Sculptor*, ed. Nathalia Wright (Madison: University of Wisconsin Press, 1972), p. 9. Since Allston was not working on small paintings at this time, it seems likely that Greenough was referring to *Belshazzar's Feast*. In July 1826, Allston mentioned the subscription plan then under the direction of Nathaniel Amory in a letter to John Cogdell. See Flagg, *Life and Letters*, p. 210.

100. "An Indenture Tripartite. . . ."

101. See letter from Franklin Dexter to Allston, December 27, 1831, giving permission for Allston to retain a part of the proceeds from his pictures: "I judge that if $500 or $600 can be paid in that manner in a reasonable time, the assignees will think they have used due diligence & will wait your convenience for the balance." Dana Family Papers. The severity of Allston's plight has never, to my knowledge, been fully recognized.

102. Washington Allston to Leonard Jarvis, June 24, 1836, in Flagg, *Life and Letters*, pp. 287-89. In this letter Allston explained his reasons for declining a commission to paint panels for the Capitol rotunda in Washington. His response to this commission, a plum sought by all his artistic contemporaries, shows the depth of his financial difficulties. In 1830 he had sought such a commission, hoping that it would prove the key to his financial distress. See exchange of letters with Gulian Verplanck, ibid., pp. 230-37. By 1836 his affairs were in assignment, and he was unable morally and perhaps legally to accept this lucrative offer before satisfying his other creditors, including *Belshazzar's* sub-scribers. Unaccountably, Allston's biographers Flagg and Richardson stress the painter's later rejection of the commission and neglect to emphasize his willing-ness to accept it in 1830. See ibid., pp. 228-29, and Richardson, *Washington Allston*, p. 134.

103. Here I disagree with E. P. Richardson, who maintains in his study of Allston that the artist had lost the idea behind Belshazzar and had he not engaged

himself to finish it "would simply have dropped [it] and gone on to other things." Richardson, *Washington Allston,* p. 126. Despite his frustrations with the painting, Allston continued to describe it in his letters as an important work, one that would justify him if he could only break free from his financial limitations to work on it.

104. Washington Allston to John Cogdell, December 5, 1839, in Flagg, *Life and Letters,* p. 304.

105. Ibid., p. 305.

106. See Sweetser, *Allston,* pp. 125-26; Flagg, *Life and Letters,* pp. 347-49. I am convinced that what Flagg calls Allston's "morbid sensitiveness" about visitors dates from this last period rather than an earlier period of work on his painting.

107. Sweetser, *Allston,* p. 149.

108. See Richard Henry Dana, Jr., *The Journal of Richard Henry Dana, Jr.,* 3 vols., ed. Robert F. Lucid (Cambridge, Mass.: Harvard University Press, Belknap Press, 1968), 1: 183.

109. Ibid., p. 177.

110. Ibid., pp. 177-85, 189-91. The handling of the painting is carefully discussed in the two-part article by William Gerdts, "Allston's *Belshazzar's Feast.*"

111. Flagg, *Life and Letters,* p. 166.

112. Richard Henry Dana, Jr., observed in his journal that Allston had placed the main figures on a platform above the table, but I believe this is in error and that Allston simply increased the distance between foreground and middle ground. It was for this reason he was obliged to enlarge the figures in the foreground. Dana, *Journal,* 1: 184.

113. Washington Allston to Charles Leslie, May 20, 1821, in Flagg, *Life and Letters,* p. 166.

114. Ibid., p. 175.

115. Samuel F. B. Morse to Mrs. Samuel F. B. Morse, February 19, 1823, Samuel F. B. Morse Papers, Library of Congress, Washington, D.C.

116. Harding, *A Sketch,* p. 143. Harding sailed for England in August 1823.

117. Dana, *Journal,* 1: 184.

118. Compare, for instance, Thomas Sully's *Lady with a Harp* (National Gallery of Art, Washington, D.C.), or Samuel F. B. Morse's *The Muse* (Metropolitan Museum of Art, New York).

119. Henry Wadsworth Longfellow Dana uses the phrase "dreamy women" to describe such paintings as *A Spanish Girl in Reverie, A Tuscan Girl, The Evening Hymn,* and *Rosalie.* See Henry Wadsworth Longfellow Dana, "Allston in Cambridgeport, 1830 to 1843," *Cambridge Historical Society Publications* 29 (1948): 34-67. Interestingly enough, these were the works singled out for praise by the fiercely independent Margaret Fuller, who appreciated Allston's sympathy for women. Margaret Fuller, "A Record of the Impressions Produced by the Exhibition of Mr. Allston's Pictures in the Summer of 1839," reprinted in Margaret Fuller Ossoli, *Art, Literature, and the Drama,* ed. Arthur B. Fuller (Boston, Mass.: Brown, Taggard and Chase, 1860), pp. 284-97.

120. Book is located in Washington Allston Archive.

121. Several important sources are explored in the first of William Gerdts' articles "Allston's *Belshazzar's Feast.*" Gerdts stresses Byron among the literary sources, mentioning More and Milman in passing. Byron included a poem,

"Vision of Belshazzar," in *Hebrew Melodies* (1815); but this poem depicts Daniel as a youth, and it bears small relationship to Allston's conception of the scene. Another Byron poem, "To Belshazzar," was published in 1831, and *Don Juan* alludes to the handwriting on the wall in canto 8, 134.

122. H. H. Milman, *Belshazzar: A Dramatic Poem* (Boston, Mass.: Wells and Lilly-Court-Street, 1822), p. 98.

123. Ibid., pp. 50, 53, 54, 106-7.

124. Ralph H. Orth and Alfred R. Ferguson, eds., *The Journals and Miscellaneous Notebooks of Ralph Waldo Emerson, Vol. 9, 1843-1847* (Cambridge, Mass.: Harvard University Press, Belknap Press, 1971), pp. 82-83.

125. Sophia Hawthorne's comment is cited by H.W.L. Dana, "Allston in Cambridgeport," p. 39.

3
THOMAS COLE:
Landscape and History

Thomas Cole was born in 1801, in the same year that Washington Allston began his formal study of art. Representing a new generation of American artists, Cole rode the rising tide of cultural nationalism to prominence as the leading painter of landscape scenes, which soon eclipsed history paintings in popularity with American audiences. Cole's twentieth-century reputation is based almost exclusively on his dynamic, attractive depictions of New York and New England scenery. Despite his prominence and popularity, Cole felt a tension between his work as a landscape artist and his aspirations toward "higher," more traditional art forms. "I am not a mere leaf-painter," he insisted.[1] He sought to resolve his dilemma by developing a style that used the techniques of landscape art to evoke the intellectual and emotional responses Reynolds and his followers associated with history paintings and the works of the Old Masters. For Cole landscape was more than a merely charming sight; it was a vehicle for the expression of spiritual truth.

Thus, although Cole belonged to a generation that triumphantly proclaimed its Americanness, he shared many of the same feelings that had drawn Washington Allston to Europe as a young man: the desire to participate in a tradition and to join an artistic fraternity, the need to confront past works of art and to learn what they had to teach. At the same time, Cole felt wary of the Old World; he searched for its meanings from a New World perspective and was eager to learn its lessons in the context of American national pride and self-consciousness.

Cole viewed the European scene both as landscape and as history. He filled sketchbooks and canvases with direct responses to Old World scenery: vine-covered ruins, green-carpeted Campagna, majestic mountains. Yet behind the beauties of the landscape were questions

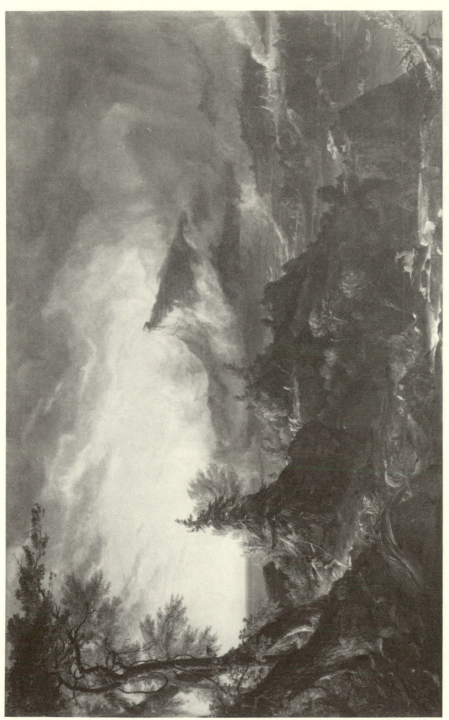

6. Thomas Cole, *The Course of Empire: The Savage State*, oil on canvas 39¼ × 63¼ in. Courtesy of The New-York Historical Society, New York City.

7. Thomas Cole, *The Course of Empire: The Arcadian or Pastoral State*, oil on canvas, 39¼ × 63¼ in. Courtesy of The New-York Historical Society, New York City.

8. Thomas Cole, *The Course of Empire: Consummation of Empire*, oil on canvas 51 × 76 in. Courtesy of The New-York Historical Society, New York City.

9. Thomas Cole, *The Course of Empire: Destruction*, oil on canvas 39¼ × 63½ in. Courtesy of The New-York Historical Society, New York City.

10. Thomas Cole, *The Course of Empire: Desolation*, oil on canvas, 39½ × 61 in. Courtesy of The New-York Historical Society, New York City.

about its meaning. What human life transpired here? What moral may we read in its traces? What lessons does the artist, especially the American artist, learn from the history of art and the history of civilization?

Cole faced these questions directly in a series of paintings entitled *The Course of Empire* (1836) that he planned in Europe and executed after his return to America. In five massive canvases he traced the rise and fall of a civilization from New World-like primitiveness through opulent splendor to picturesque ruin. Visually invoking the landscapes of Europe and America, Cole explored the relationship between the two continents. He strove to create a new kind of art that could recognize past art without becoming enslaved by it and could combine the fresh vision of landscape art with the intellectual profundity of historical painting.

Like his contemporaries William Sidney Mount and Chester Harding, Cole began his career as a self-taught artist who adapted his talents to the popular market. Born in England and trained as an engraver, Cole migrated to America with his parents at the age of eighteen. After a short stay in Philadelphia and a trip to the West Indies, he joined his family in Steubenville, Ohio, where a German itinerant artist sparked his interest in oil painting by lending him an English art book.[2] Cole adopted this new profession and tried to make a living as a traveling portrait painter, but he soon discovered that he had at least as much success selling landscape views, a genre that suited his temperament and love of nature.[3] After working his way to Philadelphia and then to New York, Cole achieved valuable recognition when he sold paintings to three prominent figures in the New York art world, Asher B. Durand, William Dunlap, and John Trumbull. All three responded to the freshness and originality of Cole's landscape paintings. The eminent Trumbull went so far as to exclaim: "This youth has done what I have all my life attempted in vain."[4] As a result of this patronage Cole soon began to receive commissions and exhibited his paintings at the newly formed National Academy of Design in 1826.

Although his landscapes quickly achieved both critical and popular success, their popularity should not obscure the broader artistic ambitions he had expressed from the very beginning of his career. As an itinerant painter in Ohio, he had tried to interest patrons in historical pictures as well as portraits, and he had used his spare time in Steubenville to begin two biblical compositions, one drawn from the Book of Ruth, and the other depicting Belshazzar's feast.[5] When Cole arrived in Philadelphia in 1823 determined to make himself a painter, he obtained permission to draw at the Pennsylvania Academy of Fine Arts, which had accumulated a substantial collection of antique casts and paintings, including, of course, Allston's *Dead Man Restored to Life*. In 1825 Cole exhibited a religious painting at the Pennsylvania Academy, entitled *Christ Crowned*

with Thorns and Mocked and described himself in the catalogue as "Thomas Cole, History Painter."[6]

In his determination to move from artisan to artist, to go beyond the craft of engraving to the higher calling of painting, Cole adopted a theory of the artistic vocation not far removed from the one that Allston had taught his pupils Morse and Leslie in London. The "English work on painting . . . illustrated with engravings" that Cole had read in Ohio in 1820 apparently conveyed to him the aesthetic principles of the English school in the tradition of Sir Joshua Reynolds, for his early enthusiasm for painting included a strong feeling for the "higher values" in art. "My ambition grew," he later reminisced, "and in my imagination I pictured the glory of being a great painter. The names of Stuart and Sully came to my ears like the titles of great conquerors, and the great masters were hallowed above all earthly things."[7] Writing this description of his early career for William Dunlap's *History of the Rise and Progress of the Arts of Design in the United States* in 1834, he could look back with amusement on his youthful struggles, when he waded through icy rivers holding the green baize bag containing his painting implements over his head and eked out a meager living painting japan-ware and copying engravings. Humor was possible because the story had a happy ending: he had fulfilled his dream of an artistic vocation. Dunlap reinforced the point with his own comments: "To me the struggle of a virtuous man endeavouring to buffet fortune, steeped to the very lips in poverty, yet never despairing, or a moment ceasing his exertions, and finally overcoming every obstacle, is one of the most sublime objects of contemplation, as well as the most instructive and encouraging, that can be presented to the mind."[8] In mid-career, Cole was proud of his origins as a self-made man; but the self he had made, he wanted to stress, was an artist in the highest tradition of the profession.

Cole's sense that he was entering a profession with high standards and an established theoretical framework pervades his correspondence with Robert Gilmor, his first important patron. Gilmor, a wealthy Baltimore merchant, had decorated his home in the Gothic style and had assembled a notable collection of medieval manuscripts as well as Dutch, Italian, and English paintings.[9] Eager to encourage the development of American art, he sought out and patronized promising young artists. Soon after Cole's discovery by Trumbull, Durand, and Dunlap, Gilmor wrote to the young artist, commissioning a picture and initiating a long correspondence on artistic principles.

In his letters to Gilmor, the self-taught artist who had risen to such sudden prominence manifested an appropriate willingness to learn from the cosmopolitan collector. "I hope to profit by the excellent advice your letter contained," Cole wrote on January 2, 1827. "It would give me great pleasure to see your collections of pictures: I have never yet seen a

fine picture of any foreign landscape painter."[10] Yet, when Gilmor turned the discussion to aesthetic theory, Cole took issue with his patron's ideas, using language that echoed the established views of an earlier generation.

In December 1826, Gilmor wrote to Cole about a painting he had commissioned and expressed his preference for scenes drawn directly from nature. "I prefer *real American* scenes to compositions," Gilmor stated. He cited the later works of the American painter Thomas Doughty as a warning example: "As long as Doughty *studied* & *painted* from nature (who is always pleasing however slightly rendered in drawings or paintings made on the spot) his pictures were pleasing because the scene was real, the foliage varied & *unmannered,* and the broken ground & rocks & moss had the very impress of being after *originals,* not *ideals.* His *compositions* fail I think in all these respects. . . ."[11] Cole, whose own work was often praised for its direct, observational qualities, responded with an appeal to authority (almost certainly Reynolds) and an affirmation of the traditions of high art:

If I am not misinformed, the finest pictures which have been produced, both Historical and Landscape, have been compositions: certainly the best antique statues are compositions. Raphael's pictures, & those of all the great painters, are something more than imitations of nature as they found it. I cannot think that beautiful landscape of Wilson's in which he has introduced Niobe and children an actual view; Claude's pictures certainly not. If the imagination is shackled, and nothing is described but what we see, seldom will anything truly great be produced either in painting or poetry.

Cole concluded his argument with a particularly Reynoldsian formulation: "I think that a young painter ought not to indulge himself too much in painting scenes, yet the cultivation of his mind ought not to be neglected, it is the faculty that has given that superiority of the fine over the mechanic arts."[12] While his patron expressed a Romantic appreciation for the spontaneity of direct observation, Cole in a serious and rather stilted rhetoric insisted on the value of artistic tradition.

As a young painter, then, Cole shared the professional ambitions of an older generation. Like Allston, and West and Copley before him, Cole saw himself not as a provincial artist but as a part of an international artistic tradition. It was inevitable that like these other artists Cole too would be drawn to Europe to study and to win professional recognition. In fact, he began to make arrangements for a trip abroad as soon as his pictures began to sell. A letter from an English cousin in August 1825 comments on Cole's plans to visit England, "where talent of every description will be so well rewarded." The cousin added a warning, however: "I think . . . that the profession which you seem wishful to pursue will not answer so well for you as a trade of some description

or other. I have been in London and made enquiries about the profession of an artist & been told that there are many who are exceedingly clever can scarcely support themselves at all, & that there are some who cannot even get the necessaries of life. That profession is completely overstocked."[13] Cole's practical cousin clearly had no sense of the sublime vocation to which the young man was dedicating himself. More congenial to Cole was the response of Robert Gilmor, who wrote, "I approve highly of your intention to go to Europe" and offered material assistance if necessary.[14]

As Cole prepared to study in Europe, he sought contact with America's most distinguished spokesman for serious art, Washington Allston. The extent of Cole's acquaintance with Allston has never been thoroughly traced, but it appears to have been significant. Several lines of communication linked Cole to Allston, including Samuel F. B. Morse, whom Cole came to know in New York when he joined Morse's National Academy of Design in its second group of founding members in 1826. On this occasion, Cole sought an introduction to Allston through Henry Pickering, a poet and merchant who had been one of Allston's early patrons. In 1825 Pickering moved from Salem, Massachusetts, to New York and met Cole soon afterward.[15] The merchant commissioned a painting from the young artist and like Gilmor entered into a correspondence with him about artistic principles, often recommending Allston as a model.[16]

As Cole's plans for European study matured, he asked Pickering to serve as an intermediary in requesting advice from Allston. Allston replied generously with a long letter on November 23, 1827, offering suggestions on travel and encouraging Cole to combine careful study of the Old Masters with a continuing reverence for nature. Urging the young man to "select his models from among the highest," he suggested a study of Claude, Titian, the two Poussins, Salvator Rosa, and Francesco Mola, as well as the English school and J.M.W. Turner, whom he praised as the finest of living painters. "You say that your friend is a passionate admirer of nature," Allston continued. "Let him never lose his love for her." The letter concluded with an evocation of the painter's high calling. "He has chosen a profession . . . that is, for its own sake, in a high degree elevating."[17]

Allston's letter was important to Cole, for it not only offered him practical advice but also welcomed him into the artistic profession in terms with which he was familiar. Allston's letter quoted Reynolds, and it affirmed the values Cole was defending to Gilmor: the importance of imagination and a poetic conception of art. Cole apparently accepted the colleagueship Allston offered and traveled to Boston to meet him in 1828. A letter from a friend in New York shows that Cole approached the meeting in a less than reverential mood. "Your description of Allston is amusing," wrote his friend, "and contributes much to my curiosity to

see this great luminary that shines so seldom and whose faults seem made only to render his brilliancy capable of being looked upon [.] By the by you say nothing of his great work. I should like to have your opinion of it."[18] Cole's apparent light tone only reflected the high spirits of a young man beginning to see his way to an important goal, for in fact, Allston's letter and Cole's visit initiated a professional relationship that continued after Cole's return from Europe. He knew Allston well enough to provide letters of introduction for Asher B. Durand and Luman Reed in 1835, and Reed reported that during their visit with Allston "your name was always with us & was never mentioned but with a regret that you was [sic] not with us."[19] Upon hearing of Allston's death, Cole wrote a graceful elegy in his journal that praised him as "a great artist, a good man, an honour to his country." "It was not my lot to have a very great intercourse with him," Cole wrote but added "that which I had has caused me to regret his loss exceedingly."[20]

Despite his extensive preparations and his long-standing desire to study in Europe, Cole could not afford to travel until 1829. He had hoped to finance his trip through the sales of his pictures, but he was disappointed. Although he tried to persuade Gilmor to purchase *The Garden of Eden* and *Expulsion from the Garden* in 1828, the collector maintained his aversion to poetic compositions and offered Cole a loan of $300 instead. At the last minute Cole sold some of his pictures and raffled off the rest.[21] The Boston merchant Thomas H. Perkins, a friend and patron of Allston, offered Cole free passage on a ship to Liverpool in exchange for a future painting, and Cole finally embarked on June 1, 1829.[22]

Cole sailed to Europe with a mixed set of expectations that reflected the state of the arts in America at the time. He wanted, like Allston before him, to obtain in Europe the training and recognition that could assure his membership in the artistic profession. He seems never to have questioned the professional necessity of such a trip. At the same time, however, by 1829 a growing sense of national pride had led Americans to begin to assert their cultural independence. Aesthetic and political commentators were beginning to discourage excessive imitation of European models, seeking instead native forms of expression. Thus, Cole's attitude toward Europe was tinged with a certain sense of caution, a fear of the possible corruption of his American spirit.[23]

This aspect of Cole's attitude toward Europe was best expressed by William Cullen Bryant in a sonnet he wrote in 1829 in honor of his friend, "To Cole, the Painter, Departing for Europe":

> Thine eyes shall see the light of distant skies:
> Yet, Cole! thy heart shall bear to Europe's strand

> A living image of our own bright land,
> Such as upon thy glorious canvas lies;
> Lone lakes—savannahs where the bison roves—
> Rocks rich with summer garlands—solemn streams—
> Skies where the desert eagle wheels and screams—
> Spring bloom and autumn blaze of boundless groves,
> Fair scenes shall greet thee where thou goest—fair
> But different—everywhere the trace of men,
> Paths, homes, graves, ruins, from the lowest glen
> To where life shrinks from the fierce Alpine air,
> Gaze on them till the tears shall dim thy sight,
> But keep that earlier, wilder image bright.[24]

Bryant's poem outlined the cultural assumptions that Cole carried with him on his voyage. The "fair but different" scenery of Europe offered a contrast and a challenge to the "wilder image" of America. The artist who had immersed himself in natural scenes—lone lakes, savannahs, rocks, streams, and skies—would now find himself confronting "everywhere the trace of men." The New World, Bryant asserted, was the province of nature and the Old World of history. In place of American groves, Europe offered graves, as well as homes, paths, and ruins. The poet acknowledged that these sights were bound to be moving and appealing, yet he urged his friend to "keep that earlier, wilder image bright." As an artist who had embodied the "image of our own bright land" on his "glorious canvas," Cole was perhaps especially susceptible to the temptations of the European scene. Bryant urged his friend to keep his art, his image-making powers, as a talisman against corruption.

Through his poem Bryant offered Cole a framework in which to place his European experiences, a way in which he could respond to Europe without losing his American identity. It is interesting that both Bryant and Cole, as well as the public who read the poem, accepted the idea that Cole had an American identity to lose, since he had spent the first eighteen years of his life in England and had lived in America for barely ten years when he set off on his voyage. The "wilder image" was not Cole's native heritage. However, he had so fully embraced the notion of the American artistic vocation that he accepted Bryant's formulation as his own. By cultivating a special relationship to nature Cole believed he could respond to the artistic lessons of Europe without losing his New World perspective.

Bryant's poem stands as a kind of blueprint for Cole's European experience, and to a certain extent the painter's reactions tallied with Bryant's projections. Cole himself wrote a poem on the occasion of his departure for Europe that forms an interesting companion to Bryant's poem. On the cover of a sketch book, according to Cole's biographer, the painter wrote:

> Let not the ostentatious gaud of art,
> That tempts the eye, but touches not the heart,
> Lure me from nature's purer love divine:
> But, like a pilgrim, at some holy shrine,
> Bow down to her devotedly, and learn,
> In her most sacred features to discern
> That truth is beauty.[25]

Bryant's influence is evident in the main thrust of Cole's poem, which is a warning to himself not to let the fair sights of art (which Bryant associated with Europe) corrupt him or divert his thoughts from nature (which Bryant identified with America). At the same time, however, Cole's poem places him firmly in the English aesthetic tradition to which he had declared his allegiance. Allston had given him almost exactly the same advice, warning him never to lose his love for nature and quoting Reynolds on the dangers of having "quitted nature without acquiring art."[26] Both Allston and Reynolds would have heartily seconded Cole's condemnation of the "ostentatious gaud of art / That tempts the eye, but touches not the heart," for both believed that the most dazzling technique was worthless without a moral purpose. But it is the last line of the poem that best signals Cole's familiarity with the aesthetic thought of his English contemporaries. If in fact he alludes to Keats' "Ode on a Grecian Urn" (1819), as he seems to do, he has brought the poem full circle, for the English poet's insight into the meaning of truth and beauty was triggered, of course, by his contemplation of an art object.

Thus, Cole sailed with complex expectations for the European scene. He had lived long enough in America and had participated fully enough in the burgeoning art world of New York to imbibe a strong sense of cultural nationalism, which he was determined to maintain. Yet, he had enthusiastically accepted the idea of an artistic vocation in the "high" tradition of European aesthetics, and he looked to Europe to provide training and experience, to confirm him in his chosen profession.

Cole's letters to friends and family soon after his arrival in England demonstrate these dual impulses at work. His first letter to his parents commented on English scenery and customs in the detached voice of an American tourist; he gave no indication that he was writing to native Englishmen about scenes they had all left just ten years earlier. In fact, the poetic tourism of Geoffrey Crayon, by 1829 an accepted guide for American reactions to the Old World, underlies his account of his voyage, his first glimpse of the picturesque English coast, his coach ride through the English countryside, and his visit to Westminster Abbey. "Nothing can exceed the excellence of English cultivation," he wrote. "All is a perfect garden. . . . There is a wonderful neatness in the cottages; the very poorest of them has its little garden before the door

and is almost buried in flowers."[27] Cole offered no acknowledgment that he, too, had once lived in England; instead he spoke with the voice of Irving's wanderer or Bryant's cautious tourist.

In his professional capacity, however, Cole plunged eagerly into London life. He lost no time in calling on Samuel Rogers who had extensive contacts among artists and art patrons. In July he attended the exhibition of the Royal Academy and began to compare his work with the works of his English contemporaries. Relieved to find that "most of them are very far from perfection in the art," he wrote to his parents that he had "reason to be satisfied with the advances I have made," although he warned them not to repeat this comment to his friends lest it be taken for vanity. "I think I shall improve very fast here, having the advantage of seeing so many fine pictures, both ancient and modern."[28]

During his first few months in England Cole earnestly pursued the professional improvement he had come to Europe to attain. He strove diligently to follow Allston's advice and example. Studying Old Masters and modern paintings, making contacts in the art world, and painting furiously in order to accumulate a body of works to show potential patrons, he sought to establish himself as an artist. Through these activities he sought to ground himself in the English school and the Old Masters before moving on to the European continent, just as Allston had recommended in his letter to Pickering. In December 1829, Cole visited Turner, whom Allston had recommended as the greatest living landscape painter.[29] Shortly before Christmas in 1829, Cole attended lectures at the Royal Academy with Morse, who was also visiting London at the time; the American artists were delighted to hear the lecturer praise Allston and quote from his poems.[30]

As the culmination of this period of professional activity, Cole sought ratification of his entry into the London art world by sending two pictures to the annual exhibition of the British Institution, which opened in February 1830. His choice of paintings reflects his strategy for establishing his professional reputation. In a gesture to both his American identity and his aspirations as an artist in the "higher style," he sent one landscape painting, *The Falls of Niagara,* and one religious painting, *Elijah at the Mouth of the Cave.*[31] Both canvases now are lost but *Niagara* can be judged by the engraving published in J. H. Hinton's *History and Topography of the United States* and *Elijah* from a drawing in Cole's sketchbook that presumably records the finished picture. Both paintings reflect Cole's efforts to enter the English art world on its own terms. *Niagara* employs a fairly conventional composition that is similar to Doughty's landscapes and Trumbull's views of Niagara. It is a relatively distant view of the falls with small human figures in the foreground. The painting uses Cole's elevated point of sight, which gives so many

of his landscapes a panoramic quality, and the inclusion of two Indians as spectators stresses the Americanism of the scene. However, its symmetrical composition, dark framing masses on both sides and the foaming falls in the middle distance, places it in a classical context reminiscent of Claude and Turner. *Elijah* represents Cole's attempt to follow in the footsteps of Allston, who had painted a similar subject twelve years earlier. Like some of Cole's earlier biblical paintings—*The Expulsion from the Garden of Eden* (1827-28), for example—*Elijah* uses landscape elements as its chief source of drama and expression. Swirling clouds and towering rock formations provide an atmosphere of terror, and the prophet's sense of divine abandonment is conveyed as clearly by the shattered, twisted trees in the foreground as by the small figure of the prophet in the center of the painting. Allston's painting, which Cole viewed in a private collection after his *Elijah* had been exhibited, also portrayed Elijah as a small figure beneath a large gnarled tree.[32]

In submitting these paintings—a religious scene in the tradition of high art and an American landscape to signal his national identity—Cole made a bid for recognition in the English art world, but he was rebuffed and disillusioned. Unlike the New York art world, where Cole's talent won him immediate patronage and recognition, the London art world was rigidly controlled by the established cultural institutions. Although an unknown painter without influential connections might be permitted to exhibit his paintings, they were likely to be assigned to dimly lit or otherwise unfavorable spots in the crowded galleries.[33] To Cole's shock and chagrin, *Niagara* and *Elijah* met just such a fate. In a letter to his sister he complained that the exhibition judges were "ignorant and illiberal."[34] When his paintings received similar treatment at the Royal Academy the following fall, Cole wrote home in disgust of the "jealousy and heart-burning" that produced "a deadness of feeling among the artists here." He went on to say, "The fact is the Royal Academy is an incubus on the Fine Arts of this country—a complete monopoly of public patronage to the aggrandiziment of its members, and to the prejudice of all artists who do not belong to it."[35]

With the realization that his attempt to gain recognition would be more difficult than he had originally optimistically imagined, Cole poured out his anger and disillusionment in a poem, "Written on my Birthday, Feb. 1, 1830." In it he reflected bitterly on his dreams of fame and fortune:

> O fickle Fortune—as the rainbow deck'd,
> Like it forever flying when pursued,
> Unjust. How oft into the lap of sloth
> Thy treasures rich are cast. . . .

11. Fenner Sears, engraving, from Thomas Cole, *A Distant View of the Falls of Niagara* in J. H. Hinton, ed., *The History and Topography of the United States* (London: Simpkin & Marshall & Thomas Wardle, Philadelphia, 1832], II, Frontispiece. Photograph courtesy of University of North Carolina Library Photographic Service from copy in North Carolina Collection, UNC Library, Chapel Hill.

12. Thomas Cole, *Elijah at the Mouth of the Cave*, pencil and ink, 10¹¹/₁₆ × 15 in. Courtesy of the Detroit Institute of Arts, William H. Murphy Fund, 39.342.

Lamenting the establishment's neglect of his cherished paintings, he contrasted the "formal insipidity" of the favored artists with his own desire to make his paintings "glow and live":

> Ye children of my fancy and my care!
> Neglected and despised and careless cast
> Into the shade, unmarked among the crowd
> . . . Are ye devoid of beauty?

In an attempt to rally his wounded spirits, Cole sought confirmation for his pride in his own paintings. As if remembering Bryant's formulation of the contrast between Europe and America, Cole defended his work by calling nature itself to witness:

> Ye mountains, woods, rocks, and impetuous streams
> Ye mantling heav'ns—speak—speak for me!
> Have I not held communion close with you
> And like to one who is enamoured, gazed
> Intensely on your ever varying charms,
> And has it been in vain?[36]

Rebuffed in his attempt to prove himself a serious painter within the English art world, Cole, in this poem, fell back on his stance as a child of American nature, the national identity that Bryant had sketched out for him.

As an indication of Cole's response to disappointment, "Written on my Birthday" proved prophetic. Although he continued to seek professional recognition, sending paintings to the Royal Academy for two seasons and trying the British Institution again the following year, Cole seems to have abandoned his attempt to enter the field of religious and historical painting. Instead, he concentrated his efforts in that area he could claim more exclusively as his own, American landscape. In October 1830, he wrote to a friend that he was just varnishing a series of paintings to be engraved for a volume entitled *The History and Topography of the United States.*[37] In March 1831, Cole sent an American landscape, *Tornado in an American Forest,* as his contribution to the exhibition held by the Gallery of British Artists, and it received better treatment than some of his earlier works.[38]

While Cole's two-year stay in England allowed him to study the works of Old Masters and contemporary artists and brought him some modest success as a landscape painter, these rewards fell far short of the recognition and acceptance he had hoped for. Perhaps he had expected Turner, like Trumbull, to exclaim that this young man had done what the older painter had attempted in vain. At any rate, Cole chafed at

feeling "a nameless, noteless individual," as he later described his experience, and concluded at the end of two years that he had made very little progress toward achieving his artistic aims.[39]

In March 1831, Cole wrote his sister that he was beginning to contemplate returning home but planned "a hasty trip to the continent" first.[40] Despite his discouragement, he seemed determined to follow his European experience through to its conclusion. Allston had recommended visits to France, Switzerland, and Italy after thorough study in England, and Cole accordingly embarked for Paris in May 1831. A rather dispirited letter to his patron Robert Gilmor mentioned his plan to spend several months on the continent and then return to America in November. Cole added as a lame summary of his European venture to date that he had been "painting incessantly. I hope improving somewhat."[41]

His spirits received no boost in Paris, where he found that the Old Masters had been removed from the Louvre and only disappointing modern pictures remained. But in early June 1831, he arrived in Florence and began the second phase of his European experience, one which would have the most profound effect upon his art. Contrary to Cole's prior expectations, it was in Italy, not in England, that he received his initiation into the world of art; and this sense of professional identity came, not through recognition from established artists with their roots in the English aesthetic tradition but through the comradeship and shared enthusiasm of a group of young American artists confronting together the European scene.

His visit to Italy offered Cole imaginative stimulation on several levels. Englishmen had regarded Italy as a magic land since the eighteenth century; for decades English literature had reflected a fascination with ancient sites and their history. Bryon's Childe Harold was only one of many guides who suggested to Cole an emotional, imaginative response to Italian scenery.[42] Cole's friend and patron, Henry Pickering, had written two long poems, Athens and The Ruins of Paestum, that centered on a meditative and associational response to ancient ruins. Italy had worked its magic on an earlier generation of American painters as well, for both West and Allston had spent time there at crucial points in their own careers.[43]

Cole's experience differed from that of West and Allston, however, in several ways. His predecessors' sojourns in Italy made a strong personal and emotional impact on them. Years later, Allston could write eloquently of the joys of Italy to friends contemplating travel there.[44] Thirty years after his own visit, he was so moved by a book on Italy, The Diary of an Ennuyé, that he wrote a poem to its author, describing how her words had conjured up his memories of "bright, peerless Italy."[45] Yet for both Allston and West, Italy represented an interlude, an emotional experience that offered them themes and images for their work but did

not shape their professional lives. Their artistic careers came to fruition in England. By contrast, Cole found not only personal and intellectual stimulation in Italy but professional definition as well.

The strongest single influence on Cole during his sixteen months in Italy was his friendship with Horatio Greenough. Greenough, a young sculptor, had also gone to Europe to attain the training and recognition necessary to establish his professional identity. The state of sculpture in the United States in the early nineteenth century resembled the condition of painting a century earlier: except for folk and commercial works, little tradition existed for the would-be sculptor to draw on. Greenough, like his contemporaries Hiram Powers and Thomas Crawford, was drawn to Europe to learn artistic techniques and to gain access to the developed marble quarries and supporting services of artisans that were so readily available in Italy.[46] Like Allston and Irving before him, he hoped to make his reputation abroad in order to practice his art at home. "I came abroad to make myself known and respected in my own country," Greenough wrote in a letter in 1830. "If I succeed, I will return and form a school, if not I will have at least the honour of laying my bones in a land so fraught with genius that even her starved out mediocrity commands a respect which I cannot earn."[47] In his passionate commitment to art, Greenough offered sympathy and stimulus to Cole, who felt defeated in his own attempts to gain recognition in England.

Greenough also offered Cole an important link to the poetic and ideal conception of art that was embodied by Washington Allston. Allston had launched Greenough on his career. As a student at Harvard, Greenough had boarded with Edmund T. Dana, the brother of Allston's old friend, Richard Henry Dana. On Saturday evenings, Allston habitually joined the Danas and their boarder for artistic and philosophical discussions. Greenough later wrote, "Allston was to me a father in what concerned my progress of every kind. He taught me first how to discriminate, how to think, how to feel. Before I knew him I felt strongly but blindly, and if I should never pass mediocrity, I should attribute it to my absence from him, so adapted did he seem to kindle and enlighten me, making me no longer myself, but, as it were, an emanation from his own soul."[48]

Cole had first met Greenough in New York in 1828, and when he arrived in Florence in June 1830, he took lodgings in the same house as the young sculptor. Thus Cole, completing his tour of Europe according to Allston's prescription, though with flagging enthusiasm, came into close contact with another pupil of Allston's, a passionate and purposeful artist. This friendship infused new life and energy into Cole's struggle for artistic definition.

In Florence Cole found the sense of fellowship he had missed in

London. In addition to Horatio Greenough, Cole came to know the painters Henry Greenough, the sculptor's brother, and John Cranch. Their mutual friend Samuel F. B. Morse had just left Florence after several months' stay. As soon as Cole joined the group Greenough began work on a bust of the young painter; and Cole in turn sketched the sculptor's portrait.[49] These mutual sketching sessions, with their probable aesthetic and philosophical discussions, resembled the invigorating artistic life Cole had known in New York, as well as Greenough's Saturday evenings with Allston. By the time Horatio Greenough left Florence in late August for a four-month stay in Paris, Cole had become a part of his artistic circle and took a ten-day trip to Volterra in August and September with Henry Greenough and John Cranch. Refreshed by the artistic fellowship, Cole soon was painting again, *"painting, painting incessantly,"* as he wrote a New York friend.[50]

Cole's work in Florence in 1831-32 clearly shows Greenough's influence. Although he made a number of sketches and paintings of Italian scenery, he also began to work again on poetical and historical subjects. He even began an ambitious biblical scene, his first since the ill-starred *Elijah* in England, which was entitled *The Angel Appearing to the Shepherds.* Greenough urged him to take up figure study, and upon his return from Paris in December 1831, he found Cole making "astonishing progress."[51] "He's going to be a great artist," Greenough wrote to their mutual friend James Fenimore Cooper. "I shall always be very proud of having induced him to study the figure—I knew by his pale face and eternal sighing that mere landskape [sic] of any class was too small a ball for his calibre."[52]

Greenough also praised Cole's development as a "serious" painter in a quarter where praise could bring results. Writing to their patron Robert Gilmor, Greenough remarked, "I cannot allow this opportunity to pass without congratulating you on the success of Mr. Cole the landskape [sic] painter in whom I know you have always taken the deepest interest—He has wonderfully improved since I saw him in New York." Perhaps because of Greenough's encouragement, Cole had begun to contemplate a series of historical landscapes, the plan for which, Greenough wrote, "struck me forcibly."[53] To Cooper, Greenough pronounced Cole's new work "glorious."[54]

By January 1832, Cole's feelings about his European sojourn had changed substantially. The homesick young man who had undertaken to spend a few months on the continent out of a sense of duty was now writing raptures about "this land of poetry and beauty." He wrote to Gilmor, "I am delighted with what I have seen of Italy, its scenery and its works of art. The galleries of Florence are paradises to a painter."[55] Under Greenough's tutelage, the European scene began to nourish Cole's artistic development.

In early February Cole set out for Rome and continued his Italian

sight-seeing in a better mood than he had begun it. Greenough remained in Florence, but he served Cole as a kind of spiritual guide. Cole took a studio in Rome in the building where Greenough had worked during his stay there in 1825.[56] Soon after his arrival, Cole wrote Greenough a high-spirited letter full of anecdotes of his journey and descriptions of the Roman sights that the two men must have discussed before his departure. "I have been to St. Peters twice and will you believe it am disappointed. . . . I have seen the Pantheon. What a portico! What light and shadow! . . . I have also seen the Moses of M Angelo—it is a sublime conception." The letter reads like a fragment of conversation that Cole expected to resume in person. "I am afraid I have explained my notions very clumsily," he wrote, "but will leave it until I see you again."[57]

He spent three months in Rome, making excursions to the countryside and collecting commissions for views of Italian scenery largely from visiting Americans.[58] In the late spring he traveled south to Naples, visiting sites of antiquity there, collecting sketches, and filling out his Italian experience. With his restored good spirits and sense of professional competence, Cole could indulge his desire to experience Italy with all the emotions his literary sources had led him to expect. His letters and journals from the trip refer to Byron; and he paid tribute to his friend and patron Henry Pickering by insisting on a visit to the ruins of Paestum.[59]

Refreshed by his travels, Cole resumed his friendship with the Greenough circle and launched into an unusually productive phase of his career. "Returned to Florence, I painted more pictures in three months than I have done in twice the time before or since," he wrote later. "I was in the spirit of it. . . . O that I was there again, and in the same spirit!"[60] Cole had hit his stride as an artist. Like Irving writing *The Sketch Book* or Allston in the golden period that produced *Uriel in the Sun* and *Elijah in the Desert* as well as *Jacob's Dream* and the studies for *Belshazzar's Feast,* Cole now found that the European environment nourished and energized his art.

In these Italian paintings Cole found a way to use his talent for landscape to evoke an emotional response to the Old World, drawing on the poetic associations and fascination with history he shared with Greenough and with their literary guides. While Cole was lodging with him, Greenough was working on his *Medora,* a subject drawn from Byron, and the two artists must have frequently discussed the works of this famous traveler. Childe Harold had used his Italian wanderings to "meditate amongst decay":

> . . . there to track
> Fall'n states and buried greatness, o'er a land
> Which *was* the mightiest in its old command,
> And *is* the loveliest, and must ever be
> The master-mould of Nature's heavenly hand.[61]

Byron had stressed the pathos of ruins, the contrast between past and present in the landscape:

> Italia! oh, Italia! thou who hast
> The fatal gift of beauty, which became
> A funeral dower of present woes and past,
> On thy sweet brow is sorrow plough'd by shame,
> And annals graved in characters of flame.[62]

At the same time, the poem brims with admiration for the beauty of ruins:

> Tully was not so eloquent as thou,
> Thou nameless column with the buried base![63]

Or again,

> . . . there is a power
> And magic in the ruin'd battlement,
> For which the palace of the present hour
> Must yield its pomp, and wait till ages are its dower.[64]

Cole's Italian scenes embody the emotions for which *Childe Harold* was one of many guides. A painting like *A View Near Tivoli, Morning* depicts the "magic in the ruin'd battlement" as Byron described it. In this painting Cole paid homage to two aspects of the Italian scene: nature and art. The ruined arches are overgrown with weeds and ivy, the leaves of which sparkle in the sunshine. In the distance mists rise on the mountains, suggesting the contrast between the ephemeral power of man and the eternal beauty of nature that made Italy, in Byron's phrase, "the master-mould of Nature's heavenly hand." Peasants pursuing their humble tasks amid the ruins provide the contrast between past and present that Byron found so moving. Cole succeeded in capturing in this landscape the poetic emotions traditionally evoked by the contemplation of European scenery.

Viewing Cole's successful Italian paintings from the period 1831-32 in light of his expectations when he embarked for Europe in 1829, it is tempting to explain the change in his style as a capitulation to the dangers of which Bryant had warned him. Cole's poetic landscapes represent a celebration of "the trace of men / Paths, homes, graves, ruins," that Bryant had contrasted to "that earlier, wilder image" of America. Yet the success of these paintings lies in their incorporation of poetic sentiments within attractive and viable landscape scenes. Rather than choosing art over nature, as Bryant and Cole himself had feared, Cole found a way to use his talent for observing and depicting land-

13. Thomas Cole, *A View Near Tivoli (Morning)*, oil on canvas, 14¾ × 33⅛ in. The Metropolitan Museum of Art, Rogers Fund, 1903.

scape to serve the artistic principles that, like Greenough, he identified with "higher art."[65] In this sense, Cole's Italian scenes marked a breakthrough in the search for the "higher style of landscape" that he had been seeking ever since *John the Baptist in the Wilderness, Expulsion from the Garden of Eden* and other early works. His Italian scenes laid the groundwork for his later allegorical paintings.

Cole was recalled from this stimulating and productive phase of his career rather abruptly by news of family problems. In August 1832, Greenough wrote Morse that he regretted Cole's departure. "He intended to have remained here another year, had commissions in abundance, and was under full sail, when he got news of sad domestic afflictions, sickness, and [death], so, like the glorious fellow he is, he sent home his spare cash, and is getting ready to follow it."[66] Although his friends urged him not to return home without rounding out his European travels, Cole settled his affairs and sailed for New York in early October 1832.[67]

Cole returned to America a more seasoned artist, surer of himself and his artistic goals. After a false start in England, his stay in Europe had fulfilled some of the hopes with which he had left America. His attempt to build a professional life after his return reflected both his own goals, tempered by his European experience, and the state of art patronage in America. Like Allston and Morse, he aspired to a life devoted to ideal art, and like them he found public taste often disappointingly shallow. Patrons and critics preferred landscape views to religious and allegorical paintings. Fortunately Cole did not despise landscapes as Morse did portraits; he loved exploring the mountains and the valleys with sketchbook in hand, and he enjoyed working up dramatic compositions like *The Oxbow* (1836) and *Schroon Mountain* (1838). But he continued to place a high value on the more "serious" aspects of his career. While seeking commissions and sales to individual collectors as he had before, Cole also experimented with public exhibitions of his works, publishing and engraving enterprises, and sales of his pictures through agents in Boston and London.[68]

In one of the first projects he undertook after returning from Europe, Cole entered the lists as a history painter. He arranged for the exhibition of *The Angel Appearing to the Shepherds,* which he had painted in Florence when Greenough had urged him to study figure painting. Such an entrepreneurial enterprise was a well-established option for artists, of course. West and Haydon had exhibited their paintings for profit in London, and in the United States, Rembrandt Peale had created a sensation with *The Court of Death* in 1820. Other American painters, however, had found private exhibitions a disappointing venture. In 1831 Allston

could not persuade Bostonians to pay to see *Spalatro's Vision of the Bloody Hand,* and in the fall of 1833 Morse received one more impetus to abandon the fine arts when he failed to turn a profit with his *Exhibition Gallery of the Louvre* in New York.[69] Thus, when Cole exhibited *The Angels Appearing to the Shepherds* in New York, Albany, and Boston in 1834, he took a financial risk. The venture did not pay. He was forced to close the exhibition in New York before the end of his lease; the project barely broke even in Albany, where his agent claimed an inordinate number of people were out of town for the summer, and Cole had to urge his friends to swell the crowds at the exhibition in Boston.[70] As the exhibition foundered, Cole became enmeshed with an ineffectual and pompous citizen of Albany, Simeon DeWitt Bloodgood, who proposed to arrange for the picture's sale to an orphanage for $1,500. After these plans fell through, Bloodgood offered to buy it for himself for $500, but although Cole eventually offered to settle for $200, he still had not received payment in December 1836, and Bloodgood had deposited the picture in a wax museum.[71] Although the outcome was unhappy, Cole's efforts to exhibit the painting and to sell it to a public institution do demonstrate that he tried to establish himself as a serious painter in the high style.

Even more significant from this point of view was another abortive project of Cole's first few years after his return to America. In 1834 he made a brief attempt to secure the commission for one of the vacant panels in the Capitol rotunda. This chimerical government commission had been tempting artists ever since John Trumbull won approval to paint the first four panels in 1817, and the entire artistic community had watched breathlessly for years as political ups and downs brought the commissions within reach only to snatch them away again.[72] Allston had been willing to undertake a panel in 1830, but the authorization failed to gain congressional approval that year.[73] In January 1834, the project was revived in Congress, and American artists found their hopes raised once more.[74] Final selection was to rest with the Library Committee, whose chairman, Edward Everett, received a barrage of letters from artists and their friends lobbying for the commissions. Among these, interestingly enough, was Cole.

Cole wrote Everett on March 10, 1834, offering himself as a candidate for the Rotunda commission. His letter began modestly, "I take the liberty of addressing you as an applicant for one of the four pictures to be painted for the capitol," adding that he "perhaps should not have ventured to solicit so important a commission if I had not been urged by sanguine friends, who in anticipating the successful accomplishment of the work, may have overlooked my demerits." Cole went on to explain why he hoped to be taken seriously as a history painter. "It is

probable that to you I am known only as a painter of Landscape, & probably little known as such; but my studies in Europe were in great measure for History & if the opinion of a talented friend with whom you are acquainted, Horatio Greenough, may be allowed, they were successful." Greenough had succeeded in his own application for a government commission and was then working in Florence on his monumental statue of George Washington. "It is little more than a year since I returned from Europe," Cole continued, "& in consequence my Historical pictures are very few—on these few which were executed under great disadvantages, I must rest my hope & trust that from them may be augured much higher excellence, when the field & faculties of the artist shall be extended."[75] Cole clearly presented himself as an aspiring history painter, referred to his European studies as an important stage in his development, and called on Greenough as his model and referee.

His endeavor to present himself as a history painter was tenuous at best, as a supporting letter from Franklin Dexter to Everett shows. Dexter began by saying frankly that Cole had asked him for a letter of support. "I will tell you precisely what I think of Mr. Cole's pretensions," Dexter continued. "He is well known as a landscape painter of great merit, he is young, has a most enthusiastic love of his art and a most cultivated & fastidious taste in it—But he cannot be said to be yet an artist of such established reputation in any department except landscape as should recommend him to execute a historical picture of the character of those which ought to fill the Rotunda." Although this sounds more like professional assassination than recommendation, Dexter then went on to say in his businesslike way that despite these limitations Cole was better suited to execute the commission than any other artist who was likely to apply. "Of course there is but one man in the country who ought to fill those walls with the history of our revolution—but Allston is so occupied with other things that I presume he is not a candidate." He concluded by saying that Cole "would do more credit to the country than any other man except Allston or Vanderlyn. . . . If I had the selection I should certainly choose him for one of the pictures."[76] Although this recommendation was less flattering than Cole might have wished, the letter itself marked a kind of accomplishment in Cole's effort to establish himself as a history painter. The young New York painter sought and received a letter of recommendation from a noted Boston lawyer, who was a friend and supporter of Allston.[77] Despite its blunt evaluation, Dexter's letter did endorse Cole's desire to follow in Allston's footsteps and thus offered support for his aspirations.

Cole must have viewed the commission as a long shot, and indeed he did not receive it or even achieve serious consideration. While his letter to Everett did not contain any specific proposals for a picture, it is interesting to speculate what his approach to such a commission would

have been. Would he have attempted a conventional history painting like *The Angels Appearing to the Shepherds*, or would he have used the commission to advance his developing idea of landscape as history painting? Dexter's letter predicted the latter. "I should expect from him a picture partaking of landscape (of the *kind* for instance of Titian's Peter Martyr in Venice) which I think would be an agreeable variety in the collection."[78] When the Rotunda commissions finally received congressional approval in 1836, Allston was offered two panels, and when he declined, the four commissions went to John Vanderlyn, Robert Weir, John G. Chapman, and Henry Inman.[79]

Even while seeking opportunities as a history painter, Cole continued to exploit his popularity as a painter of landscapes. He attempted to build on the success of the engravings made from his American views by contributing to American gift books and anthologies.[80] An American edition of the book he had illustrated in England, J. H. Hinton's *History and Topography of the United States,* appeared in 1834-35. Yet, such projects served Cole primarily as a means of support while he tried to turn his career toward the poetic subjects he found most compelling. Like Morse, Sully, Alexander, and even Greenough, who worked at portraits for profit while seeking opportunities to pursue the "higher style" of art, Cole found himself retailing his landscapes while seeking commissions that would enable him to continue the line of development he had found so fruitful in Italy. The ten paintings he exhibited at the National Academy of Design in 1833 reflect his desire to move away from simple landscapes: the works included only one American scene, painted in Europe, four European landscapes, two scenes from Byron, an Italian character study, and a religious painting.[81]

Although some of his projects proved abortive, Cole did complete one major project in the higher style during the first few years after his return from Europe, a series of pictures he would eventually title *The Course of Empire.* This project absorbed his creative energies for three years. When completed, it stood as an embodiment of his artistic ambitions and an expression of his enthusiastic response to the historical and artistic heritage of the Old World.

Cole's earliest notes for the paintings that became *The Course of Empire* coincided with the beginning of his European sojourn. In his notebook dated 1827 he kept a running list of subjects for paintings; the list functioned as a reservoir of ideas for him throughout his career.[82] On a separate page of the book, out of sequence with other entries that are easier to date, Cole recorded his ideas for a series of paintings "illustrative of the mutation of earthly things." He described four scenes: first, a sunrise in "a beautiful and partially cultivated country," second, a noonday view of "a noble city with grand temples glittering domes & a seaport

crowded with ships—splendid processions," third, "a storm, battle &
burning of a city—with all the concomitant horrors," and fourth, "a
sunset a scene of ruins . . . delapidated [*sic*] temples—sarcophagi." After
noting that "the scene of each picture might have one location," Cole
added as an apparent afterthought: "The first picture might be a savage
scene—utterly uncultivated—A Moonlight—some savages in the foreground—
seen by a fire."[83] Whenever this entry was written, it represents the
moment of discovery for the basic form of *The Course of Empire*. Cole
elaborated on the plan in an undated journal entry that precedes an entry
for December 12, 1829. It is apparent, therefore, that he first formulated
the series in the heady excitement surrounding his trip to Europe, either
just before leaving home or in the midst of his early, enthusiastic assault
on the London art world before disillusionment temporarily deflected
his energies back toward landscape.[84]

The next stage in his development of the project came with the return
of his ambition and enthusiasm under the influence of Horatio Greenough
in Florence. With Greenough's encouragement, Cole revised and ex-
panded his plans for the series and tried to secure Gilmor's patronage
for it. As Cole described the series to Gilmor in January 1832, the
basic features remained virtually unchanged:

The first picture must be a savage wilderness—the sun rising from the ocean
& the stormy clouds of the night retiring tumultuously over the mountains—
the figures must be savage—clothed in skins & occupied in the Chase—there
must be a flashing chiaroscuro and a spirit of motion pervading the scene, as
though nature was just waking from chaos. The second picture must be pastoral—
the day farther advanced than in the former—light clouds playing about the
mountains—the scene partially cultivated—a rude hamlet near the sea with
buildings erecting—small vessels in the harbour—groups of peasants either
pursuing their labours or engaged in some simple amusement. The third picture
must be a cloudless noon—a great city—gorgeous piles of Architecture, Bridges,
Aqueducts, Temples etc., port crowded with vessels—splendid processions etc.—
all that can be combined to show the fullness of prosperity. The fourth should
be a Tempest—a Battle—the burning of the city—towers falling—arches broken—
vessels wrecking in the harbor. In this picture should be fierce chiaroscuro—
masses and groups swaying about like stormy waves—this is the scene of
Destruction. The fifth must be a sunset—the mountains riven—the city a deso-
late ruin—columns standing isolated amid the encroaching waters—ruined
temples—broken fountains sarcophagi etc. no human figure, a solitary heron—
a calm & silent effect—this picture must be as the funeral knell of departed
greatness.[85]

Cole told Gilmor that he had copied this description from his memoran-
dum book, presumably his journal of 1831-32, in which he had elaborated
on his earlier plans, perhaps after talking to Greenough. While the
five paintings retained the relationship Cole had sketched in his 1827

journal entry, this description provided a more detailed and eloquent statement of the thematic structure for the series. Cole not only told what the pictures would look like but what they would mean. His symbolism became explicit: "as though nature was just waking from chaos," "combined to show the fullness of prosperity," "the funeral knell of departed greatness." He told Gilmor that his series would have various levels of meaning: it "should be the History of a Natural Scene, as well as an Epitome of man; showing the *natural* changes of Landscape, and those effected by man." Tracing successive stages of human development, the series would show man's "progress from Barbarism to Civilization—to the state of Luxury—to the vicious state of Destruction etc."[86]

Although Cole self-deprecatingly referred to his plans for the series as "Castles in Air" in his letter to Gilmor, he clearly hoped to put his ideas into practice with his newfound artistic energy.[87] With Greenough's encouragement he already had begun work on the first of the five paintings; but by late January 1832, he had realized that execution of the series would take more concentrated effort than he could give without a commission, and he asked Gilmor to take the completed picture in payment of his $300 debt. "I think it is my best picture," he wrote and added that he now had an even better idea for the first of the series and would like to exhibit the present painting under the title "A Wild" or "A Chase."[88] He described the painting to his friend J. L. Morton as "a large picture representing a romantic country, or perfect state of nature, with appropriate savage figures" and made no mention of the projected series.[89] After some confusion Gilmor did take the painting, which he praised as a work "of the genuine Salvator school," an implication of imitativeness that could hardly have pleased Cole.[90]

Gilmor's lack of interest in the proposed series reflected his coolness toward the direction in which Cole's artistic ambitions were taking him. Although the collector politely expressed continuing solicitude for Cole, he offered no further commissions. Indeed even while praising the young artist, he could not resist mentioning Old Master paintings and even the copies of them with which Cole's works had to compete on his walls.[91] Fortunately Cole soon met another patron with energy and means similar to Gilmor's but tastes more closely allied with his own: Luman Reed. Reed, who had made a fortune in the wholesale grocery business, had begun to develop a taste for the fine arts through purchases of Old Masters but had found it more rewarding to encourage the development of native art by supporting struggling young American artists. Among the beneficiaries of his interest during the 1830s were Asher B. Durand, William Sidney Mount, and Allston's nephew, George Flagg, as well as Cole.[92]

In September 1833, Cole responded to Reed's invitation to paint a

set of pictures for a room in his house by sending a description of the series he had earlier proposed to Gilmor. Cole prefaced his proposal by saying how much the project meant to him. It represented "a favorite subject that I had been cherishing for several years with the faint hope that, some day or other, I might be able to embody it." Cole went on to describe the series in terms simular to those that he had used in the letter to Gilmor; in both cases he wrote that he was "making an extract from my memorandum book." During the intervening years the series had taken on a clearer shape and sharper focus, and the letter to Reed contained more details and greater elaboration. After describing the five stages he planned to portray, Cole expanded his discussion of the series' symbolism, placing it clearly in the realm of the higher art he was struggling so hard to enter. "The philosophy of my subject," Cole wrote, "is drawn from the history of the past, wherein we see how nations have risen from the savage state to that of power and glory, and then fallen, and become extinct. Natural scenery has also its changes,—the hours of the day and the seasons of the year—sunshine and storm: these justly applied will give expression to each picture of the series I would paint." These two sentences represent an advance in Cole's thinking. Like the history painter he aspired to be, he now articulated the philosophical meaning of his painting. Furthermore, he explicitly described the method he already had begun to develop, which would reach new levels of complexity in *The Course of Empire*: the use of natural phenomena to "give expression to" moral or philosophical ideas. Cole's letter went on to describe each of the five pictures in some detail, following the outlines and using the same phrases that he had used in his letter to Gilmor.[93]

Reed proved an ideal patron from Cole's point of view. Almost immediately upon receiving Cole's long letter about the proposed series, he wrote his approval of the plan: "I am pleased with the idea of the series of pictures & with the plan of the subject & willingly accept your proposition to paint the five composing the series." He stipulated only that they should discuss the size of the paintings before Cole actually began to work. Throughout Cole's work on the series, Reed continued to offer encouragement and support, urging him to draw advances and assuring him that he was satisfied with the progress of the work. "It affords me as much pleasure to think that [the series] will establish your fame on the highest pinnacle as it does that I am to be the possessor," Reed wrote in September 1835, when Cole was struggling with a particularly difficult part of the work.[94] The commission, which occupied him from September 1833 to October 1836, was Cole's first major opportunity since his return from Europe to apply his ideas and newly refined talents to a work whose form and substance reflected his deepest ambitions and most highly developed sense of artistic vocation.

Even more than the series itself, which he executed much as he had proposed it, the broader plan Cole formulated for Luman Reed's room reveals the scope of his artistic ambitions. At the beginning of their correspondence in September 1833, Cole proposed to fill the entire room with a total of nearly thirty paintings. The series would surround a fireplace on one side of the room, its five canvases surmounted by three smaller pictures echoing the natural setting in sunrise, noon, and sunset scenes. Eighteen to twenty additional pictures would cover the remaining walls. Cole suggested that the painting at the end of the room should be hung on swings so that it could be brought into good light.[95] While Reed approved plans for the series, he delayed a decision on the paintings for the rest of the room, and since he died before the series was completed the project was never revived. However, the scope of Cole's proposal reveals his thinking about his artistic career. His ambitions for his art had been reawakened in Florence, where he found the palaces "paradises." On his return to the United States, he clearly sought patronage on a Renaissance scale, as illustrated in his hope for public commissions, like the Capitol rotunda panels, and in his approach to private patrons like Reed. No less than Morse or Allston, Cole hoped that nineteenth-century America would "renew the fifteenth century" in the style and scope of its support for the arts.

One other proposal that Cole presented to Reed further illustrates this point. Although Reed suspended judgment on Cole's broader plans for his gallery, he did ask the young painter's advice on another project, designs for a door to be embellished by sixteen painted panels. Such sumptuous decoration, strongly reminiscent of Renaissance palaces, brought an enthusiastic response from Cole. When Reed visited Cole in Catskill to discuss the project in November 1835, the painter was still struggling with the most stubborn of the paintings in his series, the central canvas, which he would name *The Consummation of Empire*. Although the series' end was not yet in sight, Cole interrupted his work to send Reed an elaborate proposal for the doors.[96] For the sixteen panels on both sides of the folding doors Cole suggested a series of paintings to be called, "Illustrations of Nature."[97] The first eight panels would portray "Inanimate Nature" and would begin with ideas of space—immensity, length, height, and depth—with four more panels showing aspects of the material world—fire, air, earth, and water. The second set of eight panels would illustrate "Animated Nature," with four portraying the "intellectual" realm—Deity, angels, spirits, and man—and four depicting "brute" nature—quadrupeds, birds, fishes, and reptiles. In his self-deprecating way, Cole continued: "When you have done smiling I will tell you how I would paint these illustrations," and went on to sketch in words some of his ideas. "Immensity might be represented by a globe like our earth suspended in a black space with a comet & stars. . . .

Length by a river flowing along the foot of a range of mountains which should retire in Aerial and Linear perfection until lost in immense distance." The first eight panels offered Cole an opportunity to develop even further his idea of using natural forms to express ideas, in this case difficult abstractions. His approach to the panels representing the "intellectual" realm directly reflects his study of European aesthetics. For angels he proposed "either original designs or copies from the most beautiful of the Old Masters," for man "original designs or copies from beautiful antiques," and for spirits "either originals or copies—Flaxman has some beautiful spirits." For the panel depicting the Deity, his proposal was cautious: "The word God with a halo & clouds would perhaps be the most appropriate manner of introducing anything emblematic of the Deity." Finally, Cole's suggestions for the decorative aspects of the doors make the Renaissance parallel even clearer. He proposed having the door frames painted to imitate bronze and the moldings gilt, warning against arabesques as unsuitable for the subject. Clearly Cole seized upon the opportunity presented to him to propose an American equivalent to the decorative projects of the Renaissance palaces he so admired. In their ambitious philosophical structure the doors represented another serious statement of high art, a sort of secular New York Sistine Chapel. Reed did not adopt Cole's plan, although he promised to save some of the panels for Cole to decorate, but rather assigned other panels to George Flagg and Asher B. Durand. This project also was interrupted by Reed's death in June 1836.[98]

Cole thus began the series that became *The Course of Empire* in a context that grew directly out of his years in Europe. While he continued to struggle with projects like the exhibition of the *Angels* and the "Picturesque Annual," this commission gave him the opportunity to regain the stride that was broken when he abruptly left Florence. The completed series marks an important point in Cole's development and in the growth of American art.

Cole built *The Course of Empire* on a foundation of ideas that fascinated members of his generation. As various commentators have observed, the idea of a cyclical theory of history, one in which human societies and their works rise, prosper, and pass away one after another, was widely accepted in America from the middle of the eighteenth century onward.[99] Edward Gibbon's *Decline and Fall of the Roman Empire* had raised questions about the fate of nations. In *The Sketch Book* Irving had reflected a Romantic interest in mutability that found further expression in numerous meditations on death, decay, and transformation in the first third of the nineteenth century. Cole's notes with their stress on the words "cycle" and "mutation" clearly show his desire to grapple with the meaning of historical change and the nature of human societies.

By the late 1820s and 1830s, the concept of a "cycle of mutation" was

closely associated with the physical remains of older civilizations. The wave of interest in classical antiquity, whose crest Benjamin West had caught on his first trip abroad, had washed over art, literature, and history by the time Cole took his intellectual bearings. In *Ruins,* published in 1791, the French writer M. Volney used a meditation on the ruins of an ancient civilization as the springboard for a philosophical discourse on human nature and government. Byron, as we have seen, made the melancholy contemplation of ruins a literary convention as well as an irresistible stance for the sensitive traveler.[100] At least two of Cole's friends and contemporaries had given literary expression to the theme of mutation and the lessons of history. Henry Pickering, who formed such an important link between Cole and Allston, had written a disquisition on greatness and decline in human history in his poem, *Athens,* published in 1824. Pickering's poem was a meditation on ruins, describing the appearance of present-day Athens and contrasting its decay with its former glory. Interestingly enough, Pickering made it clear in his notes that he had never been to Athens and that the scenes he described so minutely were actually drawn from a work of art, a panorama of the city that he saw in Boston. Nonetheless, real ruins were not absolutely necessary to evoke the philosophical response Pickering described. The pleasure he derived from contemplation of the city, he stressed, consisted in the imaginative movement from present to past, in the evocation of rich association from fragmentary reality. In his description of this act of imagination he defined the scope of his poetic ambitions in a way that must have been highly resonant for Cole:

> . . . Prospect sublime.
> And lovely as sublime! Though only such
> To him, who through the lengthen'd vista views
> With gaze intent, as backward he reverts
> The mental eye 'mid long revolving years,
> Thy glories, Athens, and thy various fate.
> But who, 'mong scenes resplendent in the page
> Of the Historic Muse, shall with bold hand
> Pourtray [sic] the wondrous change; depict severe
> The mournful triumphs of unsparing Time,
> Or ravages of man more ruthless still;
> And over all the halo warm diffuse
> Of centuries elaps'd? And, hardier still,
> Who with Promethean skill may now awake,
> Though but for one short hour, the glorious spirits
> Of elder time, and animate, (how vain!)
> The scenes once trodden by their hallowed feet?[101]

To portray "with bold hand . . . the wondrous change" from past to present, to "depict severe / The mournful triumphs of unsparing Time,"

to awaken "with Promethean skill" the spirits of the past—these ambitions
could apply equally to the earnest young painter. Pickering's poem
contained one other idea that may have been suggestive to Cole. In
a passage on the Parthenon Pickering contrasted the changing works
of man with the unchanging features of nature:

> Yet all, lov'd Athens, is not changed: thy streams,
> Thy hills remain. Look! Where the eternal rock,
> Yclep'd Cecrophia, citadel renown'd,
> With front of adamant still awes the plain;
> And bears aloft its fame majestic, great,
> Though in decay, and sinking fast beneath
> The incumbent weight of twice a thousand years.[102]

Pickering's images and ideas may well have helped Cole to formulate
his own thoughts.

A more complex and poetically more interesting meditation on human
history appeared in William Cullen Bryant's poem, "The Ages," which
the poet delivered as a Phi Beta Kappa address at Harvard University in
1821. "The Ages" ambitiously attempts to sum up all of human history
from the Egyptian empires through Greece and Rome, early Christianity,
the Renaissance and Reformation, and culminates with the settlement of
America. Like Byron in *Childe Harold,* Bryant incorporated a theory of
history into his poetry, but the limited scope of "The Ages" turned
his statements into compressed summaries, gestures toward an accepted
view of history rather than a developed analysis. Like Volney's *Ruins,*
"The Ages" used examples from history to advance an argument about
human nature and the future of society; but Bryant proposed no revolu-
tionary rethinking of the social contract. Whereas Byron adopted a
melancholy stance toward the history he depicted and Volney called for
an other-worldly view to make sense of the human tragedy, Bryant saw
signs of hope in the progression of the ages.

Setting his poem in a context of lamentation, Bryant admitted that
personal experience makes us long for "those pure and happy times—the
golden days of old." Yet, he went on to declare that human history is
not a story of decline: "despair not of their fate who rise / To dwell
upon the earth when we withdraw! / . . . A thousand cheerful omens
give — Hope of yet happier days, whose dawn is nigh." With this
argument to prove, he launched into his discussion of the rise and fall
of civilization, urging his readers to "sit at the feet of History—through
the night/Of years the steps of virtue she shall trace." After twenty
stanzas describing the civilizations of the past, Bryant followed the
course of human history to the New World, "this youthful paradise,"
where Indian violence was replaced by the productive virtue of "another

race'' that represented ''the free spirit of mankind.'' In this new society, which was built on the positive aspects of the civilizations of the ages, Bryant saw hope for the future:

> Who shall place
> A limit to the giant's unchained strength,
> Or curb his swiftness in the forward race?
> On, like the comet's way through infinite space,
> Stretches the long untravelled path of light,
> Into the depths of ages.[103]

Bryant's recapitulation of the cycles of history supported an optimistic vision of man's future.[104] His vision of the meaning of human history was highly chauvinistic, of course, for his hope for the future rested squarely on what he saw as the moral superiority of American society. In this sense, ''The Ages'' adumbrated the contrast between the Old World and the New that he later elaborated in ''To Cole, the Painter, Departing for Europe.'' ''Europe is given a prey to sterner fates/And writhes in shackles,'' he wrote in ''The Ages'' and in contrast, ''thou, my country, thou shalt never fall.''[105] America, he implied, would break the tragic cycle of human history.

Bryant's historical meditation contained several elements that may have been suggestive to Cole. Like Cole who would later write, ''natural scenery has also its changes,'' and use these to ''give expression to'' his version of past ages, Bryant looked to nature for the symbolic embodiment of philosophical truths, and his poetry abounds with examples and illustrations from the natural world.[106] Early in the poem as he began to refute the notion that the history of the ages is a story of decline, he drew his examples from nature:

> Has Nature, in her calm, majestic arch,
> Faltered with age at last? does the bright sun
> Grow dim in heaven? or, in their far blue arch,
> Sparkle the crowd of stars, when day is done
> Less brightly? . . .
> Look on this beautiful world, and read the truth
> In her fair pages; see, every season brings
> New change, to her, of everlasting youth.[107]

The sharply focused images found in Bryant's description of various stages of civilization may well have appealed to Cole. In describing the ancient civilizations known to him only through their ruins in the desert, Bryant drew a vivid picture of the state that Cole would later name ''Desolation'':

> . . . columns strown
> On the waste sands, and statues fallen and cleft,
> Heaped like a host in battle overthrown;
> Vast ruins, where the mountain's ribs of stone
> Were hewn into a city.[108]

Nature became a metaphor for history to Bryant. He described the Renaissance as a literal springtime and the Reformation as an earthquake. He compared the dawning of the modern age to a sunrise and pictured the settlement of the New World during this spiritual revival in terms that anticipated Cole's vision of "The Savage State":

> Late, from this Western shore, that morning chased
> The deep and ancient night, and threw its shroud
> O'er the greenland of groves, the beautiful waste,
> Nurse of full streams, and lifter-up of proud
> Sky-mingling mountains that o'erlook the cloud.
> Erewhile, where yon gay spires their brightness rear,
> Trees waved, and the brown hunter's shouts were loud
> Amid the forest; and the bounding deer
> Fled at the glancing plume, and the gaunt wolf yelled near.[109]

These vivid images and the elaboration of the cycles of human history in terms of natural scenes, make Bryant's "The Ages" a part of the literary and philosophical background for *The Course of Empire*.

Because Cole aspired to work in the realm of history painting, his reliance on literary sources was only natural. Sir Joshua Reynolds had recommended that history painters select their subjects from "the Poet or Historian" and specifically mentioned "the great events of Greek and Roman fable and history."[110] Although Cole based his cycle of mutation only loosely on actual history, it certainly fit Reynolds' injunction to choose a subject "in which men are universally concerned, and which powerfully strikes upon the public sympathy."[111]

Of course, the form in which Cole chose to develop his subject differed sharply from the Old Masters recommended by Reynolds or the works of subsequent history painters like West and Allston. His paintings were not historical landscapes, like Titian's *Peter Martyr*, which was praised by Reynolds.[112] Rather, Cole attempted to break away from the restrictions imposed by a single canvas and attempted to develop a new form of serial painting. In this effort he could draw on numerous models, including the panoramas and dioramas with which he was familiar in New York and London. The serial paintings by James Barry for the great room of the Society of Arts, Manufactures and Commerce in London offered a suggestive treatment of the theme of the progress of human culture. Another example of serial art integrated into room

design was available to Cole through the engravings done for Ralph Willett's *A Description of the Library at Merly in the County of Dorset,* which had been published in 1785.[113]

Turner, whom Cole visited in December 1829, also had touched on the theme of empire in his paintings *The Building of Carthage* and *The Destruction of Carthage.* In his notes on his visit to Turner, Cole commented on the first of these paintings: "The Building of Carthage is a splendid composition, and full of poetry. Magnificent piles of architecture fill the sides, while in the middle of the picture an arm of the sea or bay comes into the foreground, glittering in the light of the sun, which rises directly over it. The figures, vessels, &c., are all very appropriate."[114] Cole's choice of words to describe Turner's scene brings to mind his plans for his own series, and an early version of it appeared in his notebook on the page preceding the Turner entry. Cole even mentioned the similarity of Turner's composition to Claude's seaport scenes, and both of these predecessors would stand behind his composition for *The Consummation of Empire,* which included a glittering bay surrounded by magnificent buildings.

Cole's work bore perhaps the most immediate kinship to that of John Martin, whose large-scale panoramic canvases attracted popular interest if not critical acclaim in London. Cole had registered his debt to Martin before his trip to Europe in his *The Expulsion from the Garden of Eden,* which owed much of its composition to Martin's engravings for *Paradise Lost.* Cole probably met Martin in England, and he undoubtedly saw several of Martin's paintings during his time in London.[115] In addition to *Belshazzar's Feast,* which Charles Leslie described as "an architectural composition with small figures" and which would have interested Cole because of its association with Allston, by 1830 Martin had painted a number of scenes depicting opulent cities of the past and their destruction.[116] The engravings for *Paradise Lost* had included one architectural fantasy, entitled *Pandemonium,* which illustrated the following passage from the poem:

> . . . a fabric huge . . .
> Built like a temple, where pilasters round
> Were set, and Doric pillars overlaid
> With golden architrave; nor did there want
> Cornice or frieze, with bossy sculptures grav'n;
> The roof was fretted gold . . .[117]

Martin's composition in this engraving contained the elements that characterized his later architectural compositions and that proved so suggestive to Cole: massive piles of architecture, pillars, arches, columns, and domes of imaginary rather than historical style. Martin's interest

14. John Martin, "Pandemonium," engraving for *The Paradise Lost of Milton, with Illustrations by John Martin* (London: Charles Tilt, 1833). opposite p. 25. Photograph courtesy of University of North Carolina Library Photographic Service from copy in Rare Book Room, UNC Library.

in empire and its destruction bore fruit in a number of the canvases he exhibited during the 1820s and subsequently engraved: *The Destruction of Herculaneum and Pompeii*, 1822; *The Seventh Plague of Egypt*, 1823; *The Deluge*, 1826; and *The Fall of Nineveh*, 1829.[118]

In formulating his series, then, Cole felt that he was interpreting poetic and philosophical ideas in an art form that had ample precedent among the painters he admired. *The Course of Empire* raised important issues concerning the human spirit: the nature of man, the possibilities for good and evil in society, and the lessons of history for human development. Cole approached these questions not through the traditional form of history painting but through an allegorical landscape series. In this ambitious project, Cole sought to establish himself as a serious painter who was moving beyond mere views to philosophical works in the highest traditions of art.

As in such single-canvas meditations on the European scene as *A View Near Tivoli, Morning*, Cole used his landscape elements to suggest broader ideas. The wild forests of the first scene, the clear cool light of the second, the mellow moonlight of the fifth, all serve a symbolic as well as a literal purpose. Although Cole's chronicle emphasizes the changes that occur in the movement from one stage of society to the next, continuity was also important to him. The physical setting provides the most obvious continuity: all five scenes take place at the foot of a distinctively shaped mountain.[119] In addition, certain elements appear in each of the paintings, as if Cole were ringing changes on a set of given themes. Thus, fire appears in the crude campfire of *The Savage State*, in the more sophisticated temple and shipbuilding camp of *The Arcadian or Pastoral State*, at the summit of the sumptuous temple and in the triumphal torches on the bridge in *The Consummation of Empire*. Ironically, of course, this same fire annihilates the city in *Destruction*, and it is quenched in the cool waters of *Desolation*.[120] Similarly, animals appear in each canvas and are used to reflect the state of the civilization: the wild deer, wolves, and hunting dogs in *The Savage State*, the domesticated sheep, oxen, goats, and packhorses in *The Arcadian or Pastoral State*, proud war horses and a captive elephant in *The Consummation of Empire*, dying horses in *Destruction*, and wild herons and deer in *Desolation*.[121] Cole's early notes for the series indicate his plan to compare the various stages by including the occupations, amusements, and religion appropriate to each.[122]

Within the larger drama of the rise and fall of a civilization, Cole incorporated a reflection on the subject closest to his own heart: the relationship of the arts to the society as a whole and the role of the artist in his culture's development. As he traced his imaginary civilization's progress, he examined at each stage the development of the arts and the way in which artistic expression embodied cultural values.

The first canvas, *The Savage State,* shows man wresting a bare existence from nature. The arts are represented in their most primitive form by the small figures dancing around a campfire. As Cole wrote in a description of the completed series, "Two of the fine arts music & poetry have their germs, as we may suppose, in the singing which is the usual concomitant of the dance of savagery."[123] In the second canvas, *The Arcadian or Pastoral State,* civilization in all its aspects is beginning to flower. The birth of agriculture is represented by a ploughman, husbandry by a shepherd, commerce by men building ships, military arts by soldiers, mathematics by a man drawing a triangle, industry by a woman spinning. In a prominent scene Cole depicted the birth of painting as a boy traces a figure on the stone path. At the right edge of the picture a group dances to the music of a pipe, and Cole even placed a tiny figure reading under a tree in the middle ground to indicate the birth of poetry.[124]

In the third painting, *The Consummation of Empire,* which Cole described as the state of luxury, the arts have become highly refined but serve only as agents of the commercial empire. Architecture, which was represented in the earlier pictures by the wigwams of the savages and the Stonehenge-like temple and rude hamlet of the peasants, assumes a dominant role in the thriving empire. The entire landscape, even to the summit of the distinctive mountain, has been brought under the hand of man and redesigned in his image. Festooned columns reach the sky at the right side of the canvas. The architectural forms have their basis in Western history, for Cole designed a Doric temple and a palace supported by caryatids and crowned by a statue of Minerva. This imaginary civilization also pays its respects to intellectual values. Symbols of wisdom and enlightenment abound, from the towering Minerva to the sphinxes that guard the massive temple. Religion appears to play a large part in the society. But while the steps of the temple swarm with white-robed priests, military virtues seem to compete for prominence. The victory parade in the foreground passes beneath a triumphal arch in honor of the victorious warriors, who are shown on it as faceless giants in full battle dress. Other arts take on a martial cast as well; the magnificent throne in the foreground is flanked by carved lions, and musicians on a balcony accompany the procession with horns and cymbals. As the conqueror rides across the bridge in his golden cart, gold carvings and painted banners are carried before him; these works of art derive their value, like the chained captives at his feet, by being spoils of war. Among the observers appear two figures lost in thought, an old man in the right foreground and a younger man behind the statue of Minerva, leaning on the slab of marble that shows Cole's name in a trompe l'oeil signature. These contemplative indi-

viduals, perhaps symbolic of philosophy and poetry, find no scope for their talent in the cheering, swirling crowd.

The city that falls to the conqueror's sword in *Destruction* has changed in several ways from the thriving empire of the previous canvas. The militarism that earlier coexisted with more peaceful virtues has come to dominate the civilization, as symbolized by the massive statue of a warrior in the right foreground. In this vicious state, weakened by its luxury, the empire cannot resist the force of the savage conquerors who burn the city and mercilessly kill even women and children. The internal collapse of the civilization that preceded its destruction is indicated in its arts. Cole records his signature on the base of the warrior's statue in weak and wavering letters that contrast with the firm, clear writing on the marble block in the previous canvas. The previous symbols of enlightenment and intelligence have been destroyed. The lighthouses are broken and their lights extinguished, the flame of truth on the front steps of the temple has been replaced by a military catapult, and all the statues are decapitated, including the sphinx, the caryatids, and the warrior.

In *Desolation* the works of man's hand stand only, as Cole put it, as a "funeral knell of departed greatness." The triumphal bridge, shown crashing to pieces in the previous scene, remains as a fragment; only a few columns mark the once-majestic temple. In the fountain where boys sailed model ships in the third canvas and dying soldiers fell in the fourth, a heron dips its beak. Birds have built their nest in the ruined column. The arts live on only as a melancholy reminder of a dead civilization.

As a history of the rise and progress of the arts within a civilization, Cole's series paints a bleak picture. The arts become possible only with the growth of empire, and they remain subservient to its values, thus perishing with it. Yet it is important to realize that for the arts, as well as for civilization as a whole, Cole depicts only one kind of evolution, not a necessary fate. Cole's empire, in his own view, goes astray somewhere between the second and third canvas. *The Arcadian or Pastoral State* clearly portrays a joyous, creative stage of society. In the transition from the cool green morning light of this state to the blazing noontime glare of the luxurious city of the third canvas, Cole indicates the tragic flaw in his empire's development. Instead of living in harmony with nature, the commercial empire has sought to dominate and control the natural world. In *The Consummation of Empire*, nature is held captive like the slaves conquered by the army. Green plants writhe in ornamental pots, and well-manicured trees stand stiffly on landscaped terraces. Plants have been twisted into wreathes to pay homage to the conquerors, and flowers have been scattered at

their feet as tribute. Even these vestiges of the natural world have been obliterated in the fourth canvas; in this vicious state the empire has no room for nature, and nature retaliates by joining forces with the invaders in a fierce tempest. The resurgence of nature in *Desolation* provides one of the morals of the series. As the vines creep up the ruined column and the lichens and underbrush soften the scattered fragments, the beauty that illuminated the second canvas begins to reassert itself. As Cole wrote in his description of the finished series, "nature yet survives and the bold promontory with its isolated rock yet stands unchanged by time to tell how perishable is man and all his works."[125] In his affirmation of nature's permanence, Cole gave his story of empire a broader meaning: though man and his works may pass away, the eternal values embodied in nature remain.[126]

Just as society as a whole sinned by forsaking nature, Cole has implied, the arts followed the same course. In *The Arcadian or Pastoral State,* the arts are given a firm foothold in nature, with singing, dancing, drawing, and poetry all taking place in a natural setting. In *The Consummation of Empire* only the artifical arts flourish. Americans had believed from John Adams' day that society would lose its moral tone if the arts sank into luxury and artificiality.[127] There were no landscape artists in Cole's empire and the civilization suffered as a result. Thus, rather than a lament, *The Course of Empire* may be seen as a warning to the artist to keep his art in harmony with nature and to act, as Cole did in painting his series, as a moral interpreter and conscience for his society.

In his insistence on the proper relationship between art and nature, Cole returned to the basic dichotomy posed by his involvement with the European scene. When he embarked for the Old World he carried with him Bryant's contrast between the New World, the realm of nature, and the Old World, the realm of history, as well as a clear warning not to forsake one for the other. His series represents an attempt to profit from the lessons of Old World history without betraying his New World identification with nature.

The Course of Empire also probed the question of the relationship between Europe and the United States. Like Bryant and so many others of his generation, Cole wondered if the New World would follow the path of the Old, or if it would become what the Great Seal of the United States proclaimed it to be, "*novus ordo seclorum,*" a new order of the ages. In "The Ages," Bryant supported the latter view: America would "never fall" because its strength was based on nature. When *The Course of Empire* is read backwards from the fifth canvas to the first, the series becomes the visual equivalent of those literary meditations on history. The last canvas, *Desolation,* represents the very sort of romantic scene Cole went to Europe to see, and as Volney, Byron, Pickering, and others had stressed, the chief imaginative pleasure in such a scene consisted

of meditations on the history that lay behind it. In less complex works like *The Past* and *The Present*, painted in 1838, Cole simply contrasted past glory with present pathos, but in *The Course of Empire* he took the story of civilization back to its roots. And those roots greatly resembled the New World landscape that Bryant and others thought to be a new order outside of history. If *Desolation* suggests a European landscape, *The Savage State* looks like an American scene, and *The Course of Empire* shows it is not impossible for one to lead to another.

The period during which Cole worked on *The Course of Empire*, 1833-36, was a time of some personal turmoil and professional reassessment for him; it was also the period during which he most clearly formulated his ideas about the American landscape.[128] His "Essay on American Scenery," which he first delivered as a lecture in 1835, catalogued the virtues of American scenery—mountains, rivers, forests, sky—and recommended them to the artist for their power to awaken "a keener perception of the beauty of our existence." Since Cole was struggling at that time with *The Consummation of Empire* and its theme of the corruption of a society and its arts, his passionate argument for the importance of art, especially landscape art, carries special weight. After arguing that *"rural nature* is . . . the exhaustless mine from which the poet and the painter have brought such wondrous treasures," and that "the wilderness in YET a fitting place to speak of God," Cole stressed the importance of a love of nature in his own time and place:

In this age, when a meager utilitarianism seems ready to absorb every feeling and sentiment, and what is sometimes called improvement in its march makes us fear that the bright and tender flowers of the imagination shall all be crushed beneath its iron tramp, it would be well to cultivate the oasis that yet remains to us, and thus preserve the germs of a future and purer system. And now, when the sway of fashion is extending widely over society—poisoning the healthful streams of true refinement, and turning men from the love of simplicity and beauty, to a senseless idolatry of their own follies—to lead them gently into the pleasant paths of taste would be an object worthy of the highest efforts of genius and benevolence. The spirit of our society is to contrive but not to enjoy—toiling to produce more toil—accumulating in order to aggrandize. The pleasures of the imagination, among which the love of scenery holds a conspicuous place, will alone temper the harshness of such a state.[129]

The imagery of this passage bears a striking similarity to that of the picture on which he was working, and the warning is clear. Cole feared America was on the verge of becoming the soulless society of the third canvas, alienated from nature, trampling "the bright and tender flowers of the imagination" underfoot as surely as the "iron tramp" of the military procession crushed the flowers in Cole's painting.

Cole's correspondence during this time expressed similar fears. In a

letter to Luman Reed he railed at the "dollar-godded utilitarians" who seemed bent on destroying the landscape in their passion for progress.[130] Many of his American landscapes painted after his return from Europe contain a lament for the vanishing wilderness in the form of a freshly chopped tree stump in the foreground.[131] The appearance of this motif in *The Arcadian or Pastoral State* signals Cole's judgment on contemporary America: somewhere past the pastoral state, it might be headed for a state of luxury. It seemed to Cole that America was approaching the point at which his imaginary empire went wrong. A journal entry from August 1835 shows that at his most pessimistic Cole could envision a state of destruction in America's future:

I have of late felt a presentiment that the Institutions of the U. States will ere long undergo a change that there will be a separation of the states. Riots & public murder are common occurrences. . . . It appears to me that the moral principle of the nation is much lower than formerly. . . . It is with sorrow that I anticipate the downfall of our republican government—its destruction will be a death blow to freedom—for if the free government of the U. States cannot exist a century where shall we turn? The hope of the wisest, the govt. will have perished—and scenes of tyranny & wrong, blood & oppression such as have been acted since the world was created—will be again performed as long as man exists—There is no perfectability in this world—evil seems necessary for the production of good is like the stream flowing swiftly towards a precipice. . . .[132]

Although Cole concluded his musings with an attempt at optimism— "may my fears be foolish a few years will tell"—this passage makes it clear that he saw *The Course of Empire* as an exploration of a pattern to which America's history might possibly correspond.

This is not to say that Cole intended *The Course of Empire* as a prophecy of doom for America. As the paintings themselves make clear, his empire is a particular, not a universal case. Cole's notes suggest plans for another series that would trace a different pattern: "The Future Course of Empire" would depict "a new Empire springing out of the ruins of the old—And growing through a *Christian* civilization to the perfection of Earthly Empire."[133] America still had the capability to follow the course of Christian empire, to keep the virtues Bryant proclaimed would protect it, to follow "the pleasant paths of taste." But, Cole felt, time was running short.

The Course of Empire, Cole's ambitious attempt to formulate his views on nature and human history, directly confronted the question that had absorbed him as he embarked on his European voyage: the relationship between the Old World and the New. The series of paintings represented Cole's effort to put into practice the plans he formulated in Europe for a career in "serious" art. Like Allston, he was faithful to his artistic

ideals, but he found the realities of patronage and audience response profoundly disappointing. Luman Reed died before the series was completed, and although his heirs honored his financial commitments, Cole's hopes for a Renaissance-like commission died with him. *The Course of Empire* received enthusiastic reviews, and its exhibition earned Cole a good profit, but his patrons continued to show more interest in landscape views than allegories.[134] Cole continued to develop his concept of the "higher style of landscape" throughout his career in such works as *The Voyage of Life* and the unfinished *The Cross and the World.* Yet at the same time, he explored the artistic potential of the Hudson River landscape. Although he was one of the most popular and successful painters of his time, he never satisfactorily resolved the problem of how to respond to the twin attractions of Europe and America, of history and nature, of artistic ambition and democratic patronage, "the trace of man" and "that earlier, wilder image."

Notes

1. Louis Legrand Noble, *The Life and Works of Thomas Cole,* ed. Elliot S. Vesell (1853; reprint ed., Cambridge, Mass.: Harvard University Press, Belknap Press, 1964), p. 195.

2. Ibid., pp. 3-13.

3. So, at least, Noble maintains. Ibid., pp. 10-13.

4. William Dunlap, *History of the Rise and Progress of the Arts of Design in the United States,* 2 vols. (New York: George P. Scott and Co., 1834), 2: 360.

5. Noble, *Life and Works,* pp. 21-22. These pictures were destroyed when neighborhood boys thoughtlessly vandalized his studio. Cole's choice of the latter subject in 1822 may reflect the notoriety of John Martin's *Belshazzar's Feast,* exhibited in 1821, or the widespread anticipation of Allston's monumental work.

6. See Ellwood C. Parry III, "Thomas Cole and the Problem of Figure Painting," *The American Art Journal* 4 (Spring 1972): 66-86.

7. Dunlap, *History of the Rise and Progress of the Arts of Design,* 2: 352.

8. Ibid., pp. 357-58.

9. See Horatio Greenough's description of working in the Gothic library in *Letters of Horatio Greenough to his Brother, Henry Greenough,* ed. Frances Boott Greenough (Boston, Mass.: Ticknor and Co., 1887), p. 36. For an assessment of Gilmor as a patron see Lillian B. Miller, *Patrons and Patriotism: The Encouragement of the Fine Arts in the United States, 1790-1860* (Chicago, Ill.: The University of Chicago Press, 1966), p. 150; see also Barbara Novak, "Thomas Cole and Robert Gilmor," *Art Quarterly* 25 (Spring 1962): 41-53.

10. Thomas Cole to Robert Gilmor, January 2, 1827; in Baltimore Museum of Art, *Annual II: Studies on Thomas Cole, An American Romanticist* (Baltimore, Md.: Baltimore Museum of Art, 1967), pp. 43-81.

11. Robert Gilmor to Thomas Cole, December 13, 1826, ibid., p. 45.

12. Thomas Cole to Robert Gilmor, December 25, 1926, ibid., p. 47. Reynolds extolled composition as the basis for high art throughout his *Discourses on Art.*

In Discourse Three he stated, "Nature herself is not to be too closely copied. . . . The students who, having passed through the initiatory exercises, are more advanced in the art, and who, sure of their hand, have leisure to exert their understanding, must now be told, that a mere copier of nature can never produce anything great." Sir Joshua Reynolds, *Discourses on Art,* with an Introduction by Robert R. Wark (1797; reprint ed., New York: Collier Books, 1966), p. 43. The same discourse goes on to cite the example of the sculptor Phidias, who never used any one model for his ideal compositions. See also Discourse Ten, pp. 155-56, and Discourse Thirteen, pp. 203-9. The discourses were well-known in America; Allston had read them before he went to London, and Luman Reed, later an important patron of Cole, called them "rules of life." See Dunlap, *History of the Rise and Progress of the Arts of Design,* 2: 159, and Jared B. Flagg, *The Life and Letters of Washington Allston* (New York: Charles Scribner's Sons, 1892), p. 40. It is quite likely that Cole knew the discourses even at this early period.

13. William Pendlebury to Thomas Cole, August 25, 1825, Thomas Cole Papers, New York State Library, Albany, New York.

14. Robert Gilmor to Thomas Cole, December 5, 1827, Baltimore *Annual,* p. 53.

15. The best biographical sketch of Pickering can be found in Evert A. Duyckinck and George I. Duyckinck, *Cyclopedia of American Literature,* 2 vols. (New York: Charles Scribner, 1856), 2: 25-26.

16. For example, see Henry Pickering to Thomas Cole, July 25, 1826, Cole Papers.

17. Washington Allston to Henry Pickering, November 23, 1827, in Flagg, *Life and Letters,* pp. 203-7.

18. Thomas Cummings to Thomas Cole, August 16, 1828, Cole Papers. Apparently Cole did not see *Belshazzar's Feast,* for he wrote in his journal much later that he had never seen the painting. See Noble, *Life and Works,* p. 263.

19. Luman Reed to Thomas Cole, June 16, 1835, Cole Papers. Unlike many New York artists, Cole established strong ties with the Boston art world, exhibiting at Chester Harding's gallery and at the Athenaeum.

20. Noble, *Life and Works,* pp. 262-63.

21. See Baltimore *Annual,* pp. 58, 68; Noble, *Life and Works,* pp. 72-75.

22. Thomas H. Perkins to Thomas Cole, April 3, 1829, Cole Papers, Perkins had similarly aided Horatio Greenough the previous year. See Sylvia E. Crane, *White Silence: Greenough, Powers, and Crawford, American Sculptors in Nineteenth-Century Italy* (Coral Gables, Fla.: University of Miami Press, 1972), p. 33.

23. See Benjamin T. Spencer, *The Quest for Nationality: An American Literary Campaign* (Syracuse, N.Y.: Syracuse University Press, 1957); and Neil Harris, *The Artist in American Society: The Formative Years, 1790-1860* (New York: George Braziller, 1966), especially chaps. 2, 5, and 6.

24. William Cullen Bryant, "To Cole, the Painter, Departing for Europe," *Poetical Works of William Cullen Bryant, Collected and Arranged by the Author* (New York: D. Appleton and Company, 1878), p. 181.

25. Noble, *Life and Works,* p. 75.

26. Flagg, *Life and Letters,* p. 204.

27. Noble, *Life and Works,* p. 77.

28. Ibid., pp. 79, 78.

29. Like his viewing of the Royal Academy exhibition, this visit produced

conflicting reactions. While Cole admired some of Turner's works, he had no sympathy for the English painter's experiments in light and color. See ibid., p. 81. See also Cole journal, December 12, 1829, Cole Papers.

30. Edward Lind Morse, ed., *Samuel F. B. Morse, His Letters and Journals*, 2 vols. (Boston, Mass.: Houghton Mifflin Co., 1914), 1: 308.

31. See Algernon Graves, *The British Institution, 1806-1867* (1875; reprint ed., Bath: Kingsmead Reprints, 1969). I believe that the sketch owned by the Detroit Institute of Arts, no. 39.342, is a record copy of the *Elijah*. Another sketch, Detroit Institute of Arts, no. 39.495, also shows a different Elijah, with a composition closer to Allston's painting. Some disagreement exists about the unlocated seven-foot *Niagara* Cole exhibited in 1830. See Henry H. Glassie, "Thomas Cole and Niagara Falls," *New-York Historical Society Quarterly* 58 (April 1974): 89-111. Although the Hinton engraving is clearly related to the small painting, *A Distant View of the Falls of Niagara* (Art Institute of Chicago), neither of the other paintings Glassie discusses can be shown convincingly to be closer in composition to the large work. It seems more likely that these paintings date from his second trip to Niagara. In any case, Cole's decision to exhibit a Niagara was important, and the Hinton engraving records a painting from the same period if not the one he exhibited.

32. See letters from P. A. Labouchère to Thomas Cole, January 16, 1830, and February 6, 1830, Cole Papers.

33. For discussion of the politics of hanging committees see William T. Whitley, *Art in England 1800-1820* (Cambridge: The University Press, 1928).

34. Noble, *Life and Works*, p. 83.

35. Thomas Cole to Thomas S. Cummings, October 19, 1830, Thomas Cole Papers, Detroit Institute of Arts Research Library.

36. Thomas Cole, *Thomas Cole's Poetry*, ed. Marshall B. Tymn (York, Pa.: Liberty Cap Books, 1972), pp. 54-55.

37. Thomas Cole to Thomas S. Cummings, October 19, 1830, Thomas Cole Papers, Detroit Institute of Arts Research Library. Cole's contributions to this volume included some reworkings of previous compositions, such as *Kaaterskill Falls* and *Niagara Falls,* as well as a number of other scenes.

38. Noble, *Life and Works*, pp. 87, 79-80.

39. Dunlap, *History of the Rise and Progress of the Arts of Design*, 2: 361.

40. Noble, *Life and Works*, p. 87.

41. Baltimore *Annual*, p. 72.

42. See Alan P. Wallach, "Cole, Byron, and the *Course of Empire*," *The Art Bulletin* 50 (1968): 375-79.

43. For discussions of American travelers in Italy see Van Wyck Brooks, *The Dream of Arcadia: American Writers and Artists in Italy, 1760-1915* (New York: Dutton, 1958); Paul R. Baker, *The Fortunate Pilgrims: Americans in Italy 1800-1860* (Cambridge, Mass.: Harvard University Press, 1964); Nathalia Wright, *American Novelists in Italy, The Discoverers: Allston to James* (Philadelphia: University of Pennsylvania Press, 1965); E. P. Richardson and Otto Wittman, Jr., *Travelers in Arcadia: American Artists in Italy* (The Detroit Institute of Arts and the Toledo Museum of Art, Catalogue of an exhibition, 1951); Barbara Novak, "Americans in Italy: Arcady Revisited," *Art in America* 61 (January 1973): 56-69.

44. Flagg, *Life and Letters*, pp. 292-93, 319-20.

45. Washington Allston, *Lectures on Art and Poems, 1850; and Monaldi, 1841,* ed. Nathalia Wright (1850; 1841; reprint ed., Gainesville, Fla.: Scholars' Facsimiles and Reprints, 1967), pp. 377-80.

46. See Crane, *White Silence,* for a thorough discussion of American sculptors in Italy.

47. Horatio Greenough to James Fenimore Cooper, December 20, 1830, in *Letters of Horatio Greenough, American Sculptor,* ed. Nathalia Wright (Madison: University of Wisconsin Press, 1972), p. 67.

48. Henry Tuckerman, *A Memorial of Horatio Greenough* (1853; reprint ed., New York: Benjamin Blom, 1968), p. 15.

49. Greenough's bust of Cole is now in the Wadsworth Atheneum; Cole's sketch, *Portrait of Horatio Greenough,* is on p. 42 of Sketchbook, 1829-30, William H. Murphy Fund, 39.561, Detroit Institute of Arts, Detroit, Mich. See Esther I. Seaver, *Thomas Cole, 1801-1848, One Hundred Years Later* (Wadsworth Atheneum and Whitney Museum of American Art, Catalogue of an exhibition, 1948), no. 56, plate 4.

50. Thomas Cole to J. L. Morton, January 31, 1832, in Noble, *Life and Works,* p. 99.

51. Horatio Greenough to Samuel F. B. Morse, January 5, 1832, in Greenough, *Letters,* p. 103.

52. Horatio Greenough to James Fenimore Cooper, December 17, 1831, ibid., p. 101.

53. Horatio Greenough to Robert Gilmor, October 10, 1831, ibid., p. 84.

54. Horatio Greenough to James Fenimore Cooper, December 17, 1831, ibid., p. 100.

55. Thomas Cole to J. L. Morton, January 31, 1832, in Noble, *Life and Works,* p. 99. Thomas Cole to Robert Gilmor, in Baltimore *Annual,* p. 74.

56. Cole described his studio in Dunlap, *History of the Rise and Progress of the Arts of Design.* 2: 364. For Greenough's studio see Crane, *White Silence,* p. 26.

57. Thomas Cole to Horatio Greenough, February 16, 1832, Cole Papers.

58. Gilmor had predicted that traveling Americans would be Cole's best European patrons. See Baltimore *Annual,* p. 71. For a description of Cole's Roman stay, see Dunlap, *History of the Rise and Progress of the Arts of Design,* 2: 364.

59. See Noble, *Life and Works,* pp. 117-20. Alan Wallach has discussed Cole's early attraction to Byron and his later repudiation of the poet on moral grounds in "Cole, Byron and the *Course of Empire.*"

60. Dunlap, *History of the Rise and Progress of the Arts of Design,* 2: 364.

61. Lord Byron, "Childe Harold's Pilgrimage," *The Poetical Works of Lord Byron,* 8 vols. (London: John Murray, 1870), 1: canto 4. 25, p. 199.

62. Ibid., canto 4. 42, p. 226.

63. Ibid., canto 4. 110, p. 234.

64. Ibid., canto 4. 129, p. 237.

65. Cole had expressed his fear of losing his feeling for nature not only in the poem quoted earlier, but also in his diary of his trip to Volterra. See Noble, *Life and Works,* p. 94.

66. Greenough, *Letters,* p. 144.

67. Francis Alexander, a fellow painter and erstwhile travel companion, urged him to come to Venice in a letter of August 12, 1832, Cole Papers. H. I.

Hoyt lamented Cole's inability to visit Switzerland in a letter of August 24, 1832, ibid. For Cole's own sense of regret at departing, see Dunlap, *History of the Rise and Progress of the Arts of Design,* 2: 364.

68. Joshua Bates handled the paintings he had left behind in London. See letters from Bates, April 4 and June 3, 1833, Cole Papers. In the spring of 1833, Cole sent a picture to Jonathan Mason in Boston, who agreed to try to sell it for him. J. Mason to Thomas Cole, April 8, 1833, ibid. Mason was handling a picture for Allston at the same time.

69. Richard Henry Dana, ms. notes, Dana Family Papers, Massachusetts Historical Society, Boston, Oliver W. Larkin, *Samuel F. B. Morse and American Democratic Art* (Boston: Little, Brown and Comapny, 1954), pp. 114-15.

70. See letters from John Trumbull about Cole's lease of the exhibition rooms in New York, June 12 and 16, 1834, John Ferguson Weir Papers, Archives of American Art, Smithsonian Institution, Washington, D.C. See also letters from Edwin T. Bennet in Albany, July 12 and 26, 1834, Cole Papers. See letters from Cole to Francis Alexander, September 1 and 23, 1834, in Noble, *Life and Works,* pp. 136-37.

71. See letters between Cole and Bloodgood, Cole Papers. This episode is also described by Parry, "Thomas Cole and the Problem of Figure Painting."

72. See Miller, *Patrons and Patriotism,* pp. 45-47.

73. Allston's hopes for the Rotunda commission are described in chapter 2. See Flagg, *Life and Letters,* pp. 236-37.

74. Miller, *Patrons and Patriotism,* p. 52.

75. Thomas Cole to Edward Everett, March 10, 1834, Edward Everett Papers, Massachusetts Historical Society, Boston, Mass.

76. Franklin Dexter to Edward Everett, March 12, 1834, Edward Everett Papers.

77. Dexter was one of the "noble-hearted" friends who took over Allston's finances for him in early 1835. See chapter 2.

78. Dexter to Everett, Edward Everett Papers.

79. Miller, *Patrons and Patriotism,* p. 56. Ultimately, W. H. Powell, rather than Henry Inman, painted the fourth panel.

80. See Seaver, *Thomas Cole,* pp. 47-49, for representative examples.

81. In order, these were no. 49, *A Tornado in the Wilderness;* nos. 18 and 51, *A View Near Tivoli, Morning;* no. 76, *Landscape Composition, Italian Scenery;* no. 141, *View of the Temples at Paestum;* no. 97, *The Fountain of Egeria;* no. 101, *Manfred;* no. 122, *Head of a Roman Woman;* and no. 104, *Christ and the Woman of Samaria.* The tenth painting, no. 117, is untitled in this list, Cole Papers.

82. See Baltimore *Annual,* Appendix 2, pp. 82-101, for publication of this list. Howard Merritt traces the origins of *The Course of Empire* in ibid., pp. 24-40.

83. Ibid., pp. 24-25.

84. Howard Merritt implies that the first notebook entry might date from as early as 1828, but I can see no reason to believe the notebook entry preceded the journal entry by any significant length of time. The early months of his stay in London seem to be a likely time for the formulation of ambitious schemes like this one. Ellwood C. Parry III suggests that the addition of the savage scene as an afterthought reflects his exposure to James Barry's paintings in London. If true, this would date the entry after his arrival in Europe. For Merritt's views,

see ibid., pp. 25, 89. For Parry's views, see Ellwood C. Parry III, "Thomas Cole's *The Course of Empire*, A Study in Serial Imagery" (Ph.D. diss., Yale University, 1970), pp. 39-41.

85. Thomas Cole to Robert Gilmor, January 29, 1832, in Baltimore *Annual*, pp. 72-74.

86. Ibid., p. 72.

87. Ibid., p. 74.

88. Ibid.

89. Thomas Cole to J. L. Morton, January 31, 1832, in Noble, *Life and Works*, p. 99.

90. Robert Gilmor to Thomas Cole, April 15, 1833, in Baltimore *Annual*, p. 77.

91. "Your two former pictures hang in my dining room opposite a fine Ruysdael & a fine Berghem, with a fine copy of Raphael by *Mignard* between them," Gilmor wrote Cole on April 15, 1833, reprinted in Baltimore *Annual*, p. 77. Gilmor had earlier written that he had Old Master paintings "lying about the house like lumber for want of room to hang them up," ibid., p. 59.

92. See Miller, *Patrons and Patriotism*, pp. 154-55.

93. Thomas Cole to Luman Reed, Steptember 18, 1833, in Noble, *Life and Works*, pp. 129-31. The complete text of the letter, including some financial details Noble omitted, is in the Cole Papers, as is a draft of the letter, which shows Cole writing out the two sentences described above, but marking "&c—&c" for much of the descriptive material, which he presumably copied directly from his notebook.

94. Luman Reed to Thomas Cole, September 14, 1835, Cole Papers.

95. Thomas Cole to Luman Reed, September 18, 1833, ibid. The Cole papers at the New York State Library also contain a sketch for the room showing the series and its pendant pictures arranged around the fireplace.

96. Draft of a letter from Thomas Cole to Luman Reed, ibid. The draft is undated, but comparison with other correspondence about the doors suggests a date of November 30, 1835.

97. Cole wrote "sixteen panels on each side," but his plan and sketches suggest a total of sixteen.

98. Draft of a letter from Thomas Cole to Luman Reed [November 30, 1835], Cole Papers. See also undated fragment, "Notes on Mr. Reed's doors," and letters from Cole to Reed on January 20, February 6, February 18, February 19, 1836, ibid. For an excellent discussion of this project and identification of surviving panels see Ellwood C. Parry III, "Thomas Cole's Ideas for Mr. Reed's Doors." *The American Art Journal* 12 (Summer 1980): 33-45.

99. See Stow Persons, "The Cyclical Theory of History in Eighteenth Century America," *American Quarterly* 6 (Summer 1954): 147-63.

100. The influence of Volney and Byron on Cole are discussed in Wallach, "Cole, Bryon and the Course of Empire," and in Parry, *"Course of Empire,"* pp. 35-37.

101. [Henry Pickering], *Athens: and Other Poems* (Salem, Mass.: Cushing and Appleton, 1824), p. 6.

102. Ibid., pp. 7-8.

103. William Cullen Bryant, "The Ages," *Poetical Works*, pp. 4, 7; 17, 19.

104. Persons, "The Cyclical Theory," describes the change from a cyclical to a

progressive theory of history in the first half of the nineteenth century. From this point of view, Bryant's poem is a pivotal document that uses examples of rise and fall to argue for ultimate perfectibility.

105. Bryant, "The Ages," *Poetical Works*, pp. 19, 20.

106. This similarity between the techniques of the two men has been amply explored. See Evelyn L. Schmitt, "Two American Romantics: Thomas Cole and William Cullen Bryant," *Art in America* 41 (Spring 1953): 61-68; Donald A. Ringe, "Kindred Spirits: Bryant and Cole," *American Quarterly* 6 (Fall 1954): 233-44; Charles L. Sanford, "The Concept of the Sublime in the Works of Thomas Cole and William Cullen Bryant," *American Literature* 28 (January 1957): 434-48.

107. Bryant, "The Ages," *Poetical Works*, p. 6.

108. Ibid., pp. 8-9.

109. Ibid., p. 15.

110. Reynolds, *Discourses*, p. 55.

111. Ibid.

112. Ibid., p. 176.

113. For the background of serial painting see Parry, "*Course of Empire*," especially pp. 39-45. Parry ably outlines the visual sources for *The Course of Empire*.

114. Noble, *Life and Works*, p. 81.

115. For evidence of Cole's contact, with Martin, see Seaver. *Thomas Cole*, p. 16.

116. Flagg, *Life and Letters*, p. 162.

117. *The Paradise Lost of Milton, with Illustrations by John Martin* (London: Charles Tilt, 1833), bk. 1, 1. 710, pp. 25-26.

118. Wolfgang Börn mentions a London panorama depicting *Pandemonium* as a source for Cole's *Consummation of Empire*, but Martin would appear to stand behind this intermediate source as well. Wolfgang Börn, *American Landscape Painting: An Interpretation* (New Haven, Conn.: Yale University Press, 1948). As Ellwood C. Parry III has pointed out, other examples of panorama were available to Cole as well. Parry, "*Course of Empire*," p. 118.

119. See an excellent discussion of this and other unifying devices in Parry, "*Course of Empire*," pp. 87-90 and elsewhere.

120. As Ellwood C. Parry III points out, the broken sarcophagus is decorated with the carving of a torch. Ibid., p. 128.

121. Parry notes the motif of hunting, from *The Savage State* where men shoot deer to *The Consummation of Empire* where a hunting scene is engraved on the pediment of the temple to *Desolation* where deer reappear to claim the landscape. Ibid., pp. 108, 129.

122. Baltimore *Annual*, p. 89.

123. Fragment, "The Course of Empire," Cole Papers.

124. So he wrote in his description, ibid. This figure can just barely be discerned beyond the shepherd.

125. Ibid.

126. Cole's sense of the importance of this theme must have strengthened as he worked on the series, for in his original plan he envisioned desolation overtaking nature, too, with the "mountains riven"; the sketch he sent to Reed showed the promontory changing its shape in the last canvas. Thomas

Cole to Robert Gilmor, January 29, 1832, in Baltimore *Annual,* p. 73. Sketch in the Cole Papers.

127. See Harris, *The Artist in American Society,* chap. 2.

128. For Cole's self-doubts see journal entries in Noble, *Life and Works,* pp. 141-42, 153, 155. His unhappiness seems to have been partly due to professional pressures and partly personal.

129. Thomas Cole, "Essay on American Scenery" (1836), in *American Art 1700-1960. Sources and Documents,* ed. John W. McCoubrey (Englewood Cliffs, N.J.: Prentice-Hall, Inc., 1965), pp. 100-101.

130. Noble, *Life and Works,* p. 161. The correct date for this letter is actually March 6, 1836. See Cole Papers.

131. See, for example, *The Notch of the White Mountains,* 1839 (National Gallery of Art, Washington, D.C.). Perry Miller has pointed out that Cole's celebration of wilderness values reached its peak at the very time wilderness itself was beginning to recede under the ax of progress. Perry Miller, "Nature and the National Ego," in *Errand into the Wilderness* (1956; reprint ed., New York: Harper & Row, Harper Torchbooks, 1964), pp. 204-16.

132. Thomas Cole, "Thoughts and Occurrences," August 21, 1835, Cole Papers.

133. Undated fragment, ibid.

134. See comments on *The Course of Empire* by Bryant, Cooper, and others, printed in Noble, *Life and Works,* pp. 166-68. For financial account of the exhibition see letter from Theodore Allen to Thomas Cole, January 23, 1837, Cole Papers.

JAMES FENIMORE COOPER:
History and Society

Iconoclastic, prickly, stubborn James Fenimore Cooper seemed the least likely member of his generation to succumb to the blandishments of the European scene. William Cullen Bryant, who was his friend as well as Cole's, need not have reminded him to "keep that earlier, wilder image bright."[1] Unlike Cole, who went to Europe hoping to improve himself as an artist, Cooper crossed the ocean in 1826 well satisfied with his formula for literary success. As soon as he arrived in Paris he sat down to turn out another Leatherstocking tale (*The Prairie*, 1827). He harbored no romantic yearnings for the glories of the past and sought no kinship with the great luminaries of Western art. He traveled for the practical purpose of promoting his book sales, and once he got there he looked around with a critical, analytic eye.

Yet, European travel did influence him, almost in spite of himself. Although he later claimed that America, not he, had changed, he returned to the United States in 1833 to find himself profoundly out of step with his countrymen. *Home As Found* (1838) chronicles the dislocation a cultured, well-traveled family feels upon returning to a provincial American town; in thinly-disguised fiction Cooper complained about everything from American manners to property laws. His stay in Europe had given him a new perspective on American society. His changed views found expression throughout the rest of his life in the pages of his books, in newspaper columns, and occasionally in bitter personal feuds.

Cooper's European journey also brought changes in his ideas about art. Like Cole, he found intellectual stimulation in the American art colony in Italy. His friendship with these painters and sculptors influenced his own aesthetic goals. He wrote several books with Old World settings, both travel accounts and historical romances, and in these works he

raised moral, philosophical, and aesthetic questions about the meaning
of Europe for an American observer. *The Bravo* (1831) was the best
and most unified of these European works. Unfortunately, it was also
the most controversial, and it provoked one of Cooper's angriest quarrels
with his critics. In the end, European travel stimulated Cooper's imagi-
nation and gave increased depth to his thought and his art; but his
changed perceptions and artistic practices alienated him from his
American audience.

The magnet that drew Cooper to Europe in 1826 was largely economic.
Although he had earned critical acclaim since his debut as a writer
in 1820 and had shown an excellent sales record for six successive books,
his finances remained in a precarious state. A promising inheritance
from his father had dwindled in the depression following the War of
1812, and speculation in real estate and a whaling ship proved un-
fruitful.[2] Between 1821 and 1823 Cooper engaged in a long correspondence
with the Navy Department over $190 that appeared on their books as
a debt he owed from his days as a recruiter. His financial situation
was so precarious that he described the debt as "a loss which my circum-
stances will not afford," and endeavored to persuade the navy to cancel
the obligation.[3] He had married into a wealthy family, but his wife's
relatives apparently distrusted his unsteady career and questioned his
financial judgment. The property given to Susan Cooper by her father
was held in trust by her brothers to prevent it from being "encumbered
or alienated by the said James Cooper or subjected to any change what-
ever on account of his debts."[4] In 1822 and 1823, Cooper lost the last
of his inherited property in a series of forced sales. He himself narrowly
escaped bankruptcy when his household goods were seized and inven-
toried by the sheriff of New York.[5]

These financial problems forced Cooper to take a practical approach
to his literary career, and he resolved to develop a European as well as
an American market for his books. The absence of an international
copyright law at this time meant that books published in one country
usually would appear in pirated editions elsewhere; but if the public
showed sufficient interest in a writer, publishers would pay something
for quick access to new works. Ever since the publication of *The Pioneers*
(1823), Cooper had reaped modest profits from English editions.[6] Wash-
ington Irving had advised him about the financial aspects of trans-
atlantic publication, and in the mid-1820s Cooper began to consider
taking his family abroad in order to supervise a broader and more
profitable literary enterprise.[7] Writing to John Miller, a potential pub-
lisher, in 1826, Cooper gave different reasons for wishing to travel to
Europe: "My object, is my own health and the instruction of my children
in the French and Italian languages—Perhaps there is, also, a little

pleasure concealed, in the bottom of the cup—." In a letter to a friend he was more candid about the role of economic considerations: "That pole star interest keeps luring me on."[8] Luckily, the demands of family, health, and finances coincided and left even "a little pleasure concealed, in the bottom of the cup," for his stay in Europe proved enjoyable, healthful, and economically advantageous.[9]

The Cooper family sailed from New York to England and proceeded quickly to Paris, where they lived from July 1826 to July 1828. Cooper spent several months in London during the spring of 1828, and the entire family toured Switzerland in the summer of 1828, then lived in Florence from October 1828 to July 1829. After a stay in Naples they spent the winter of 1829-30 in Rome. Political developments during their visit to Germany in the summer of 1830 took them back to France. They remained in Paris from August 1830 to June 1833, except for a short trip to Switzerland in 1832. A final summer in London preceded their embarkation for New York in September 1833.[10]

Unlike so many of his contemporaries, Cooper did not go to Europe with the expectation of gathering literary material. He planned to use his trip to stimulate the sales, not the content of his work. A disciplined and steady worker, he apparently planned to continue writing the same kinds of books he had written at home, taking cognizance of his surroundings only in his free time, as an aspect of his family's recreation.[11] The four books he produced between 1827 and 1829 all dealt with American subjects. While *Notions of the Americans* (1828) reflected his European experiences as he wrote it at the urging of Lafayette, its subject was American. The other three novels, *The Prairie* (1827), *The Red Rover* (1828), and *The Wept of Wish-ton-Wish* (1829) were frontier and sea romances of the type he had already popularized. They bore no significant traces of his European residence.

Furthermore, he maintained a healthy skepticism about the picturesque charms of Europe. He had traveled before as a sailor, and he distrusted European, and especially English, attitudes toward America. His first recorded letter home, written to his sister, passes briefly over the scenic pleasures of his journey to complain about the extortive demands of English servants and the filth of their accommodations in France. He prophesied England's rapid downfall as a nation and added, "It is an exceedingly unpleasant Country for a stranger, especially an American."[12] Of France, he concluded that "there is an unaccountable mixture of gentility and meanness, of tawdriness and dirt, in all that I have yet seen."[13] He was not a sentimental traveler but a hard-headed, suspicious realist, who sized up his surroundings carefully. Initially, at least, the tourist and the romancer were separate beings.

But Cooper's final response to Europe was profoundly influenced by the two types of friendships he formed there: artistic and political.

In New York, he had been part of the literary-artistic circle that had included Samuel F. B. Morse, William Cullen Bryant, and Thomas Cole, among others.[14] Pursuing these ties in Europe brought Cooper into contact with the same expatriate artistic colony that inspired Cole—the Greenough circle in Florence. Like Cole, with whom he exchanged friendly messages as they visited the same cities at different times, Cooper was swept up by the excitement and élan of these productive young artists. As he shared travel experiences with his countrymen, he soon found himself influenced by their aesthetic passions as well.

Cooper spent considerable time with Greenough in Florence in 1828. He toured art galleries and sat for a portrait bust. He commissioned a sculpture from Greenough entitled *Chanting Cherubs* and based on a group from a Titian painting. He soon was lending the sculptor money and writing letters recommending him for a government commission.[15] Greenough's own career was blossoming, and he was filled with energy, enthusiasm, and idealistic talk about the arts in the manner of his mentor, Washington Allston. Cooper, who had met Allston casually in America, took a new interest in the older painter now, inquired respectfully after his health and progress, and even tried to buy one of his paintings from a European collector.[16]

Walking in Allston's footsteps, Greenough and Morse stimulated Cooper's interest in the Old Masters as supreme interpreters of human experience. In Paris he commissioned Morse to copy for him a painting by Rembrandt, and he accompanied the artist to the Louvre for long sessions of sketching and conversation. He, Greenough, and Morse sat up late at night discussing such topics as "the means of renovating art" and "the improvement of Mankind."[17]

These long conversations about the meaning of the Old Masters, about art and history, may well have helped Cooper to consider seriously the question of what implications the European scene, rich in history and human remains, held for Americans. At the time of their friendship in Paris, Morse was working on his huge *Gallery of the Louvre* (1833) in which he paid tribute to the Old Masters by reproducing twenty or more well-known paintings and showing earnest young painters respectfully copying them. In his work Greenough too was exploring the meaning of classical forms for American artists. He was to carry out his ideas most fully in his controversial *George Washington* (1840) whose toga-draped torso was intended to express symbolically the virtue and nobility of the subject. In turning to a kind of costume drama in *The Bravo* and the other European novels, Cooper was creating literary analogues to the artistic efforts of his friends. In contrast to Cole, who took his view of European history from literary sources—notably Byron— Cooper found his interest in the Old World past given new direction by the concerns of visual artists.[18]

At the same time that his American friends were developing his appreciation of Europe's artistic heritage, Cooper found himself increasingly drawn to discussions of politics and political systems. Always intensely ideological and evangelical about his beliefs, Cooper acquired a stake in the outcome of European politics through his friendship with one of the great heroes of his day, the Marquis de Lafayette. He had met Lafayette during the latter's triumphal tour of America in 1824, and the Frenchman went out of his way to be cordial to the American author in Paris. Although Cooper had resolved to keep his political beliefs to himself and not to meddle in foreign affairs, his conversations with Lafayette stimulated his interest in politics, and he identified strongly with the French statesman's cause.[19] When Lafayette rose to power during the Revolution of 1830, Cooper hurried back to Paris to witness and to participate to some extent in the resulting political changes. He became Lafayette's political confidant and was presented by him at court.

Under the influence of Lafayette, who has been called by one biographer an alternative father-figure for Cooper, the writer found himself drawn into active participation in European politics.[20] In 1828 *Notions of the Americans* paid tribute to Lafayette indirectly by using the Frenchman's successful visit to America as a backdrop to its narrative. Three years later, Cooper supported Lafayette more directly and entered into a political controversy that proved extremely detrimental to his literary career in America and abroad.

Lafayette had been engaged in a debate over the relative feasibility of a republican, as opposed to a monarchical, form of government. The discussion had finally focused on finances, and a French editor, Émile Saulnier, had cited the example of the United States to prove that a republic was actually more expensive than a monarchy. Lafayette appealed directly to Cooper and asked him to expose the fallacies in Saulnier's article. The controversy attracted Cooper for a number of reasons, including his interest in comparing different systems of government, his desire to defend American democracy, and his loyalty to Lafayette. His letters on the subject, published in December 1831, were thoughtful and carefully argued. However, when American officials in Paris refused to support his position and in one case argued on Saulnier's side, Cooper's retorts became angry and embittered. Meanwhile the American press wondered why a writer of novels had thrown himself into a political argument at all. To some of his critics, his entry into the controversy looked like just the sort of meddling in foreign affairs he had earlier disavowed.[21]

It is now obvious that the excitement of living in the midst of change and upheaval in France, and the sense of participation in the course of history through his friendship with Lafayette, helped to turn Cooper's

thoughts toward larger questions of political philosophy. Like other Americans in Europe he began to ponder the weight of history, so notably lacking in America, as a force determining present possibilities. Whereas Cole and others were struck by the tangible ruins of past generations, Cooper was fascinated by the brooding remnants of institutions—monarchy, aristocracy, church—and the lessons they held for the contemporary world. His letters to friends brimmed with speculation on European history and politics and their implications for America. Inevitably, these concerns began to make themselves felt in his literary work. Four novels—*The Water-Witch* (1830), *The Bravo* (1831), *The Heidenmauer* (1832), and *The Headsman* (1833)—and five travel books chronicle his imaginative development and literary experimentation.

Although the travel books were published after his return to America in 1833, they provide the most direct picture of Cooper's response to Europe and its effect on his imagination. Soon after his return, he began to assemble journal passages and letters to friends and relatives, rewriting them only enough to produce coherent volumes.[22] He published *Sketches of Switzerland* and *Sketches of Switzerland, Part Second* in 1836, *Gleanings in Europe: [France]* in 1837, *Gleanings in Europe: England* in 1837, and *Gleanings in Europe: Italy* in 1838.[23] In these volumes Cooper combined social and political analysis with observations of landscape, monuments, and society. Cooper was well aware that lengthy descriptions of familiar sights could easily degenerate into warmed-over guidebooks, for many Americans already had published rapturous descriptions of Alpine scenery and English villages. "It may seem to be late in the day, to give an account of the more ordinary characteristics of Europe," he wrote apologetically in the preface to *Gleanings in Europe: [France]*.[24]

By publishing European travel books Cooper invited comparison with his chief American literary rival, Washington Irving. The ghost of Geoffrey Crayon stalked the travel books. In almost every volume Cooper felt compelled to strike a Crayonish pose. "You will recollect," he wrote in *Switzerland I*, "that I have promised to give you little more than can be gleaned in this imperfect manner; for we Americans generally travel through Europe 'unknowing and unknown.' "[25] He expanded this metaphor in the titles of his three later works, calling them "*gleanings of a harvest already gathered.*"[26] In his insistence on a rambling rather than a methodical approach to his travel observations, Cooper echoed Geoffrey Crayon's claim that his "vagrant imagination" had led him into "nooks, corners, and by-places." In "The Author's Account of Himself," Irving's Crayon mockingly lamented that "his sketch-book was . . . crowded with cottages, and landscapes, and obscure ruins; but he had neglected to paint St. Peter's or the Coliseum; the cascade of Terni,

or the Bay of Naples; and had not a single glacier or volcano in his whole collection."[27] Cooper offered volcanoes and glaciers as well as the Bay of Naples, but it was clear that by the 1830s the "by-places" had become obligatory stops for American writers of travel literature. *England* also contains a number of passages that follow in Irving's footsteps. Cooper could not resist offering a set-piece on Westminster Abbey, including a description of Poets' Corner reminiscent of Crayon's. "It was a strange sensation," Cooper wrote, "to find one's self in the midst of those whose names are hallowed in English literature and English art. . . . Albeit little given to ultra-romanticism, I felt a thrilling of the nerves as I read them."[28]

In other aspects, however, Cooper's travel volumes departed substantially from the Crayon tradition. The present, not the past, held center stage for Cooper. His fascination with European politics drove him into a deeper and deeper analysis of all aspects of life in the Old World. The self-proclaimed American democrat found his imagination especially challenged by a realm foreign to his previous experience: the world of manners. Cooper studied and chronicled the behavior of aristocrats, nobles, and politicians, as if their social relations contained the clue to their power. In *Gleanings in Europe: England,* for example, at least six chapters center around social occasions, which are described in lavish detail, while numerous other chapters offer further anecdotes of dinner parties and receptions. *Gleanings in Europe: [France]* contains chapters on etiquette and diplomatic dinners, as well as observations on royal behavior. *Gleanings in Europe: Italy* contains a description of his cordial reception by the Grand Duke of Tuscany, and both parts of *Switzerland* contain observations on private and public social customs.

In his attention to the behavior of polite society, Cooper veered uncomfortably close to the deferential "tuft-hunting" of which he accused his fellow American travelers.[29] The English critic William Hazlitt charged that Cooper exploited his social contacts in Paris with immodest enthusiasm. "He strutted through the streets with a very consequential air," Hazlitt wrote, "and in company held up his head, screwed up his features, and placed himself on a sort of pedestal to be observed and admired. . . ."[30] Cooper clearly enjoyed the cosmopolitan social world, just as he had enjoyed New York social life, but his habits could hardly be considered ostentatious. He led a secluded life on his arrival in Paris, and he and his family refused all social invitations they considered improper.[31] In Florence the family lived so quietly that Mrs. Cooper reported they had "almost affronted the Lords and Dukes, and Princes by declining their invitations."[32] Cooper's response to European social life seems far more balanced than his critics charged. He found polite society attractive, but his enjoyment did not blunt his critical faculties, and his social life became food for his active imagination.

His exploration of European manners and social forms produced a

travel literature quite different from the genteel, respectful *Sketch Book*. In contrast to Irving's steady, even, dreamy tone, Cooper ranged from the poetic to the choleric. Whereas Irving presented sentimental confrontations with the writers of the past, Cooper dryly described dinner parties with the literary lions of the present. Instead of Irving's gentle plea for transatlantic understanding in "English Writers on America," Cooper delivered a biting critique of English character and attitudes toward America in "National Prejudices" and "Comparative Merits." Unlike Irving, who presented an affectionate portrait of a country squire in his Christmas sequence and later in *Bracebridge Hall*, Cooper attacked the English class system in "Aristocracy" and "Under Patrician Roofs." One of the most striking aspects of the travel books is Cooper's constant sense of a clash of cultures. Although the books are about Europe, their running subtheme is the definition of an American national character. Irving used *The Sketch Book* to establish a sense of identity through affinity or imaginative kinship with his subject; Cooper struggled throughout his five travel works to find an identity in opposition, in conflict and contrast.

At times this oppositional stance veered close to carping, and Cooper's detractors complained that he was overly critical or supersensitive.[33] Indeed, the travel books brim with incidents that Cooper angrily interpreted as evidence of European hostility toward or ignorance of America. From the hostess of a fashionable dinner party in London to a group of fellow-travelers at a Swiss inn, Europeans repeatedly asked him how he had learned to speak English so well.[34] He was outraged to find English sailors in Marseilles singing songs insulting to America and an English theater troupe in Florence offering a skit that satirized the American character to a "yell of delight" from the audience.[35] As an American in England, Cooper felt constantly on the defensive and recorded instance after instance of social snubs and insults.[36] He felt such incidents revealed a basic misunderstanding and undervaluation of America. Europeans, he noted, used the terms "civilization" and "Christendom" to include only their continent. "All this time, 'great and glorious' America and the 'twelve millions,' were no more thought of, than you would think of a trading factory on the coast of Africa, in enumerating the countries that speak French. . . . The European, in his ordinary discourse, does not appear to admit the western hemisphere at all within the pale of his civilization."[37]

This sense of cultural conflict drove Cooper to a clearer sense of his American identity. Yet, his nationalism was hardly the uncritical sort. Throughout the travel books he stressed the faults and limitations of his American fellow-travelers as well as of his European hosts. Complaining of "the great ignorance of our situation which prevails all over Europe," he added, "I know of nothing to which it can be so

aptly compared, as it may be to the ignorance of Europe which exists all over America."[38] American travelers often deserved the rudeness with which English society treated them, Cooper admitted: "It is, to a certain extent, our own fault."[39] In the preface to *Sketches of Switzerland,* Cooper angrily critized those fellow countrymen who were either too deferential toward Europe or too insistent on American superiority.[40]

To some of his contemporaries, Cooper's critiques of both European and American customs seemed inconsistent: he compared European to American society and did not like either.[41] But it was the process of analysis as much as the specific findings that intrigued Cooper. To his thinking, American and European national characteristics represented two sides of the same coin. He did not think of his books as a defense of Europe or America; rather he was interested in the revelations that could be obtained by the study of contrasting social forms and cultural habits.

The travel books provide a clue to the workings of Cooper's imagination during his years abroad. Increasingly involved in political debate and discussion, increasingly aware of the weight of tradition for good in art and for ill in corrupt institutions, Cooper discovered the depth of meaning that could reside in customs, manners, and social form. He became a keen and discriminating observer. Nuances of public behavior furnished examples of national character for him and revealed the impact of political institutions.

Even before his visit to Europe, Cooper's work reflected an interest in social forms and the relationship between a character's actions and his values. At this early stage, however, his analysis was relatively straightforward and uncomplex. *Precaution,* a halting and imitative inaugural work, was intended to be a novel of manners; yet characterization and social interchange were handled in the broadest possible terms. From the ludicrous social climbers to the rogue posing as a gentleman and the true gentleman in disguise, the characters in the novel fall into neat slots; manners provide direct signposts of worth. Although the early novels contain numerous examples of maquerade and disguise—George Washington incognito in *The Spy* and the hidden Major Effingham in *The Pioneers*—the disguises hold no surprises for the reader, and the mysteries move inevitably to happy endings.

Cooper's feeling for manners and the broader implications of social form deepened as a result of his European experiences. Already disposed to view his society with an analytical eye—in Robert Spiller's phrase, a critic of his times—Cooper discovered new scope for his imagination in Europe. Like the fictional characters Henry James would portray half a century later, Cooper found his frame of reference shifting as he saw new meanings in social forms and conventions. The study of society became for him even more highly charged, even more pertinent to his

deepest interests. As he absorbed the impact of his European experiences Cooper sought to explore with more insight the relationship between manners, the outward manifestations of a culture, and belief, its inner principles. The European scene, rich in history and variety of social experience, stimulated grave reflections and ambitious literary endeavor. Thus, contrary to his previous expectations, Europe was not simply a neutral background against which his career could continue to unfold. Travel changed his perspective and caused him to see things in a new way. In writing about his European travels Cooper often used the language of awakening sensibilities. In *Gleanings in Europe: [France]*, the volume describing his first responses to Europe, he somewhat facetiously catalogued his five most impressive "sensations," ranging from his visit to Westminster to his first sight of Paris. In a more serious vein, he described these imaginative epiphanies as the true fruit of his European travels. "There is a sensation on first seeing Rome," he wrote in a letter in 1830, "which one can only feel at such [a] time, and but for once in a life. . . . Indeed this is the true and principal enjoyment of traveling."[42] Not a simple recreational activity but a rigorous intellectual enterprise, travel came to seem to Cooper an opportunity and a challenge. In *The Heidenmauer* (1832) he defined the responsibility of the traveler:

To divest one's self of impressions made in youth; to investigate facts without referring their merits to a standard bottomed on a foundation no better than habit; to analyze, and justly to compare the influence of institutions, climate, natural causes, and practice; to separate what is merely exception from that which forms the rule; or even to obtain and carry away accurate notions of physical things; and, most of all, to possess the gift of imparting these results comprehensively and with graphical truth. . . .[43]

Cooper set high standards for himself. Response to travel, he implied, tested one's entire imaginative capacity. "The intellectual existence of every American who goes to Europe is more than doubled in its intensity," he wrote. "The multiplicity of objects and events that exist in the old countries to quicken the powers of the mind has no parallel [in America]."[44] By the early 1830s, Cooper was writing about travel with the evangelical passion he displayed throughout his career for subjects close to his heart. It is hardly surprising to learn that he soon began to embody his changed perspectives in fiction.

The first signs of Cooper's changing approach to his fiction came in *The Water-Witch* (1830), which he wrote soon after his visit to Florence. Although this novel is set in America, it differs from his earlier works in language, characterization, and theme.[45] In a preface written for Bentley's 1834 reissue of the novel, Cooper called *The Water-Witch*

"probably the most imaginative book ever written by the author."
In terms that anticipate Hawthorne's prefaces, he acknowledged the
difficulty of writing a romance set in America: "The facts of this country
are all so recent, and so familiar." As a result, he wrote, he found himself
"blending too much of the real with the purely ideal."[46] In retrospect
Cooper felt he had not found the proper balance between fantasy and
social observation. Despite its faults the book represents a first step in
the direction his fiction was to follow, incorporating more self-conscious
literary effects and moving toward a more probing social outlook.

A tale of love, piracy, masquerade and revelation, *The Water-Witch*
recounts the exploits of the dextrous smuggler, Skimmer of the Seas,
whose graceful ship, the *Water-Witch*, is a floating palace with luxurious
damask and mahogany cabins served by a silk-clad page boy who has
never set foot on land. The devoted crew swears to the magic powers
of the ship and the benign protection of its prophetic figurehead. The
brigantine glides in and out of coves and channels, defying its more
earth-bound pursuers, although Cooper's seacraft ultimately provides
a plausible explanation for every maneuver. The book's plot is equally
romantic: a beautiful young woman disappears after the smugglers
have visited her uncle's seaside house and is sought by two suitors, an
English naval officer and a Dutch patroon. After mysterious interviews,
sea-chases, a battle between an English man-of-war and a prowling
French warship, and a mid-sea rescue, the revelation of a concealed
identity provides a happy ending. The heroine is restored unscathed to
marry her military suitor, and the *Water-Witch* sails off to distant oceans.

In its general outline, the plot of *The Water-Witch* resembles that of
The Pioneers, The Last of the Mohicans, and *The Prairie.* All revolve around
chases and rescues, culminating in the marriage of a genteel hero and
heroine and the departure of the book's true hero, the "mock-renegade,"
the figure who chooses to remain outside society.[47] In the frontier
romances, Natty Bumppo plays this role; in *The Water-Witch* it is Skimmer
of the Seas. However, in *The Water-Witch* this plot takes on a different
atmosphere and meaning. The romantic world of the brigantine, portrayed
in lush detail, offers a compelling and attractive alternative to the world
of mundane reality represented by the Dutch patroons and the English
officer. The conflict between these alternate realities provides the true
theme of the novel.

The competing worlds of the novel are outlined largely through
characterization. The heroine's uncle, Alderman Van Beverout, represents
the practical, calculating, businesslike world of debts and credits. When
his niece Alida vanishes under compromising circumstances, the alder-
man continues to insist on her marriageability, describing her as if she
were a slightly damaged but still marketable commodity. His favored
suitor, the Patroon of Kinderhook, shares this Dutch practicality but

focuses on property rather than commerce; he sees the proposed match as a profitable merger of estates. The English suitor, Captain Ludlow, has all the virtues and limitations of an upright military officer, courage, devotion to duty, sense of honor and fair play, at the expense of imagination and flexibility.

Cooper contrasts these characters and their land-bound values of practicality or military values of law and order with the denizens of the *Water-Witch*, the bold Skimmer of the Seas and the poetic Seadrift, who represent an imaginative freedom outside the ordinary bounds of society. The smugglers are outlaws, yet they provide an infusion of aesthetic and poetic values without which society would be dull. As Seadrift points out, many respectable lords and ladies condemn smuggling but nonetheless wear smugglers' products on their sleeves and at their necks. Alida, like most of Cooper's heroines, a bellwether of true value, admires the silks and laces in Seadrift's treasure chest and listens breathlessly to tales of foreign lands and distant seas. The beauty of the brigantine and the charms of both its spokesmen argue the value of this other realm. Even the language of the smugglers, wild and poetic, contrasts favorably with the practical sea speech of Ludlow and the counting house metaphors of Van Beverout.[48]

Alida enters this world of fantasy and imagination like the middle-class children of James Barrie's *Peter Pan* escaping to Never-Never Land. Although she ultimately returns to the orderly world of her military suitor, both she and he are marked by the experience. After the smuggler saves their lives, Ludlow declares he can no longer think of arresting him and offers to resign his commission, a gesture that luckily proves unnecessary. The novel's ending offers a final ratification of the imaginative realm represented by the *Water-Witch*. Seadrift, who turns out to be a woman masquerading as a man, is revealed as Alderman Van Beverout's daughter and Alida's cousin. But instead of taking her rightful place in society and marrying the Patroon, who has enough imagination to propose to her, she sails off into the unknown with Skimmer of the Seas. This romantic marriage easily overshadows the genteel marriage of Alida and Ludlow, and Cooper gives the world of fantasy a viability that it had never achieved in his previous novels.

In drawing this contrast between competing moral systems, and by giving such weight to the imaginative realm, Cooper registered the impact of his European travels. As early as *The Spy* his fiction had taken its energy from the notion of conflict, divided loyalty, and neutral ground.[49] In *The Pioneers* he had successfully shown the virtues of two opposing worlds: the stable and orderly life of the settlement embodied by Judge Temple, who shares Van Beverout's practicality, the Patroon's rootedness, and Ludlow's sense of duty, and the wilderness world embodied in Natty Bumppo, who, like the smugglers, represents anarchic

individualism and freedom. Despite the novel's sympathy for both
points of view, in *The Pioneers* Cooper's heart was in the settlements,
where all the characters except Natty remained at the book's conclusion.
The dignified Judge Temple is an eminently serious figure, while Natty,
for all his virtues, is portrayed as a comic character. In *The Water-Witch*
the fictive values are reversed: the smugglers win the reader's sym-
pathy while the advocates of stability have taken on a comic cast.
The action of the novel takes place primarily outside society, on the
seas, in the domain of the advocates of anarchic liberty. In this shift
in his novel's moral center, Cooper signaled a change in his own values.
His introduction to European art had made him more receptive to the
rich, sensuous, imaginative aspects of life that he might have shunned
earlier as luxurious and corrupt. At the same time his involvement
in European politics had increased his sympathy for his rebellious
characters and made him more suspicious of the status quo. These
changes in attitude are reflected in his abstract, almost symbolic
handling of plot and characterization in *The Water-Witch*.

Cooper set his struggle between freedom and conventionality on an
international stage. Although the action takes place in colonial New York,
it has no American flavor; all the characters are Dutch, English, or
French.[50] The denizens of the brigantine are specifically associated with
Europe, thus evoking the ambivalent combination of love and fear that
Americans traditionally had felt in the presence of Old World exoticism.[51]
The Skimmer of the Seas first appears in a "rich India-Shawl," which
is pinned to his shirt by an ivory-handled knife; Seadrift wears "a light
frock . . . of a thick purple silk, of an Indian manufacture," a scarlet
and gold cap and a scarlet silk belt.[52] Van Beverout introduces Seadrift
to his niece by saying that she "has heard thou comest from the old
countries . . . and the woman is uppermost in her heart." Seadrift
responds in the spirit of the smugglers' trade: "Here are silks from the
looms of Tuscany, and Lyonnais brocades, that any Lombard or dame
of France might envy. Ribbons of every hue and dye, and laces that
seem to copy the fretwork of the richest cathedral of your Fleming!"[53]
But Seadrift and Skimmer of the Seas do not merely peddle the material
treasures of Europe; they themselves are exotics, free spirits, exuding
the romantic atmosphere of the countries they have visited. In particular,
they claim kinship with Italy, where the looms supply the silk they carry
and where the commercial empire, Venice, provided the early model for
their far-flung trade. Writing the romance in Sorrento in a rented home
so lovely that he described it in Seadrift's rhapsodic paean to the Italian
landscape, Cooper expressed his own growing passion for the European
scene.[54]

In style as well as theme, this romance is far different from his previous
ones. There are no blunt-spoken frontiersmen; even common sailors

like Tom Trysail speak a kind of poetical language that looks ahead to
Melville's Shakespearean cadences.[55] In fact, Shakespeare's influence
pervades *The Water-Witch*.[56] The text alludes directly to *The Merchant
of Venice*, and Cooper used quotations from Shakespeare as epigraphs
for all but one of the book's thirty-four chapters. Even the seagreen
lady of the brigantine delivers her mysterious prophecies in the form of
Shakespearean quotations.

Deliberately artful, determinedly cosmopolitan, *The Water-Witch*
strikes a light, rather than a somber note. Yet it also gestures toward
larger political and philosophical issues. Early in the book Seadrift
defends the smuggling trade by contrasting it with the conventions of an
unjust society. "We rovers deal little in musty maxims, that are made
by the great and prosperous at home, and are trumpeted abroad, in order
that the weak and unhappy should be the more closely riveted in their
fetters." When Alida protests, "These are opinions that might unsettle
the world," Seadrift responds with a vision of natural law: "Rather
settle it, by referring all to the rule of right. When governments shall
lay their foundations in natural justice, when their object shall be to
remove the temptations to err, instead of creating them, and when bodies
of men shall feel and acknowledge the responsibilities of individuals—
why, then, the *Water-Witch* herself might become a revenue-cutter, and
her owner an officer of the customs!"[57] In a later discussion with Ludlow,
a less sympathetic listener, Seadrift argues even more eloquently for the
location of virtue in the individual, outside society. "We are not to learn,
at this later hour, that in order to become respectable, roguery must
have the sanction of government." Unconvinced, the military commander
replies, "There is little novelty in the expedient of seeking to justify
the delinquency of individuals by the failings of society." "I confess
it is rather just than original," responds Seadrift, launching into an
impassioned attack on ambitious kings and religious rulers who wage
war to satisfy their ambition. "The gallows awaits the pickpocket;
but your robber under a pennant is dubbed a knight. . . . Before society
inflicts so severe censure on acts of individuals . . . I must say it is
bound to look more closely to the example it sets, in its collective
character."[58]

This revolutionary rhetoric lies deeply buried in the romantic plot.
The political themes that emerged so forcefully in Cooper's next few
novels stirred only faintly in *The Water-Witch*. Yet Cooper had begun
to move in a new direction in this novel. His sympathetic treatment of
the smugglers and their never-never land of physical luxury, poetry,
and music took him part of the way down the road traced by Bryant
in his sonnet to Thomas Cole: Cooper was moving from American to
European subjects, from nature to history. He still felt uneasy about
the shift and tried to return his fantasy to earth with realistic explanations

for his marvels. Such apologetic patchwork did not satisfy critics of his day or our own.[59] Successful treatment of the European scene would require fuller commitment to its implications.

In *The Bravo* (1831) Cooper turned seriously to the questions he had begun to raise in a light vein in *The Water-Witch*. The conflict of values is no longer a subject for romance but a matter of life and death, and political repression is no side issue but the heart of the novel. In this novel Cooper confronted the European scene head-on, plunged into Old World history and probed its meaning for the contemporary world.

The Bravo is set in early eighteenth-century Venice, as the powerful commercial empire is entering the period of its decline. Though nominally a republic, the state was actually an oligarchy. Both the Doge and the senate were figureheads and real power rested in the Council of Three, which operated a kind of secret police system in order to enforce its decrees. All the main characters in the book come into conflict with this governing power in one way or another. As usual in a Cooper novel, one plot involves a romance between a genteel hero and heroine: Don Camillo Monforte, a Calabrian who vainly seeks to recover an inheritance from the greedy Venetian government, courts Donna Violetta, a ward of the state whom the authorities forbid to marry a non-Venetian. When she declares her love for him, the secret police kidnap her and Don Camillo must win her back in a dramatic rescue. The heavy hand of Venice extends to its humbler citizens as well, and another plot concerns an old fisherman, Antonio, whose only surviving relative, a young grandson, has been conscripted into the galleys. Antonio tries to plead for the boy's release before the Doge and finally seeks to dramatize his case by winning a gondola race against tremendous odds. When his fellow fishermen take up his cause, Antonio is judged a danger to the state and assassinated.

An even more sinister view of Venice emerges from the third subplot, involving Jacopo, the bravo of the novel's title. A mysterious figure who haunts the novel from its very beginning, Jacopo is known in Venice as the most ruthless of the bravos, or hired assassins of the state. But Jacopo too is a victim of the government, which forces him to assume the undeserved reputation of assassin through heartless blackmail, holding his sick and aged father in prison to secure his cooperation. Cooper reveals Jacopo's true character gradually through his sympathy for the genteel lovers and old Antonio and his ability to win the love of the pure and innocent Gelsomina. Finally, disgusted by the murder of Antonio, Jacopo defies his former masters, helps Don Camillo and Donna Violetta to escape, and suffers the wrath of the state, which executes him.

Through this somber and remorseless plot Cooper dramatized his

response to the city of Venice, where the luxury, power, and decadence of the Old World had reached their height. Cooper told a friend that a visit to Venice had "seized my fancy . . . in a manner not to be spoken of."[60] *The Bravo* is remarkable for its detailed portrayal of a physical setting.[61] From the opening scene in Saint Mark's square where merry-makers swarm through moonlit streets to the closing scene where the revelry becomes a horrible mockery of the city's grim reality, Cooper simultaneously pictures the fascinating city and probes for the meaning beneath its glittering surface. The cavernous palaces, meticulously described, mirror the intrigues of their corrupt occupants, and the twisting waterways and streets present a physical analogue to the devious ways of the state. The colorful spectacle of the city's night life has a sinister aspect, as masked citizens meet in the crowded piazzas to plot assassinations and kidnappings while mingling with the festive throngs. Even the impressive pageantry of the ceremony marking the city's marriage to the Adriatic has lost its sacred character and becomes an occasion for secular competition. So warped are the values Venice represents that a prison becomes a symbol of innocence, for it harbors Jacopo's wronged father, nurtures the virtuous Gelsomina, and provides a refuge for the fleeing Donna Violetta. Like Cole in *The Course of Empire*, Cooper responded to the overwhelming grandeur of Europe: "Everywhere the trace of men," as Bryant had put it. Venice, as depicted in *The Bravo*, started its slide from the unnatural splendor of *Consummation* to the suicidal decadence of *Destruction*.

Cooper used this incisive evocation of scene as a means to a still larger end. *The Bravo*, unlike *The Marble Faun*, could not be used as a guidebook by tourists in search of monuments. It was not the architecture of the Doge's palace but the political maneuverings within it that claimed Cooper's most passionate attention. "The government of Venice," he wrote later, ". . . became the hero of the tale."[62] Cooper used his plot and setting to explore questions of history and political theory arising from his European experiences. As a friend of Lafayette and an activist for Polish freedom, he felt he had a stake in Europe's political life. His letters are full of alarm for the fate of "free institutions" in the face of "a deep conspiracy of Aristocrats, who wish to take the place of the kings they have been, effectually, deposing." "I engage you . . ." he concluded in one such letter, "to read my next tale, The Bravo, where these matters are occasionally alluded to."[63] Several years later Cooper recalled a specifically didactic purpose for *The Bravo*: to warn American audiences of the danger of believing "that nations could be governed by an irresponsible minority, without involving a train of nearly intolerable abuses." The Venetian tale was the first of a series of books that were to "lay bare the wrongs that are endured by the weak, when power is the exclusive property of the strong; the tendency of all exclusion to heartlessness; the irresponsible and ruthless movement of an aristocracy,

the manner in which the selfish and wicked profit by its facilities, and in which even the good become the passive instruments of its soulless power."[64]

Modern critics have tended to view *The Bravo* narrowly as "a thesis novel . . . carefully shaped to argue the evil of aristocracy."[65] To do so, however, ignores the complexity of the book itself and the subtlety of Cooper's political opinions. This son of a Federalist judge was no admirer of the masses. From the bedraggled "posse" that tries to arrest Leatherstocking in *The Pioneers* to the band of fishermen in *The Bravo* who allow their rightful wrath to be deflected onto a scapegoat by their rulers, Cooper portrayed the common man as politically weak and untrustworthy. By training and temperament a gentleman, he admired such enlightened aristocrats as Lafayette. The institution of aristocracy was not itself the danger Cooper warned against; if so, the issue would have had little meaning in America. Cooper's real concerns were with the abuses of power as he defined them in the passage quoted above: irresponsibility, heartlessness, ruthlessness, soullessness. These abuses could infect any political system. Venice was a particularly chilling example because it was nominally a republic like the United States; yet, despite its lip service to "the justice of St. Mark," it was really ruled by "a set of political maxims that were perhaps as ruthless, as tyrannic, and as selfish, as ever were invented by the evil ingenuity of a man."[66] It was this kind of subversion of an apparently sound system that Cooper feared.

In accordance with this theme, Cooper stressed throughout *The Bravo* the dangerous disjunction between appearance and reality. Venice appears to be a republic but is in fact a despotism. The Doge seems wise and powerful but is in reality an ineffectual puppet. Deception and masquerade dominate Venetian life, and intriguers are often caught in their own traps: the gondolier Gino gives a ring to the wrong masked figure, a scheming Jew reveals important secrets to a masked Jacopo. Even the gondola of the state can be masked, for it arrives in the guise of the escape boat Don Camillo had ordered. The powerful members of the Council of Three wear masks while they interrogate their victims, and because they are unknown to their countrymen they are always disguised. Only after their grim deeds are done do they lay aside their masks, literally and figuratively, to reveal their private follies: "Didst hear of my affair with the mousquetaire at Paris?" "The many pleasant hours that I have passed between the Marais and the Chateau! Didst ever meet La Comtesse de Mignon in the gardens?" "Wert thou of the party, Alessandro, that went in a fit of gayety from country to country till it numbered ten courts at which it appeared in as many weeks?"[67] Cooper chillingly contrasts their ruthless, bloodthirsty public lives with their banal, self-indulgent private lives.

The act of reading *The Bravo* involves the reader in an attempt to

penetrate disguise. Even the central character, Jacopo, must be evaluated in the light of misleading and contradictory clues. From his first appearance in the novel, striding silently across the piazza while two gondoliers intone his name with horror, he is a forceful and ambiguous figure. The language used to described him is appropriate to either a Gothic villain or a Byronic hero: "The cheeks were bloodless, but they betrayed rather the pallid hue of mental than of bodily disease. . . . The face was melancholy rather than sombre, and its perfect repose accorded well with the striking calmness of the body. . . . Out of this striking array of features gleamed an eye that was full of brilliancy, meaning, and passion."[68] With his cold reserve, Jacopo seems to deserve his dreadful reputation. Disdainfully he accepts a packet of secret letters, carriers information to the unscrupulous Signor Gradenigo, bears a message of warning to the old fisherman Antonio. Yet, when Antonio calls upon his friendship with Jacopo's father and urges him to reform, "a paleness crossed [the bravo's] cheeks," and he responds in "a low, struggling voice."[69] Although Cooper invites the reader to penetrate Jacopo's disguise, he offers ambiguous clues. Unlike Oliver Edwards, who harbors a benign secret in *The Pioneers,* Jacopo does not reveal his true character at first glance. When he enters the festival gondola race masked and eschewing the protection of saints in favor of "mine own arm," Jacopo seems demonic; but at the last minute he generously slackens his speed to let old Antonio win the race. He functions as the servant of the state in bringing Antonio before the tribunal, but he tries to protect the fisherman from the council's wrath. His attempt to save Antonio from assassination marks the beginning of his movement to the center of the stage, and his midnight colloquy with Don Camillo in the heretic's graveyard wins the reader's sympathy, so that his subsequent actions can be interpreted favorably. Only at the novel's conclusion does Cooper reveal Jacopo's true story, bringing him full circle from criminal to victim.

Jacopo's unmasking leaves the reader still one more surprise, however. A happy ending seems inevitable: Don Camillo and Donna Violetta have escaped to far-off Calabria, and Jacopo has been befriended by the Carmelite priest, Father Anselmo, who rushes with Gelsomina to the Doge's palace to bring the truth to light. A pardon is promised, and the two innocents expect it until the executioner's ax falls with a suddenness that, as one critic put it, "stuns us into enlightenment."[70] Jacopo dies, and his fiancée goes mad. The last mask has fallen: we have not been reading a romance but a tragedy.

Like all Cooper novels, *The Bravo* has its flaws. Parts of it are tedious, the dialogue is often ponderous, and some of the turns of plot strain our credulity.[71] Nevertheless, the book is remarkable for its moral depth and for the consistency of tone that marks its plot, setting, and characterization. After dispensing with the novel's details, some of them effective,

some silly, the reader is left with a vivid and intense evocation of "the power of blackness" in human life.[72]

A decade before the emergence of Hawthorne, Poe, and Melville, Cooper attempted in *The Bravo* a portrayal of that most un-American of subjects, sustained, unreconstructed evil. He found his heart of darkness in the decay and corruption of the Old World and throughout *The Bravo* he keeps whispering, "the horror." Like Poe, he found a vehicle for portraying this discovery in the literary conventions of the Gothic, and his book reflects the chase-and-escape plot and labyrinthine setting frequently used by Gothic romancers.[73] *The Bravo*, however, is no mere exercise in sensationalism. It was not the emotions of his characters but the moral implications of the forces acting on them that fascinated Cooper.

Cooper's previous works had contained glimpses of a comparable evil, such as the massacre scene in *The Last of the Mohicans* or the mutual destructiveness of Puritans and Indians in *The Wept of Wish-ton-Wish*. But although good characters are sometimes killed in Cooper's novels— Conanchet in *The Wept of Wish-ton-Wish*, Harvey Birch in *The Spy*, Uncas and Cora in *The Last of the Mohicans*—in no other book had he portrayed an evil so powerful, pervasive, and inescapable. The forces of darkness rule in Venice, and there is no way to escape their taint. In his parting words to Don Camillo, Jacopo warns him to "distrust Venice to your dying day," never, never to return.[74]

Cooper drives home his point about the corrupting power of evil with the vignette of Paolo Soranzo, a newly appointed member of the Council of Three. Young, attractive, good-willed, an upright family man, Signore Soranzo would have been in another age "a noble in opposition," a thoughtful, critical intelligence. In the sinister Venetian system, he is putty in the hands of his duplicitous colleagues. Without realizing the nature of the institution he serves, he allows his "great natural excellence of character" to be perverted in the service of the state. Unwittingly he becomes the agent of the innocent Jacopo's doom. In a striking metaphor, Cooper describes the way Soranzo is schooled in the abuse of power: his two older colleagues "were like two trained elephants of the East, possessing themselves all the finer instincts and generous qualities of the noble animal, but disciplined, by a force quite foreign to their natural condition, into creatures of mere convention, placed one on each side of a younger brother, fresh from the plains, and whom it was their duty to teach new services for the trunk, new affections, and haply the manner in which to carry with dignity the howdah of a Rajah."[75] After serving on the council, Soranzo returns to his "luxurious and happy dwelling" feeling "a distrust of himself," for, as Cooper stresses, "he had taken the first step in that tortuous and corrupting path, which eventually leads to the destruction of all those generous and

novel sentiments which can only flourish apart from the sophistry and fictions of selfishness."[76] Complicity in evil corrupts even the most promising individuals, and this moral blight is the final tragedy of Venice. For Cooper in this case the lesson of history is plain: abuse of power by the few corrupts all.

The Bravo represents Cooper's skillful and mature response to his European experiences. Like *Belshazzar's Feast* it was intended to form a transatlantic link, to bring to an American audience the fruits of a European education, but like Allston's ill-fated painting, *The Bravo* was tuned to a key unfamiliar to Americans, and it never achieved its intended impact. Cooper's novel was badly misunderstood by his contemporaries and set off a wave of controversy that swamped the novelist's subsequent career.

Cooper might have anticipated some negative reactions to his choice of a European subject. He frequently had been praised as the "American Scott," developing the literary potential of the American scene. The letter he wrote to his publishers defending his choice of a European subject probably did not help matters. Alluding to an earlier comment in *Notions of the Americans* on the poverty of materials for romance in America, he asserted:

My opinion there, and it ever has been and is still my fixed opir.ion, is that America is of all countries one of the least favorable to all sorts of works of the imagination. . . . If America is so favorable to fiction why do not people avail themselves of it: Heaven and Earth is ransacked for materials, and yet who has made anything out of America? We have writers of our own, too, by dozens, and what is their success? Why has not Scott tried his hand, with these fertile materials—. . . . He has not tried, because he is a master in his art, and he knows what to touch and what to let alone. For myself I can write two European stories easier than I can write one American, and they shall be better and more interesting too.[77]

In justifying himself by criticizing his earlier literary stance, Cooper seemed to attack his own defenders.

Always combative and intense, Cooper was out of touch with the American literary and political scene and had become involved in issues and activities not well understood at home. Although he tried to remain indifferent to reviewers' remarks, he found himself increasingly impatient when he did not receive what he considered fair treatment. "Reviews give me little concern, whether favorable or the reverse," he wrote in May 1831. "What I have written, is written, as the Turks say, and it cannot be helped."[78] Yet he complained to another friend about a comment in a New York review that seemed to put his business practices in a bad light. "Critical remarks on a writer's head, and statements of

fact on transactions which involve his principles are very different things," he fumed, and asked for help in rebutting the charges.[79] By early 1832, Cooper was enmeshed in the debate over Lafayette's finance controversy and feeling the pinch of public displeasure at home. Whether their motives were political or literary, American reviewers had begun to subject him to critical scrutiny. The previous summer he had begun to chafe at attacks by "fellows with spectacles and fine sentimental feelings—Gentlemen who will shut their ears on a sea beach, and riot on the ripple of a [penstock]."[80] By March 1832, he took an even more choleric view of his detractors. "I rarely see my name mentioned even with respect in any American publication, and in some I see it coupled with impertinences" he wrote, ". . . If I had seen one frank manly gentlemanly allusion to myself as a writer in a single American publication in five years I would not have thought of it. One fact is beyond dispute—I am not with my own country—the void between us is immense —which is in advance time will show."[81] Reading massive rejection in a few unfavorable reviews, Cooper began to sketch the quarrel he would fight again and again during the next few years. His public disavowed him, he maintained, because he had gotten ahead of them; he was being hounded for his advanced ideas.

Cooper's sense of alienation from his American public came to a head with one particularly outspoken review. The *New York American,* a newspaper that had previously reviewed *The Bravo* favorably, published a scathing attack on the book and on Cooper on June 7, 1832. Writing under the pseudonym "Cassio," the author described *The Bravo* as "the veriest trash in the world," "destitute of merit," one of the "imbecile efforts of exhausted genius," and "the most purposeless, incomplete medley that the dreams of a novelist ever conceived." He accused Cooper of writing for money with "no ambition, no hope—nay, no desire of producing anything else," and, alluding to William Dunlap's drama, *Abaellino,* charged that the novel's plot was "borrowed from the labors of another's pen." Although ostensibly the review focused on *The Bravo*'s literary merits, Cassio's criticisms were almost laughably unperceptive. Among other things, he accused Cooper of a faulty sense of "poetical justice" in having Jacopo killed while the villains went undetected. Less than half the review dealt with the novel; instead, Cassio dwelt upon Cooper's reputation and his responsibility to his American public. "It happens that our author's name is honorably identified with the literature of his country, and therefore we claim that he is bound either to sustain his reputation, or hold his peace," the review asserted and went on to urge Cooper "by every patriotic consideration, to forbear undermining and destroying the monument of his own and his country's honor, which the world confesses he has raised." The editors of the *New York American* did little to soften the blow when they published the review with a halfhearted

demur, asserting that Cooper "has done much for the literary character
of the country," urging respect for him although he was "now, we fear,
written out."[82]

The Cassio review turned Cooper from a posture of disappointed
alienation to a position of enraged opposition. It seemed a gratuitous
slander. The viciousness of the attack convinced Cooper and his friends
that politics, not art, lay at the root of the matter. When they realized
that Cassio has reviewed the French, rather than the American or
English, edition of the novel, they thought they detected a foreign
source for the article. Cooper had long lamented the fact that American
journals reprinted and uncritically agreed with European reviews of
American writers.[83] Now he came to believe that the New York American
had merely translated a French article written to discredit him in the
finance controversy.[84]

Because he was furious that partisan politics had interfered with a fair
reception of his book, Cooper answered the Cassio review with a sarcastic
letter which Morse had printed in the Albany Daily Advertiser in June
1833.[85] Unfortunately, his venom, his trivial textual analysis, and his
insistence that the article was a mere translation injured his own cause.
"Cassio" was in fact an American, Edward S. Gould, whom Cooper had
met in Paris; Gould had used the French edition because he had read
the novel while traveling. The Gallic literary constructions Cooper
thought he had discovered in the article were proved to be a figment of
his imagination. Although other friends tried to dissuade him—"I did
not think you were so thin skinned," wrote Peter Augustus Jay in
September 1832—Cooper turned the Cassio attack and subsequent
controversy into a showdown over his relationship with his American
public.[86] When his critics refused to yield, he resolved to abandon his
literary career. "The book on which I am now employed will probably
be my last," he wrote to Dunlap in November 1832. "I can stand no
longer what I have received from home for the last four years, and I
have made up my mind to retire while I can do it without disgace. . . .
Were I [to] tell you that my plans are not deranged and my hopes cruelly
deceived I should mislead you & myself. But opinion is too strong for
me."[87] After his return to America in 1833, he wrote one last review
of the controversy and a defense of his actions in A Letter to his Country-
men, which he concluded by announcing his determination to lay aside
his pen.[88]

As the controversy over The Bravo unfolded, Cooper wrote two more
novels in the European series he had projected: The Heidenmauer (1832)
and The Headsman (1833). Neither of these books achieves the focus and
coherence of The Bravo, although both continue his endeavor to draw
moral lessons for Americans from European history. For Cooper, in-

creasingly out of step with his countrymen, didacticism became more and more impossible. In 1832 he bitterly remarked: "There is no blunder more sure to be visited by punishment, than that which tempts a writer to instruct his readers when they wish only to be amused. The author has had these truths forced upon him by experience. . . ."[89] Yet in the remaining two European novels and in others throughout his career, Cooper continued to tell his countrymen things they did not want to hear. Later books were well received, and Cooper continued to be counted by literary enthusiasts as one of America's natural resources, but after the Cassio controversy his relationship with his public was never again the same.

Critics viewing Cooper's career as a whole tend to agree that in some strange way "Europe . . . unfitted him for life in America."[90] To some extent the suspicion of the Old World articulated by Bryant has persisted into our own time, and Americans who become too cosmopolitan have been considered "spoiled." But for Cooper as for Cole and later Hawthorne, a trip to Europe did not so much corrupt his American innocence as stimulate his thinking along lines that were not particularly congenial to those who stayed behind. Like others of his generation, Cooper sought to penetrate the meaning of the European scene, to learn from its art and its history. The passionate concern for the human condition that his friends had taught him to see in the Old Masters and the ambiguous complexity he discerned in European society and politics influenced his thinking and ultimately his writing. *The Bravo* stands out among Cooper's works and those of his contemporaries as an ambitious and complex work, a disciplined examination of the darker aspects of human nature. It became his *Belshazzar's Feast,* a stern judgment on the ravages of luxury and the abuse of power. It was his *Course of Empire,* a meditation on the meaning of history for human society. It did not achieve popularity at home and indeed was misunderstood because it raised issues that Americans living in the buoyant 1830s were not ready to examine. In recoiling from the rebuffs his literary efforts met, Cooper found his whole relationship with his reading public and his countrymen changing radically.

Cooper returned to take up arms against a previously congenial American society not because his tastes or manners had changed. Like his fictional counterparts Christopher Newman or Lambert Strether, Cooper had learned to see anew in Europe. Like Thomas Cole, he found Americans largely indifferent to the issues that excited his imagination. Europe had unlocked vital and profitable themes for him, but his short temper and sensitivity to criticism deflected him from his work. While Cole continued to paint and hope and sometimes mutter, Cooper took on

his critics in destructive detail. He did not return to the European theme in his fiction, but the literary and moral discoveries he made abroad remained with him as his legacy from the European scene.

Notes

1. William Cullen Bryant, "To Cole, the Painter, Departing for Europe," *Poetical Works of William Cullen Bryant, Collected and Arranged by the Author* (New York: D. Appleton and Company, 1878), p. 181.

2. James Fenimore Cooper, *The Letters and Journals of James Fenimore* Cooper, ed. James Franklin Beard, 6 vols. (Cambridge, Mass.: Harvard University Press, 1960), 1:24.

3. Ibid., p. 77; see also pp. 70-74, 76-79, 92-93, 105-7.

4. Ibid., p. 87. Cooper quarrelled with the DeLanceys and moved away from the land in question. Although communications were later restored, Peter DeLancey's will, dated January 23, 1823 and probated in March 1828, left his bequest to his daughter in trust "for her sole and separate use independent of her husband." Ibid., p. 344.

5. Ibid., p. 84. Beard offers a great deal of important information about Cooper's financial situation.

6. See James Grossman, *James Fenimore Cooper,* The American Men of Letters Series (New York: William Sloan Associates, 1949), p. 40.

7. See reference to Irving in an 1826 letter to Henry Colburn, in Cooper, *Letters,* 1:166.

8. Ibid., p. 127; 2:156.

9. According to Beard, Cooper not only paid off his debts but accumulated considerable capital during his European stay. Ibid., 2:47.

10. The best source for Cooper's activities in Europe is Robert Spiller, *Fenimore Cooper, Critic of his Time* (1931; reprint ed., New York: Russell & Russell, 1963).

11. William Charvat stressed Cooper's disciplined professional habits in "Cooper as Professional Author," in *James Fenimore Cooper, A Re-Appraisal,* ed. Mary Cunningham (Cooperstown: New York State Historical Association, 1954), pp. 497-98.

12. Cooper, *Letters,* 1:148.

13. Ibid., p. 152.

14. See James T. Callow, *Kindred Spirits: Knickerbocker Writers and American Artists, 1807-1855* (Chapel Hill: University of North Carolina Press, 1967).

15. See Horatio Greenough, *Letters of Horatio Greenough, American Sculptor,* ed. Nathalia Wright (Madison: University of Wisconsin Press, 1972), pp. 24, 168. Cooper wrote to President Andrew Jackson, recommending Greenough for a government position. See Cooper, *Letters,* 2:233-35.

16. Cooper, *Letters,* 1:111. Greenough to Allston, April 18, 1829, Dana Family Papers, Massachusetts Historical Society, Boston, Mass. In 1833 Cooper tried to buy a painting of Allston's *Elijah in the Desert Fed by Ravens,* owned by Henry Labouchère in London. See Cooper, *Letters,* 2: 397.

17. Cooper, *Letters,* 2:165, 239. Greenough, *Letters,* p. 153. Cooper, *Letters,* 2:163.

18. In a different context, Blake Nevius discusses the changes in Cooper's

picturesque vision brought about by his European travels in *Cooper's Landscapes, An Essay on the Picturesque Vision* (Berkeley and Los Angeles: University of California Press, 1976).

19. The best account of Cooper's friendship with Lafayette is Robert Spiller, "Fenimore Cooper and Lafayette: The Finance Controversy of 1831-32," *American Literature* 3 (March 1931): 28-44. See also Spiller's *Fenimore Cooper, Critic of his Times.*

20. Stephen Railton, *Fenimore Cooper: A Study of his Life and Imagination* (Princeton, N.J.: Princeton University Press, 1978).

21. See Spiller, "Fenimore Cooper and Lafayette."

22. Many of the original letters and journals are unlocated, but several can be found in Cooper, *Letters.* Comparisons with the published versions show little significant change.

23. Only *France* and *England* have been reprinted in the twentieth century, edited and introduced by Robert Spiller for Oxford University Press in 1928 and 1930.

24. James Fenimore Cooper, *Gleanings in Europe: [France],* ed. Robert E. Spiller (1837; reprint ed., New York: Oxford University Press, 1928), p. xxxiii.

25. [James Fenimore Cooper], *Sketches of Switzerland, by an American,* 2 vols. (Philadelphia: Carey, Lea & Blanchard, 1836), 1: 173.

26. *Gleanings in Europe: [France],* p. xxxiii.

27. Washington Irving, *The Sketch Book of Geoffrey Crayon, Gent.,* 7 vols. (New York: C. S. Van Winkle, 1819), 1:10.

28. James Fenimore Cooper, *Gleanings in Europe. Volume Two. England,* ed. Robert E. Spiller (1837; reprint ed., New York: Oxford University Press, 1930), p. 35.

29. Ibid., pp. 79-80.

30. Quoted in Grossman, *Cooper,* p. 56. Hazlitt attacked Cooper to make his hero Walter Scott shine more brightly by comparison.

31. These included Sunday parties and gatherings with political implications. See Cooper, *Letters,* 1: 146; Cooper, *Gleanings in Europe: [France],* p. 350.

32. Cooper, *Letters,* 2: 346.

33. See reviews cited by Cooper in *A Letter to his Countrymen* (New York: John Wiley, 1834).

34. Cooper, *Gleanings in Europe: England,* pp. 71-72. Cooper, *Sketches of Switzerland,* 1: 243-44.

35. [James Fenimore Cooper], *Gleanings in Evrope, Italy: by an American,* 2 vols. (Philadelphia: Carey, Lea, and Blanchard, 1838), 1:103, 41-42.

36. Cooper, *Gleanings in Europe: England,* pp. 29-30, 81, 111, 150-51, 167n, 209, 286-92.

37. Cooper, *Sketches of Switzerland,* 1:244.

38. Ibid., p. 23.

39. Cooper, *Gleanings in Europe: England,* pp. 79-80.

40. Cooper, *Sketches of Switzerland,* 1: 87-88, 1-10.

41. See reviews quoted in Cooper, *Letters to his Countrymen.*

42. Cooper, *Letters,* 1: 425.

43. James Fenimore Cooper, *The Heidenmauer, or the Benedictines* (New York: G. P. Putnam's Sons, Leatherstocking Edition, n. d.), p. 85.

44. From *Miles Wallingford,* quoted by Beard in Cooper, *Letters,* 3: 140-41.

45. In this assessment I disagree with a number of critics, including James Grossman and Donald Ringe, who list *The Water-Witch* among the other novels with American settings, rather than with the European trilogy that followed. See Grossman, *Cooper,* pp. 70-73, and Donald Ringe, *James Fenimore Cooper* (New York: Twayne Publishers, Inc., 1962), pp. 53-54.

46. James Fenimore Cooper, *The Water-Witch* or *The Skimmer of the Seas* (New York: G. P. Putnam's Sons, Leatherstocking Edition, n. d.), p. iii. For date of preface see Arvid Schulenberger, *Cooper's Theory of Fiction, His Prefaces and their Relation to his Novels* (Lawrence: University of Kansas Publications, 1955), p. 34.

47. For discussion of the "mock-renegade" in Cooper's fiction, see Harry B. Henderson III, *Versions of the Past: The Historical Imagination in American Fiction* (New York: Oxford University Press, 1974), pp. 51-54.

48. Grossman finds the alderman to be "the true romantic figure in the tale," praising "his elaborate rhetoric, rich with the imagery of trade and ledgers," which "turns the world into gold." Grossman, *Cooper,* p. 72. Such a view, while interesting, ignores the novel's broader value structure; Cooper would not agree.

49. For a careful exploration of this structure throughout Cooper's works see John P. McWilliams, Jr., *Political Justice in a Republic: Fenimore Cooper's America* (Berkeley: University of California Press, 1973).

50. National character-types were used in *The Pioneers,* but there they served chiefly for comic relief and atmosphere. None of the major figures was portrayed in a national stereotype.

51. See Neil Harris, *The Artist in American Society: The Formative Years, 1790-1860* (New York: George Braziller, 1966), especially chap. 2.

52. Cooper, *Water-Witch,* pp. 28-29, 89.

53. Ibid., p. 100.

54. Ibid., p. 276; Cooper, *Letters,* 1: 424-25.

55. See, for example, Cooper, *Water-Witch,* p. 245.

56. A number of critics have commented on the influence of Shakespeare, and particularly *The Merchant of Venice.* See Yvor Winters, *In Defense of Reason* (Denver, Colo.: Alan Swallow, 1947), p. 197; George Dekker, *James Fenimore Cooper, the American Scott* (New York: Barnes & Noble, Inc., 1967), pp. 123-25.

57. Cooper, *Water-Witch,* pp. 107-8.

58. Ibid., pp. 294-95.

59. See Grossman, *Cooper,* p. 71; Ringe, *James Fenimore Cooper,* p. 50.

60. Cooper, *Letters,* 2: 75.

61. See Ringe's discussion of *The Bravo* in *James Fenimore Cooper,* and also in *The Pictorial Mode, Space & Time in the Art of Bryant, Irving & Cooper* (Lexington: University of Kentucky Press, 1971), pp. 114-21.

62. Cooper, *A Letter to his Countrymen,* pp. 11-13.

63. This last passage was cancelled in the manuscript but has been restored by modern editors. See Cooper, *Letters,* 2: 98.

64. Cooper, *A Letter to his Countrymen,* pp. 11-13.

65. McWilliams, *Political Justice,* p. 160; also see Russell Kirk, "Cooper and the European Puzzle," *College English* 7 (January 1946): 198-207. See also an in-

teresting discussion of Cooper's concept of "aristocracy" in Allan M. Axelrad, *History and Utopia: A Study of the World View of James Fenimore Cooper* (Norwood, Pa.: Norwood Editions, 1978).

66. James Fenimore Cooper, *The Bravo* (New York: G. P. Putman's Sons, Leatherstocking Edition, n. d.), pp. 148, 147.

67. Ibid., pp. 170-71.

68. Ibid., p. 9. For the connection between Gothic and Byronic heroes, see Mario Praz, *The Romantic Agony*, 2d ed., trans. Angus Davidson (New York: Oxford University Press, 1970), chap. 2.

69. Cooper, *The Bravo*, p. 87.

70. Grossman, *Cooper*, p. 79.

71. In particular, I feel the moonlight meeting in the heretic's graveyard is poorly handled from the point of view of plot. Cooper has Jacopo reveal his secret to Don Camillo but keeps the reader in suspense.

72. See Harry Levin, *The Power of Blackness, Hawthorne, Poe, Melville* (New York: Alfred A. Knopf, 1958).

73. There was a Gothic novel on a similar subject, Monk Lewis' *The Bravo of Venice* (1805), an adaptation of J.H.D. Zschokke's *Abaellino, the Bravo of Venice* (1794), which also formed the basis of a play by William Dunlap, published in 1820. See Nathalia Wright, *American Novelists in Italy, the Discoverers: Allston to James* (Philadelphia: University of Pennsylvania Press, 1965), pp. 127-28. However, Cooper apparently learned of Lewis' book only after finishing his own. See Cooper, *Letters*, 2: 80.

74. Cooper, *The Bravo*, p. 342.

75. Ibid., p. 364.

76. Ibid., p. 381.

77. Cooper, *Letters*, 2: 169-70.

78. Ibid., p. 88.

79. Ibid., p. 134.

80. Ibid., p. 110.

81. Ibid., p. 237.

82. "Cassio," review of *The Bravo, New York American*, 13, no. 4190 (June 7, 1832): 1-2.

83. See, for example, a letter to Mrs. Peter Augustus Jay, June 16, 1831, in Cooper, *Letters*, 2: 110-11.

84. Cooper's friends gave him ill-considered support in this belief. A naval friend, Thomas Paine, erroneously reported that he had seen the original article in the *Journal des Débats*, and Samuel F. B. Morse wrote from America that he had investigated the article's origin and a conspiracy was definitely afoot. See Dorothy Waples, *The Whig Myth of James Fenimore Cooper* (New Haven, Conn.: Yale University Press, 1938), pp. 92-94.

85. See Cooper, *Letters*, 2: 376-81.

86. James Fenimore Cooper, *Correspondence of James Fenimore-Cooper*, ed. James Fenimore Cooper, 2 vols. (New Haven, Conn.: Yale University Press, 1922), 1: 295.

87. Cooper, *Letters*, 2: 360.

88. Cooper, *Letter to his Countrymen*, p. 94. Although Cooper was wrong about the authorship of the Cassio review, he was correct in asserting that the attacks

on him had political overtones. Twentieth-century critics have shown that Cooper's examination of European political systems played into the raging debates between Democrats and Whigs and gained the furious animosity of the Whigs. (See Waples, *The Whig Myth;* McWilliams, *Political Justice.*) His attack on aristocracy and his defense of popular institutions had implications for American politics, as his readers were quick to notice. However, it is important not to give the political element more weight than it had for Cooper himself. He did not write *The Bravo* as Democratic party propaganda.

89. Quoted and dated in Shulenberger, *Cooper's Theory of Fiction,* p. 25.

90. Grossman, *Cooper,* p. 258.

5
NATHANIEL HAWTHORNE:
The Ambiguous Heritage

By the middle of the nineteenth century the relationship of Americans, particularly American artists, to the Old World had changed substantially. No longer did they present themselves as cultural supplicants, artistic apprentices, or presumptive savages, as had Allston and Cole, Irving and Cooper. Americans could point to a thriving native school in both art and literature. In 1858 the first transatlantic cable linked England with her former colony, and Samuel F. B. Morse made a contribution in science that he could never achieve in art as his code carried a message between Queen Victoria and President Buchanan. Americans no longer felt the excruciating pressure to prove themselves in European eyes that had afflicted Irving after his bankruptcy or Cole after his cold reception by the Royal Academy. The first phase of the American imaginative response to Europe was drawing to an end, while the second phase, epitomized by the international novels of Henry James and the historical meditations of Henry Adams, was about to begin.

At the point of transition between the earlier artistic voyagers in search of a national and artistic identity and their more critical, more self-confident successors, stands Nathaniel Hawthorne. Hawthorne sailed for Europe in 1853, at the height of his career, a well-recognized writer whose work had skillfully presented American subject matter in a polished, literate, cosmopolitan style. A European sojourn offered a rich field of material for a writer of his imaginative cast, and he expected a bountiful literary harvest from the experience. In some ways his expectations were fulfilled. *The Marble Faun*, published in 1860 and one of his most successful romances, used Italian art and architecture to explore questions of history and morality. But Hawthorne's European voyage also produced one of his bitterest disappointments, his inability

to finish a romance set in England. He was to struggle with this project for the remainder of his life.

Hawthorne's European phase has puzzled his critics. Some have dismissed the last decade of his life as an "anticlimax," a "precipitous descent" into artistic incoherence.[1] Others have admired his strenuous self-education, his responsiveness to new sights and his earnest efforts to incorporate his discoveries into his thoughts and works.[2] Certainly the attempt to shift the scene of his fiction so dramatically was a bold experiment for a writer so identified with a particular region, so immersed in its history and its meaning. Henry James, aware of the similarities between himself and Hawthorne but even more conscious of the gulf that separated them, saw Hawthorne as a kind of Lambert Strether, rising to the challenge of his new experiences although unable to recast his career in response to them. "I know of nothing more remarkable, more touching," he wrote, "than the sight of this odd, youthful-elderly mind, contending so late in the day with new opportunities for learning old things, and, on the whole, profiting by them so freely and gracefully." Yet, James concluded that despite all his efforts Hawthorne remained "the last of the old-fashioned Americans . . . the last specimen of the more primitive type of man of letters."[3]

Hawthorne approached Europe with many of the same questions, using much of the same vocabulary, as the previous generation had. He too sought to ponder the meaning of art and the meaning of history for an American artist. A satisfactory exploration of these questions continued to elude him, perhaps because of his own tendency to seek ambiguity, or perhaps, as James suggested, because he had so much to absorb. Like Allston, his vision outran his ability to express it, and he never completed the important work he hoped would deal with these questions.

Hawthorne too traveled to Europe largely for financial reasons. Although he had a solid literary reputation by the 1850s, his writings alone did not provide an adequate income for his family. Financial stability had been a problem for him from the beginning of his commitment to a literary career; it had delayed his marriage for several years, inspired him to invest his savings in the Brook Farm experiment, and led him to seek such dull but secure positions as that of surveyor in the Salem Custom House. As late as 1851 he had written to his sister-in-law that his budget was so tight he could not afford life insurance.[4] A promising opportunity for political patronage appeared when his friend and college classmate Franklin Pierce ran for president in 1852. Hawthorne put aside his literary projects to write a campaign biography, and the victorious Pierce repaid him by appointing him American consul in Liverpool.

Although Hawthorne welcomed the chance to travel abroad, the

financial reward was his primary inducement for accepting the office. The Liverpool consulate was considered an especially lucrative post, for the consul received a direct fee for each transaction at the busy port. Soon after taking office Hawthorne described his new job in his notebook and wryly pictured himself as a man of business counting up his profits: "The pleasantest incident of the day, is when Mr. Pierce (the vice-consul or head-clerk) makes his appearance with the account books, containing the receipts and expenditures of the preceding day, and deposits on my desk a little rouleau of the Queen's coin, wrapt up in a piece of paper."[5] "I like my office well enough," he wrote a friend in 1854, "but any official duties and obligations are irksome to me beyond expression. Nevertheless, the emoluments will be a sufficient inducement to keep me here. . . ."[6] Although he did not enjoy the work, Hawthorne felt he was making necessary progress toward financial security.

In practice, the consulate did not meet Hawthorne's most optimistic expectations, but it did provide for his basic needs. He had barely assumed office when Congress began to debate a law that would change the pay basis for consuls from fee collection to straight salary. Although he tried to mobilize the efforts of Horatio Bridge and other friends to fight the measure, Hawthorne saw his anticipated earnings dwindle. At his most pessimistic he wrote to Bridge that the reduction "will render the office not worth any man's holding," but when the bill finally passed in 1855 with provisions to be invoked in January 1856, he made the best of it.[7] "I shall get a pile big enough to live on, even putting my pen out of the question," he wrote William Ticknor and added that he would begin making economies immediately.[8] Although he frequently talked of resigning, he kept the post until the change in administrations brought a replacement in 1857. By the time he left office, Hawthorne had fulfilled his goal of storing up a nest egg for his family; in June 1855, Ticknor's accounts showed that he had reached his minimum goal of $20,000, and by March 1857, he estimated that he had saved $30,000. "This would have seemed to me a fortune, five or six years ago; but our ideas change with our circumstances, and I now perceive that is a bare competence. But the embroidery and trimmings shall come out of my inkstand."[9]

Hawthorne's service in the Liverpool consulate, then, represented a financial venture that was designed to generate capital needed for his family's future. It was a prudent gesture on the part of a forty-nine-year-old father of three children with no savings, but it had troubling implications for his literary career. His government post involved a substantial expense of energy and personality. Meeting American travelers, speaking at civic banquets, and visiting hospitals, prisons, even madhouses on behalf of American citizens left Hawthorne feeling drained and used up. "Thank heaven, I am a sovereign again, and

no longer a servant," he wrote in relief after resigning his position.[10]
With such a demanding schedule, Hawthorne felt he could not do any
writing during his term as a government official.[11] In taking up the
consul's duties he laid aside his pen at the very height of his popularity
and productivity.

Hawthrone had earlier interrupted his literary work in search of
financial security. During his residence at Brook Farm and during his
term of office as surveyor in the Salem Custom House he wrote little,
concentrating his energies on the job at hand. The surveyorship tapped
the sociable, gregarious side of Hawthorne's nature that also manifested
itself in his lifelong friendships with men of affairs like Franklin Pierce,
Horatio Bridge, William Ticknor, and James Fields.[12] Although he
complained about the tedium of his government post, he enjoyed his
contact with ordinary, unliterary folk. The experience provided "a
change of diet," he later wrote, from his spiritual and intellectual
friendships.[13] Similarly, the Liverpool consulate brought him into contact
with interesting characters who widened his experience of human
nature and offered possible subjects for later literary exploration.[14]
Although he protested that he found his official duties distasteful,
Hawthorne fulfilled these social obligations with style and a sense of
humor, even learning to deliver polite after-dinner speeches at official
banquets.[15] But, as he had found earlier in Salem, this bustling public
career left him little time for the quiet reflection he needed for his writing.

During his years as consul, then, Hawthorne's responses to the European
scene were confined to his letters and journals. These sources indicate
three different stages in his attitude toward his European experiences.
The notebooks he kept in England begin rather sparsely with accounts
of his activities as consul, family life, and rare sight-seeing excursions.
During these early months, Hawthorne devoted most of his energies
to his public duties. He turned down an invitation to join his friend
Ticknor in London shortly after his arrival because "it will be just at
the beginning of my administration, and it will never do for me to run
away at once" and generally stayed close to Liverpool and his work
during his first year abroad.[16]

After the disappointing struggle over consular salaries, Hawthorne
felt less committed to his office and began to yearn to move away from
business and to resume his imaginative and literary activities. In April
1855, he wrote of his impatience with his consular duties: "I don't think
I am quite so well contented here, as before this disturbance about the
Consular Bill. . . . I have confined myself too closely to the consulate
during my stay here. There is no sense in making a prisoner of myself,
and so I mean to enjoy England while I have the opportunity."[17] Be-
ginning in the spring of 1855 the Hawthornes traveled more extensively
in England, and the notebooks reflect his growing interest in observing

and recording the scenes around him. As his commitment to public life weakened, his literary activities increased, and during his last thirty-two months in England, Hawthorne wrote in his notebook at a rate triple that of his first twenty-one months.[18] This attention to his journal marked the shift in Hawthorne's energies back toward the literary realm. In October 1854, he had answered Ticknor's question about the possibility of his writing a new book with a firm refusal: "There is no prospect of that, so long as I continue in office." But in January 1855, he wrote that he was ripening "the germ of a new Romance in my mind."[19] By the end of his stay in England, he was including in his notebook running thoughts on this new romance and stocking it with descriptions of places and scenes to serve as the basis for later writing.[20] He even felt a certain pride in the journals as literary efforts themselves, although he denied their suitability for publication: "It would bring a terrible hornet's nest about my ears."[21]

Hawthorne and his family left England in January 1858 for a visit to the Continent. In this third stage of his development, public life no longer interfered with his writing, but tourism did. He struggled to bring his ideas into focus while handling the day-to-day details of a peripatetic existence and making the most of his travels in France and Italy. He cautioned Ticknor not to be too eager for a new work: "As regards the announcement of a book, I am not quite ready for it. If I could be perfectly quiet for a few months, I have no doubt that something would result; but I shall have so much to see while I remain in Europe, that I think I must confine myself to keeping a journal."[22]

In seeking a way to turn his European experiences to literary account, Hawthorne found himself working under conditions different from those he had formerly found productive. His best writing had always been done in isolation, first in the bachelor solitude of his youth, then in such snug family retreats as the Little Red House in Lenox and the Old Manse and the Wayside in Concord. He delighted in portraying himself as shy and retiring; in the preface to the 1851 edition of *Twice-Told Tales* he described himself as "the obscurest man of letters in America."[23] Although it is now clear that Hawthorne was by no means the moonbeam-stricken recluse he sometimes pretended to be, his American tales and romances represented a long, slow process of assimilation and meditation.[24] In Europe he had to contend not only with the demands of a public career and an unsettled life but also with the novelty and changeability of the very impressions he was trying to record. A lifetime in New England had prepared him to write his American romances; now he was trying to write about an environment he saw in new ways every day. Fresh impressions and reevaluations of old ones continued to flood his notebooks even while he labored to shape them into fiction.

In Europe, Hawthorne was trying to make romance out of his ex-

periences as a tourist. Like Cooper and every other American traveler
for the preceding thirty-five years, he was well aware of the brilliant
literary use Irving had made of the tourist's stance of observation and
meditation. Still, Irving had worked within a clearly defined framework
of assumptions about the European scene. As Hawthorne prepared his
own literary response to the Old World, he had to deal with the con-
ventions that governed Americans' views of Europe. His notebooks
show him watching himself watching the scenery, observing his own
responses and comparing them to his expectations.

Hawthorne and his family had crossed the ocean well prepared with
guidebooks and history books. They were dutiful sightseers, although he
admitted that his wife's judgment rather than his own often shaped their
excursions.[25] Sophia Hawthorne, who had studied art as a young woman,
led her family on a round of churches, galleries, museums, and art
exhibitions in England and in Italy, which she had longed to visit since
girlhood.[26] Sparked by his wife's enthusiasm, Hawthorne struggled to
adopt a conventional response toward European art and history and
hoped that the experience of travel would be "elevating and refining"
for them all.[27]

Despite his desire to take a reverential stance toward the European
scene, Hawthorne continually found himself vexed by his inability to
sustain the expected mood and tone. Even the sceptical Cooper had been
moved to a state of ecstatic "toosey-moosey" by his first visit to an
English ruin.[28] In contrast, Hawthorne mourned the inadequacy of the
Chester Cathedral on his first visit there: "An American must always
have imagined a better cathedral than this; although it is a great, old,
dreary place enough."[29] The more famous the historical site, the deeper
Hawthorne's disappointment seemed to be. "I have come—I think,
finally—to the conclusion, that there was a better St. Peter's in my mind,
before I came to Rome, than the real one turns out to be. . . . This
gay piece of cabinet-work, big as it strives to be, cannot make up for
what I have lost."[30] Again and again the journals record Hawthorne's
sense of the difference between the way he felt he should respond to
various sites and the way he did respond. He concluded that "it is useless
to attempt a description" of Westminster Abbey. "These things are not
to be translated into words; they can be known only by seeing them, and,
until seen, it is well to shape out no idea of them."[31] Yet the problem
lay not with his own craftsmanship but with the endeavor itself: Hawthorne
was flogging himself to participate in a tradition that had lost its vitality.
The sights he struggled to depict in the journals had been portrayed so
often in words and in pictures that it was almost impossible for him to
feel their impact directly. "It is wearisome, on the whole, to go the
rounds of what everybody thinks it necessary to see. It makes one a
little ashamed; it is somewhat as if we were drinking out of the same

glass and eating from the same dish as a multitude of other people."[32] Irving had been able to laugh at his own reverence for the European scene, but Hawthorne probed and scrutinized his responses, and marveled at their fragility.

Hawthorne most directly faced his sense of discomfort at walking in well-trodden paths during his visits to literary sites. Throughout his stay in England, he planned trips and excursions to places associated with writers of the past, paying tribute to Scott at Abbotsford, Burns at Dumfries, Shakespeare at Stratford, Byron at Newstead Abbey, Johnson at Uttoxeter, Wordsworth and Southey in the Lake District. But viewing these sites, in many cases visiting the homes of these writers, aroused contradictory emotions in Hawthorne.

The first and most conventional of these literary pilgrimages exemplified the contradictions. Hawthorne visited Stratford-on-Avon in June 1855, during his family's earliest tour of England. At Stratford he was forced to confront not only his own feelings of awe and reverence for Shakespeare but also the long tradition of visits, and descriptions of visits, by other writers, Irving among them. In his journal account of the excursion he tried to summon up the proper spirit, remarking for instance "cottages . . . so old that Shakespeare might have passed them in his walks, or entered their gates"; but he could not conceal his disappointment at the encounter. Shakespeare's birthplace was "almost a worse house than anybody could dream it to be." Furthermore, he continued, "it gives a depressing idea of the humble, mean, sombre character of the life that could have been led in such a dwelling as this." Irving too had been disappointed in Shakespeare's house, but he had used his visit to the grave and the Lucy mansion to evoke a sense of kinship with the great writer. Hawthorne could only record the afternoon's sights and wonder at his inability to respond to them. "I felt no emotion whatever in Shakespeare's house—not the slightest—nor any quickening of the imagination," he wrote. "It is agreeable enough to reflect that I have seen it; and I think I can form, now, a more sensible and vivid idea of him as a flesh-and-blood man; but I am not quite sure that this latter effect is altogether desirable." Instead of feeling a sense of communion with a literary mentor he was left with the sense of fulfilling the dreary obligation of a conscientious tourist. "We had now done one of the things that an American proposes to himself as necessarily and chiefly to be done, on coming to England," he wearily concluded.[33]

Almost all his literary pilgrimages ended on this discordant note. His trip to Uttoxeter to see the spot where Samuel Johnson had performed a penance gave him a brief sense of pleasure; but his difficulty in catching a return train left him weary and distinctly unsentimental: "I spent I know not how many hours in Uttoxeter, and, to say the truth, was heartily tired of it; my penance being a great deal longer than

Dr. Johnson's."[34] When a guide pointed out Wordsworth's house at Rydal Lake, he joined his family in their admiration for the spot, "peer[ing] about" and "quickening up our enthusiasm as much as we could, and meditating to pilfer some flower or ivy-leaf from the house or its vicinity, to be kept as sacred memorials."[35] But Hawthorne had depicted his own enthusiasm only to deflate it: the guide was misinformed, and they narrowly missed memorializing the wrong house. Byron's home made Hawthorne feel once more like a part of a tourist throng: "I suppose ten thousand people (three-fourths of them Americans) have written descriptions of Newstead Abbey."[36] A visit to Burns country left him as depressed as the visit to Shakespeare's house, and Abbotsford was smaller and less impressive than he had imagined: "Its aspect disappointed me," he wrote, adding ruefully, "so does everything."[37]

Hawthorne's experience at Abbotsford helps to explain why the literary pilgrimages were so difficult and so important for him. On a tour of the house, he tried to summon up a sense of Scott's presence from the various memorabilia he was shown: clothing, a walking-stick, a bust. He felt this effort to be most successful in the room Scott died: "It seemed to me that we spoke with a sort of hush in our voices, as if he were still dying here, or but just departed." In the writer's study, however, the guide brought Hawthorne into conjunction with Scott in an unsettling way, for it cut to the heart of his purposes in these visits. "The servant told me I might sit down in this chair," Hawthorne wrote in his journal, "for that Sir Walter sat there while writing his romances; 'and perhaps,' quoth the man, smiling 'you may catch some inspiration!' What a bitter word this would have been, if he had known me to be a romance-writer! 'No, I never shall be inspired to write romances,' I answered, as if such an idea had never occurred to me." Characteristically, Hawthorne responded to the incident with self-deprecating humor. As he well knew, literary creativity was no simple matter of lightninglike inspiration. Yet he was traveling to "catch" something that would be of use to him in his writing. The unexpected invitation to compare himself with Scott only increased his discomfort. The last thing he wanted, as he wandered idly through England, was to be compared to the prolific author of the *Waverley* novels. Moreover, Scott's world was closed to him. Irving had been entertained at Abbotsford, and Cooper had known Scott in Paris; but the great romancer had been dead for a quarter of a century, and Hawthorne could approach no closer to him than he could to Shakespeare or to Burns. "I felt angry with myself," he wrote after leaving Abbotsford, "for not feeling something which I did not and could not feel. . . . I cannot but confess a sentiment of remorse for having visited the dwelling-place—as, just before, I visited the grave—of the mighty minstrel and romancer, with so cold a heart, and in so critical a mood;—his dwelling place and his grave, whom I so admired and loved,

and who had done so much for my happiness, when I was young." Try as he might, he could not respond to his experience in the terms outlined by the previous generation of literary travelers: "I, and the world generally, now look at him from a different point of view."[38] Even Scott, who remained Hawthorne's touchstone of literary success (he read the *Waverley* novels aloud to his family during the dark days of the Civil War) did not give him what he expected to find, and his own responses remained a source of puzzlement to him.

Like so many other Americans, Hawthorne the tourist sought in the European scene remnants of a Western heritage: works of art and historical remains. As a writer, however, he sought his heritage in another sense, pondering the scenes that could give him a sense of belonging to a literary tradition. Like Allston he wanted to walk in the footsteps of the Old Masters, to claim their fellowship. In one particularly moving passage from his Italian notebook Hawthorne recorded his shifting thoughts as he stood at Petrarch's birthplace before a well that had figured in one of Boccaccio's tales. "There is no familiar object, connected with daily life, so interesting as a well; and this well of old Arrezzo, whence Petrarch had drunk, around which he had played in his boyhood, and which Boccaccio has made famous, really interested me more than the Cathedral." In the midst of a literary pilgrimage, Hawthorne thought with pride of his own achievements, in this case, "Rills from a Town-Pump," a frequently reprinted sketch. "As I lingered round it, I thought of my own Town Pump, in old Salem, and wondered whether my townspeople would ever point it out to strangers, and whether the stranger would gaze at it with any degree of such interest as I felt in Boccaccio's well." Although he answered his own question with apparent modesty—"Oh, certainly not,"—he went on to affirm his sense of literary achievement:

But yet I made that humble Town-Pump the most celebrated structure in the good town; a thousand and a thousand people had pumped there, merely to water oxen, or fill their teakettles; but when once I grasped the handle, a rill gushed forth that meandered as far as England, as far as India, besides tasting pleasantly in every town and village of our own country. I like to think of this, so long after I did it, and so far from home, and am not without hopes of some kindly local remembrance on this score.[39]

Wandering far from his own roots, Hawthorne pondered the meaning of rootedness. In paying homage to the talents of classic writers his thoughts turned to his own hopes for literary immortality.

Passages like these show that Hawthorne the tourist was still Hawthorne the writer. Although he tried to share in the conventions of European sightseeing, filling his notebooks with views of "St. Peter's or the Coliseum; the cascade of Terni, or the Bay of Naples," the well-trodden paths

continually disappointed him.[40] The scenes that most fully engaged his attention were those that brought him into contact with his literary predecessors, and the confrontation often was not a comfortable one.

Even before he left the consulate, Hawthorne had begun to consider various possible literary uses for his European materials. Although he had warned his publisher he might not attempt any fiction before returning home, he made a few notes in Liverpool and began the work of drafting scenes and outlining the plot for an English romance, The Ancestral Footstep, in Rome in April 1858. He worked steadily on the project until his family departed for a tour of the Italian countryside in late May. In six weeks of work he produced an outline with several promising elements and many problems. As the organizational difficulties multiplied, he found himself distracted by other projects. Later that summer when his family settled in Florence, he began to develop some ideas he had jotted down after a visit to a sculpture gallery. By September 1, 1858, he had completed a preliminary sketch for The Marble Faun (1860), and he revised it in England in the summer and fall of 1859.

After his return to America in June 1860, Hawthorne resumed work on the English romance and wrote two more drafts of it. By the autumn of 1861, however, he had become discouraged again and laid the manuscript aside to work on a new romance with a different theme and to complete a series of essays on English life for the Atlantic. When the English essays were collected in Our Old Home (1863), Hawthorne reluctantly bade farewell to his hopes for the romance based on his English experiences: "I once hoped, indeed, that so slight a volume would not be all that I might write. . . . I should not mention this abortive project, only that it has been utterly thrown aside, and will never now be accomplished."[41] After this publication, Hawthorne's health declined rapidly, and he died in 1864. Following his death, his son and other literary executors published the first working draft of The Ancestral Footstep, as well as a composite of his English manuscripts entitled Doctor Grimshawe's Secret, and two fragments of the final project, Septimius Felton and The Dolliver Romance.

From the chaos of Hawthorne's final years, The Marble Faun stands as a successful work, unified, effective, and promptly executed. This romance fulfils many of its author's hopes for his European venture. It uses its setting in the Italian landscape, among Roman antiquities and in the artist's colony to provide romance, mystery, and a link with past ages; and it contrasts the moral condition of the New World with that of the Old. As Hawthorne wrote in the preface to the romance in a passage that strongly impressed Henry James, America had "no shadow, no antiquity, no mystery, no picturesque and gloomy wrong, nor any-

thing but a common-place prosperity, in broad and simple daylight.''[42] Like Cole and Bryant, Hawthorne pondered in Europe "the trace of men" and its meaning for Americans.

Hawthorne was especially successful in *The Marble Faun* in evoking the conventions of European travel as a basis for his romance. Employing the viewpoint of an artist, a "Man of Marble," Hawthorne capitalized on his readers' interest in the lives of American artists abroad.[43] In his descriptions of the monuments of Rome and its surroundings, Hawthorne used a frame of reference so familiar to his readers that, as James noted, *The Marble Faun* itself became a sort of guidebook for American tourists in Italy.[44] The romance brims with vignettes of the Roman Empire that are often truncated or allusive, as if referring the reader to a well-known heritage. As surely as Cooper and Cole, Hawthorne found in the material remains of Italy concrete symbols of empire, of the mystery of the rise and fall of nations. In "A Moonlight Ramble" and the following chapters, the American artists wander through Rome, stopping at various monuments that reflect the lessons of the past for the present. "There are sermons in stones," proclaims Hilda, "and especially in the stones of Rome.''[45] They sing "Hail Columbia" as they walk, thus contrasting their own hopeful New World empire with the hallowed but bloodstained one whose remains they trace.

Hawthorne's Italy, however, is the province of art as well as history, and his descriptions of art objects give *The Marble Faun* much of its thematic unity. Hawthorne's notebooks show his diligent efforts to educate himself in the visual arts. In Rome and Florence he visited and revisited picture galleries and sculpture halls, and wrote long descriptions of famous art works. But it was no easier for him to accept a pious and conventional view of art objects, like the ones his wife Sophia recorded in her journals and the ones his exemplary maiden Hilda articulated, than it was for him to view his literary pilgrimages without irony. "I cannot always 'keep the heights I gain,' " he complained. "After admiring and being moved by a picture, one day, it is within my experience to look at it, the next, as little moved as if it were a tavern-sign.''[46] On another occasion he observed, "As regards the interpretation of this, or any other profound picture, there are likely to be as many as there are spectators. . . . Each man interprets the hieroglyphic in his own way; and the painter, perhaps, had a meaning which none of them have reached; or possibly he put forth a riddle without himself knowing the solution." A great picture, he continued, is "a great symbol, proceeding out of a great mind; but if it means one thing, it seems to mean a thousand, and often opposite things.''[47]

If these comments show his frustration with the aesthetic principles commonly accepted by his contemporaries, they also point to the solution he found to the problem of how to write about art in his romance.

The great symbol maker recognized in the visual arts another hieroglyphic awaiting interpretation. Like the celestial "A" in *The Scarlet Letter*, art objects in *The Marble Faun* function as reflectors, revealing less about themselves than about the viewer. Miriam's response to the painting of the archangel Michael, for instance, shows her lively awareness of the struggle between good and evil, while Hilda's shows her serene moralism. Descriptions of Guido Reni's *Beatrice Cenci*, the *Faun* of Praxiteles, Kenyon's statue of Cleopatra, and numerous other art works provide his romance with just the sort of dense and meaningful atmosphere he found most favorable to the imagination.

The Marble Faun has been well discussed by Hawthorne's critics, but placing it in the context of a previous generation's fascination with art and history, we may appreciate even more fully Hawthorne's skillful exploitation of the conventions of European travel. Because he combined the detachment of a traveler with the sympathy of an artist, Hawthorne's American characters were able to explore the Old World without being corrupted by their experiences. Kenyon and especially Hilda stand outside their friends' situation, viewing it, judging it, moralizing upon it, but not themselves changing in any significant way. The success of *The Marble Faun* depends upon the steady viewpoint of its artist-travelers.

It was this steady point of view that was just what was lacking in the English romance. In all its various versions, the English romance dealt with an American who surrendered his detachment, who stepped outside the role of tourist to seek connection with the Old World. The hero of the romance, an American claimant to an English estate, was to undergo a process of change in the course of the book, but Hawthorne could never settle on a successful formula for depicting either the character's transformation or the circumstances that evoked it. This unrealized book, even more than the successful Italian romance, illustrates Hawthorne's prolonged struggle with the imaginative issues posed for him by his experience in the Old World.

Hawthorne had first recorded the idea for an English romance in his journal on April 12, 1855; "In my Romance, the original emigrant to America may have carried away with him a family secret, whereby it was in his power (had he so chosen) to have brought about the ruin of the family. This secret he transmits to his American progeny, by whom it is inherited throughout all the intervening generations. At last, the hero of the Romance comes to England, and finds that, by means of this secret, he still has it in his power to procure the downfal[l] of the family."[48] Hawthorne's first draft, entitled *The Ancestral Footstep*, begins with its hero, Middleton, coming upon the family mansion he seeks, and the romance in this version consists of his struggle to establish his claim, followed by his decision to relinquish it. In *Etherege*, the manuscript Hawthorne began after returning to America, he decided to

account for his hero's quest through a mysterious upbringing: the idea of his claim to an English estate is implanted in him in his youth by an eccentric doctor who becomes more sinister with each revision.[49] The book begins in America, with the hero as a young boy in Dr. Etherege's household. After a lapse of time, the boy, Ned, now grown, goes to England to unravel the mystery, the details of which Hawthorne could never quite decide. By the end of his work on *Etherege*, Hawthorne developed the idea that the doctor was evil and the hero's claim false. The true heir now becomes the old pensioner who had first appeared as a guide in *The Ancestral Footstep*. The third manuscript, *Grimshawe*, describes in great detail the household of the old doctor, now named Dr. Grimshawe. Clues are introduced for the resolution of the mystery along the lines indicated at the end of *Etherege*. However, *Grimshawe* breaks off shortly after the hero's arrival in England. Although the story has remained similar, *Grimshawe* ends where *The Ancestral Footstep* began, and the hero's actual prosecution of his English claim remains undeveloped.

The intensity of Hawthorne's struggle with his English material is reflected in the form of the three manuscripts. He wrote his notes for *The Ancestral Footstep* in the form of a journal with dated entries containing scenes from various sections of the book, summaries of the plot, and the author's notes to himself on the story's progress and problems. Several times Hawthorne paused to review his plot, trying out different twists of characterization or turns of events. "I have not yet struck the true key-note of this Romance," he complained, "and until I do, and unless I do, I shall write nothing but tediousness and nonsense."[50] The second manuscript, begun after his return to America, made little linear progress on the romance. After writing several chapters Hawthorne would recast the whole plot, bringing crucial incidents or relationships up for revision. As the manuscript lengthened, his patience wore thin. He filled pages with facetious suggestions: "Shall he be preternatural?— not without a plausible explanation. What natural horror is there? A monkey? A Faulkenstein? A man of straw? A man without a heart, made by machinery? . . . What? What? What? A worshipper of the Sun? A cannibal? A ghoul? A vampire? . . . He has been poisoned by a Bologna sausage, and is being gnawed away by an atom at a time."[51] At the same time, he commented despairingly, "I can't make it out," " 'Twon't do," "What unimaginable nonsense?" "Pshaw."[52] Again and again Hawthorne spun off into frustrated babble only to admonish himself, "Try back again," and sketch out another version of the plot.[53] The third manuscript, *Grimshawe*, is a sustained effort at rewriting and contains many interpolations for stylistic alterations but none of the lengthy meditations on doubts about the plot that characterized the first two drafts. The *Grimshawe* manuscript, however, comes to an end at the beginning of the

English part of the plot. Rather than confront the problematic section of the romance, Hawthorne simply abandoned the project.

The common element to all three versions of the English romance is the American's search for an English heritage. At the beginning of *The Ancestral Footstep,* Middleton is only half in earnest in his claim, describing his errand as "half the amusement, the unreal object, of a grown man's play-day," a "dream," a "fantasy." Hawthorne notes, however, that the quest soon assumes more serious proportions for the hero, until finally "he sought his ancient home in [England] as if he had found his way into Paradise, and were there endeavoring to trace out the signs of Eve's bridal bower, the birth-place of the human race and all its glorious possibilities of happiness and high performance."[54] The Edenic imagery emphasizes Hawthorne's desire to portray a return to moral origins as well as historical ones.

The American's English connection is not solely a blessing; he seeks an ambiguous heritage. As Hawthorne conceived of the story, the original immigrant was the victim (or, later, the perpetrator) of a great wrong, and the American descendent carried with him the power to bring past misdeeds to light and perhaps to cause evil himself. In *The Ancestral Footstep,* Middleton pauses before a visit to his ancestral home to ponder the possible results of his claim: "He remembered to have heard or read, how that once an old pit had been dug open, in which were found the remains of persons, that, as the shuddering by-standers traditionally remembered, had died of an ancient pestilence; and out of that grave had come a new plague, that slew the far-off progeny of those who had first died by it. Might not some fatal treasure like this, in a moral view, be brought to light by the search into which he had so strangely been drawn?"[55] In *Etherege* and *Grimshawe,* the American's claim is manufactured by the doctor, who weaves a web as subtly—and perhaps as lethally—as the spiders he studies. "Hold on to this," Hawthorne reminded himself as he sketched the doctor's character: "A dark, subtle manager, for the love of managing, like a spider sitting in the centre of his web, which stretches far to east and west."[56] The English estate, seemingly so desirable, may be a pestilence or a trap.

The dark aspects of the English connection are symbolized most directly by the old manor house itself. From beginning to end, Hawthorne associated his English romance with a legend that he had first heard at a dinner party in 1855. Two of his fellow guests, Mr. and Mrs. Ainsworth, had told him about a bloody footstep in the entrance hall of their home, Smithell's Hall, which was said to have been left by a martyr of the reign of Queen Mary. Hawthorne later visited the house and recorded his impressions in great detail, commenting, "the legend is a good one."[57] Literally the impress of a past wrong, the bloody footstep seemed to offer just the sort of dense symbol that Hawthorne could use to organize his

romance. In all three drafts, the footstep provides the sign by which the American claimant can recognize his ancestral home. In Hawthorne's formulation, the footstep records not religious persecution but fraternal enmity; it marked the departure of the original emigrant "in a bloody agony," guilty of a crime against his brother or violently sought by him.[58] In returning to the mansion and putting his own foot on the bloodstained spot on the stone, as the American does in both *The Ancestral Footstep* and *Etherege,* he symbolizes his return to his origins and takes upon himself the burden, for good or ill, of the past.

The subject of the English romance, then, is the American's search for a connection with an English past. He seeks a heritage that is ambiguous at best and perhaps positively evil. It is shrouded in mystery and leads back to the archetypical crime: the violence of brother against brother. Despite the risks, Hawthorne's hero finds himself drawn, impelled almost in spite of himself, to make that connection. In *The Ancestral Footstep* Hawthorne describes the hero's return to his origins as a jolt of electricity between two points "which being joined, an instantaneous effect must follow," comparing it to "the wires of an electric telegraph" united across the sea. Later in the same manuscript, Middleton reflects "how strong within him was the sentiment that impelled him to connect himself with the old life of England; to join on the broken thread of ancestry and descent, and feel every link well established."[59] In *Etherege* in which the impulse comes at least partly from the influence of the sinister old doctor, Hawthorne's American hero uses more florid language to describe his longing for a sense of connection. When the pensioner tries to warn him to abandon his quest, Ned Etherege breaks into an impassioned monologue:

My dreaming childhood dreamt of this. If you know anything of me, you know how I sprang out of mystery, akin to none, a thing concocted out of the elements, without visible agency—how, all through my boyhood, I was alone; how I grew up without a root, yet continually longing for one—longing to be connected with somebody—and never feeling myself so. . . . I have tried to keep down this yearning, to stifle it, annihilate it, with making a position for myself, with being my own past, but I cannot overcome this natural horror of being a creature floating in the air, attached to nothing; nor this feeling that there is no reality in the life and fortunes, good or bad, of a being so unconnected.[60]

In a sense, Hawthorne was forced to make the doctor evil in order to account for the otherwise unpalatable vehemence of his hero's desire for an English connection. As Nina Baym has pointed out, this change makes young Etherege more sympathetic because the obsession with an English claim can be accounted for by external rather than internal influences.[61] Yet still, the longing for connection, no matter how exaggerated, forms the core of the romance. Hawthorne's failure in the

romance sprang from his inability to find circumstances that would explain and then resolve that longing. The rift between the brothers was attributed to everything from love rivalry to murder to the enslavement of an impressionable servant. In the first draft the American was the true heir; later he became a collateral heir and then no heir at all but the unknowing instrument of the doctor's scheme of revenge. No matter how he manipulated the plot, Hawthorne could not give his romance a fictional life equal to the vivid emotion of longing that lay at its core.

What was the source of this passionate longing for connection? Why did Hawthorne struggle so to make it the heart of his romance, and why did he fail? In his journals, Hawthorne had recorded his own sense of connection to an English past: "My ancestor left England in 1635. I return in 1853. I sometimes feel as if I myself had been absent these two hundred and eighteen years—leaving England just emerging from the feudal system, and finding it on the verge of Republicanism. It brings the two far separated points of time very closely together, to view the matter thus."[62] In identifying himself directly with his ancestor and seeing his arrival as a return, Hawthorne indicated his own sense of connection with England, which he referred to in a series of essays as *Our Old Home*. Yet Hawthorne was hardly an Anglophile. His essays provoked angry criticism in England because of his derogatory remarks about English institutions and national character. His journals record a mixed set of reactions, including impatience with all things English. The mysterious sense of connection went beyond questions of judgment or even attraction.

Hawthorne expanded the image of the traveler as returned immigrant in an essay, entitled "Leamington Spa," which appeared in the *Atlantic* in 1862 and later in *Our Old Home*. "I felt, indeed, like the stalwart progenitor in person, returning to the hereditary haunts after more than two hundred years, and finding the church, the hall, the farmhouse, the cottage, hardly changed during his long absence—the same shady by-paths and hedge-lanes—the same veiled sky, and green lustre of the lawns and fields—while his own affinities for these things, a little obscured by disuse, were reviving at every step." As he pondered the reasons for his strong feelings for the English landscape, he realized that it was the product of a cultural, rather than a personal heritage. "Of course, the explanation of the mystery was, that history, poetry, and fiction, books of travel, and the talk of tourists, had given me pretty accurate preconceptions of the common objects of English scenery, and these, being long ago vivified by a youthful fancy, had insensibly taken their places among the images of things actually seen."[63] In his introduction to *The Sketch Book*, Irving had described the vicarious adventures of a young American reading travel books, and Allston had written that

he had read enough about Sir Joshua Reynolds to feel that he knew him. Hawthorne shared with many of his countrymen the shock of trans-atlantic recognition, the excitement of the traveler confronting his cultural roots.

In writing the preceding passage Hawthorne attributed his feelings of familiarity with England to the agency of literary tradition. For an American writer especially, England represented the old home, the source and inspiration of the tradition of which he wished to be a part. Yet, English society and institutions continually disappointed Hawthorne; as he wrote, "an American seldom feels quite as if he were at home among the English people."[64] Hawthorne would not have been tempted, as his hero was, by the possession of an English manor house and title. He had planned, in the introductory sketch to the romance, to deal humorously with the many deluded Americans who passed through his consular office seeking to prove their title to English estates. But he did seek one heritage vigorously and unambiguously: membership in the ranks of great writers. The issue with which he wrestled again and again in his notebooks as he toured Stratford, Abbotsford, Newstead Abbey, as he walked the streets of London thinking of Johnson and Pope, and as he visited Boccaccio's well, was the same issue that animated the English romance: how to establish a connection, to find one's rightful place, to receive one's due recognition. The English romances bear witness to the fact that Hawthorne, no less than Irving, Allston, Cole, and even Cooper, sought to participate in an artistic tradition and to wrest from the Old World recognition and confirmation of his own status as a writer.

Hawthorne used the image of the traveler as the personified progenitor in two of the drafts of the English romance. In *The Ancestral Footstep,* Middleton debates whether to continue his search, reflecting that "his rights here were just as powerful and well founded as those of his ancestor had been, nearly three centuries ago; and here the same feeling came over him, that he himself was that very personage, returned after all these ages, to see if his foot would fit that bloody footmark left of old upon the threshold."[65] In *Etherege* the American hero gazes raptly at the manor house that he thinks is his. "The thought thrilled his bosom, that this was his home;—the home of the wild western wanderer, who had gone away centuries ago, and encountered strange chances, and almost forgotten his origin, but still kept a clue to bring him back, and had now come back and found all the original emotions safe within him. . . . 'Oh home, my home, my forefathers' home! I have come back to thee! The wanderer has come back!' "[66] *Grimshawe* ends before this point, but even in the few pages with an English setting that are completed, there are a few references to his hero's mysterious affinity with his surroundings: " 'The lark! The lark!' exclaimed the

traveller, recognizing the note (though never heard before) as if his childhood had known it."[67] Yet despite his sense of exhilaration in recognizing his (presumed) English heritage, Hawthorne's hero in all three drafts keeps his identity a secret long after he has found the home for which he longs. He provokes discussions about the legend of the bloody footstep and even of the possibility of an American heir without revealing his own interest in the estate. Although he seeks the connection, he seems to fear it. He relishes his anonymity. Similarly, Hawthorne often enjoyed concealing his identity as a writer, as in the incident at Abbotsford when he told the guide, "I never shall be inspired to write romances." In France he had watched with amusement when his children's governess bought a copy of *The Wonder-Book* in French and engaged the bookseller in a discussion about the author.[68]

The connection with tradition that is so ardently desired by the hero of the English romance brings with it a combined excitement and anxiety. He desires recognition as the true heir, but open assertion of his claim will bring with it responsibility and perhaps a repetition of the ancient wrong. At various times Hawthorne sketched out violent confrontations between his American hero and the owner of the manor house: the Englishman shoots himself accidentally while attacking the claimant in one version, plots to poison him in another, imprisons him in yet another. By the end of *Etherege,* Hawthorne had invented an aged prisoner, concealed in the old manor house, who can bear witness to the Doctor's vendetta against the English family. Although Hawthorne could never hit upon a successful form for it, he continued to envision disaster as the inevitable result of the American's effort to claim an English heritage. Although Hawthorne desired recognition as a writer in the great tradition, perhaps he feared it as well. If he wrote a successful English romance would he betray his American origins? Would he place himself in uncomfortable competition with the present occupants of the house of English letters? Did the theme of fraternal strife unleashed by the American's claim reflect his own uneasy relationship with the brotherhood of writers? Although he attended many literary dinners and evenings, Hawthorne stayed curiously remote from most of his English peers. He recorded stories about Thackeray and Dickens but never met them; when he noticed Tennyson at a public exhibition in Manchester he circled about but did not approach him directly. Like his American hero, he both desired and avoided open acknowledgment of his fraternal claim.

Despite all his efforts, the English romance never surmounted its many weaknesses. To some extent, its fictional themes were already stale. He already had dealt exhaustively with the question of the influence of the past on the present and the expiation in one generation of sins committed in another in *The House of the Seven Gables* (1851).

In that book the heritage of the past also is symbolized by an old house, and the true heir, Holgrave, the descendent of the unjustly evicted Maule, knows the whereabouts of papers that could change the fate of the family. In *The Ancestral Footstep* Hawthorne had experimented with a scene directly reminiscent of the ending of *The House of the Seven Gables*: Middleton opens a secret compartment in an old chest, but the documents he exposes have crumbled into dust. As Hawthorne struggled to organize his plot he kept reaching for devices reminiscent of the earlier romance: a mysterious prisoner, a fresh and innocent American girl, a scheme for revenge. In one of his meditations on the plot, Hawthorne reminded himself, "The story must not be founded at all on remorse or secret guilt—all that I've worn out."[69] Although he had claimed that America could not furnish examples of a "picturesque and gloomy wrong," he had in fact dealt with that subject far more effectively in a New World setting than he could in his English romance.

Ultimately, Hawthorne failed to resolve the tension between the positive and negative aspects of the American claimant's quest in the same way that he failed to reconcile his own divided attitude toward literary tradition. His inability to solve the problems of the English romance disappointed him in a double sense. He had hoped, as he wrote in the preface to *Our Old Home*, to use his observations and anecdotes of England "for the side-scenes, and back-grounds, and exterior adornment, of a work of fiction, of which the plan had imperfectly developed itself in my mind, and into which I ambitiously proposed to convey more of various modes of truth than I could have grasped by a direct effort."[70] The English romance would have exploited picturesque material, but even more importantly, it would have conveyed the sort of truth he could only attempt in a work of fiction. The romance itself would have been his claim to the estate of literary tradition. Like *The Sketch Book*, which was simultaneously a book about England and a book about being an American writer, the English romance would have spoken to Hawthorne's own situation as an American artist in Europe. Irving had found himself energized, his artistic identity confirmed by a confrontation with literary tradition; Hawthorne found the process unnerving and ultimately disabling. He could respond to the theme of empire and write a romance on the subject of the human soul, but he could not come to terms with his own feelings of attraction and repulsion toward the Old World and its traditions.

Notes

1. For example, see Newton Arvin, *Hawthorne* (Boston, Mass.: Little, Brown and Company, 1929), p. 222, and Edward Hutchins Davidson, *Hawthorne's Last Phase* (New Haven, Conn.: Yale University Press, 1949), p. 149. Davidson

sees *The Marble Faun* as a flawed precursor of the later "precipitous descent to the romances of the last phase."

2. Randall Stewart takes this view in *Nathaniel Hawthorne: A Biography* (New Haven, Conn.: Yale University Press, 1948), chaps. 8-9. Nathalia Wright views the European years in a similar light in *American Novelists in Italy, The Discoverers: Allston to James* (Philadelphia: University of Pennsylvania Press, 1965), chap. 4.

3. Henry James, *Hawthorne,* English Men of Letters Series (New York: Harper & Brothers, 1879), pp. 156-57.

4. Ibid., p. 117.

5. Nathaniel Hawthorne, *The English Notebooks,* ed. Randall Stewart (New York: Modern Language Association, 1941), p. 3.

6. Horatio Bridge, *Personal Recollections of Nathaniel Hawthorne* (New York: Harper & Brothers, 1893), pp. 135-36.

7. Ibid., pp. 137-38.

8. Nathaniel Hawthorne, *Letters of Hawthorne to William D. Ticknor 1851-1864,* 2 vols. (Newark, N.J.: The Cartaret Book Club, 1910; reprint ed., 1 vol., Washington, D.C.: NCR/Microcard Editions, 1972), 1: 82-84.

9. Ibid., 1: 95; 2: 45.

10. Hawthorne, *English Notebooks,* p. 620.

11. See Sophia Hawthorne's letter to her father explaining their plans, quoted in Julian Hawthorne, *Nathaniel Hawthorne and his Wife,* 2 vols. (Cambridge: University Press, 1884), 2: 30-31.

12. See Bridge, *Personal Recollections* and Hawthorne, *Letters to Ticknor.*

13. Nathaniel Hawthorne, "The Custom House," *The Scarlet Letter,* vol. 1, Centenary Edition of the Works of Nathaniel Hawthorne (1850; reprint ed., Columbus: Ohio State University Press, 1962), p. 25.

14. See, for example, Hawthorne, *English Notebooks,* pp. 437-40, 442, 562.

15. See ibid., pp. 12, 323. Compare Hawthorne, *Letters to Ticknor,* 2: 51.

16. Hawthorne, *Letters to Ticknor,* 1: 13.

17. Ibid., pp. 85-86.

18. In Randall Stewart's edition of *The English Notebooks,* entries from August 1853 to May 1855 occupy 107 pages; from May 1855 to January 1858, they take up 510 pages.

19. Hawthorne, *Letters to Ticknor,* 1: 66.

20. See for instance Hawthorne, *English Notebooks,* pp. 107, 439-40, 442.

21. Hawthorne, *Letters to Ticknor,* 2: 15. See also ibid., 1: 100-101.

22. Ibid., p. 68.

23. Nathaniel Hawthorne, *Twice-Told Tales,* vol. 9, Centenary Edition of the Works of Nathaniel Hawthorne (1837, 1851; reprint ed., Columbus: Ohio State University Press, 1974), p. 3.

24. Randall Stewart's biography, *Nathaniel Hawthorne,* was instrumental in reversing this long-held view of Hawthorne.

25. See for example Nathaniel Hawthorne, *The French and Italian Notebooks,* vol. 14, Centenary Edition of the Works of Nathaniel Hawthorne, ed. Thomas Woodson (Columbus: Ohio State University Press, 1980), pp. 32, 123. (Hereafter cited as *French and Italian Notebooks.*)

26. Sophia Peabody to Elizabeth Peabody, September 5, 1832, quoted in

Norman Holmes Pearson, Introduction to "The French and Italian Notebooks of Nathaniel Hawthorne" (Ph.D. diss., Yale University, 1941), p. xi.

27. *French and Italian Notebooks,* p. 230.

28. See Susan Fenimore Cooper, "Small Family Memories" in James Fenimore Cooper, *Correspondence of James Fenimore-Cooper,* 2 vols., ed. James Fenimore Cooper (New Haven, Conn.: Yale University Press, 1922), 1: 20.

29. Hawthorne, *English Notebooks,* p. 29.

30. *French and Italian Notebooks,* p. 136.

31. Hawthorne, *English Notebooks,* p. 212.

32. Ibid., p. 174. See also p. 525.

33. Ibid., pp. 130, 131, 132, 134.

34. Ibid., p. 153.

35. Ibid., p. 166.

36. Ibid., p. 487.

37. Ibid., p. 341. For Burns see pp. 499-506.

38. Ibid., pp. 343, 342, 344.

39. *French and Italian Notebooks,* pp. 269-70.

40. Washington Irving, *The Sketch Book of Geoffrey Crayon, Gent.,* 7 vols. (New York: C. S. Van Winkle, 1819), 1: 10.

41. Nathaniel Hawthorne, *Our Old Home: A Series of English Sketches,* vol. 5, Centenary Edition of the Works of Nathaniel Hawthorne (1863; reprint ed., Columbus: Ohio State University Press, 1970), p. 4.

42. Nathaniel Hawthorne, *The Marble Faun: Or, The Romance of Monte Beni,* vol. 4, Centenary Edition of the Works of Nathaniel Hawthorne (1860; reprint ed., Columbus: Ohio State University Press, 1968), p. 3. James echoed this passage in his famous catalogue in his biography, *Hawthorne,* pp. 43-44.

43. *The Marble Faun,* p. 4.

44. James, *Hawthorne,* p. 160.

45. Hawthorne, *The Marble Faun,* p. 151.

46. *French and Italian Notebooks,* p. 307.

47. Ibid., pp. 334-35.

48. *English Notebooks,* p. 107.

49. Anyone who studies the American claimant manuscripts owes a great debt to Edward Hutchins Davidson, who disentangled the murky publication history and provided a clear understanding of the various drafts of the English romance in his books, *Hawthorne's Last Phase* (New Haven, Conn.: Yale University Press, 1949) and *Hawthorne's "Doctor Grimshawe's Secret"* (Cambridge, Mass.: Harvard University Press, 1954), and as an editor of the Centenary volume containing these manuscripts. I follow his designations for the three manuscripts: Nathaniel Hawthorne, *The American Claimant Manuscripts: The Ancestral Footstep, Etherege, Grimshawe,* vol. 12, Centenary Edition of the Works of Nathaniel Hawthorne, ed. Edward H. Davidson, Claude M. Simpson, L. Neal Smith (Columbus: Ohio State University Press, 1977).

50. Hawthorne, *American Claimant,* p. 58.

51. Ibid., p. 265.

52. Ibid., pp. 198, 262, 268.

53. For example, ibid., p. 323.

54. Ibid., p. 3.

55. Ibid., pp. 8-9.

56. Ibid., p. 244.

57. Hawthorne, *English Notebooks,* pp. 106, 193-99, 194.

58. Hawthorne, *American Claimant,* p. 284.

59. Ibid., pp. 8, 6, 38-39.

60. Ibid., pp. 257-58.

61. Nina Baym, *The Shape of Hawthorne's Career* (Ithaca, N.Y.: Cornell University Press, 1976), p. 255.

62. Hawthorne, *English Notebooks,* p. 92.

63. Hawthorne, *Our Old Home,* p. 63.

64. Ibid., p. 64.

65. Hawthorne, *American Claimant,* p. 13.

66. Ibid., pp. 259-60.

67. Ibid., p. 444.

68. Hawthorne, *English Notebooks,* p. 342; *French and Italian Notebooks,* p. 532.

69, Hawthorne, *American Claimant,* pp. 198-99.

70. Hawthorne, *Our Old Home,* pp. 3-4.

6

CONCLUSION

For Irving, Allston, Cole, Cooper, and Hawthorne and for many of their contemporaries as well, a journey to Europe was a voyage of discovery. Perhaps rediscovery would be a better term, for the European scene was not unknown to them. Coming of age in a young country that retained many provincial attitudes, these Americans had explored Europe in their imaginations long before they had done so in fact. Like Geoffrey Crayon poring over travel guides—and Nathaniel Hawthorne studying *The Sketch Book*—or Cole and Allston drinking in engravings of Old Master paintings, Americans of the antebellum period looked to the Old World with the love-hate ambivalence of a child to its parent.[1] For this generation especially a European voyage brought with it the "shock of recognition."[2]

Recognition, however, can take many forms. Allston found the well-studied Old Master works almost inexpressibly thrilling when he saw them in person, but Hawthorne could never rid himself of the nagging feeling that reality did not measure up to expectation. Still, the excitement of experiencing something so thoroughly imagined—a visit to Westminster Abbey or Saint Peter's, to Shakespeare's birthplace, or to the gallery of the Louvre—was like enacting a scene from a dream and became a profound, sometimes disturbing, extremely revealing moment for these Americans. Unlike European travelers in the United States, Americans in Europe felt a prior involvement in the observed scene. They had a sense of discovering or rediscovering something of immense value to themselves.

Fascinated by the long vistas of European history, Americans saw the Old World almost exclusively in terms of the past rather than the present. None of the three writers described here systematically depicted the Industrial Revolution that was transforming Europe. They observed

dukes and princes rather than Dickensian street urchins, cottages and palaces rather than factories. Cooper, perhaps the most involved in contemporary events, cloaked his political commentary in the trappings of historical romance.

These traveling Americans remained largely aloof from contemporary European artistic life. Individual friendships influenced them, sometimes profoundly—Irving's with Scott, Allston's with Coleridge, Cooper's with Lafayette—but on the whole their contact with their colleagues in other countries was surprisingly perfunctory.[3] Cole visited Turner only once; Hawthorne was too shy to introduce himself to Tennyson in Manchester. The Americans tended to band together: Leslie and Newton in London, Greenough and later Powers in Florence, Morse in Paris, formed a kind of emigré community in which visiting Americans could feel at home. Typically, Americans in Europe socialized with other Americans and drew their artistic inspiration from the masters of the past: Raphael, Michelangelo, Titian, Shakespeare, Milton, and (after his death) Scott. In paying homage to dead artists, Americans avoided a sense of competition and perhaps unflattering comparison with con- temporaries. The Old Masters belonged to the ages, and Americans hastened to claim their heritage.

From the American vantage point, Europe was the realm of art and of history. The United States at this period of its existence believed it had neither.[4] For creative individuals who saw themselves as artists or aspired to do so, the galleries, streets, and monuments of Europe were a kind of horoscope, a forecast of their own potential for success or frustration. Like Irving walking through the meadcws at Stratford, American artists saw their own hopes and fears in the remains of their predecessors. Irving made literature out of his anxiety about making literature; Hawthorne faltered in the attempt. For all five artists a voyage to Europe dramatized and shaped their struggle to define themselves professionally.

As the confrontation with the European scene heightened their aware- ness of themselves as artists, it also underscored their American identity. Gertrude Stein once said she felt more alone with her eyes and her English when she lived in a foreign country.[5] Antebellum Americans were fascinated by the aspects of Europe that contrasted most with America: cultivation as opposed to wilderness, refinement rather than rawness, and above all, the theme that would fascinate the following generation, European corruption in contrast to American innocence. Each of the works discussed here attempts in its own way to draw a portrait of the European scene and registers a sense of its vast difference from the artist's native environment. Whether handled through comedy as in Irving or tragedy as in Cooper and Hawthorne, each work expresses a degree of cultural shock, the artist's sense of observing and describing a foreign and to some extent sinister realm.

The two works of visual art, *Belshazzar's Feast* and *The Course of Empire,* make this same point symbolically rather than directly. They do not depict the European scene literally, but both touch on the same themes that haunt the fictional portrayals of Europe: splendor, decadence, and the meaning of evil. Allston portrayed the abuse of power by a corrupt and luxurious ruler as starkly as Cooper. Like Hawthorne, he tried to examine the implications of such an environment for the human soul. Cole explored themes of luxury and corruption. His depiction of an empire so power hungry that it seeks to overwhelm nature itself drew its details from the various civilizations that flourished in the Old World; it was clearly inspired by his contact with European art and history. In visiting a continent just recovering from the Napoleonic wars, surrounded by monuments to wealth and privilege and reminders of the transitory nature of power, American writers and painters alike pondered the glories and dangers of empire.

As Bryant and others had eloquently insisted, Americans in the first half of the nineteenth century felt themselves fortunately exempt from the moral ills associated with the European empires. Yet these artistic depictions are full of didactic urgency. Without openly questioning the myth of American innocence, these artists found themselves troubled by the implications of what they saw. Cole formulated the archetypal pattern: a preserve of unspoiled nature spawning a corrupt civilization and crumbling under the weight of its own evil. In depicting the evil that could lurk beneath the surface in a government ostensibly republican, Cooper spelled out the political implications. Antebellum America, expanding westward with military and economic might, began to envision itself as a benign empire, nature's imperial nation. American artists, contemplating the ruins of past empires in the Old World, began to ask themselves whether or not the New World could expect to escape similar corruption.

By asking such difficult questions, American artists risked alienating their audiences. Irving won immense popularity by offering Americans a comfortable stance toward history and art. As his struggle with self-doubt shows, he was treading a fine line. Cooper, who lacked Irving's geniality, offended many readers by insisting on the moral lessons to be drawn from the past. Cole and Allston found their greatest disappointment in public indifference to their lofty aims. Antebellum America throve on its buoyant sense of exceptionalism, and powerful voices pointing out the lessons of history and probing the darker side of human experience raised issues many countrymen preferred not to face.

These major artists thus experienced some friction with their American audiences as a result of their interpretation of the European scene. Yet all of them returned to America to try to reconcile their new insights with their American identity. None chose the path of James Joyce's protagonist, Stephen Dedalus, through "silence, exile, and cunning,"

although all shared his desire "to forge in the smithy of my soul the uncreated conscience of my race."[6] Not until the twentieth century could an artist find a way to pay tribute to his country by venting his anger at it. Even Cooper, the most volatile of the group, continued to insist he had no quarrel with "American principles." Nevertheless all five of these figures, like so many other American travelers, experienced a change in perspective, an alteration in their views of themselves and their country, as a result of their European travels, and each of them struggled with these alterations in at least one major work of art.

It would take another generation, more cosmopolitan, less naive, more critical, to plumb the depths of the American confrontation with the Old World. Five years after Hawthorne's death, Mark Twain spoofed the whole tradition of American tourism in *The Innocents Abroad* (1869), and five years after that, Henry James in *Roderick Hudson* (1874) told the story of the artistic voyager as a tragedy of American innocence. The antebellum generation saw the Old World as it appeared to them as aspiring artists and citizens of a new nation. In their confrontation with the European scene they made important discoveries about their art, their country, and themselves.

Notes

1. See Stephen Spender, *Love-Hate Relations, English and American Sensibilities* (New York: Random House, 1974).

2. See Edmund Wilson, ed., *The Shock of Recognition: The Development of Literature in the United States Recorded by the Men Who Made It* (New York: Random House, Modern Library, 1955).

3. Allston was of course a major exception, for he entered into the art world abroad on an equal footing with English artists.

4. Tocqueville was convinced that a democracy would never produce great works of art. See Alexis de Tocqueville, *Democracy in America*, 2 vols., trans. Henry Reeve (New York: J. & H. G. Langley, 1840), 2: 49-54.

5. Gertrude Stein, *The Autobiography of Alice B. Toklas* (1933; reprint ed., New York: Random House, Vintage Books, 1960), p. 70.

6. James Joyce, *A Portrait of the Artist as a Young Man* (1916; reprint ed., New York, The Viking Press, 1964), pp. 247, 253.

BIBLIOGRAPHY

Americans in Europe – 1800-1860

Baker, Paul R. *The Fortunate Pilgrims: Americans in Italy 1800-1860.* Cambridge, Mass.: Harvard University Press, 1964.

Brooks, Van Wyck. *The Dream of Arcadia, American Writers and Artists in Italy, 1760-1915.* New York: Dutton, 1958.

Denny, Margaret, and Gilman, William, eds. *The American Writer and the European Tradition.* Minneapolis: Published for the University of Rochester by the University of Minnesota Press, 1950.

Earnest, Ernest. *Expatriates and Patriots: American Artists, Scholars, and Writers in Europe.* Durham, N.C.: Duke University Press, 1968.

Flexner, James Thomas. *The Light of Distant Skies, 1760-1835.* New York: Harcourt Brace, 1954.

LaBudde, Kenneth. "American Romanticism and European Painting." *American Quarterly* 12 (Spring 1960): 95-101.

Larkin, Oliver W. "Two Yankee Painters in Italy: Thomas Cole and Samuel Morse." *American Quarterly* 5 (Fall 1953): 195-200.

Novak, Barbara. "Americans in Italy: Arcady Revisited." *Art in America* 61 (January 1973): 56-69.

_____. "Influences and Affinities. The Interplay between America and Europe in Landscape Painting before 1860." In *The Shaping of Art and Architecture in Nineteenth-Century America.* New York: The Metropolitan Museum of Art, 1972.

Rahv, Philip, ed. *Discovery of Europe, The Story of American Experience in the Old World.* 1947. Reprint. Garden City, N.Y.: Anchor Books, 1960.

Richardson, E. P., and Wittman, Otto, Jr. *Travelers in Arcadia: American Artists in Italy.* The Detroit Institute of Arts and the Toledo Museum of Art, 1951.

Sanford, Charles. *The Quest for Paradise, Europe and the American Moral Imagination.* Urbana: University of Illinois Press, 1961.

Spender, Stephen. *Love-Hate Relations, English and American Sensibilities.* New York: Random House, 1974.

Spiller, Robert E. *The American in England During the First Half Century of Independence.* New York: H. Holt and Company, 1926.

Strout, Cushing. *The American Image of the Old World.* New York: Harper & Row, 1963.

Wittmann, Otto, Jr. "The Italian Experience (American Artists in Italy 1830-1875)." *American Quarterly* 4 (Spring 1952): 3-15.

Wright, Nathalia. *American Novelists in Italy, The Discoverers: Allston to James.* Philadelphia: University of Pennsylvania Press, 1965.

Artists and Writers – General

Blunden, Edmund, "Romantic Poetry and the Fine Arts." In *Proceedings of the British Academy* (28). London: Humphrey Milford, Oxford University Press, 1942.

Boas, George. "The Rediscovery of America." *American Quarterly* 7 (Summer 1955): 142-52.

Callow, James T. *Kindred Spirits: Knickerbocker Writers and American Artists, 1807-1855.* Chapel Hill: University of North Carolina Press, 1967.

Hagstrum, Jean. *The Sister Arts, The Tradition of Literary Pictorialism and English Poetry from Dryden to Gray.* Chicago, Ill.: University of Chicago Press, 1958.

Jones, Howard Mumford. "James Fenimore Cooper and the Hudson River School." *Magazine of Art* 45 (October 1952): 243-51.

———. "Prose and Pictures: James Fenimore Cooper." *Tulane Studies in English* 3 (1952): 133-54.

Lee, Rensselaer W. *Ut Pictura Poesis: The Humanistic Theory of Painting.* 1940. Reprint. New York: The Norton Library, 1967.

Noyes, Russell. *Wordsworth and the Art of Landscape.* Bloomington: Indiana University Press, 1968.

Praz, Mario. *Mnemosyne, the Parallel Between Literature and the Visual Arts.* The A. W. Mellon Lectures in the Fine Arts, 1967. Princeton, N.J.: Princeton University Press, 1970.

Price, Martin, "The Picturesque Moment." In *From Sensibility to Romanticism,* edited by Frederick Hilles and Harold Bloom. New York: Oxford University Press, 1965.

———. "The Sublime Poem: Pictures and Powers." *The Yale Review* 58 (December 1968): 194-213.

Ringe, Donald A. "James Fenimore Cooper and Thomas Cole: An Analagous Technique." *American Literature* 30 (March 1958): 26-36.

———. "Kindred Spirits: Bryant and Cole." *American Quarterly* 6 (Fall 1954): 233-44.

———. "Painting as Poem in the Hudson River Aesthetic." *American Quarterly* 12 (Spring 1960): 71-83.

———. *The Pictorial Mode, Space & Time in the Art of Bryant, Irving & Cooper.* Lexington: The University Press of Kentucky, 1971.

Sanford, Charles L. "The Concept of the Sublime in the Works of Thomas Cole and William Cullen Bryant." *American Literature* 28 (January 1957): 434-48.

Schmitt, Evelyn L. "Two American Romantics: Thomas Cole and William Cullen Bryant." *Art in America* 41 (Spring 1953): 61-68.

Storch, R. F. "Wordsworth and Constable." *Studies in Romanticism* 5 (Spring 1966): 121-38.

Tinker, Chauncey Brewster. *Painter and Poet, Studies in the Literary Relations of English Painting.* The Charles Eliot Norton Lectures for 1937-38. Cambridge, Mass.: Harvard University Press, 1938.

Stubbs, John C. "The Ideal in the Literature and Art of the American Renaissance." *Emerson Society Quarterly* 55 (2nd quarter 1969): 55-63.

Washington Irving

Aderman, Ralph M., ed. *Washington Irving Reconsidered.* Hartford, Conn.: Transcendental Books, 1969.

Beach, Leonard; Hornberger, Theodore; and Wright, Wyllis E. "Peter Irving's Journal." *Bulletin of the New York Public Library* 44 (August 1940): 591-608.

Brevoort, Henry. *Letters of Henry Brevoort to Washington Irving.* Edited by George S. Hellman. New York: G. P. Putnam's Sons, 1918.

Ellmann, Richard. "Love in the Catskills." *The New York Review of Books* 23 (February 5, 1976): 27-28.

Hedges, William L. *Washington Irving: An American Study, 1802-1832.* Baltimore, Md.: Johns Hopkins Press, 1965.

Irving, Pierre M. *The Life and Letters of Washington Irving.* 4 vols. New York: G. P. Putnam; Hurd & Houghton, 1865.

Irving, Washington. *Bracebridge Hall.* Vol. 6. *The Works of Washington Irving, Author's Revised Edition of 1848.* New York: G. P. Putnam and Son, 1857.

_____. *Journal of Washington Irving (1823-1824).* Edited by Stanley T. Williams. Cambridge, Mass.: Harvard University Press, 1931.

_____. *Journals and Notebooks, Volume I, 1803-1806.* Edited by Nathalia Wright. Madison: University of Wisconsin Press, 1969.

_____. *The Journals of Washington Irving (From July, 1815 to July, 1842).* Edited by William P. Trent. New York: The Grolier Club, 1921.

_____. *Notes While Preparing Sketch Book &c. 1817.* Edited by Stanley T. Williams.

_____. *Letters of Washington Irving to Henry Brevoort.* Edited by George S. Hellman. New York: G. P. Putnam's Sons, 1918.

_____. *Notes and Journals of Travel in Europe, 1804-1805.* With an Introduction by William P. Trent. New York: The Grolier Club, 1921.

_____. *Notes While Preparing Sketch Book &c. 1817.* Edited by Stanley T. Williams. New Haven, Conn.: Yale University Press, 1927.

_____. *The Sketch Book of Geoffrey Crayon, Gent.* 7 vols. New York: C. S. Van Winkle, 1819.

_____. *Tour in Scotland 1817 and other Manuscript Notes.* Edited by Stanley T. Williams. New Haven, Conn.: Yale University Press, 1927.

Pattee, Fred Lewis. *The Development of the American Short Story.* New York: Bilbo and Tannen, 1966.

Pochmann, Henry A. "Irving's German Sources in *The Sketch Book.*" *Studies in Philology* 27 (July 1930): 477-507.

————. "Washington Irving: Amateur or Professional?" In *Essays on American Literature in Honor of Jay B. Hubbell,* edited by Clarence Gohdes. Durham, N.C.: Duke University Press, 1967.

Prown, Jules David. "Washington Irving's Interest in Art and his Influence Upon American Painting." Master's thesis, University of Delaware, 1956.

Scott, Sir Walter. *Familiar Letters.* 2 vols. Boston, Mass.: Houghton Mifflin & Co., 1894.

Weatherspoon, Mary A. "1815-1819: Prelude to Irving's *Sketch Book." American Literature* 41 (January 1970): 566-71.

Williams, Stanley T. *The Life of Washington Irving.* 2 vols. New York: Oxford University Press, 1935.

Yarborough, M. C. "Rambles With Washington Irving. Quotations from an Unpublished Autobiography of William C. Preston." *South Atlantic Quarterly* 29 (October 1930): 423-39.

Washington Allston

Albro, John A. *The Blessedness of those who die in the Lord, A Sermon Occasioned by the Death of Washington Allston, Delivered in the Church of the Shepard Society, Cambridge, July 16, 1843.* Boston, Mass.: Charles C. Little and James Brown, 1843.

Allston, Elizabeth Deas. *The Allstons and Alstons of Waccamaw.* N.p., 1936.

Allston, Susan Lowndes. *Brookgreen, Waccamaw, in the Carolina Low Country.* Charleston, S.C.: Walker, Evans & Cogswell Co., 1935.

Allston, Washington. *Lectures on Art and Poems, 1850; and Monaldi, 1841.* Introduction by Nathalia Wright. Gainesville, Fla.: Scholars' Facsimiles & Reprints, 1967.

Bolton, Kenyon C. III, and Johns, Elizabeth. *The Paintings of Washington Allston.* Coral Gables, Fla.: The Lowe Art Museum, University of Miami, 1975.

Boston, Massachusetts. Boston Athenaeum manuscript collection.

Boston, Massachusetts. Massachusetts Historical Society. Dana Family Papers.

Cambridge, Massachusetts. Harvard University. Houghton Library-Washington Allston Trust.

Cambridge, Massachusetts. Longfellow National Historical Site. Washington Allston Archive.

Cambridge, Massachusetts. Longfellow National Historical Site. "Washington Allston: Romantic Poet and Painter," by H.W.L. Dana.

Catalogue. Allston Club. First Exhibition, 1866. Boston, Mass.: Alfred Mudge & Son, 1866.

Channing, W. "Reminiscences of Washington Allston." *Boston Advertiser,* July 24, 1843. Reprinted from *Boston Christian World.*

Chase, George Davis. "Some Washington Allston Correspondence." *New England Quarterly* 16 (December 1943): 628-34.

Coburn, Kathleen. "Notes on Washington Allston from the Unpublished Notebooks of Samuel Taylor Coleridge." *Gazette des Beaux Arts,* Series 6, 25 (1944): 249-52.

Craven, Wayne. "The Grand Manner in Early Nineteenth-Century American

Painting: Borrowings from Antiquity, the Renaissance, and the Baroque." *American Art Journal* 11 (April 1979): 5-43.

Dana, H.W.L. "Allston at Harvard, 1796 to 1800." *Cambridge Historical Society Publications* 29 (1948): 13-33.

_____. "Allston in Cambridgeport, 1830 to 1843." *Cambridge Historical Society Publications* 29 (1948): 34-67.

Dana, Richard Henry, Jr. *The Journal of Richard Henry Dana, Jr.* 3 vols. Edited by Robert F. Lucid. Cambridge, Mass.: Harvard University Press, The Belknap Press, 1968.

Description of the Grand Historical Picture of Belshazzar's Feast Painted by Washington Allston and Now Exhibiting at the Corinthian Gallery, Federal Street. Boston, Mass.: Eastburn's Press, 1844.

Detroit, Mich. Detroit Institute of Arts Research Library. Thomas Cole Papers.

Dexter, Arthur. "The Fine Arts in Boston." In *The Memorial History of Boston,* 4 vols., edited by Justin Winsor, 4: 383-414. Boston, Mass.: James R. Osgood and Company, 1881.

Dunlap, William. *History of the Rise and Progress of the Arts of Design in the United States.* 2 vols. New York: George P. Scott and Co., 1834.

Easterby, J. H., ed. *The South Carolina Rice Plantation, as Revealed in the Papers of Robert F. W. Allston.* Chicago, Ill.: University of Chicago Press, 1945.

Exhibition of Pictures Painted by Washington Allston at Harding's Gallery, School Street. Boston, Mass.: John H. Eastburn, 1839.

Flagg, Jared B. *The Life and Letters of Washington Allston.* New York: Charles Scribner's Sons, 1892.

Fuller, Margaret. "A Record of Impressions Produced by the Exhibition of Mr. Allston's Pictures in the Summer of 1839." Reprinted in Margaret Fuller Ossoli, *Art, Literature, and the Drama,* edited by Arthur B. Fuller. Boston, Mass.: Brown, Taggard and Chase, 1860.

Gerdts, William H. "Allston's 'Belshazzar's Feast.' " *Art in America* 61 (March-April 1973): 59-66.

_____. "Belshazzar's Feast II: 'That is his shroud.' " *Art in America* 61 (May-June 1973): 58-65.

_____. "Washington Allston and the German Romantic Classicists in Rome." *Art Quarterly* 32 (Summer 1969): 166-96.

_____, and Stebbins, Theodore E., Jr., *'A Man of Genius,' The Art of Washington Allston (1779-1843).* Boston, Mass.: Museum of Fine Arts, 1979.

Groves, Joseph A. *The Alstons and Allstons of North and South Carolina, Compiled from English, Colonial and Family Records with Personal Reminiscences also Notes of Some Allied Families.* Atlanta, Ga.: The Franklin Printing and Publishing Company, 1901.

Harding, Chester. *A Sketch of Chester Harding, Artist, Drawn by his Own Hand.* Edited by Margaret E. White. 1929. Reprint. New York: Da Capo Press, 1970.

Irving, Washington. "Washington Allston." In *Cyclopedia of American Literature,* 2 vols., edited by E. A. Duyckinck and G. L. Duyckinck. 2: 12-19. New York, 1855.

Jameson, Mrs. [Anna]. *Studies, Stories and Memoirs.* Boston, Mass.: Houghton Mifflin, 1895.

Johns, Elizabeth. "Washington Allston: Method, Imagination, and Reality." *Winterthur Portfolio* 12 (1977): 1-18.

———. "Washington Allston's Library." *American Art Journal* 7 (November 1975): 32-41.

Leavitt, Thomas W. "Washington Allston at Harvard." *Harvard Alumni Bulletin* 58 (April 21, 1956): 550-53.

Leslie, Charles R. *Autobiographical Recollections*. Boston, Mass.: Ticknor and Fields, 1860.

Milman, H. H. *Belshazzar: A Dramatic Poem*. Boston, Mass.: Wells and Lilly-Court-Street, 1822.

More, Hannah. "Belshazzar: A Sacred Drama." In *The Works of Hannah More*. 7 vols. New York: Harper & Brothers, 1835.

Morse, Edward Lind, ed. *Samuel F. B. Morse, His Letters and Journals*. 2 vols. Boston, Mass.: Houghton Mifflin Co., 1914.

New Haven, Connecticut. Yale University. Sterling Memorial Library. Morse Family Papers.

New York. New-York Historical Society. BV American Academy of Fine Arts.

New York. New-York Historical Society. Misc. Manuscripts, Allston.

Peabody, Elizabeth. *Last Evening with Allston and Other Papers*. 1886. Reprint. New York: AMS Press, 1975.

Richardson, E. P. *Washington Allston, A Study of the Romantic Artist in America*. 1948. Reprint. New York: Apollo Edition, 1967.

"Some Unpublished Correspondence of Washington Allston." *Scribner's Magazine* 11 (January 1892): 68-83.

Soria, Regina. "Washington Allston's Lectures on Art: The First American Art Treatise." *Journal of Aesthetics and Art Criticism* 18 (March 1960): 329-44.

Sweetser, Moses Foster. *Allston*. Boston, Mass.: Houghton, Osgood & Company, 1879.

Ware, William. *Lectures on the Works and Genius of Washington Allston*. Boston, Mass.: Phillips, Sampson and Company, 1852.

Washington, D.C. Library of Congress. Samuel F. B. Morse Papers.

Washington, D.C. Smithsonian Institution. Archives of American Art. Washington Allston Papers.

Welsh, John R. "Washington Allston: Expatriate South Carolinian." *The South Carolina Historical Magazine* 67 (April 1966): 84-98.

Whitley, William T. *Art in England, 1800-1820*. Cambridge: The University Press, 1928.

Wright, Cuthbert. "The Feast of Belshazzar." *New England Quarterly* 10 (December 1937): 620-34.

Thomas Cole

Albany. New York State Library. Thomas Cole Papers.

Alper, M. Victor. "American Mythologies in Painting, Part 4." *Arts* 46 (Summer 1972): 50-54.

Baltimore Museum of Art. *Annual II: Studies on Thomas Cole, an American Romanticist*. Baltimore, Md.: Baltimore Museum of Art, 1967.

Börn, Wolfgang. *American Landscape Painting: An Interpretation.* New Haven, Conn.: Yale University Press, 1948.

Boston. Massachusetts Historical Society. Edward Everett Papers.

Bryant, William Cullen. *A Funeral Oration Occasioned by the Death of Thomas Cole, Delivered Before the National Academy of Design, New York, May 4, 1848.* New York, n.p. 1848.

Cole, Thomas. "Essay on American Scenery." *The American Monthly Magazine.* New Series. 1 (January 1836). Reprinted in *American Art 1700-1960, Sources and Documents,* edited by John W. McCoubrey. Englewood Cliffs, N.J.: Prentice-Hall, Inc., 1965.

———. *Thomas Cole's Poetry.* Edited by Marshall B. Tymn. York, Pa.: Liberty Cap Books, 1972.

Detroit. Detroit Institute of Arts. The Estate of Thomas Cole Print Collections.

Exhibition of the Paintings of the Late Thomas Cole, at the Gallery of the American Art-Union. New York: Snowden & Prall, 1848.

Flexner, James Thomas. *That Wilder Image: The Painting of America's Native School from Thomas Cole to Winslow Homer.* New York: Bonanza Books, 1962.

Glassie, Henry H. "Thomas Cole and Niagara Falls." *New-York Historical Society Quarterly* 58 (April 1974): 89-111.

Goethals, Martha Gregor T. "A Comparative Study of the Theory and Work of Washington Allston, Thomas Cole, and Horatio Greenough." Ph.D. dissertation. Harvard University, 1966.

Greene, George Washington. *Biographical Studies.* New York: G. P. Putnam, 1860.

Greenough, Horatio. *Letters of Horatio Greenough, American Sculptor.* Edited by Nathalia Wright. Madison: University of Wisconsin Press, 1972.

———. *Letters of Horatio Greenough to his Brother, Henry Greenough.* Edited by Frances Boott Greenough. Boston, Mass.: Ticknor & Co., 1887.

Hinton, J. H., ed. *The History and Topography of the United States.* 2 vols. London: Simpkin & Marshall; Philadelphia, Pa.: Thomas Wardle, 1832.

LaBudde, Kenneth James. "The Mind of Thomas Cole." Ph.D. dissertation. University of Michigan, 1954.

———. "The Rural Earth: Sylvan Bliss." *American Quarterly* 10 (Summer 1958): 142-53.

Lanes, Jerrold. "U.S.A." *Burlington Magazine* 107 (March 1965): 152-56.

Lanman, Charles. "Cole's Imaginative Paintings." *United States Magazine and Democratic Review* 12 (June 1843): 598-603.

Lesley, Everett Parker, Jr. "Some Clues to Thomas Cole." *Magazine of Art* 42 (February 1949): 43-48.

———. "Thomas Cole, the Life and Art of an American Romantic." Ph.D dissertation. Princeton University, 1948. Typescript at New-York Historical Society.

———. "Thomas Cole and the Romantic Sensibility." *Art Quarterly* 5 (Summer 1942): 199-219.

Merritt, Howard S. *Thomas Cole.* Catalogue of an exhibition held at Memorial Art Gallery of the University of Rochester, Munson-Williams-Proctor Institute, Albany Institute of History and Art, Whitney Museum of America Art. Rochester, Minn.: Memorial Art Gallery, 1969.

Nathan, Walter L. "Thomas Cole and the Romantic Landscape." In *Romanticism in America,* edited by George Boas. Baltimore, Md.: Johns Hopkins Press, 1940.

New York. New-York Historical Society. E. Parker Lesley Collection of Thomas Cole Papers.

Noble, Louis Legrand. *The Life and Works of Thomas Cole.* Edited by Elliot S. Vesell. 1853. Reprint. Cambridge, Mass.: Harvard University Press, Belknap Press, 1964.

Novak, Barbara. "American Landscape: The Nationalist Garden and the Holy Book." *Art in America* 60 (January 1972): 46-57.

_____. *American Painting of the Nineteenth Century.* New York: Praeger, 1969.

[_____.] "Cole and Durand: Criticism and Patronage (A Study of American Taste in Landscape, 1825-65)." Ph.D. dissertation. Radcliffe College, 1957.

_____. "Grand Opera and the Small Still Voice." *Art in America* 59 (March 1971): 64-73.

_____. "Thomas Cole and Robert Gilmor." *Art Quarterly* 25 (Spring 1962): 41-53.

Parry, Ellwood C. III. "Thomas Cole and the Problem of Figure Painting." *The American Art Journal* 4 (Spring 1972): 66-86.

_____. "Thomas Cole's *The Course of Empire,* A Study in Serial Imagery." Ph.D. dissertation. Yale University, 1970.

_____. "Thomas Cole's Ideas for Mr. Reed's Doors." *The American Art Journal* 12 (Summer 1980): 33-45.

Richardson, E. P. "The Romantic Genius of Thomas Cole." *Art News* 55 (December 1956): 43, 52.

Seaver, Esther I. *Thomas Cole, 1801-1848, One Hundred Years Later.* Catalogue of an exhibition at the Wadsworth Atheneum and the Whitney Museum of American Art. Hartford, Conn.: Wadsworth Atheneum, 1948.

Volney, M. *The Ruins; or a Survey of the Revolutions of Empires, to which is added, the Law of Nature. Translated from the French.* London: Edward Edwards, 1822.

Wallach, Alan P. "Cole, Byron, and the *Course of Empire.*" *The Art Bulletin* 50 (1968): 375-79.

_____. "Origins of Thomas Cole's 'Course of Empire.' " Master's thesis. Columbia University, [1965].

_____. "Thomas Cole: British Aesthetics and American Scenery." *Artforum* 8 (October 1969): 46-49.

Washington, D.C. Smithsonian Institution. Archives of American Art. John Ferguson Weir Papers.

The Works of Thomas Cole. Catalogue of an exhibition at the Albany Institute of History and Art. Albany, N.Y., 1941.

James Fenimore Cooper

Axelrad, Allan M. *History and Utopia: A Study of the World View of James Fenimore Cooper.* Norwood, Pa.: Norwood Editions, 1978.

Beard, James F., Jr. "Cooper and his Artistic Contemporaries." In *James Feni-*

more Cooper, A Re-Appraisal, edited by Mary Cunningham. Cooperstown: New York State Historical Association, 1954.

Bewley, Marius. The Eccentric Design, Form in the Classic American Novel. New York: Columbia University Press, 1963.

"Cassio." Review of The Bravo. New-York American 13 (June 7, 1832): 1-2.

Charvat, William. "Cooper As Professional Author." In James Fenimore Cooper, A Re-Appraisal, edited by Mary Cunningham. Cooperstown: New York State Historical Association, 1954.

Cooper, James Fenimore. The Bravo. 1831. Reprint. New York: G. P. Putnam's Sons, Leatherstocking Edition, n.d.

_____. Correspondence of James Fenimore-Cooper. 2 vols. Edited by James Fenimore Cooper. New Haven, Conn.: Yale University Press, 1922.

_____. Excursions in Italy. Paris: Baudry's European Library, 1838.

_____. Gleanings in Europe. [France]. Edited by Robert E. Spiller. 1837. Reprint. New York: Oxford University Press, 1928.

_____. Gleanings in Europe. Volume Two. England. Edited by Robert E. Spiller. 1837. Reprint.New York: Oxford University Press, 1930.

[_____.] Gleanings in Europe, Italy: by an American, in two volumes. Philadelphia, Pa.: Carey, Lea, and Blanchard, 1838.

_____. The Headsman or the Abbaye des Vignerons. 1833. Reprint. New York: G. P. Putnam's Sons, Leatherstocking Edition, n.d.

_____. The Heidenmauer, or the Benedictines. 1832. Reprint. New York: G. P. Putnam's Sons, Leatherstocking Edition, n.d.

_____. A Letter to his Countrymen. New York: John Wiley, 1834.

_____. The Letters and Journals of James Fenimore Cooper. 6 vols. Edited by James Franklin Beard. Cambridge, Mass.: Harvard University Press, 1960, 1964.

_____. Notions of the Americans Picked up by a Travelling Bachelor. Edited by Robert E. Spiller. 1828. Reprint. New York: Frederick Ungar Publishing Co., 1963.

_____. A Residence in France; with an Excursion up the Rhine, and a Second visit to Switzerland. In two volumes. London: Richard Bentley, 1836.

[_____.] Sketches of Switzerland, by an American. In two volumes. Philadelphia, Pa.: Carey, Lea & Blanchard, 1836.

[_____.] Sketches of Switzerland. By an American. Part Second. In two Volumes. Philadelphia, Pa.: Lea & Blanchard, 1836.

_____. The Water-Witch or the Skimmer of the Seas. 1830. Reprint. New York: G. P. Putnam's Sons, Leatherstocking Edition, n.d.

Dekker, George. James Fenimore Cooper, the American Scott. New York: Barnes & Noble, Inc., 1967.

Grossman, James. James Fenimore Cooper. The American Men of Letters Series. New York: William Sloane Associates, 1949.

Henderson, Harry B. III. Versions of the Past, the Historical Imagination in American Fiction. New York: Oxford University Press, 1974.

Kirk, Russell. "Cooper and the European Puzzle." College English 7 (January 1946): 198-207.

Loveland, Anne C. "James Fenimore Cooper and the American Mission." American Quarterly 11 (Summer 1969): 244-58.

McWilliams, John P., Jr. *Political Justice in a Republic: James Fenimore Cooper's America.* Berkeley and Los Angeles: University of California Press, 1972.

Nevius, Blake. *Cooper's Landscapes, An Essay on the Picturesque Vision.* Berkeley and Los Angeles: University of California Press, 1976.

Peck, Daniel. *A World by Itself, The Pastoral Moment in Cooper's Fiction.* New Haven, Conn.: Yale University Press, 1977.

Railton, Stephen. *Fenimore Cooper, A Study of his Life and Imagination.* Princeton, N.J.: Princeton University Press, 1978.

Ringe, Donald A. *James Fenimore Cooper.* New York: Twayne Publishers, Inc., 1962.

Shulenberger, Arvid. *Cooper's Theory of Fiction, His Prefaces and their Relation to his Novels.* Lawrence: University of Kansas Publications, 1955.

Spiller, Robert E. *Fenimore Cooper, Critic of his Times.* 1931; Reprint ed. New York: Russell & Russell, 1963.

_____. "Fenimore Cooper and Lafayette: The Finance Controversy of 1831-1832." *American Literature* 3 (March 1931): 28-44.

_____. "Second Thoughts on Cooper as a Social Critic." In *James Fenimore Cooper, A Reappraisal,* edited by Mary Cunningham. Cooperstown: New York State Historical Association, 1954.

Wallace, David H. "The Princess and *The Bravo:* A Pleasant Passage in Anglo-American Relations." *New-York Historical Society Quarterly* 37 (October 1953): 317-25.

Waples, Dorothy. *The Whig Myth of James Fenimore Cooper.* New Haven, Conn.: Yale University Press, 1938.

Winters, Yvor. "Fenimore Cooper or the Ruins of Time." In *In Defense of Reason.* Denver, Col.: Alan Swallow, 1947.

Nathaniel Hawthorne

Arvin, Newton. *Hawthorne.* Boston: Little, Brown and Company, 1929.

Autrey, Max L. "Flower Imagery in Hawthorne's Posthumous Narratives." *Studies in the Novel* 7 (Summer 1975): 215-26.

Baym, Nina. *The Shape of Hawthorne's Career.* Ithaca, N.Y.: Cornell University Press, 1976.

Bridge, Horatio. *Personal Recollections of Nathaniel Hawthorne.* New York: Harper & Brothers, 1893.

Brodtkorb, Paul Jr. "Art Allegory in The Marble Faun." *PMLA* 77 (June 1962): 254-67.

Crews, Frederick. *The Sins of the Fathers, Hawthorne's Psychological Themes.* 1966. Reprint. New York: Oxford University Press Paperback, 1970.

Davidson, Edward Hutchins. *Hawthorne's Last Phase.* New Haven, Conn.: Yale University Press, 1949.

_____., ed. *Hawthorne's "Doctor Grimshawe's Secret."* Cambridge, Mass.: Harvard University Press, 1954.

Fogle, Richard Harter. *Hawthorne's Fiction: The Light and the Dark.* Norman: University of Oklahoma Press, 1952.

_____. *Hawthorne's Imagery, The "Proper Light and Shadow" in the Major Romances.* Norman: University of Oklahoma Press, 1969.

_____. "Hawthorne's Pictorial Unity." *Emerson Society Quarterly* 55 (2d quarter 1969): 71-76.

Gollin, Rita K. *Nathaniel Hawthorne and the Truth of Dreams.* Baton Rouge: Louisiana State University Press, 1979.

Hart, James D. "Hawthorne's Italian Diary." *American Literature* 34 (January 1963): 562-67.

Hawthorne, Julian. *Nathaniel Hawthorne and his Wife.* 2 vols. Cambridge: University Press, 1884.

Hawthorne, Nathaniel. *The American Claimant Manuscripts: The Ancestral Footstep, Etherege, Grimshawe.* Edited by Edward H. Davidson, Claude M. Simpson, L. Neal Smith. Volume 12. Centenary Edition of the Works of Nathaniel Hawthorne. Columbus: Ohio State University Press, 1977.

_____. *The English Notebooks.* Edited by Randall Stewart. New York: Modern Language Association of America, 1941.

_____. *The French and Italian Notebooks.* Edited by Thomas Woodson. Volume 14. Centenary Edition of the Works of Nathaniel Hawthorne. Ohio State University Press, 1980.

_____. "The French and Italian Notebooks of Nathaniel Hawthorne." Edited by Norman Holmes Pearson. Ph.D. dissertation. Yale University, 1941.

_____. *Letters of Hawthorne to William D. Ticknor 1851-1864.* 2 vols. Newark: The Carteret Book Club, 1910. Foreword by C.E. Frazer Clark, Jr. Reprint in 1 vol. Washington, D.C.: NCR/Microcard Editions, 1972.

_____. *Love Letters of Nathaniel Hawthorne 1839-1863.* Chicago, Ill.: Society of the Dofobs, 1907. Foreword by C.E. Frazer Clark, Jr. Reprint. Washington, D.C.: NCR/Microcard Editions, 1972.

_____. *The Marble Faun: Or, The Romance of Monte Beni.* Volume 4. Centenary Edition of the Works of Nathaniel Hawthorne. 1860. Reprint. Ohio State University Press, 1968.

_____. *Our Old Home: A Series of English Sketches.* Volume 5. Centenary Edition of the Works of Nathaniel Hawthorne. 1863. Reprint. Ohio State University Press, 1970.

Hijiya, James A. "Nathaniel Hawthorne's *Our Old Home.*" *American Literature* 46 (November 1974): 363-73.

Hull, Raymona E. *Nathaniel Hawthorne, The English Experience, 1853-1864.* Pittsburgh, Pa.: University of Pittsburgh Press, 1980.

James, Henry, Jr. *Hawthorne.* English Men of Letters Series. New York: Harper & Brothers, 1879.

Kerston, David B., ed. *The Merrill Studies in "The Marble Faun."* Columbus, Ohio: Charles E. Merrill, 1971.

Lathrop, Rose Hawthorne. *Memories of Hawthorne.* 1897. Reprint. Boston, Mass.: Houghton Mifflin, 1923.

Levin, Harry. "Statues from Italy: *The Marble Faun.*" In *Hawthorne Centenary Essays,* edited by Roy Harvey Pearce. Columbus: Ohio State University Press, 1964.

Lundblad, Jane. *Nathaniel Hawthorne and European Literary Tradition.* Upsala and Cambridge: The American Institute in the University of Upsala, 1947.

McPherson, Hugo. *Hawthorne as Myth-Maker, A Study in Imagination.* Toronto; University of Toronto Press, 1969.

Martin, Terence. "Hawthorne's Public Decade and the Values of Home."
 American Literature 46 (May 1974): 141-52.
Schubert, Leland. *Hawthorne the Artist, Fine-Art Devices in Fiction*. New York:
 Russell & Russell, Inc., 1963.
Scrimgeor, Gary J. *"The Marble Faun:* Hawthorne's Faery Land." *American
 Literature* 36 (November 1964): 271-87.
Stewart, Randall. *Nathaniel Hawthorne*. New Haven, Conn.: Yale University
 Press, 1948.
Stubbs, John C. *The Pursuit of Form: A Study of Hawthorne and the Romance*.
 Urbana: University of Illinois Press, 1970.
Turner, Arlin. "Hawthorne's Literary Borrowings." *PMLA* 51 (June 1936):
 543-62.
_____. *Nathaniel Hawthorne, A Biography*. New York: Oxford University
 Press, 1980.
Waggoner, Hyatt H. *Hawthorne, A Critical Study*. Rev. ed. Cambridge, Mass.:
 Harvard University Press, Belknap Press, 1963.
Weglin, Christof. "Europe in Hawthorne's Fiction." *ELH* 14 (1947): 219-45.
_____. "The Rise of the International Novel." *PMLA* 72 (June 1962): 305-10.

INDEX

Abbotsford, 13-14, 172-73

Allston, Washington, 43-83; artistic goals, 48; changes in *Belshazzar's Feast,* 70-73; Cole and, 92, 93-94, 96, 97, 102, 115, 121; Coleridge and, 47-48; comparative conclusions, 187-90; Cooper and, 140, 156, 159; empire portrayed by, 75; Europe: first trip, 45-46; Europe: second trip, 48-53; financial practices, 50-52; financial problems in America, 65-69; Gothic imagery in, 57-58, 67; Greenough and, 103; Hawthorne and, 166, 173, 181; Haydon and, 50, 53, 65, 67, 68, 108; health problems, 66; Irving and, 13, 14, 43, 54; Italy and, 102-3; Martin and, 62-63; Old Masters and, 47; praised by lecturer at Royal Academy, 97; relationship with family, 45-46; returns to America, 53-54; Westall and, 60-61; West and, 46, 48, 50, 59, 66. Works: *The Angel Liberating St. Peter from Prison,* 52, 58; *Belshazzar's Feast,* 43, *44,* 45, 56-76; *Belshazzar's Feast* (color study), *56; Belshazzar's Feast* (sepia study), *55;*

Dead Man Restored to Life by Touching the Bones of the Prophet Elisha, 50, 52, 53, 58, 65, 75; *90; Elijah in the Desert Fed by Ravens,* 54, 98; *Jacob's Dream,* 52, 58; *Jeremiah Dictating the Prophecy of the Destruction of Jerusalem to Baruch the Scribe,* 65; *Spalatro's Vision of the Bloody Hand,* 109; *Uriel in the Sun,* 51, 52, 58, 70

Artistic tradition, 26, 31, 35, 46-47, 76, 91, 92, 97, 140-41, 173-74, 181-83, 188

Barrie, James, 148

Barry, James, 120-21

Beaumont, Sir George, 52-53

Bloodgood, Simeon DeWitt, 109

Bracebridge, Simon (character), 24-25

Brevoort, Henry, 8-9, 10-11, 13, 17, 19-20, 23

British Institution, London, 51, 97

Bryant, William Cullen, 106, 128, 137, 140, 150, 159, 175. Works: "The Ages," 118-20, 126; "To Cole, the Painter, Departing for Europe," 94-95

Byron, George Gordon Lord, 13, 73, 102, 105-6, 117, 118, 126, 172

Page numbers in italic indicate photographs.

About the Author

JOY S. KASSON is Associate Professor of American Studies at the University of North Carolina at Chapel Hill. Her scholarly articles have appeared in journals such as *American Quarterly* and *Studies in the Novel*.